SUSPENDED CONVERSATIONS

MARTHA LANGFORD

SUSPENDED CONVERSATIONS

The Afterlife of Memory in Photographic Albums

McGill-Queen's University Press
Montreal & Kingston · London · Ithaca

© McGill-Queen's University Press 2001
ISBN 978-0-7735-2174-2 (cloth)
ISBN 978-0-7735-3392-9 (paper)
Legal deposit third quarter 2001
Bibliothèque nationale du Québec
Printed in Canada on acid-free paper

First paperback edition 2008

This book was first published with the help of a grant from the
Humanities and Social Sciences Federation of Canada, using
funds provided by the Social Sciences and Humanities Research
Council of Canada.

McGill-Queen's University Press acknowledges the financial
support of the Government of Canada through the Book
Publishing Industry Development Program (BPIDP) for its
activities. It also acknowledges the support of the Canada
Council for the Arts for its publishing program.

All the albums illustrated in this book are from the Notman
Photographic Archives of the McCord Museum of Canadian
History and are reproduced through the generous permission of
the museum.

Canadian Cataloguing in Publication Data

Langford, Martha
 Suspended conversations : the afterlife of memory in
 photographic albums
 Based on a collection of albums, compiled 1860–1960, held by
 the McCord Museum of Canadian History.
 Includes bibliographical references and index.
 ISBN 978-0-7735-2174-2 (bnd)
 ISBN 978-0-7735-3392-9 (pbk)
 1. Photograph albums – Social aspects. 2. Oral tradition.
 3. Photographs in genealogy. 4. Photography in historiography.
 5. McCord Museum of Canadian History. I. McCord Museum of
 Canadian History. II. Title.
 TR650.L35 2001 907'.2 C00-901406-3

Typeset in Scala 9.75/13
by Caractéra inc., Quebec City

CONTENTS

PREFACE: HELLOHELLOHELLO

Besides how could you remember everybody? Eyes, walk, voice. Well, the voice, yes: gramophone. Have a gramophone in every grave or keep it in the house. After dinner on a Sunday. Put on poor old greatgrandfather Kraahraark. Hellohellohello amawfully-glad kraark awfullygladaseeragain hellohello amarawf kopthsth. Remind you of the voice like the photograph reminds you of the face. Otherwise you couldn't remember the face after fifteen years, say. For instance who? For instance some fellow that died when I was in Wisdom Hely's.
James Joyce, *Ulysses*

How shall we remember everybody? Bloom's modest proposal – the talking tombstone – holds considerable promise, but only on a Bloomsday was it likely to be heard.[1] By 1904, photographs, plain and simple, were the going thing. The prime virtue of photography was its vulgar success. Great-grandfather's portrait, the daguerreotype, was the trades-man's heirloom; Grandmother's album of cartes-de-visite was her proof of connection to the famous and the dead.

In mid-nineteenth-century parlours, genteel photographic phantoms lay quiet until stirred to half-life by polite inquiry. Illustrated calling cards, known as cartes-de-visite, and later products of the nineteenth-century studio, the cabinet card and the promenade, uttered their commonplaces with clarity

and refinement, but the language of photography was about to change. In the 1880s Eastman's Kodak introduced the vernacular effect. Its snapshot, however tightly composed, bore the name and the stamp of a rougher modernity, sudden, excessive, and noisy. Twentieth-century photography sped up with the action, everybody popping up everywhere, too many faces and names. Like Joyce's gramophone, the photographic record threatened to babble and distort over time. The amateur photographer, with his embalming pursuits, was in a race with truly murderous technologies; photography changed from a process to an industry whose products, like telegrams, were the markers of lives lived.

Still today, when natural or human-made disaster strikes, what does the reporter hear? "We got the order to evacuate. Our albums are all we have left." Such comments illustrate the importance of the photographic album, but they do not fully explain it.

Photography did not come quietly into the world, and its impact on the culture is an inexhaustible subject of debate. Even its origins remain in question. On one hand, we have a discovery, or multiple discoveries, that transformed the nature of pictorial information and revolutionized society; on the other, photography is described as the natural outgrowth of tendencies and conditions that predated its invention, that made it somehow inevitable. These arguments intertwine, and since neither side can imagine a world without photography, the ontological debate tends to shift ground, focusing on the legitimacy and competence of photography as an instrument of knowledge and deeper meaning.

Exponents of something called visual literacy, we have formulated our task in terms of translation, literally as the inscription of the photographic. Much has been written; but overtaken now by William J. Mitchell's "post-photographic era," we are still struggling to capture the photographic in words. The mystery of photography – its powerful grip on the popular imagination – remains unsolved.

Perhaps we should look at some alternatives. Bloom's suggestion is sound, and very sound is his suggestion. The parallels between orality and photography are striking. The structure and content of oral tradition – the fabric of memory in oral consciousness – are met in the photographic condition. In the thrall of written language, we speak always of *reading* the photograph; what I want to suggest instead is that we pause in the still of our photographic vaults and try just for a moment to listen. *How could you remember everybody?* The photographic album holds the key. Our photographic memories are nested in a performative oral tradition.

ACKNOWLEDGMENTS

The start of this book can be traced to a day in November 1992 – Friday the 13th, to be precise – when Stanley G. Triggs, then curator of the Notman Photographic Archives, introduced me to one of the McCord Museum of Canadian History's lesser known collections, a large group of amateur photographic albums. My lucky day was to stretch into weeks, months, and years, much of which I spent in the warm and knowledgeable company of the McCord's professional staff – with Stanley Triggs, until he retired, and with his colleagues at the Notman, Nora Hague, Tom Humphry, Anette McConnell, and Heather McNabb. As the project expanded, I was graciously helped by other members of the museum's staff, including Marylin Aitken, Suzanne Morin, Nicole Vallières, and Moira McCaffrey. The director of the McCord, Victoria Dickenson, deserves both public and personal thanks for her vision of the museum as a place of communication and research.

The progenitor of *Suspended Conversations* was a PhD dissertation written under the supervision of Dr Thomas L. Glen, associate professor of art history at McGill University. Dr Shirley L. Thomson, then director of the National Gallery of Canada, made it possible – indeed, encouraged me to undertake graduate work at McGill. A Max Stern Fellowship in Art History and a fellowship from the Social Sciences and Humanities Research Council of Canada supported the doctoral phase of the research, while three travel grants from the Faculty of

Graduate Studies and Research (1994), the Post-Graduate Students' Society (1994), and the division of International Cultural Relations in the Canadian Department of Foreign Affairs and International Trade (1996) enabled me to air some preliminary findings at conferences. The publication of this book has been assisted by the Humanities and Social Sciences Federation of Canada; I thank Simon Lapointe and his colleagues for their continued efforts on behalf of Canadian scholarship.

Over the years, lectures drawn from the work-in-progress were presented at the Canadian Museum of Contemporary Photography in Ottawa, the Foto Biennale Enschede in the Netherlands, the Institute for the Humanities at Simon Fraser University in Vancouver, and the Society for Photographic Education in Los Angeles. Martha Hanna, Megan Richardson, Michael Gibbs, and Petra Watson were among the tireless organizers of those events. Of the publications that ensued, I am indebted to Josephine Van Bennekom, Bas Vroege, and Wallace Polsom for their attention to my work.

Close, critical response is everything to an author. Comments from members of my oral defence committee – Dr Lon Dubinsky, Dr John M. Fossey, Dr John Marszal, Dr Constance Naubert-Riser, and the outside reader, Dr Jerald Zaslove – were just that kind of response, engaged and creative. Through Lon Dubinsky and the Canadian Museums Association program "Reading the Museum," I went on to coordinate a workshop for literacy learners at the Carrefour d'Éducation Populaire de Pointe St-Charles, where animator Johanne Bouffard and the eight learners taught me a great deal more about albums and orality. And two anonymous readers gave me sound, detailed advice on the penultimate draft of the book; I hope that this version meets their generous expectations.

There are people I can name who have shared information, recommended sources, or read the work at different stages: Louise Dési and David Harris of the Canadian Centre for Architecture; Pamela Realffe of the Missisquoi Historical Society; Andrew Rodgers of the National Archives of Canada; Roya Abouzia, Sophie Bellissent, Kathryn Harvey, Gerry Rodgers, Joachim Schmid, Joan Schwartz, Neil Sendall, Lorraine Simms, George Steeves, Timm Starl, Meeka Walsh, and Val Williams.

Robert Graham deserves special mention as the living embodiment of Aby Warburg's "good neighbour." Susan Alain, who found and donated the featured album to the McCord, provided what information she had and generally echoed my feelings about its richness. Gretta Chambers was kind enough to grant me an interview about her grandfather's photographic album; her valuable contributions to this study are woven throughout.

At McGill-Queen's University Press, I found a thoughtful reader and a kind, funny, no-nonsense coach in the person of editor Aurèle Parisien. Editorial assistant Joanne Pisano kept us both straight. Their colleagues on the second floor, production manager Susanne McAdam and coordinating editor Joan McGilvray, met the book with energy and serenity, the latter trait most appreciated by me. Elizabeth Hulse copyedited the book, which is to say that she very sensitively improved it, as did designer Glenn Goluska with his elegant vision of the book as a whole.

During my studies at McGill, I was privileged to work with Dr Thomas L. Glen. As a teacher and an art historian, Professor Glen has a particular affinity for human experience – the artist's, the beholder's, and the interpreter's. His observations and intuitions about the people who compiled these albums have been stimulating throughout. Dr Glen's sensitivity, knowledge, curiosity, integrity, and warmth have benefited many students, and this one in particular owes him a great deal. Having graduated to the status of friend, I can finally say, Thanks, Tom.

The warmth, support, and human comedy afforded by a loving family has been much on my mind as I have pored over these photographic records of private life. I am very thankful for my Langford and Coupal connections, and especially for my parents, Warren and Lucille Langford, my brothers, John and Stuart, and my sister, Suzanne Morrison. Three committed photographers in my extended family, Georgia Cumming, Laura Langford, and Kate Seaborne, deserve special mention. Through them, I thank the photographers and compilers whose albums are the foundation of this work.

Finally, I dedicate this study of photography and memory to my husband, Donigan Towers Cumming – or rather, offer it to him – in thanks for his faith and inspiration.

SUSPENDED CONVERSATIONS

The Afterlife of Memory in Photographic Albums

INTRODUCTION: SHOW AND TELL

Each of us values our own photographs and rightfully sees them as unique, even as we stumble on their doubles in the collections of friends and strangers. *Curiouser and curiouser*, recognizing ourselves in others seems somehow to increase the significance of our photographic trove, its predictability compensated by our greater sense of belonging and stability. This mixture of feelings, and a rush of others, is excited by personal photographs and concentrated in the presence of a photographic album.

Other collections may affect us, but never in the same way. What makes the album so special? Well, memories, of course. The photographic album symbolizes connections with the past. Consider Roland Barthes's inventory of signifying objects in a photographed composition: "a window opening on to vineyards and tiled roofs; in front of the window a photograph album, a magnifying glass, a vase of flowers." His deductive analysis follows: "we are in the country, south of the Loire (vines and tiles), in a bourgeois house (flowers on the table) whose owner, advanced in years (the magnifying glass), is reliving his memories (the photograph album)." The owner of the house is François Mauriac; the still life has been taken in Malagar; the photograph appeared in *Paris-Match*, illustrating a text that "renders the connotation explicit."[1]

Connotative, yes, but hardly explicit, for even as the landscape resolves at infinity, the true contents of the album are

vast and indeterminate, quite beyond even Barthes's formidable powers of inscription. The translation of an album poses an impossible task. Words, like photographs, are furious multipliers, a thousand for each picture, or so the saying goes. To match the photograph, every element in the picture (every propagator of codes) must be measured, weighed, and entered on a mental list, and that is just the beginning. A close reading of a photograph is like a stone dropped in a pond, with its ever-expanding inclusions, occlusions, and allusions. A book of photographs layers surface upon surface of real and virtual intersections; clusters and breaks are spaces of association whose meaning must be taken into account.

An unabridged translation of the Mauriac still life would be a borderless text, and Barthes has found a way around it. In an economic series of gestures, he outlines each object in the picture and fills it with latent meaning. The album as described is closed, its infinite connotations compressed between covers into a single word, "memories."

As in Barthes's mind, so in the public imagination, the line between photography and memory was easily drawn and instantly turned into the shorthand of advertising. James E. Paster's analysis of nineteenth-century print advertisements placed by Eastman Kodak documents the company's early discontinuation of technological claims and its prescient adoption of these slogans: "the snapshot as memory; the camera as storyteller; photography's ability to 'capture' time and extend the experience of the moment."[2] Kodak's dream became an industry standard. In 1919 an Ansco Vest-Pocket Camera advertisement counselled, "Keep the Doors of Memory Open with an Ansco," adding, "Pictures always tell a story better and quicker than words." The accompanying illustration (drawn, not photographed) depicts a fashionable young woman cuddled up beside an elderly lady, as together they gaze at the pictures in an album.[3]

For sociologist Richard Chalfen, this kind of encounter meets the purpose of family photography, "primarily a medium of communication."[4] He defines the family album as a site of cross-generational exchange and cultural continuity,

transformative and moderating as family members are exposed to the external pressures of acculturation. He reasons further that the phenomenon he calls "Kodak culture" may be permanently altering the nature of storytelling. While oral and written traditions have not completely disappeared, Chalfen suspects that memory "is being aided and probably reorganized in new ways."[5]

His hunch fits into an old and unresolved dispute. As long as photography has existed, claims for its usefulness as a repository of memory have been countered by arguments that echo the ancient distrust of writing, the fear that reliance on any system of recording ultimately leads to mental degeneration, to a condition of mnemonic atrophy. In neither case has the hypothesis been proven; nor is it likely to be. Mechanical reproduction, even in the most skilful hands, cannot match the operations of human consciousness; the photograph is both too selective and too retentive. Finally, it is too productive of visual description. If photography seems on the surface to have crept in everywhere, its visible effects on custom and communication are not automatically transferable to the workings of the mind; other factors may also be at work. Art historians, such as Heinrich Schwarz and Peter Galassi, have catalogued signs of cultural readiness that explain the nineteenth century's reception of photography, a fixation on progress mixed with a demand for illusionism in art that returned to the Renaissance.[6] Adopting an interdisciplinary approach, Geoffrey Batchen has posed the hard question of why photography emerged when it did, his answer drawing the desire for photography even closer to the aesthetics of the European culture that spawned it and complicating the genealogy of photography with a binary-busting play of difference.[7]

Histories of photography that are ontological, ideological, technological, and to a certain degree, illogical interest us now. We seek such nuanced explanations because we know that states of consciousness, human impulses, and social authorities change at imperceptible rates. At the same time, the success story of photography is a fact that continues to

dazzle and bemuse. The Victorian era is generally considered a period of calcified values and social restraint, yet we hardly question the ascendance of the photographic album, purchased in a shop around the corner and installed just as quickly on the family shrine. The widespread acceptance of the album – the same basic instrument in use today – suggests that more was at stake than keeping up with the Joneses. The album seems to have awakened dormant forces, filling a void, as Anne-Marie Garat has inferred. "The family album, in its naive and defective way, certainly satisfies the immense need for a *story* [*le dit*] which for lack of written documents [*l'écrit*] haunts each family."[8] Henry Sayre says something quite similar yet provocatively different when he describes the slide show and the family album as "the mnemonic devices of a new oral history."[9] This is another way of saying that the album functions as a pictorial *aide-mémoire* to recitation, to the telling of stories.

The showing and telling of an album is a performance. Most of us are spoiled by the ideal circumstances in which we normally encounter an album – with an interpreter in the home. Viewing an album in company must be considered the normal spectatorial experience, so persistent is the framework in scholarly and literary description. This is not because a private album is so openly accessible, but precisely because it is not. Its personal nature and intended restriction to a circle of intimates, even to an audience of one, licenses singular arrangements of situational images that need explanation and are enhanced by a tale. So firmly established is this concept of togetherness that the solitary inspection of an album can effectively be used by novelist Cormac McCarthy as a catalyst for alienation, confusion, and grief. "The old musty album with its foxed and crumbling paper seemed to breathe a reek of the vault, turning up one by one these dead faces with their wan and loveless gaze out toward the spinning world, masks of incertitude before the cold glass eye of the camera or recoiling before this celluloid immortality or faces simply staggered into gaga by the sheer velocity of time."[10]

Looking at another person's snapshots, slides, home movies, or tapes can indeed be killing: presentations are rarely of short duration, and repetition seems endemic to the genre. The real-life domestic experience is loaded with compensatory pleasures – intimacy, conviviality, emotional investment, perhaps a slice of cake. Inside stories frame the pictures, animating the most stilted of studio portraits with family secrets and subversive tales. Emotions run high, as in 1917, when Jessie Robinson Bisbee looked and listened with her heart. "We smile as we remember the old family groups, some of them stiff and inappropriate, some of them a bit faded and dim with the years, but close to every smile there lurks a tear, for 'the touch of a vanished hand and the sound of a voice that is still' comes vividly before us with the memory."[11]

Voices must be heard for memories to be preserved, for the album to fulfill its function. Ironically, the very act of preservation – the entrusting of an album to a public museum – suspends its sustaining conversation, stripping the album of its social function and meaning.

When we enter the museum, what do we see? At the McCord Museum of Canadian History, albums are frequently on display. The lighting of these works on paper will necessarily be dim, and the object will likely be set in a glass cabinet. The album will be closed if the cover is unusual or, if its contents are pertinent, open to a representative page. The visitor is permitted to gaze on this fragment, which is labelled according to contents, medium, dates, and donor. Occasionally, an album is included in a drawing-room setting, with a group of costumed mannequins dumbly looking on. Succumbing to the urge to animate this crowd, to touch the album or to turn the page, will bring a guard into the picture, and eviction from the building will be swift. Albums are delicate objects, and much like stuffed animals, the more they were enjoyed, the more they appear to have been abused.

Privileged access to the albums is granted by appointment and takes place in the museum library or vault. Here the atmosphere changes completely from one of artificial cosiness and regulated distance to bibliographic sobriety and the

chance to browse. The photographic surroundings are some-what daunting, comprising the Notman Photographic Archives (400,000 images alone!) and some 300,000 works by other photographers, including an estimated three hundred photograph albums (how such a collection came to be is revealed in appendix 1). These represent the three categories of albums that emerged in the nineteenth century and carried on through the twentieth: personal albums, specialty albums, and official albums. Under personal albums, historian William Welling includes the crafted albums of wealthy European amateurs, as well as those specially designed for cartes-de-visite or stereographs.[12] Personal albums reflect the predilections and experiences of the compilers whose collections, memoirs, travelogues, or family histories they are. These four subcategories of the personal photograph album are well represented at the McCord Museum. Over two hundred albums are laid out in drawers, assigned according to medium (cartes-de-visite, postcards, or snapshots), theme (family, region, or period), and availability of space.

In the clinical surroundings of the vault, the luxurious materials of the covers make a striking impression: jewel-like miniatures in brilliant morocco; mother-of-pearl and japanned covers; gold stamp and gilded edges; burgundy velours and brass fittings. Beautiful and immutable, they appear as private worlds, preserved for the ages in their conditioned resting place. When their pages are turned, some albums and pictures seem remarkably fresh, otherworldly in their direct mediation with the past. Others, lifted from the drawer for inspection, are revealed in pitiable fragility: bindings weakening or splitting; cartes-de-visite sunk into their pockets; pictures fading; photo corners dried and springing loose; botanical samples (or tokens of affection), once tucked safe between the pages, now crumbling to a greenish dust.

Closed covers, reinforced with white muslin ribbons, lend an air of completeness and uniformity that the contents themselves betray. Loose prints or clippings, tucked between the pages, wait for the compiler's attention. Blank pages interrupt the narrative flow, and many signs of alteration, pictures lost or excised, offend the orderly mind. Despite the institutional setting, the drawers seem stubbornly to retain the unruliness of the domestic hoard so accurately described by the American writer Padgett Powell: "One's personal history, it seems dangerously obvious to me, is ordered precisely as a drawer of family snapshots: it is *not* ordered, it is lost, it is illogically duplicate (there are several copies of insignificant photos, while dear ones are absent – one lives dull days again and again, while the big moments go forever underexposed), it is finally random. To recount a history, you open a drawer."[13]

I am opening a drawer in the vault of the McCord Museum, drawer 88D. An expandable album catches my eye, and not for any particular reason; perhaps its very plainness gives me permission to pick it up. The album has a soft, brown leather cover; its loose-leaf pages are black; photo corners hold the prints; a black cord keeps the album together and carries the museum tag with its accession number, MP 035/92. That part at least can be decoded: the album was the department's thirty-fifth acquisition of 1992.

In the same drawer are a number of family albums. Many have come directly to the McCord from their compilers or their descendants; they are accompanied by lists, genealogies, clippings, and personal letters that place the albums in a familial context. Nothing accompanies this album, save the name of its donor, Mrs Susan Alain, and an oral history of its acquisition. Mrs Alain purchased the album in Montreal from a collectibles outlet, The Little Shop, whose owner, Mrs Silverstone, remembered buying the album at Les Glaneuses, a second-hand store in the east end of the city. Both women had found the album interesting and worth preserving, but neither knew anything more about it.

The museum's acquisition of the object had resulted in a short written description, justifying its value and cataloguing the lot. For institutional purposes, it seemed sufficient to say that the album consisted mainly of some 250 snapshots, many taken in the vicinity of Ste-Adèle, Quebec, during the thirties and forties. This was an accurate reflection of the limited data – inscriptions on the borders or surfaces of the

prints – supplemented by a cataloguer's recognition of cars, fashions, social trends, and the topography of the Laurentians. The place names, dates, and some few precious comments had been written in French, so the language question was settled. Illustrating such leisure activities as touring, boating, and ice cream making, the album was welcomed by the McCord because it complemented the museum's concentration on Canadian social history while illustrating the enthusiasms and possessions of a *typical* Quebec family.

Leafing through the album, I consider this turn of events. MP 035/92 is the work of enthusiastic amateurs, its pictures clumsy to competent, its technical experiments naive. In the twentieth century, wherever ordinary men and women had access to photography, snapshot albums like this one were compiled. Most people would be surprised to learn that a museum would be interested in such a homely object; they would compare it with more polished examples, perhaps even their own family album, and this modest, undefended example would inevitably come up short. Probably the most surprised of all would be the album's compilers. Nothing in their lives – nothing visible in the album and no signposts in the culture – offered them that possibility. Whoever they were, they made this album for themselves, ignoring the most basic requirements of posterity, with the result that what was once private is now anonymous. Its title stamped in the factory, this sparrow-brown album has come down to us as "Photographs," linguistic camouflage for the pure product of French Canada in Quebec.

This private album is now a public document, and so its official inventory begins. The album contains 234 gelatin silver prints (3 unmounted, 3 hand-coloured), 5 studio portraits, 6 postcards, 1 "In Memoriam" card, and 1 newspaper clipping. The dates and place names can be listed, even those hidden on the backs of the prints, which I am authorized by the museum to record. Inscribed dates run from 1924 to 1945. Inscribed locations, mainly in the province of Quebec, include Beaconsfield (1), Cap-de-la-Madeleine (1), Caughnawaga (3), Lac Noir (5), Rigaud (2), St-Barnabé (2), St-Donat

(7), St-Esprit (2), St-Jean (1), St-Maurice (4), St-Ours (3), Ste-Adèle (9), Ste-Agathe (1), Ste-Julienne (3), and Terrebonne (3). This little exercise is revealing, though in quite unexpected ways. The emphasis on Ste-Adèle and the Laurentians, noted in the registrar's description, suddenly seems misplaced. The registrar's entry was based on the written word, but on visual inspection the absence of writing becomes much more telling: of the 234 prints, only 47 are inscribed with place names. Correlating places and dates shows that many of the inscribed pictures were taken at the same time. What about the rest? Other sites, some photographed year after year, are unnamed. Places forgotten? Unlikely; the reverse would seem to be true: the weighting of inscriptions skews the data because only the ephemeral is inscribed. After all, one shoreline in the Laurentians looks pretty much like another. So the beach at the rented cottage is carefully identified, while the compiler's permanent address or regular haunts are withheld. But the irony is that none of this really matters. A historical geographer, led to the album by a search for place names in Quebec, would be sorely disappointed, for the landscapes and buildings of the Laurentians are nothing more than picturesque backdrops for the important work of the album, which is portraiture.

Richard Brilliant explains how the portrait seizes the imagination as an "oscillation between art object and human subject," as an expression of the "intended relationship between the portrait image and the human original," a relationship bound up in what Hans-Georg Gadamer calls "occasionality," capturing the "function of the art work in the world ... the cause of its coming into being." Brilliant's study of portraits is, as he explains, a book about relationships. We might ascribe the same intentions to our private album. But implicit in Brilliant's take on the portrait – indeed, explicit in his text – is the problem of representation, the artistic expression of identity that characterizes the Who who is the subject.[14]

There are two principal subjects in this album, both women. Dates and places inscribed on their portraits range from 1929 in St-Ours to 1945 in Ste-Adèle; these are the

biographical milestones. The older of the two women is pictured approximately 115 times, the younger approximately 88 times. Three secondary figures (man, woman, and young man) each appear more than 20 times. Other people have been photographed more than once, singly and in groups. Their relationships, celebrated again and again, are the core of the album, though these relationships remain unclear. Any artifact extracted from its original context poses questions of provenance and significance; a once-private photographic album is perhaps more poignant and insistent in its appeal to reconstruction. Poring over this album for clues to its origins, one is struck by the irony of a direct equivalence between intimacy and loss. So familiar at one time were these faces, places, and dates that there was little need for the compiler to write them down. Now they are lost forever, and they are not the only misplaced keys. Powell's rules of order seem to be in force, "*not* ordered ... lost ... illogically duplicate ... random." By the rule of randomness alone (for there is no real evidence), we might decide that the album represents a family. The names of individual members are lost, but perhaps we can learn something about them by reading their picture-story from the beginning.

The compilation glows with intimacy and affection. The dedication on the inside front cover is a red paper heart pierced by an arrow: *Amor vincit omnia* (Love conquers all). The same motif is repeated in the heart-shaped photo corners that affix the earliest pictures in the book. The red corners seem to have run out or been discarded in the twenties, when conventional black corners came into use. The last heart appears on page 16, where heart-shaped corners glued down for a missing photograph hold only one corner of its smaller replacement. Though the format of the photographs varied over time, the hearts are the real indicators of change. Their use and placement suggest that the album was compiled by at least two people in succession. The heart-shaped corners were used by the first compiler, whose project was somehow interrupted, taken over by another, and partially erased. The evidence lingers in bits of red paper still stuck to the album's black sheets. That it changed hands and was continued by another is not very unusual. What is intriguing is the blending of the two chronicles, the second compiler's discreet attempts to preserve, while reordering, the past.

From the dedicatory heart, the album opens up into a melee of impressions. Tucked between the inside cover and the first page is a single, unmounted snapshot of a woman dressed in the flowing trousers and striped jersey of the forties, posing on a ladder at the back of a freight car. She waves gaily at the photographer. Though unfixed, this photograph stakes its claim to the front of the album, for its pendant is mounted with black photo corners on the very first page. Another woman, wearing her own version of feminized trousers, hangs from the other side of the train, smiling at the photographer, whose elongated shadow streams across the bottom third of the frame. This photograph is in the middle of page 1. On the left, inscribed "1936," the very first picture in the album shows a little girl standing beside her rocker in a paved front garden that features an outdoor staircase and a wrought-iron fence, both typical of Montreal. On the right, a toddler, a woman, and a man on a balcony: standing in the background, the man engages with the photographer over the head of the woman, who squats beside the child, trying to ready him or her for the camera. This photograph is affixed with red-heart corners used upside down, so that the points, instead of the curves, stick out from the corner of the print. And yet this image seems of the same vintage as the first, since it is printed with a matching curlicue border.

From left to right across pages 2 and 3, there is, first, a vertical image of a woman. She stands, smiling broadly with arms folded, leaning toward the camera. Her printed dress has a distinctive leafy collar that suits her implantation in the landscape, where she is partially screened by a bush and dwarfed by a tree. The back of the print is inscribed, "4 septembre 1933 Baie Georgia." Next, five flappers in short skirts and cloche hats pose in front of a fountain with blast furnaces in the background, a view identified as "St-Jean." The heart corners are more cleverly applied, with curves at the top and

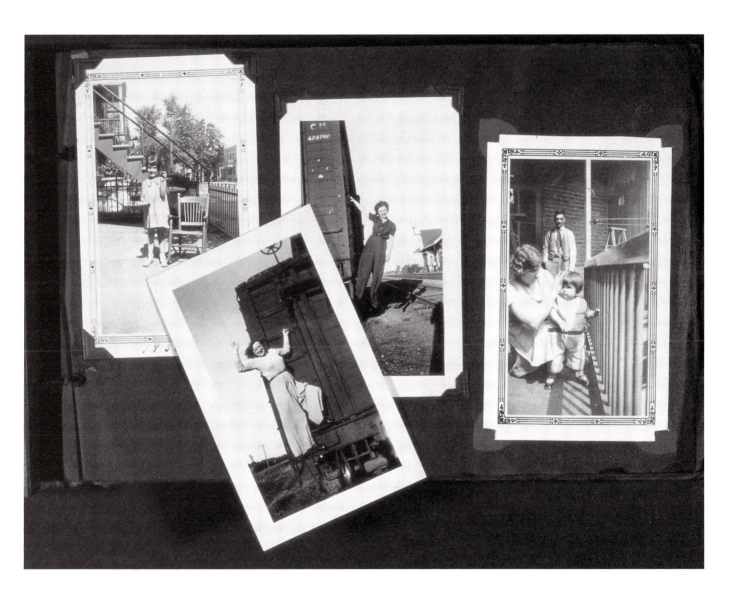

"Photographs" 1916–1945 (MP 035/92), 1

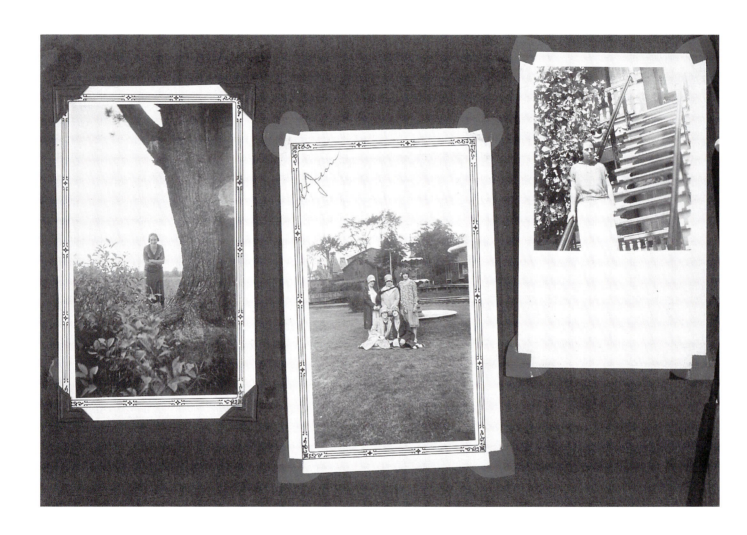

points at the bottom; perhaps the St-Jean portrait was put in by a different hand. The third picture is of a young woman, probably in her late teens, posing on an outdoor staircase, which, if we check back, is not the one we saw on the previous page. The print has an odd format, a deep bottom border that is nowhere repeated in the album. Possibly from a home darkroom, it was likely given to the compiler. This photograph is also affixed with hearts.

On page 4 a wedding picture from the twenties or early thirties catches a couple and their guests descending the stairs of a public building, possibly the church. Beside it is an image of eight men and women lined up to be photographed in dark overcoats and hats. A light covering of snow suggests early winter or spring and a special occasion, since the women's footwear is a mixture of boots and shoes. The figures and costumes do not match the picture on the left, and the format is also different, a plain, narrow border instead of a printed one. Across the bottom of the page, two excursion or holiday snapshots complete the spread. On the left, "Cap de la Madeleine" is inscribed across the light part of the print, a white rock. Sharing the frame are two women and two boys, whose "Sunday best" belongs to the twenties. They seem to be at an organized picnic or pilgrimage; a cross pokes up behind one head, and the participants are wearing ribbons. On the right, "Baie Georgia 1933" jumps forward in time, but points back to an image on the opposite page. Our lady of the printed collar, her radiance somewhat diminished, is now surrounded by two women and a boy. The women stand; the boy crouches. All four hold glasses from their picnic hamper, which is a cardboard box. Glancing back at "Cap de la Madeleine" reveals that the female figure shown in three-quarter profile in both images is one and the same person; likewise the boy, who has now sprouted into an adolescent.

Pages 4 and 5: the inscriptions suggest a span of eight years, from 1933 to 1941, but this is deceptive, for the pictures go as far back as the teens and wander through Montreal, St-Donat, Ste-Adèle, and other locations unknown. Several figures are beginning to recur, but fluctuations in age and situation make them hard to identify. Just in time, our lady of the printed collar springs to the eye, in the familiar setting of a picnic. Now we meet the man who took the previous shot, for the Cap-de-la-Madeleine woman has taken up the camera. The pretext here is ice cream; they have been making it on the spot (a different spot, for we are now in St-Donat), and they pose in flushed triumph before a split-rail fence, saluting the photographer with their bowls and spoons.

There are eight pictures in this double-page spread and almost as many ways of grouping them. Three small, deteriorating snapshots (held by hearts) can be dated by comparison with pictures on page 7 to the mid-twenties. Two of these most certainly record one wedding, while a third of the same vintage is rather less formal in costume and setting. Two larger photographs of a group of adolescents and teenagers mark another rite of passage, possibly their graduation. Eight girls and boys form a receding line, hands on each other's shoulders, with a ninth figure, the proverbial kid brother, bringing up the rear. They are standing in a field behind a row of houses; the background is screened by a high clapboard fence. The companion picture has been taken down a long banquet table set outdoors. A grinning face now growing familiar is among these celebrants. The same girl pops up in a third group, seven spirited young women dressed up for an outing, posing on the deck of a ferry or ship.

One picture, the first in this spread, remains to be described. It is a horizontal snapshot of a woman with short, dark hair wearing a severe, forties-style costume: striped jacket, necktie, and straight skirt with brogues. She is standing in a field, legs firmly planted, head turned to her left; the effect in this montage is one of guardianship over the pictures. This photograph was taken on 1 September 1941, toward the end of the period covered by the album. It marks a trip that this woman and the grinning girl, by then around forty, took to Ste-Adèle.

One could go on describing spread after spread, but perhaps these examples are enough to demonstrate the rule of randomness and its resistance to reading. Pages 1 through 5

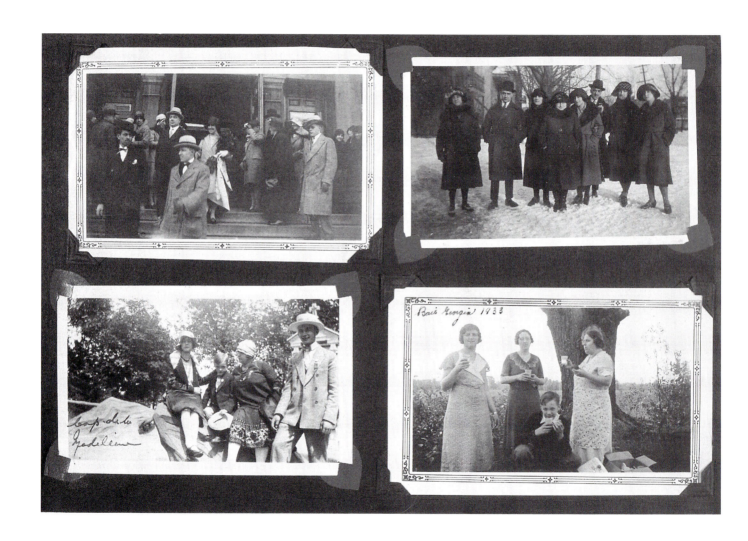

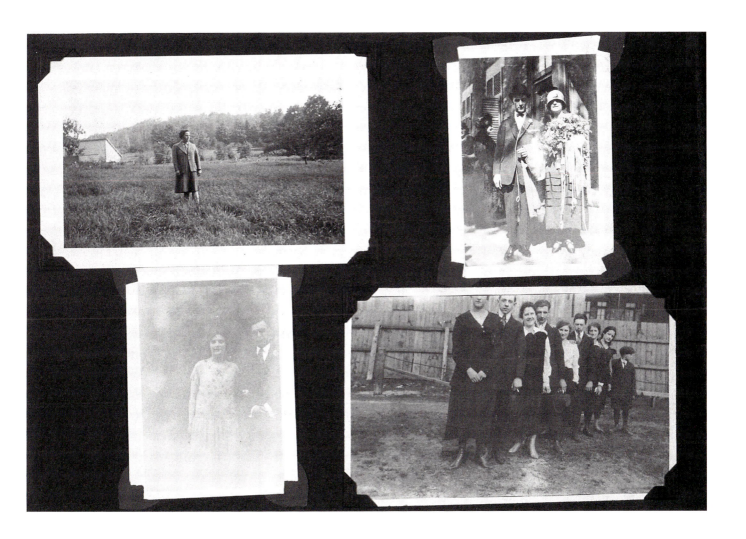

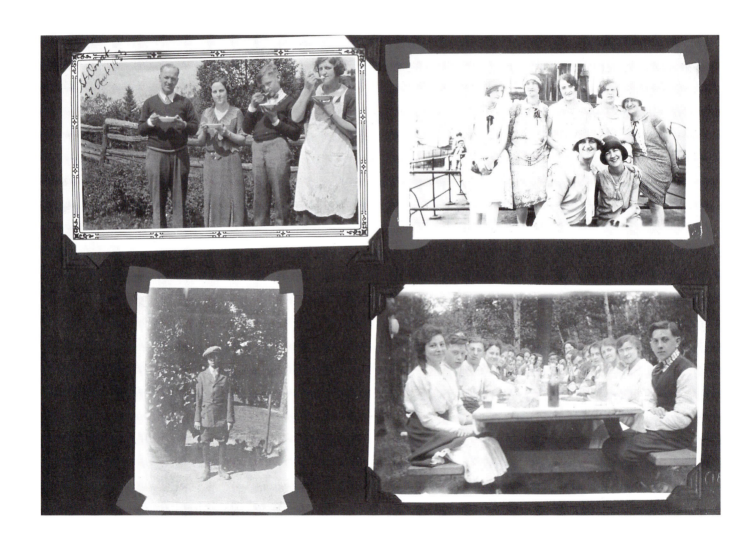

of the album use multiple presentation, strategic organization, ritualized performance, and formal emulation to build internal references and recapitulations (order of a kind) in a jumble of photographic memories. This is a very turbulent stream of impressions that begins to calm down on page 9.

Here we have three photographs. Two are clearly inscribed "St Ours." They are portraits taken on a summer day of two young women. The third image, in the middle of the page, seems a bit of a digression, different in form and content (a small snapshot of a little, fair-haired girl posing straight as a poker in front of a house). The first St-Ours picture captures the woman with short, dark hair (our lady of the printed collar; the woman in the tailored suit) as a girl in her late teens. She is standing behind a flowering bush on a village street. Behind her is a one-and-a-half-storey clapboard house with a high-pitched roof and a post-and-beam porch wrapping around the front and side – a village house typical of the region, the Montérégie. The other St-Ours picture shows the same girl perched on the arm of a rocking chair in which our grinning girl, all grown up, is sitting with a magazine. Closeness and a strong family resemblance suggest that they might be sisters; the rest of the album corroborates that impression.

In the St-Ours pictures the sisters are both rather glamorous, in fashionably loose, low-waisted dresses, sheer stockings, and Cuban heels. Certainly they would have been noticed in the sleepy agricultural community of St-Ours, where, as the town clerk put it, most people at that time stayed in the parish, rarely venturing further afield than St-Jean. By the beginning of the century, the world was already rolling past St-Ours. The village had put its trust in the Richelieu River and missed out on the railroad.[15] These pictures are not dated, but another, taken on the same day by the river and mounted on page 23, is dated on the back "1929." A fourth picture, showing the older girl on the riverbank (uncaptioned, undated, page 12), completes the St-Ours group. The two riverbank pictures mark a defining moment in the creation of the album, the first in a cycle of paired portraits that the sisters will make.

Mentally, we are beginning to race back and forth – or rather, to be lobbed back and forth by the album's cross-references and connections. Links between pictures, whether by place, date, costume, pose, composition, physical resemblance, or placement on the page, demand to be checked. Once we have gone through this album from front to back, a maddening game of concentration begins. The young woman on page 1, hanging from the train – did you see her on page 74? Now there is an odd trio of pictures. The young woman stands on the railroad tracks, the steel rails gleaming to a point beyond the horizon. Bottom right, an elderly woman lying in bed looks at a magazine with a young female companion. The patient is a key figure in this album and the only person whose name is inscribed. Rachel first appears on page 14, photographed in 1929. Her name is given much later, accompanying a picture from the thirties in which she is shown sitting beside a porch in a rocker. She is very strong in these photographs. When we find her on page 74, she is old, her physical strength diminished, but she is still very magnetic as she receives a young visitor in her bedroom. Top right is a funny little party of sailors, their dinghy pulled up in the reeds. Middy blouses and balloons suggest a regatta held sometime long ago – long before now and long before the other two pictures on the page. The boating scene is echoed on the opposite page by a picture of our two sisters in a rowboat, "Août 1938." And so it goes, combining and layering pictures by degrees of pastness and immediacy, with silliness, sentiment, and bravado leavening the mix. Lives are leaping across these pages, back and forth through time and space, with almost unbearable agility. The compiler's disregard for chronology places the very nature of this album in question since experts have told us that the family album is supposed to represent continuity.

MP 035/92 contains photographs gathered over thirty years, a substantial chunk of family history. The first period of compilation might have flowed smoothly into the second. The album might have been organized to reconstruct the life histories of the principals from adolescence to middle age;

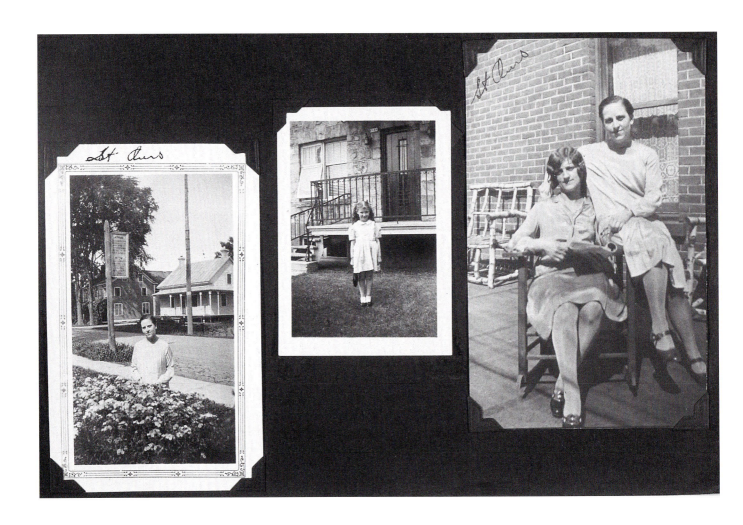

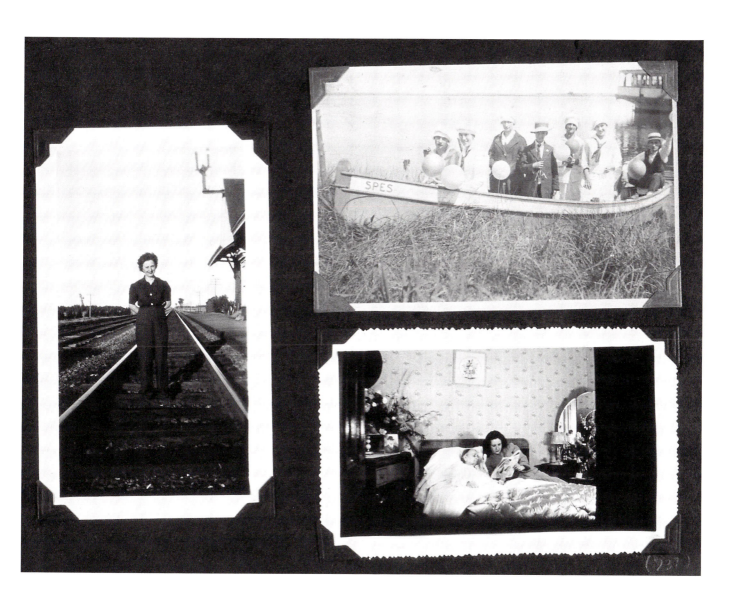

major events, such as births, weddings, new cars, family reunions, and funerals, might have been presented in the order in which they occurred. This was not done, and our examination of a substantial sampling of private albums held by the McCord Museum will show that it was almost never done. Some other imperative guided the hand of the compilers, creating albums of thematic clusters and serpentine narratives. In the last chapter, we will return to this album called "Photographs" and immerse ourselves in its motive force.

Should the motivation not be obvious? Was this family not simply following fashion in recording its collective history? In a way, it was, but where did this fashion sense come from? When the compilation of photographs into albums began, a number of directions were available: bound collections of prints, drawings, postcards, and stamps; commonplace books of prayers, poems, aphorisms, and keepsakes; specimen books; diaries, journals, and memoirs; travellers' sketchbooks; and family Bibles. These were the cabinets of nineteenth-century curiosity, the private repositories of material culture. As people began to accumulate and organize photographs, one might expect the influence of these precedents to be felt, and it was. Personal photograph albums are also anthologies, adventures, meditations, and shrines. Understanding the nuances of these different forms of expression brings us closer to the intentions of the photographic compiler.

But as we shall see in our examination of album-collections, album-memoirs, album-travelogues, and album-genealogies, proto-photographic or contiguous categories are both helpful and inadequate; no photographic album that I have seen quite fits the non-photographic mould. Single images do multiple duty as portraits, tokens of affection, and records of place; they are combined with others in mysterious fashions; the albums deny closure by categorization. Carte-de-visite and snapshot albums are equally elusive and dichotomous, their frippery and spontaneity so obviously the product of planning and paste. How shall we reconcile these contradictory traits? By paying attention to the particulars: patience is what the album teaches. For just as the fascination of photography cannot be explained without recourse to the whole history of the culture, neither can the ontology of the album be restricted to the trends and humours of its short existence, or even to the conventions of its direct precursors. We need to look closely at this object and to imagine it in use. Actually, this is not such a leap of the imagination, for the album *is* in use. *We* are looking at it *now*.

The removal of an album from a private situation to the public sphere does not deprive it of a context, but substitutes one set of viewing conditions for another. An institutional setting, however impersonal, is never neutral: just as there is no generic compiler, so there is no standard museum. A private album in a public museum is a microcosm that bridges two macrocosmic collections, the compiler's and the custodial institution's.[16] Their histories intersect, with interesting lessons for the historiographer. Eilean Hooper-Greenhill has identified two traditions in writing the history of museums, the first chronological and incremental in objects and personalities, the second a closer, more contextual variation on the first. Neither approach interrogates the material to the satisfaction of Hooper-Greenhill, who calls for a third approach, an "effective history" of museums that replaces linear histories with patterns of convergent historical factors. Her proposal is almost overwhelming in its implications, substituting explanations of links between objects on an encyclopedic chart with detailed questions about the gaps.[17]

Questions about gaps are all too familiar to the student of private photographic albums. In the mind of photographic historian Timm Starl, the apparent absence of rational interconnections between elements discourages integral or biographical readings of albums; statistical analysis of the contents by types of subject is the only sensible course.[18] But gaps, as unexplained links, have their own lucidity. While they can never be resolved with unquestionable finality, they are no different from any other ambiguous element in a work of art, neither mistakes nor secrets. At the same time, there is no guarantee that the compiler was aware of, or

could have explained, his or her leaps and digressions. Not all communication is conducted in the open or with full consciousness of its effects. We are accustomed in conversation to weighing both words and silences. The same factors are at play with an album that silently submits itself to verbal translation.

At the McCord Museum a translation of albums has already occurred, in the sense that they have been moved, as relics, from the private to the public sphere. Their function and meaning have been modified in the process. As a museum of social history, the McCord collects albums as examples of professional and amateur activity and as quarries for photographic illustration – a kind of Faustian pact allows the document to survive. Searching an album for its original meaning and recording one's findings is a retranslation that tries to be faithful, not just to the object as it was in life (in the hands of the compiler), but as it survives in what Walter Benjamin called its afterlife (where the translator finds it). In the afterlife of a photographic album, *pure past* is a mirage, a set of conditions seemingly visible yet irrecoverable even in the imagination. The world as experienced has been transformed by each act of translation (visible world to photograph; photograph to album; private album to public realm; public realm to individual reception). In "The Task of the Translator," Benjamin is talking about canonical, therefore highly disputable, works of art, and he is also talking about writing. But what he says about all great texts, that they "contain their potential translation between the lines,"[19] applies equally to the photographic album as found in a public museum.

For what we know from experience to be the album's normal method of presentation – pointing, talking, filling in, holding forth – is missing and must be supplied from the visual evidence and the framework of its display. Conceiving the album as an act of communication means reactivating a suspended conversation that fills in those gaps by reawakening the actors, the agents that Barbara Hardy calls "tellers and listeners." Enter the average person, for as Hardy explains,

The man in the street who says that he could write a novel if only he had the time isn't necessarily a laughing-stock. Like everyone else, he is telling stories and scraps of stories every day of his life, assembling and revising the stories of his days into an informal autobiography. It wouldn't necessarily be a readable narrative, let alone a best-seller or a work of genius, and it might be too inarticulate, unformed, and uninventive to be interesting even as a tape-recording of the mind, a type of *récit vérité*. But even if we take the dimmest view of the narrative powers of the dimmest mind, story-telling doesn't have to be brilliant in order to perform its good or bad functions. It is characteristic of great story-tellers to warn us not only off books, but also off brilliance.[20]

Point taken, with one cautionary note: however bookish its appearance, the photographic album needs to be distinguished from analogous forms, both visual and textual, and analyzed in specific photographic terms. For if the album collects photographs, its subject matter has been selected from the visible, reproducible world. The invisible, mechanically irreproducible states of reflection, cult, fantasy, and desire have somehow found a place in its indexical relations. There is room in the most ingenuous photograph for information and speculation, objective description and copious "what if." In an individual photograph there is, if anything, too much room. The Swiss-born photographer of *The Americans*, Robert Frank, put it very plainly when he said, "Photographs leave too much open to bullshit."[21]

Marshall McLuhan perceived the photograph as a visual report "without syntax." If so, might the insertion of a photograph into an album not function correctively? Compilation ought to bring the album's constituent photographs to order within what McLuhan might have recognized as a larger "net of rationality,"[22] a particular syntactical structure that is more than a convention or a genre. But even in the simplest arrangements of photographs, that structure can be elusive. Transparentness, like a photograph, is an illusion, nothing more than a glass surface that must be cracked into a network of connections. Call it McLuhan's "net of rationality," Roland

Barthes's "message without a code," or an analogue of story-telling and memory that we shall examine more closely, John Berger's "field of coexistence," the beholder's dilemma remains the same.[23] As we examine our collection of albums, we find a style of photographic exposition that is never linear, but idiosyncratic, meandering, stubbornly non-Aristotelian. Against the stability of any text, however provisional, the album seems structurally unleashed, more like Hardy's insistent man on the street. The organization of the album *reflects* the workings of his mind.

Garat sees the family album as a hybrid novel – a saga, a chronicle, a life story, an autobiography, a legend, a photo romance – all these things at once. "A draft always started over in a recitation for several voices. Family photography makes people loquacious. It engenders a text from the oral tradition – collective and sustained by successive contribution."[24]

The album is an instrument of collective show and tell. "It engenders a text" that is not a text but a conversation. An album is an oral-photographic performance. That is a very simple statement and a provocative one. For if the meaning of an album depends on oral presentation, there must be links between photographic culture and oral tradition that could be understood better and put to use in the interpretation of albums.

Others have tried to understand the album, and we will begin by retracing their steps. Scholarly and artistic interpretation of amateur photography has been very active since the 1960s, and the album has been a part of interdisciplinary studies and museum displays. But a photographic historian setting out to analyze the contents of an anonymous album in a public collection finds surprisingly little to go on. There are exceptions, of course, but most references to the personal album in photographic literature and works of art tend to replace the personal with the collective, discouraging any hope of specific analysis and finding reasons in the content and structure of albums to do so. Accordingly, much of the discourse – texts and objects – centres around a notion that I have called the *idea* of album – a paradigm, a metaphor, and a ritual – an object of thought, not a tangible object at all. We shall pursue this concept in the next chapter, tracing its history and influence on several generations of photophiles and photophobes, whose pronouncements on the album have been energizing, to say the least.

This study is determined to take hold of the tangible object, to grapple with its specific contents, structure, and reception. The McCord Museum offers an exceptional opportunity to do so because the collection is large, varied, and authentic, and it spans not just *a* photographic century but *the* century of the photographic album, 1860 to 1960. The forty-one albums discussed in this book reflect the breadth and strengths of the host collection. They are all very interesting, some quite exceptional in terms of subject matter and creative presentation. Applying formal and contextual analysis to forty of these, *reading them* as cultural texts and, as Griselda Pollock says, "re-reading ... symptomatically as much for what is not said as for what is," we will discover what can and cannot be learned.[25] The same albums will be further analyzed through recourse to oral tradition. But as our primary example, we will follow Hardy's advice and concentrate on MP 035/92, which in its off-brilliance matches the profile of amateur compilation that the *idea* of album enshrines. MP 035/92 belongs to all categories, touching on collecting, reminiscing, travelling, and family life. Its time frame is also fortuitous since it begins around 1916, about halfway through the album's first century, and ends quite close to our era.

Close, but only close, a fact that brings me to a small point of caution. Strangers in our own fluid present, we have a relationship to the compilers of these albums that is one of difference and distance, tinted by nostalgia and shaped by our knowledge of subsequent events. With regard to the last point, we have to be careful. Hindsight on the calamitous century now ended wants to turn prosaic pictures into poetry, and this is a very natural response.[26] What we need to understand is that previous generations, whose pictures these are, also used them figuratively to emblematize the stories of their

lives. The ordinary and the expected are only what is pictured; the album gives voice to the intensity of human experience. We should not presume to know in advance what those seminal experiences were, or how individual, social, and political factors should be weighted.[27]

Using a *typical* example, I will argue that the roots of the photographic album run far deeper than our vision of bourgeois typicalism characteristically allows. I will trace the structure and contents of the album through to the primary mnemonic formations of orality. Further still, I will suggest that rather than changing our ways of remembering, the organization of photographs into albums has been one way of preserving the structures of oral tradition for new uses in the present.

My approach combines what Walter J. Ong has called "the psychodynamics of orality"[28] with interactional techniques variously employed by sociologists, ethnologists, folklorists, and photo therapists who bring photographic albums into their work. In all these applications, participatory presentations stir up memories and stimulate re-enactments of the informants' stories. Chalfen emphasizes the "telling and retelling during exhibition events ... the story does not appear in the album or on the screen; it is not 'told' by the images."[29] For an art historian, the performative model is extremely instructive, even if the principal actors can no longer be assembled. Something like the compiler's performance must take place if the album is to be unlocked. One might be tempted to describe the process in vampirish terms as an interview with a dead document. This study proposes reasons for this meeting based on the evidence at hand, for what we find in the album is an accommodation of technology within the continua of ancient formations. The new (the photographic) has been received. Mnemonic structures that serve oral recitation are put to use as the scaffolding of the pictorial *aide-mémoire*. We cannot see them, of course. Oral scaffolding is by nature impermanent. The album is what remains.

It may at first seem preposterous to argue that a product of the industrial revolution, a survivor of the electronic age, could perpetuate the oral condition. But the combination is not so very strange. The photographic moment and speech have much in common; visual literacy and memory less so, though they are complementary. The accumulation of photographic moments does not replace memory; rather, it overburdens recall with visual data that explodes in the retelling. That we desire to retain all that data in a permanent structure in which it can be visited, from which memories can be retrieved, fits with our faith in literacy, but challenges its rules. Our mimetic *photographic memories* need a mnemonic framework to keep them accessible and alive. The album reflects that need and preserves its evanescent conditions. To *speak* the photographic album is to hear and *see* its roots in orality.

THE IDEA OF ALBUM

TYPICAL AND ATYPICAL

A brief encounter with an anonymous album stirs a combination of feelings that is not very propitious for scholarly research: a balmy sense of delight and recognition met by the strong, countervailing winds of individual encryption that chill our relationship with the past. The infusion of memory that the compilation represents becomes a tease when the evidence fails to accrue, when the data cannot be read. Turning the pages of the McCord Museum's album MP 035/92 can be just such an experience; the palpable engagement of the participants is infectious, but the pleasure can only go so far before "the doors of Memory" clang shut. Walk a dog down a darkening street on a late fall afternoon, when the living-room lamps have been lit, but the inhabitants have forgotten to pull the shades, and you will have a similar "snapshot" experience of other lives, a flash of intimacy that only lasts to the end of the block. You are an outsider looking in, and the arrangements of these lives are only faintly legible, measurable against the standards of your neighborhood; the inhabitants may be judged more or less *typical,* but they are not known. Most essays on photographic albums accept these conditions as a given, and many album works of art are born from the heat of the flash and the latent images of suggestion.

In the introduction to this book, I proposed that the oral scaffolding of the album was the hidden key to its understanding, and that the re-erection of the oral-photographic framework would reactivate the album as an instrument of meaning. What that program assumes is a living spark of intentionality. We have to agree that a personal photographic album is not typical, but rather, that it has been formed in a conscious or unconscious sense of atypicality that wanted, and wants still, to communicate. It is only fair to inform the reader that this rather ordinary observation flies in the face of the literature, where a general *idea* of album seems to have replaced the actuality, where the album becomes an oasis of typicality in the overheated worlds of socialization, propagation, memory, and desire.

In this chapter we shall explore the history of this concept, its infiltration of cultural studies and reinforcement by artists who use the album as a motif or structuring principle in their work. As a critical angle, the latter may seem a little unorthodox, putting high art to the task of interpreting the low – it is usually the other way around. But artists since the 1960s have been very busy with the album form, and their transformations of its individual, temporal, and spatial specificities have been impressive. We have an *idea* of album that photographic historians, theorists, and practitioners have managed by dint of repetition to reinforce. A historiography of the album obtains as to the charms of its subject – picturesque, anecdotal, confessional, and repetitious. The *idea* of album seems to have evolved as the album itself: "a draft always started over in a recitation for several voices." We need to enter this conversation by engaging with the scholars, artists, and popularizers who have conditioned our reception of the album until now.

AUTOGRAPH TO PHOTOGRAPH

The album itself holds out the promise of a fresh start. The Latin root word, *album* (a blank tablet for lists), was inspired by the whiteness of the sheet. The album was known in the seventeenth century as the repository of autographs. This was a foreign custom, according to Samuel Johnson; albums of autographs and verses seem to have been popular in Germany. The custom diversified and spread, so that by the mid-nineteenth century the *idea* of album was ripe for Dickensian satire. In *David Copperfield* (1850) the canny cosmetician Miss Mowcher makes the connection between social status, fetishistic collecting, and good business: "I said, what a set of humbugs we were in general, and I showed you the scraps of the Prince's nails to prove it. The Prince's nails do more for me in private families of the genteel sort, than all my talents put together. I always carry 'em about. They're the best introduction. If Miss Mowcher cuts the Prince's nails, she *must* be all right. I give 'em away to the young ladies. They put 'em in albums, I believe."[1]

Albums of photographs originated with the first successful prints, sometimes to record photographic progress. The Brewster Album, for example, was started by Juliet Brewster in 1842 as "a book of specimens,"[2] preserving the first precious experiments of her husband and others in the St Andrews circle. Such work proceeded at a dignified pace. The mania for collecting belonged at that time to the cancelled stamp, whose dedicated album appeared in the 1860s; the photographic album followed suit.

The first commercial album was designed for cartes-de-visite, small photographs mounted as visiting cards, an inspired idea patented in 1854 by a Parisian, A.A.E. Disdéri, who soon after brought out the album.[3] The amateur of the carte-de-visite was a commissioner and collector of miniature portraits, reproductions, and views. In practical terms, the carte-de-visite album was an early attempt to furnish the photographic consumer with a tool for collection management: convenient, safe, and flexible storage for the stacks of cartes-de-visite left by relatives, friends, and acquaintances, and recklessly augmented by purchase. As the studios began to offer larger pictures – the cabinet cards that emerged in the 1860s – albums would be designed to hold the different sizes in pleasing and varied arrangements.

Luxuriously bound, the album quickly claimed a place among the appointments of the Victorian home. The format had already been established in function and respectability: the autograph album and albums of watercolour or sepia views were already on display on drawing-room tables; photographs, verses, and autographs could be prettily combined. Victorian intellectual pastimes could be transposed onto photography: sketching, collecting, and preserving specimens; mounting theatrical productions; storytelling and conversation. These hobbies and habits of mind left their mark on the first generation of compilers and continued to influence their descendants.

The photographic compiler, like any hobbyist, was cultivated by example and supply. A comparative study of nineteenth-century albums shows that the initial urge to collect remained strong, even as the source and selection of subject matter passed from the studio photographer to the shutterbug at home.

Compilations of snapshots followed the introduction of a simple, roll-film camera in 1888, but slowly; the photographic system had its flaws. The first Kodak camerist had a hundred frames to expose before Kodak could "do the rest." By 1892 a daylight-loading roll film had reduced the number of exposures to twelve. The introduction of the Brownie in 1900 made picture-taking simpler, cheaper, and more immediately rewarding. Styles of photographic representation changed accordingly. Milestones are easy to identify since they correspond to vigorous advertising campaigns by the manufacturers proclaiming the new and improved. Accessibility encouraged spontaneity; fewer technical skills were required. The new compact cameras were no burden, even to a lady. Best of all, photography was coming down in price, well within range of the working middle class.

For the compiler, things were not changing quite so quickly; some basic criteria never do. If the amateur botanist and the obsessive philatelist collected for preciousness, comprehensiveness, variation, and aberration, so did the amateur compiler: special occasions, annual outings, photographic novelties, and

social high jinks were samples preserved from life. As the Kodak made it easier to document the family, so more esoteric subjects came within reach. Albums became increasingly unruly and eclectic, laying on social history a proverbial chicken-and-egg – whether an evolving definition of the family modified the family album or the other way around.[4]

We can be certain of two things: first, that the album found its domestic niche by assuming the shape of acceptable Victorian pastimes, and second, what any history of the medium justly claims, that photography was a popular invention which worked its way quickly into private life – a pleasure for some, a social obligation for others – and that some people found albums the best way to order and display their pictures. The nature of the album and its function within the family are more open to speculation.

ALBUM TO FAMILY ALBUM

Robert Taft's *Photography and the American Scene*, published in 1938, was an early social history of photography's first fifty years. In a chapter dedicated to the family album, he tells a remarkable story that has been much repeated (by Chalfen, for instance) to illustrate the album's apotheosis. Taft recounts that a pioneer family of the 1860s marked the founding of a new home by placing the family Bible and the photograph album on the cabin's makeshift table. "The Bible was the consolation of these wayfarers from a far country; the album was the most direct tie to their past life, for it contained the images of those most loved but now far distant: Father – Mother – Aunt Sue – Sister Mary, and a host of others."[5] The connection between Bible and album is forcefully made. We know what the Bible contains, but are we as certain of the contents of this album? We need to look more closely at this enduring tale.

Taft identified his source as *Covered Wagon Days*, a first-person account of pioneer life published in 1929 by A.J. Dickson and based on the experiences of his parents. In his

preface to *Covered Wagon Days*, Dickson emphasized the authenticity of his account, which he had drawn from his father's journals and papers. Interesting background, for not every man travelling by covered wagon kept a diary, and not every son whose father did was moved to expand and publish the results. But the Dickson story is not precisely as Taft understood it.

Jerome Dickson's memoirs are colourful and detailed. Their remarkable acuity becomes even more striking, and rather poignant too, when one realizes that the diarist is not a man but a thirteen-year-old boy who is not the son of the house; rather, he is the child of a woman who remarried: "according to a current practice, he had been bound out to Mr. and Mrs. Ridgley until he should come of age." Joshua Ridgley ("'Dad,' as he was familiarly called") and his wife, Rebecca, kept a tavern at their farm north of La Crosse, Wisconsin.[6] Jerome, however kindly treated, was their servant.[7] In 1864, when the Ridgleys migrated to Montana, the boy Jerome had been with them for three years. Mrs Ridgley may have instilled a propensity for detail in her charge; Jerome remembers her as a great manager and maker of lists. The family Bible is first mentioned at the moment of departure in an inventory of indispensable possessions that also includes the clock. And the album? Yes, it appears in the unpacking and is placed on the flour-barrel table with the family Bible. Next added to the white-curtained room are "a box of seashells, a vase of feather flowers, a small mirror and a colored print or two," Rebecca Ridgley's homey touches.[8]

The album remains unopened, and there is no indication whatsoever that "it contained the images of those most loved but now far distant." There were certainly other options. In 1864 John Towles, editor of *Humphrey's Journal*, gave his summary of the album: "Everybody keeps a photographic album, and it is a source of pride and emulation among some people to see how many cartes de visite they can accumulate from their friends and acquaintances ... But the private supply of cartes de visite is nothing to the deluge of portraits of public characters which are thrown upon the market."[9] In the Civil War era, the keeping of an album was a social activity and a mark of civilization.

Back home in Wisconsin, the gregarious Ridgleys had been well placed to build their own small collection, though not necessarily to be photographed themselves. There are no pictures of the couple among the photographic illustrations in *Covered Wagon Days*. Jerome alone is pictured at sixteen. Perhaps he was photographed when he went back east to visit his recently widowed mother. Though he remained in contact with the Ridgleys, there are no further references to their photographic album; Father, Mother, Aunt Sue, and Sister Mary are conspicuous by their absence.

Taft tells this story to illustrate the importance placed on the album by the American family. He creates a powerful image, but the actual circumstances of the boy Jerome are more moving still. So many elements of the whole Dickson story are reflected in the albums (often labelled "family albums") held by the McCord: the equation of private album and family album from the evidence of happenstance and adjacency; the exaltation of kinship that idealizes the past and exaggerates contrasts with the present; a "family history" resulting from the close observation of an intimate outsider; the romance of the tale as told and the harsh realities of the omissions; the valued album that drifts away.

The album as *idea* admits none of these contingencies. Just as Taft attributed a *typical* family album to a *typical* pioneer family, so have later writers and artists (Barthes, in the previously quoted passage, is typical of them) built their arguments on their agreement with an abstraction.

The American semiologist Susan Stewart offers a remarkable example. Analyzing the folkloric tableau, she draws a photographic analogy to illustrate her idea of a closed text:

Here we might think not only of sculpture but also of the photograph, which has made possible the dramatization and classicization of the individual life history. Such "still shots," say, before the family car or the Christmas tree, are always profoundly ideological, for they eternalize a moment or instance of the typical in the

same way that a proverb or emblem captions a moment as an illustration of the moral working of the universe. Thus, while these photographs articulate the individual, they do so according to a well-defined set of generic conventions. It is not simply that the family album records an individual's rites of passage; it does so in such a conventionalized way that all family albums are alike.[10]

Stewart's comparison of folkloric expression and photographic formula is very apt: she correctly identifies the symbiotic relationship between conventional structure and individual articulation; she admits both the non-temporal and the temporal to her photographic tableau. These tensions are indeed characteristic of snapshots and their albums; they are in fact among their conventions. All that being said, Stewart's reductive conclusion that "all family albums are alike" comes rather out of the blue, though she obviously feels no need to qualify or support it. In citing the album, she makes confident use of a clear and uncontroversial definition – a paradigm that encompasses the form.

THE SHAPE OF AN IDEA

But whose paradigm is it? In *On Photography*, Susan Sontag, whose version of the *idea* we will come to presently, writes in accordance with "a sociological study done in France."[11] This authority can be none other than French sociologist Pierre Bourdieu, whose survey of amateur photographic practice, conducted in the 1960s, became a force to be reckoned with. In *Camera Lucida*, Barthes imagines the disapproval of "a team of sociologists" that has already dealt with "the category 'Amateur Photographs.'"[12] That must be the same crowd. For a range of readers, from the amateur snapshooter to the professional critic Rosalind Krauss, Bourdieu's report was not an easy pill to swallow.[13] *Un art moyen* (*Photography: A Middlebrow Art*) pricked one of photography's prime conceits by proving empirically that the invention had not revolutionized

society, but had actually served to reinforce social stratification by confirming the middle class in its traditional values. Thus Bourdieu describes the amateur photographer's capitulation to the "strained, posed and stereotyped photography of the family album."[14]

A few sentences later, however, a certain reverence creeps into Bourdieu's text as he sketches a modern rite of initiation, the presentation of the family album to the stranger "in chronological order, the logical order of social memory." This tribal ritual, he says, confers solidarity and decency on the group, whose collective interest overrules the individual. Through this process, according to Bourdieu, "all the unique experiences that give the individual memory the particularity of a secret are banished from it, and the common past, or perhaps, the highest common denominator of the past, has all the clarity of a faithfully visited gravestone."[15]

By collective will, the strained, the posed, and the stereotyped are redeemed. The concentration of family photographs in an album appears to consecrate the object as a reliquary of socialization and faith. It follows that the album is greater than its parts, which are subsumed by a higher order that concretizes the relationship of the family. Is our sociologist being ironic? Apparently not. So uplifting is this passage from the otherwise trenchant Bourdieu that historian Jacques Le Goff is moved to echo and to refine it with an appeal to motherhood. The mother, he suggests, is often the family photographer. Le Goff asks, "Should we see in this a relic of the feminine function of the conservation of remembrance or, on the contrary, a conquest of the group memory by feminism?"[16]

Unfortunately for Le Goff, Bourdieu's study indicates nothing of the sort. His survey suggests higher levels of activity among male photographers than among female.[17] Bourdieu clearly identifies the father as the children's historian. Photographing the children is assigned to the head of the nuclear family, another paradigm that needs no introduction.[18] Bourdieu does not address the matter of authorship, that is, who actually maintains the album or whose version of events is enshrined in the compilation. Nevertheless, his

text inspires another attempt at attribution, this one by Sontag, who, contrary to Le Goff, comes down for group memory: "each family constructs a portrait-chronicle of itself – a portable kit of images that bears witness to its connectedness."[19]

Still searching for the compiler, we are left with two influential opinions, both based on Bourdieu. His discovery of an overarching social order determining the domestic use of the camera has seeded far and wide the notion of a bourgeois family's ritualistic self-presentation. Sontag continues: "As that claustrophobic unit, the nuclear family, was being carved out of a much larger family aggregate, photography came along to memorialize, to restate symbolically, the imperiled continuity and vanishing extendedness of family life. Those ghostly traces, photographs, supply the token presence of the dispersed relatives. A family's photographic album is generally about the extended family – and often, is all that remains of it."[20] Le Goff, more optimistic, automatically assigns authorship to the mother (continuity or conquest), and he is not alone. The photographic album and the mother are often linked.

Serge Tisseron, writing on photography's function as an envelope, or container, for the photographer and subject, finds his ultimate example in the album: "These characteristics are confirmed by albums that often respond to the desire to gather up the scattered pieces of a family puzzle, as in those families where the mother keeps close to hand images of her children who have spread out across the world."[21] Autobiographical fiction follows suit. The restlessness of Jack Kerouac is anchored by his mother, whose attributes he identifies as "her essential sewing basket, her essential crucifix, and her essential family photo album."[22] In Ralph Eugene Meatyard's *The Family Album of Lucybelle Crater*, the masked matriarch appears in every frame and everyone in the album is called "Lucybelle Crater." The same association is exploited by Wim Wenders in his futuristic film *Until the End of the World* (Australia, 1991), in which a son risks his vision and his life to assemble the components of a family album that can only be reconstituted as a form of virtual reality in the mind of his blind mother. Here again, Bourdieu's statistical input is something of a spoiler since he reports a decrease in the activity and intensity of photographic practice correspondent to the dispersal of the urban family.[23] But facts on the ground have little to do with Wenders's intriguing image. Photographic theory maintains an implicit connection between the mother's album and the mother tongue, the "lingua materna," the speech form of the vernacular.[24]

A GRAMOPHONE IN EVERY GRAVE

As a "faithfully visited gravestone," the archetypal album fosters a rotation through pain and consolation. Where in this cycle the beholder comes to rest is more open to question than Bourdieu's still life would suggest. Critic Johanne Lamoureux has described her uneasiness when, as a child, she was shown her family's only photographic album, which chronicled the funeral of a brother who had died before she was born. Despite her mother's patterned and religious narration, Lamoureux formed her own interpretation. The album forced her to recognize again and again that the integrity of the family was highly vulnerable to sudden, shattering loss.[25]

The line between photography and death has been drawn many times by writers such as Philippe Dubois, Christian Metz, Jay Ruby, Susan Sontag, and others to be cited below. Their observations are rife with provocative ambiguity: to be photographed is somewhat akin to dying; to photograph is an act of soft murder; to be photographed is an act of self-perpetuation. None of these notions could justly be ascribed to one author. They are founded on a mood that has been visited on photography since its first ghostly appearance in an antipodal century of positivism and pessimism. On 4 June 1857 photography had not yet attained the age of majority when Edmond and Jules de Goncourt made the following observation in their journal: "At the Hôtel Drouot saw the first sale of photographs. Everything is becoming black in this century: photography is like the black clothing of things."[26]

Photographic reception is tinged with a sense of finality. The photographic album as both photography and book may be doubly cursed, for the inscription of ideas has always borne the charge of murder; before photography, this was the burden of the text.[27] Pondering the nature of photography, film critic André Bazin used the photographic album to illustrate the deathliness that resides in the indissolubility of the photographed object and the photograph. "Hence the charm of family albums. Those grey or sepia shadows, phantomlike and almost undecipherable, are no longer traditional family portraits but rather the disturbing presence of lives halted at a set moment in their duration, freed from their destiny; not, however, by the prestige of art but by the power of an impassive mechanical process: for photography does not create eternity, as art does, it embalms time, rescuing it simply from its proper corruption."[28]

The dilemma posed by a medium that perpetuates life by stopping it has been re-examined by Thierry de Duve, who argues that a photograph excites in the viewer a pre-symbolic condition, a mood not unlike manic depression. According to de Duve, mania and depression coexist in front of every photograph, not mingling but alternating in a complex spectatorial reaction.[29]

Carol Mavor's reading of Lewis Carroll's photographic albums follows the same bifurcated vein, the desire for perpetual life (the perpetual desire) that kills. Mavor writes: "Carroll's little girls, pasted into his albums, were flattened flower buds – some from last spring, others from many springtimes ago – all pressed, pasted, preserved, and arranged into Victorian albums ... Carroll wanted his child-friends to be forever little, to remain as Persephone was *before* she plucked the tender, sweet-smelling narcissus that metaphorically stood for her own breakage, loss, and marked change."[30]

Such an album is a performative site of desire, according to Mavor, whose analysis fits well the type of compilation to which she has been drawn, a photographic cabinet stuck with the label of fetishism. The family album is somewhat different, though, according to Marianne Hirsch, it is no less potent with desire.

In *Family Frames*, Hirsch's Lacanian reading distinguishes two forms of spectatorial engagement, the familial gaze – founded on an ideological and mythological construction – and the familial look – made up of local and mutual desire.[31] As she states, "Recognizing an image as *familial* elicits ... a specific kind of readerly or spectatorial look, an *affiliative look* through which we are sutured into the image and through which we adopt the image into our own familial narrative." Adoption, Hirsch continues, is a phenomenon akin to Roland Barthes's "punctum ... idiosyncratic, untheorizable: it is what moves us because of our memories and our histories, and because of the ways in which we structure our own sense of particularity."[32]

Barthes, deep in mourning for his mother, had defined a photograph's *punctum* in contradistinction to the beholder's fascination with content as "that accident which pricks me (but also bruises me, is poignant to me)." There is pleasure in Barthes's *punctum*, in part because of its indeterminacy; there is no code, and Barthes was unwilling to impose one, just as he chose not to publish the photograph that was the cornerstone of his book. The unpublished photograph of his mother, a little girl of five posing with her brother in a winter garden, had been marked by its provenance: "The corners were blunted from having been pasted into an album." Barthes, however, would take his pleasures sadly, slowly, and individually. He would not be reconstituting the album.

No: neither album nor family. For a long time, the family, for me, was my mother and, at my side, my brother; beyond that, nothing (except the memory of grandparents); no "cousin," that unit so necessary to the constitution of the family group. Besides, how opposed I am to that scientific way of treating the family as if it were a fabric of constraints and rites: either we code it as a group of immediate allegiances or else we make it into a knot of conflicts and repressions. As if our experts cannot conceive that there are families "whose members love one another."[33]

Hirsch can obviously conceive of such love, especially for her own mother, but the space opened up by Barthes's either/or has drawn her in. Writing objectively from a psychoanalytical perspective and stressing the "particularity" of individual readings, she struggles with what she sees as the rule of family photography: to smooth out the wrinkles of private life and, when necessary, to lie. Hirsch sounds like Bourdieu when she writes, "Family albums include those images on which family members can agree and which tell a shared story." For Hirsch, such complicity is fragile, and in any case, far from ideal. The album either/or is a contested space: "But even within the album, images remain opaque, objects of a quick glance but not objects of scrutiny, reading, or interpretation – lest looking beyond the surface of the image, or outside its frame, might upset the delicate balance of agreement on which the construction of the album and the narrative of family rests."[34]

How has that delicate balance been achieved? Hirsch does not say, though she entertains the notion that telling stories might break through the surface of the photograph and out of "the hermetic circle of familial hegemony."[35] She is able eventually to tell such a story on herself. But the thrust of her program is the decoding of parallel texts and "imagetexts" that relate in her mind to the album;[36] her readings underscore the processual nature of photography and its accommodation of the unseen: "Reading these texts against one another and against the images embedded within them is in itself a form of agency, one which has occasioned for me a process of rereading my own adolescence as a space of many possible stories, with many possible interpretations."[37]

Hirsch's own story has been conditioned by what she refers to as "postmemory," the memories of children of Holocaust survivors; the blocked vantage point of postmemory is the valuable "particularity" of her approach. *Family Frames* makes the point that, for many people and for many different reasons, a great deal of psychological work needs to be done just to locate the doors of memory. Hirsch seeks to break through the veil of "privacy" and to reanimate the possibilities

of her youth; she seeks, in effect, to restore to the pictures of her life what Michael André Bernstein has tried to restore to the narratives of a whole generation of parents: the "sideshadows," or contingencies, that murderous determinism took away.[38] *Family Frames* does, in fact, tell stories; Hirsch compiles her meta-album from the photographic fiction of others.

META-MOMENTS

In the latter half of the twentieth century, there is no shortage of compilatory works based on (sometimes resistant to) the *idea* of album. Generally, this is the "family album," and interpretation of this meta-genre is also a "family affair," based on epistemic agreement as to the nature, function, and limits of the norm. The framework of the amateur album serves the artist's album as a pretext (a container or a disguise) for the discourse embedded in its contents. The exegesis is thus performative: the shared story, a meta-story about the ideal album, is a starting point for re-creation.

The image of an image, like the play within the play, is hardly an innovation, though its invasion of the culture as an exegetic virus seems to have thrived under postmodernism. Works of re-enactment and appropriation are as familiar to us now as their substantive works, the snapshots and the albums. Inarguably, and to their credit, postmodern copyists have succeeded in their goal of interrogating and reinterpreting the "originals." But not all emulative programs are critical. Artists' adaptations of the photographic vernacular predated the postmodern critique, establishing precedents for more sympathetic points of view. David Heath's multi-projector slide presentation of copied family photographs, *Le grand album ordinaire* (1973, 1994), and Raymond Depardon's autobiographical play *La Ferme du Garet* (c. 1999) are two projects that come to mind.[39] Whether labelled "late modern" or "early postmodern", or as some criticism implies, "latent postmodern," appropriative works have one thing in common. Their symbols and allusions must be standardized for

the emulative, deconstructive, or satiric piece to work as a whole. In other words, an appropriative work is not the occasion to linger over the particulars. For its *essential* nature to emerge, the album as *idea* must be kept closed.

Ralph Eugene Meatyard's *The Family Album of Lucybelle Crater*, published posthumously in 1974, is a perfect example of productive pretextual enclosure. Meatyard used the paradigm of the album to delineate an anti-ideal condition, a photographic grotesque. Each photograph in the series features its central character, Lucybelle Crater. She wears an opaque mask with the downcast features of an elderly female, while her various companions, Lucybelles all, have their features distorted by a semi-transparent disguise. The masks wrench Meatyard's staged domesticity out of normality, creating an oddly subdued carnival atmosphere – an unspecified secular ritual that never seems quite to begin. The ritual is grotesque, therefore, in more than physical appearance; it is grotesque in relation to time, as Mikhail Bakhtin explains: "For in this [grotesque] image we find both poles of transformation, the old and the new, the dying and the procreating, the beginning and the end of the metamorphosis."[40] In still pregnancy, the album shifts from a pronouncement (the last word) on family into a purgatorial state of transition whose resolution depends on a meeting of opposites. Capturing that state of in-between was Meatyard's intention; siting its disturbing nowhereness in a photographic paradigm of stability was his insight into the grotesque.[41] As a meta-album, the work must fulfill spectatorial expectation; as a grotesque album, spectatorial expectation must be foiled; either way, expectation rules and the paradigm is reinforced in its conventional reading.

Meta-albums as artistic statements have been part of the discourse for thirty years, first appearing in the 1960s and coalescing over the next decade under photographic movements such as the Snapshot Aesthetic and the Social Landscape. An arresting and still enigmatic example is *Michael Snow / A Survey*, a catalogue designed by the artist to accompany his mid-career solo exhibition at the Art Gallery of Ontario. The opposite of *raisonné*, Snow's catalogue is an eccentric compilation of family photographs, juvenilia, snapshots of art-world happenings, reproductions of paintings, and photographs of his sculptures in situ. The publication effects chaos at every step, apparently culminating in a very bad night on press: overprinting, duplications, and blank pages.[42] In Snow's case, the elevation of the snapshot from mass culture to high art fits the big picture of Neo-Dada, Pop, performance art, and experimental cinema. Within the photographic community, the snapshot's moment was perhaps more decisive; it was certainly more paradoxical as the overthrow of the young modernist canon by outmoded "snapshot" values.[43]

As Nathan Lyons remarked in his 1966 essay defining the Social Landscape, the look of the snapshot had exercised influence on all graphic media since its inception.[44] But the characteristics of the snapshot were only part of what Duane Michals extolled as its "simplicity and directness,"[45] a state of grace achieved within an authentic photographic tradition. A professional photographer like Michals returning to the snapshot could be seen as a photographic heresy and a reversal of biological order: "When I was a child, I used to talk like a child, and think like a child, and argue like a child, but now I am a man, all childish ways are put behind me."[46] Photography, still banging on the doors of institutional validation, was not supposed to be a childish pastime but a vocation. For Roy Stryker, the irrevocable change in photography's purpose and status had taken place thirty years earlier: "In 1936 photography, which theretofore had been mostly a matter of landscapes and snapshots and family portraits, was fast being discovered as a serious tool of communications, a new way for a thoughtful, creative person to make a statement."[47]

Yet even in the thirties, and right under Stryker's nose, amateur photography still exerted a hold on the professional. In his spare and dispassionate style, Walker Evans recorded two anonymous snapshots, pinned up on the walls of an Alabama sharecropper's cabin.[48] The doubling of desire, latent in the act of photographing a photograph, was fleshed out in words by his partner, James Agee:

A small octagonal frame surfaced in ivory and black ribbons of thin wicker or of straw, the glass broken out: set in this frame, not filling it, a fading box-camera snapshot: low, gray, dead-looking land stretched back in a deep horizon; twenty yards back, one corner of a tenant house, central at the foreground, two women: Annie Mae's sister Emma as a girl of twelve, in slippers and stockings and a Sunday dress, standing a little shyly with puzzling eyes, self-conscious of her appearance and of her softly clouded sex; and their mother, wide and high, in a Sunday dress still wet from housework, her large hands hung loose and biased in against her thighs, her bearing strong, weary, and noble, her face fainted away almost beyond distinguishing, as if in her death and by some secret touching the image itself of the fine head her husband had cared for so well had softly withered, which even while they stood there had begun its blossoming inheritance in the young daughter at her side.[49]

The anonymous snapshot rephotographed in its allusive power encouraged the development of an analogous photographic style that expressed both mechanism and affinities. The style was everfresh; the term was relatively old, inspired by hunting and predating the Kodak as a name for photographic instantaneity. In 1936 László Moholy-Nagy retained the hunter's quick reflexes as one way of photographic seeing: "Rapid seeing by means of the fixation of movements in the shortest possible time: snapshots."[50] In 1960 Siegfried Kracauer's definition of the photographic listed its affinities for the unstaged, the fortuitous, the endless, and the indeterminate.[51] After one hundred years, photography in its essential nature still seemed the fulfillment of Baudelaire's modern urbanity. But when the snapshot was officially revived by visual historians and artists as an object of study and imitation, the repertoire of affinities seemed to shrink and lose its sophistication. Steven Halpern placed content first. "From its beginnings the snapshot has had two basic characteristics: a constant focus on family life and an informal, casual style that was consistent with the new freedom within the family and derived from the mobility of the hand-held camera."[52] This back-formed, social definition of the snapshot still holds today, influencing our reading of the snapshot album – the "family album," whether it be about holidays, horses, or houses – and carried forward into art.

Ironically, in pseudo-snapshots and meta-albums the manner of artistic re-enactment and the effect of emulation are often more authentic than the contents. Snapshot art conflates the direct representation of the vernacular as object, or sign, and its indirect representation as action, or trace. Conceptual art's devaluation of the object values the loose feeling of the Instamatic, the Polaroid, the Diana, the Lure Camera, the One-Shot, the Super-8, and the camcorder. In the heyday of conceptual art, photographs could be produced by throwing the camera into the air. The influential teacher Lisette Model recognized what was happening in a flash – for the artist, the snapshot was a performance. "The moment may be unstructured, but the photographer is not."[53] In a snapshot economy, artlessness equals candour equals truth; in practice, the scale and reproducibility of machine-processed prints encourages multiplicity, repetition, juxtaposition, erasure – methods that refer to the amateur and the amateur album, and keep family values alive within the avant-garde. Andy Warhol's snapshots of his performing pseudo-family at The Factory are one famous example. Nan Goldin's photographs of her New York tribe, *The Ballad of Sexual Dependency*, were characterized by the artist as "the history of a re-created family, without the traditional roles."[54]

Now spanning a half-century, the work of photographer and filmmaker Robert Frank is marked throughout by his attraction to the icons and effects of popular culture. After his book *The Americans* (1958, 1959), Frank's spontaneous photographic manner translated onto his films, while the sequential and narrative elements of the cinema entered his photography, emerging publicly in the autobiographical "scrapbook" *The Lines of My Hand* (1972) and in photographic collages made of cheap colour prints, souvenirs, letters, and scratched titles. Increasingly, since the late seventies, Frank has placed his private feelings on public display. A videotape,

Home Improvements (1985), features his loved ones and himself, as well as the trash collector and the postman. A sequence of stops and starts, leaps and digressions, the tape has been likened to a "visceral diary of daily thoughts and events."[55] The raw material and flat commentary also refer to domestic videography (the electronic album), though the tape is a performance, of course. Frank's utterances, in their verbal and pictorial totality, are knowingly reflexive as he ponders his own lack of innocence.

Home Improvements, like other artists' forays into the vernacular, uses formulary devices in the offhand manner of "secondary orality," a distinction proposed by Walter Ong for activities founded on, though departing from, an individualized introversion of the age of writing, print, and rationalism. Instrumentality is not the key; the identifying mark of Ong's secondary orality is self-consciousness. In 1971 the example before him was Pop art, which he defined as a "supercharged romanticism: strangeness is found even in the cliché through exaggerating confrontation with it."[56] We find the same oppositions in artists' quotations or allusions to the photographic album – magnifications of its formal devices and motifs. Self-consciousness, or a consciousness of the self within a social or political order, is a reliable feature of the secondary album, which emulates, but does not replicate, the primary form.

Artists emulate and amateurs imitate ... Could the classic distinction be more simple or more wrong? Separating the true snapshot from artistic or commercial facsimiles, Chalfen cites substantial differences in intention, presentation, and audience.[57] His reasoning complements Model's; the decisive factor is the object, not the agent. Thus we would infer that the photographs of Edgar Degas depicting friends in intimate surroundings, made for pleasure and limited circulation, must be snapshots (some art historians disagree).[58] The same rules would also disqualify from art the quintessential amateur Jacques-Henri Lartigue, leisured for life to keep diaries and photographic albums and only "discovered" by the art world when he was in his sixties.[59] There are countless examples that blur the lines between amateur and artist. Our view of nineteenth-century photography is populated with amateurs and applied photographers whose œuvres have been invested by modernist historians with artistic motives, and then divested of those motives by postmodern critics who suspect the motives of the modernists.[60] In the end, it comes down to status, that of the individual and the status accorded to photography as a whole – that stale issue, is photography an art?

Who cares? But the photographic vernacular's *call to disorder* is an interesting part of the debate. In 1974 Richard W. Christopherson analyzed photography's struggle for legitimization as an art form within a framework of tradition – the history of art and the history of fine art photography. He based his discussion on E.C. Hughes's observation, "New occupations, like new families, seek a heroic genealogy to strengthen their claims to license and mandate."[61] Then insufficiently ripe for consideration, the anti-hero culture of the 1960s might have provided Christopherson with an interesting epilogue: the *anti-heroic* photographic genealogy that presents itself in facsimiles of the amateur album. They are just as effective today as an appeal to status through the sheer cussedness of anti-aesthetics. Artist Joachim Schmid's interpretive recycling of discarded snapshots and albums is illuminated by his declaration of principle: "No new photographs until the old ones are used up!"[62] In the dauntless spirit of R. Mutt, the authority of the artist is asserted through the photographic ready-made.

ALBUM-ARCHIVES

Found photographs, appropriated from individual collections or archives, form the basis of a whole category of work in which the alienation of the image from its original context is an ontological source of meaning. In the early 1970s Christian Boltanski's album-type installations, such as *Album de photos de la famille D., 1939–1964* (1971), were fictional biographical reconstructions based on the artist's hypotheses

and deductions from the images.[63] Such projects can be related to developments in cultural anthropology; Boltanski has acknowledged the indirect influence of his brother, Luc Boltanski, a colleague of Pierre Bourdieu and a contributor to *Un art moyen*.[64] If Christian read one line of his brother's report, it surely pertained to the spiritual qualities of the album; like the anonymous albums of the McCord, like our MP 035/92, his visual diaspora is haunted by questions about the fate of the subjects.

The questions posed by his work become more urgent, more like self-interrogations, when the images appear to mask something disturbing. In much of his production, Boltanski has achieved what Ernst van Alphen has termed the "Holocaust-effect," a transformation of presence into absence, uniqueness into anonymity, that the spectator is intended to experience as a re-enactment. In a book work, *Sans-Souci* (1991), assembled by Boltanski from German family albums found at a flea market, the effect is one of Bourdieu-esque normality as Nazi soldiers and their families and friends enjoy their ritual pleasures. As van Alphen explains, Boltanski's interest in the material resides in its cultural codes. He is still the master of effect as he re-presents this archival material, an effect powerful enough to persuade van Alphen that Boltanski has uncovered a system of lies (cultural codes) which is the basis of all family albums. In other words, the fictional album that Boltanski has created as a work of art invites us into the universe of lies that the Nazi regime created, and it starkly illuminates (as by one of Boltanski's famous bare light bulbs) the conditions under which *all* albums are created, not necessarily evil, but at considerable distance from the truth.[65]

A comparable project though much cooler, Hans-Peter Feldman's *Porträt* (1994) is an album-type artist's book derived from the photographic archives of a woman whose identity is concealed from the beholder. Three hundred and twenty-four photographs of this woman, taken by two hundred photographers and spanning more than fifty years, have been gathered and organized by Feldman in strict chronological order. Minimal captions are provided in a list at the back of the book. The artist's intervention, the strict imposition of the "logical order of social memory," strips the photographs of contextual meaning and makes the objectification of the woman complete, as though she had been chosen from birth for lifelong observation.[66] And that is Feldman's message, not specifically about this woman, but about all of us and our blind faith in the photographic album.

The petty pace of life and its vernacular expression take on monumental proportions in the avant-garde work of two other German artists, Hanne Darboven and Gerhard Richter. Since the early 1960s, Richter has been accumulating photographs and photographic reproductions, initially as source material for his Photo Paintings but eventually coalesced into a public artwork-in-progress called *Atlas*.[67] Richter's index has also expanded from snapshots of known provenance to anonymous portraits, historical photographs, likenesses of friends and personalities, kitsch, sex, aerial views of cities and model cities, topographical views of land, and canvas. He arranges these images by subject on boards in grids or clusters. Thus while Richter continues to make paintings that equivocally probe the objectivity of the photograph, his relentless activity as a compiler constitutes a vast and elastic amassing of photographic data. Darboven's monumental project *Kulturgeschichte 1880–1983* [*Cultural History 1880–1983*] (1980–83) is a finished work consisting of 1,590 sheets (layouts of postcards, pin-ups, diagrams, photographs of doorways and portals, magazine covers, and mementos of past exhibitions) and nineteen elements/sculptures. Exhibited in 1997 at the Dia Center for the Arts, Darboven's archive metamorphosed into spectacle. As Lynne Cooke explained, "Weaving together cultural, social, and historical references with autobiographical documents, it synthesizes the private with the social, and personal history with collective memory ... Such is the magnitude of its scale that it does not invite being read, however, so much as experienced visually."[68]

Works of art composed of thousands of photographs represent and augment the phenomenon that sociologist Franco

Ferrarotti has blamed for the end of conversation: "The flood of images which now flows out every day on a global scale tends to deprive the image of its value as basic evidence. We shall have to start thinking that in the beginning there was not the word but rather the image."[69] Hungarian-born artist George Legrady has turned to the ancient art of memory to manage the flow.[70] His *An Anecdoted Archive from the Cold War* (1994), is a CD-ROM assembled from "home movies, video footage from Eastern Europe, books, family documents, propaganda materials, sound recordings, identity cards, money, and other objects," images arrayed over eight virtual rooms "superimposed on the floor plan of the former Workers' Movement Museum in Budapest – the original contents of which have been in storage since 1990."[71] Other artists have recognized the dilemma of memories in surplus and made Hobson's choice – neither words nor photographs nor virtual collections, but albums themselves as symbols.

Work in this genre privileges the *idea* of the container over what is actually contained. Pictures of empty albums serve as memento mori in the work of Mari Mahr and Christian Gattinoni, as generic monuments to the displaced or the disappeared. Nancy Spector has discussed the album motifs of Felix Gonzalez-Torres in the same vein. Whether fragmented, as a jigsaw puzzle, or constituted whole and empty, as a vessel of remembrance, the album is considered an indexical sign for the human trace, an emblem of mortality.[72] This *idea* of album paradoxically fulfills the critical prophecy of conformity as a gravestone in a field of gravestones, as one unit of remembrance among many.

ALBUM-EXCAVATIONS

As photographs have begun to be credited by social and scientific research, cultural theorists, intent on exploring the psychological, biological, social, and political aspects of representation, have addressed the family album. Patricia Holland includes albums with "those public narratives of community, religion, ethnicity and nation which make private identity possible."[73] Here again, discoveries of anomalies, deviations from the norm, naturally depend on agreements as to the normal state of things, however the rule is imposed. According to Victor Burgin, "domestic snapshots characteristically serve to legitimate the institution of the family."[74] Holland describes the album as an instrument of forced conformity and suppression of difference. The family album, she argues, overvalues the nuclear family, neglecting "the worlds of production, politics, economic activity and the institutional settings of modern life."[75] In this process of idealization, negative images of divorce, anti-social behaviour, illegitimacy, disease, disability, and violence are suppressed. Or more precisely, they are not pictured, which is not to deny their latent presence in the content of the work.

The Smithsonian Institution's Family Folklore Program, conducted between 1974 and 1976, involved thousands of informants in the reconsideration of their family albums. Researcher Amy Kotkin was impressed by the difference between happy photographs and the sad stories that they sometimes rekindled in the participant.[76] In 1979–80 a more focused study of the interconnectedness of family photograph albums and family narratives was conducted in the Toronto area by folklorist Pauline Greenhill, who reported, "Family photographs ... contribute to some extent to the stability of family narrative traditions. But because they record events of symbolic importance and have a great deal of ambiguity they allow constant reinterpretation to fit changing circumstances, which may contribute to their survival as a tradition and an institution."[77]

In 1997, at the international art exhibition *Documenta X*, a methodological fusion of psycho-sociological fieldwork and avant-garde art was manifest in the work of an Israeli artist, Michal Heiman, who "stationed at a desk a live person who gave interested visitors a psychological test in which the subject responded to photographs from anonymous family albums dating from the early years of Jewish settlement in the Mideast."[78] This description of the piece evokes a passage

from Saul Friedländer's *When Memory Comes*. Reflecting on his youthful impressions of Israel, Friedländer writes: "One has only to leaf through the albums of photographs of that time to recapture the reassuring, unquestioning mythology that was ours in those days. I have rediscovered one of these albums, sumptuously bound in beige imitation leather ... I cannot help contemplating it with a certain incredulity. A mere twenty-five years later and everything looks to me like one immense sentimental print of the nineteenth century."[79]

For Friedländer, subsequent events have accelerated the transformation of personal photographic histories into collective myth. The work of Ilya Kabakov, "Soviet society's secret anthropologist ... archaeologist ... chronicler ... allegorist ... explorer," as Robert Storr has struggled to define him, operates in the same nebulous zone between fact and fiction.[80] His hybrid "albums" are of interest to us here – not photographic but partially inspired by the photographic, collages of drawings, documents, and text, mounted on card and decoratively boxed, which the artist began in 1974 to present to small audiences as durational works in performance.[81] Temporal, spatial, aural, and photographic, Kabakov's 1997 installation, *Treatment with Memories*, inserted the spectator into a suite of hospital rooms where personal photographs were being projected onto a wall for the benefit of the imagined patient. However clinical the environs, the work is obliquely autobiographical, combining storytelling with the photographic archives of the artist and his wife, Emilia Kabakov.[82]

The real-life deconstruction of family photographs begins at the kitchen table and extends through therapeutic practice to photo therapy displayed on gallery walls. British artist Jo Spence founded her work on the basis of popular and formulaic imagery, social constructs that she unpacked through re-enactment and incisive commentary. Spence's partner in photo therapy, Rosy Martin, restaged a picture of herself as child, extracting the "'good little girl' image" from the pages of the family album: "I wanted to examine, recreate and transform this construction, to reclaim myself as a child, in all her aspects, to take back the power I/she had, the capacity to be creative, autonomous, joyous, independent – as well as angry, grief stricken and vulnerable."[83] In *Family Secrets,* Annette Kuhn drew on her father's photographs of her as a child, and in a passage on dressing, or being dressed by her mother for the camera, she pointed up the tension between outward appearance and unconditional love that seeped into her relationship with her mother: "Counting the cost is not appropriate. Sure enough, the family as it is represented in family albums is characteristically produced as innocent of such material considerations, above price: to this extent, the family album constructs the world of the family as a utopia. And yet I feel sure that my mother, whose own childhood had been so marked by poverty, must have known, or even calculated, the exact cost – to herself, at least – of having and keeping me."[84] Still, both mother and child are recorded smiling for the camera. Kuhn is compelled to write against the evidence that her own album gives.

Sociologist Celia Lury situates this kind of struggle on the shifting border between public and private, citing the "uneven availability of experimental individualism to subjects and their photographers as mothers, fathers and children, husbands and wives, that is, as members of families and the problems this new form of individualism poses for the visual regimes of copy and cont(r)act." Within the art world, Lury detects a certain level of uncertainty in the critics' reactions to Sally Mann's photographs of her children: "both critical anxiety and praise are connected to the possibility that suggestion may be being reworked as suggestiveness, contact as contract."[85] As a counterpoint to the very public nature of Mann's depictions of childhood, historian Anne Higonnet describes the children's private albums, where their mother's snapshots ("the ordinary flux of things") cohabit with some of the more suggestive images ("a stiller, more resonant world") that have made their collective fame. Higonnet's just and provisional conclusion is this: "If the ideal mother is a selfless guardian of the domestic sanctuary, then clearly Mann is no model mother. If."[86]

The most innocent-looking or conventional personal photographs may elicit memories that take shape in cathartic works of art. Photo therapy's integration of autobiography and political activism in photographic art has encouraged such projects as Paul O'Neill's *A Picture That Hangs Upon Your Wall* (1995), in which survivors of sexual abuse write letters to their tormentors on the surface of photographs that depict the survivors as children in normal family life. The text partially masks the photograph; the stories laid down on the surface of the image bind recovered memories to a photographic shell that inscription is now, finally, breaking through. These are very affecting works. To discover a hurt child behind a photographic gloss of happiness is a betrayal that never loses its sting. But the effectiveness of this album-type work depends equally on detachment from specific and overburdening circumstance. Or rather, effectiveness depends on the overt and productive erection of attachment and detachment as a binary conceptual framework. Everychild and his mother must be masked, blurred, or otherwise abstracted.[87] Their home must be Middletown; their vacation, an odyssey; their cabinet, our world.

The *idea* of album engages the spectator by opening the doors of social memory. The raw material may be private, but its transformation in a place of public encounter is complete. Since the late 1980s Lorie Novak has been creating photographic projections that combine pictures of herself in childhood or adulthood with pictures of known and unknown historical figures (Ethel Rosenberg, child deportees to Nazi concentration camps, Novak's parents), images abstracted and further altered by features of the gallery space. As Julia Ballerini has written of *Fragments* (1987), these relocations "disrupt a logical narrative of family album, addressing the elusive psychological conjunctions of an immaterialized camera."[88] *Collected Visions* (1993) is a three-screen projection built from the images of about seventy-five women, including a sequence that traces girls from infancy through adolescence.[89] Hamish Buchanan's photographic installation *Some Partial Continua* (1991–96) weaves a fragmentary personal history from a collection of private snapshots and public photographs, including art reproductions, commercial stereotypes, and male erotica.[90] In Ken Lum's *Photo-Mirrors* (1997) the authority of the author is more ambiguous still. Anyone who looks at this work becomes its central figure, an image reflected in a large mirror, surrounded with snapshots that are tucked into the edges of the frame.[91] The stratification of these compositions insists on a process of mental excavation. But the same operation can be initiated by a work that follows the "logical order of social memory" – a series of group portraits faithfully taken and arranged to mark the passing of time.

Henry Sayre chooses Nicholas Nixon's extended portrait of the Brown sisters to introduce his notion of postmodern photographic portraiture's conflation of mimesis and deconstruction: "They not only ask what *is* the family, they ask us to contemplate whether the family is itself only a simulacrum – a simulacrum, perhaps, of the very idea of community."[92] This philosophical problem is found in a series of photographs of biological sisters who gather for their group portrait every year. Simple pretexts that want to raise such profound questions must assume some degree of competence in the beholder, some formative experience that enables them to recognize and participate in the protagonists' photographic performance; the Browns are fortuitously named. Nixon and Sayre can be reasonably confident that this double mimesis will be sensed if not precisely understood, for this sister act is the very *picture* of ritual.

RITES OF REPETITION

The viewing of an album is a tribal ritual, according to Bourdieu, within the repertoires of family ritual and photographic ritual, the intertwining of the two. The attribution to photography of myth, magic, and quasi-religious ceremony is a commonplace of the literature, aiming to explain the intensity of spectatorial identification. In a much quoted essay, Sontag has defined the taking of pictures as "a rite of family life."[93]

Agnostics may have assumed that she was using the term strictly in its social sense, without any spiritual connotation, as in "the elegant rite of afternoon tea," but Sontag's debt to Bourdieu suggests an extension of his more traditional views. From mechanism to myth in one hundred and fifty years – one wonders how this marvel has occurred.

Secular ritual fits the image of a "post-capitalist" secular society, but "rituals in family living" have been known far longer, to echo the title of an American study reported in 1956 by James Bossard and Eleanor Boll. At that time, photography had not attained to ritual status. Bossard and Boll found different levels of photographic practice, separated by class and tradition: the regular commissioning of group family portraits set in the home of the rich; the spottier attendance at commercial studios by children of the middle class. The keeping of a family scrapbook was attributed to only one upper-class family, which gathered annually in the trophy room to update and celebrate its family cause. Overall, photographic practices were likelier to signify in families where the pictorial tradition was already engrained; they attached therefore to the family's historical sense of identity, which was already objectified in its portrait gallery or shrine.[94]

Less than a decade later, Bourdieu and Sontag seem to have found a greater truth. Let us rehearse their reasoning. The family participates in a form of ancestor worship by going to the cemetery; members of the family look at pictures of their ancestors and themselves in the album; going to the cemetery is a ritual; looking at the album is a ritual. But wait. Is the act of photographing the family at the cemetery also a ritual? If so, why are there no photographs of families looking at albums?

We can choose a less morbid example, the very one that Sontag adopts to reinforce her point. Weddings are rituals, and they are photographed. They are generally photographed in the same way from a list dictated by custom. Certainly, for as long as the marriage lasts, the photographs are valued by the couple, and children of divorce seem to find them more magical still. Inarguably, there is something

very powerful at work, but its source has been misidentified. Sontag explains, "For at least a century, the wedding photograph has been as much a part of the ceremony as the prescribed verbal formulas."[95] Can this be true? Not on the basis of albums held by the McCord Museum, and not according to Amy Vanderbilt, the doyenne of American etiquette. In 1962 she reminded her readers that photographs, meaning formal photographs of the bride, were normally taken at the trousseau shop or at home before the wedding. She also took note of society's awakening desire for candid coverage of the entire event.[96] But the era of Instamatics and camcorders in the church was not yet upon us. Some may scoff at Vanderbilt's prescriptions, just as some people scoff at marriage, but those who chose to marry in the 1960s probably did not.

Some bending of the rules had begun twenty years earlier as a way of replicating the conditions of the trousseau shop in the makeshift studio of the backyard. Two world wars and other conflagrations loosened the stays of convention; given a young male's life expectancy, there was good reason to take a picture of the groom.[97] But many marriages were made without the benefit of photography, a practice that continues to this day.

Perhaps the notion of ritual is a bit overworked. Anthropologist Jack Goody has argued for limits on its use, requiring a more precise definition that distinguishes transformative ritual from normative practices, in part by the elimination of the merely repetitive.[98] Repetition, or sameness, looms large in vernacular photography and in orality as well; we will visit the subject again. For the moment, we can perhaps agree that ritual and habit are not interchangeable; that repetition may be redundant or it may obtain to transformation. Sociologist Barbara Myerhoff finds instances of transformation in the secular world by invoking Suzanne Langer's sense of the term as miraculous. As Myerhoff explains, "Those present when such transformations occur are filled with wonder and gratitude, and are likely to experience the intense camaraderie Turner has called 'communitas.'"[99] They would be likely

to re-experience that transformation, and to share it with others, through the medium of photography. But they would have to be prepared to talk.

A certain level of confusion bedevils photography, a chronic inability to distinguish what is proper to photography from the features of the subject. In Sontag's case, we sense some difficulty in separating photographic ritual from the business of recording ritual as it takes place before the camera. Lining up for wedding pictures is a rite of passage because of the content, not the process. The organization of the pictures did not originate with photography, but belongs to a higher order of choreographed movements that manifest the social (for some, spiritual) rearrangements of the wedding day. The pictures record the outward appearance of an invisible transformation. The ritual aspects of the wedding photograph – its mythic, transformative powers – come into effect after the ceremony, as a story, in the retelling.

ALBUM-STORIES

Lisa McCoy situates the married woman's narration of her wedding album in a continuum of planning and acting in the spectacle of her wedding day. In this, she follows John Berger: "The private photograph ... is appreciated and read in a context *which is continuous with that from which the camera removed it.*"[100] The album "reflects a kind of essential wedding,"[101] an ideal in relation to the actual event. McCoy divides the wedding album into three levels of representation: the symbolic ceremony, its imperfectly staged enactment, and its candid explication as given to her on tape. Her breakdown, while insightful, nevertheless creates a false impression. The bride's meticulous planning of the wedding and her subsequent awareness of the make-believe aspect of the pictures are kept strictly apart. Yet the complicity of the bride and her advisers in choosing from the repertoire of photographic motifs and adapting them in performance is what brought the album into existence in the first place. As every mother

knows, the aging bride will be called upon many times to replay the day of her wedding. The commissioned album is a scenario for improvised recitation that is both formulaic and attuned to its audience. Researcher McCoy's interest is the occasion for a revival of the album and a revision of its performance. The former bride, now a married woman, navigates between past and present – her audience then and her auditor now – when she allows McCoy into the story and takes her backstage.

Berger's notion of continuousness evokes what Mircea Eliade termed the "the Great Time, the sacred time,"[102] entered by detachment from profane time through the ritual re-enactment or recitation of a myth. Berger's sacred state of consciousness is memory. By outlining the differences between private and public photography, he is admonishing professional photographers, including artists, to learn from private photographs – to study their relationship to memory. Picking up from Sontag, Berger argues that the public photograph is declarative and closed. The camera, which surveys from a position of authority, obviates the necessity for memory. One could dispute this point but not its antithesis, which is that the private photograph remains open and alive because it respects the laws of memory. This is really the key. According to Berger, the structure of memory is not unilinear in its relationship to events but criss-crossed with multiple associations. As we saw in McCoy's interaction with the bride, Berger's radial memory must also be understood as performative and additive. To enter the private photograph, even as a spectator, is to alter its meaning. Berger calls for an alternative use of photographs in a dense and multiplistic context of words and images. "Narrated time becomes historic time when it is assumed by social memory and social action. The constructed narrated time needs to respect the process of memory which it hopes to stimulate."[103]

Berger expands this conceptual framework in a work co-authored with photographer Jean Mohr. *Another Way of Telling* proposes the arrangement of photographs in "a field of coexistence like the field of memory." Here again Berger is

addressing issues of photographic production, art, and communication. The private photograph in private hands is held up as a model that coalesces materiality and experience in an ideal condition, the last bastion of "timelessness."[104]

Surely this condition is at risk when the private photograph becomes public. The interpretive problem is very tricky: how to create pathways to the latent memories in the album without pouring their continuous flow in concrete? The situation is aggravated in public presentation. Mnemonic axes rarely find their way into museums, where exhibitions combining images and text are biased toward unilinear reception – toward reading. The model that Berger and Mohr have assembled in their book does not escape linearity, but it effectively thickens narration to the point of imitating the convergence of three experiential fields: the photographer-teller, the spectator-listener, and the subject-protagonist. The critic-compiler reconstructs their meeting.

In Berger's case, the critic is also a novelist who has followed his concepts of continuity and axiality to the peasant culture of France, from which he has drawn his trilogy *Into Their Labours*.[105] As a writer, he is working as close as he can to the processes of memory – at one imaginative remove. Conflating criticism and storytelling, Berger offers a model of engaged, multi-voiced analysis that admits any and all reasons for self-presentation through pictures, and expects more, not less, from the amateur compilation. His is surely a voice to heed as we enter a large public collection of private albums.

THE ALBUM AS COLLECTION

MEET THE FAMILY

We have been looking at a paradigm, at the *idea* of album, its construction and deconstruction at the hands of human scientists, literary critics, and artists. Many of the texts and works of art discussed in the previous chapter seem to equate the personal album with the family album, thus setting up a pattern of dissolving the individual into the collective. I would not take issue with Maurice Halbwachs's essential definition of "collective memory." I would only reiterate what he actually said: "While the collective memory endures and draws strength from its base in a coherent body of people, it is individuals as group members who remember."[1] The albums that we will look at in this and the following two chapters show precisely what Halbwachs meant. Memory blossoms within much-varied combinations of social structure that are sometimes reinforced, but more often transformed, through individual expression. Investigating four categories of personal compilation – album-collections, album-memoirs, album-travelogues, and album-genealogies – *reading* these albums takes us down four separate paths that all somehow meet at the intersection of convention and nonconformity. Or, considering the multiple forces at play, should I not say "intersections"? For Halbwachs also stresses, in both childhood and adult remembrances, the

importance of intersections, those memorable moments when social influences, two or more frameworks, combine within the medium of individual experience. The syncretic nature of personal albums should by this reasoning increase their share of memories. We shall see how that concept works as we examine our four basic categories of compilation.

The first photographic albums were collections, so let us begin there. The album-collection is a very broad category, evoking not a theme but a way of life that can manifest itself through the accumulation of any kind of object. The album-collection is the album-chameleon that looks like its subject category, until it suddenly mutates into another form of acquisitive desire. A perfect example is the prototype of the collector's album, The Royal Album (MP 2162), compiled in the early 1860s by its British creator, J.E. Mayall, and an unknown purchaser. The album, donated to the McCord Museum by Francis McLennan in December 1928, was recorded as follows: "Royal Album Containing eighteen photographs of members of the Royal Family, photographed by J.E. Mayall, London." This description is not quite correct and misses Mayall's marketing strategy by a mile. The Royal Album was conceived as a small collection that could be supplemented by a few cartes-de-visite of the purchaser's choosing. Those four empty slots personalized the collection and started the client down the road to collecting more cartes-de-visite, which studios alone could supply. The anonymous compiler of this Royal Album did not quite take the hook. His version contains fourteen cartes-de-visite by Mayall, which are listed in the album's table of contents: "The Queen and Prince Consort," "The Queen and Princess Beatrice," "The Queen," "The Prince Consort," "The Prince of Wales and Princess Alice," "The Princess of Wales," "Princess Alice," et al. The last four cartes-de-visite are neither by Mayall nor listed in the spaces provided: they are royal celebrities from England, Belgium, and Denmark. One of the additions, identified as "Princess Royal," is accompanied by a botanical specimen, an oak leaf, pressed between the pages.

Mayall's imprint notwithstanding, our anonymous purchaser's intervention transforms his Royal Album into an individual work, a collection that is also a genealogy, a travelogue, and a memoir all in one. We have entered the eclectic world of the photographic amateur, not the amateur photographer or camera buff but one who loves, or has a taste for, photographic images and collects them as a pastime. Photography being what it is, the tangible object, the print, may be secondary in importance to the photographic subject or type of subject. A collector's attachment can be expressed in different ways, from the reverential treatment of a single, precious icon to the promiscuous buildup of its like. Susan Stewart has shown that the most insignificant object is transformed by the act of collecting; her reasoning applies to the heirloom as well as to the crummiest souvenir.[2] Stewart's ideas will be considered in more depth after we have examined a range of collection-type albums, from the paper museum to the memorial scrapbook. Heirlooms and souvenirs will be contemplated in the process. The miracle of the McCord is its faithfulness to both.

THE CABINET OF THE SELF

A hobbyist's way of collecting and organizing pictures may mimic scientific or curatorial practice. Or the amassing of metonymic images may function as an individual life history, replacing the diarist's chronological entries with an autobiographical collage. The American writer Ian Frazier captured these strategies in a simple device when he labelled the boxes of his parents' papers and photographs "THE DAD MUSEUM" and "THE MOM MUSEUM."[3] Those boxes were full of stories, but they were nothing yet approaching a book; the nesting patterns of his parents had preserved their life histories in alternative ways.

The album as collection (the paper museum) groups objects, or images of objects, that somehow relate. How so is not always very clear. Experience suggests that at some point in the process, either reason or passion was in control, though with titles, dates, and other signposts missing, one

can begin to doubt. But this very lack of textual support, combined with a pattern of internal association, contains real clues to the nature of the album and its connection to oral tradition. In an album as collection, the organization of images gives material form to the ancient art of memory.

The trick, if one can call it that, is remembering by visual association. Roman rhetoric considered memory as a storehouse of knowledge and devised various methods for memorizing oral recitations. The one that interests us here was a system linking parts of a speech with the objects and features of a familiar space (*loci mnemonic*). Called to the floor, the orator reconstructed his speech by revisiting the objects in his imagination; one after the other, they surrendered their mnemonic cache. Frances Yates has traced the art of memory from the ancients to the moderns. She shows that a working method of artificial memory evolved into an architectonic arcana of retention and discourse – a form of mastery over the universe through possession and recitation of emblematic marvels.[4] The art of memory was applied to mysticism, alchemical formulae, and cult secrets – things that were not written down but remembered in a chain of association prompted by a leading image.

The Roman way of organizing knowledge for retrieval was taught well into the eighteenth century, influencing the associative organization of real objects held and displayed in private collections. The cabinet of curiosities – a theatre of the world – was opened to the visitor by the performance of its keeper, who remembered each object's store of knowledge by association (adjacency, kinship, analogy, and subordination, according to Michel Foucault).[5] Returning through the cabinet of curiosities to the art of memory excites a number of photographic connections, many already made in metaphysical readings of photography by André Bazin[6] and more recently by Philippe Dubois, who rehearses Yates's discoveries, emphasizing the photographic inscription of mental images on the unconscious.[7]

Katherine C. Grier's analysis of the Victorian parlour casts this central room and its centrepiece album in the same light.

Within the strict demarcations of a Victorian home, Grier defines the parlour as a public space whose arrangements of furniture and decoration, built by symbolic connection, were "sites for certain kinds of conventionalized cultural information, which families could 'own' in the form of possessions." The parlour, however modest, synthesized domesticity, intuition, and judgment within complex systems of classification and transmission. The room's centre table, illuminating the family circle by its single, precious lamp, constituted a shrine of domestic treasure: "hair wreaths in glass frames, photo albums, and large family Bibles with decorative covers." For Grier, "the image of the 'memory palace' is a suitable metaphor for what decor could mean to properly susceptible and sensitive Victorians."[8] What is more, as Grier had earlier discovered, the image of the parlour had migrated from the home to the photographic studio, lavishly emulated in reception rooms for the clientele.[9] Backstage, where the operator performed his magic, fewer props were needed: the carte-de-visite would be taken in a sketch of a parlour, a painted backdrop, a chair, a table, and a piece of carpet simulating the symbolic decor of the room.

Perfect symmetry by design, for the nineteenth-century album is also an architectural conceit. Cartes-de-visite and cabinet cards are set in arched windows whose borders of line and shadow add to the effect of a niche. Within this fictive space, the illusionism of a photograph gives roundness and depth to the figure. The portraits are like sculptures arranged within the blind arches of a court, an impression rarely spoiled by the intrusion of a caption. Most albums designed for cartes-de-visite contain an index page to keep the inscriptions at bay. In The Royal Album the names of the royal subjects were printed on the contents pages. In the McCord Museum's copy no names were added to the list when portraits of four supplementary royals were slipped into the empty slots. Anyone looking at the album would have asked who these people were, and the answer would have been much more than a name. Each acquisition would have entailed a story.

The Arthur Lindsay Album (MP 2146), compiled after 1866, is a much expanded royal album. The sequence

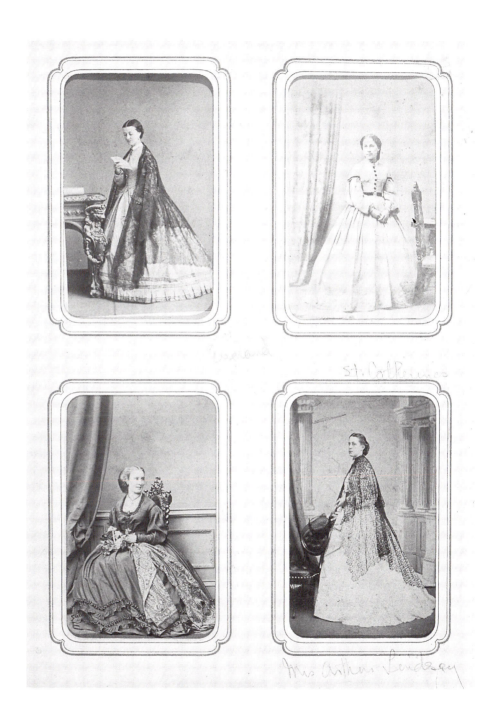

follows protocol for over one hundred cartes-de-visite, tracing Britain's royal family down through to its aristocracy, continuing with the royal houses of Europe, visiting family and friends in North America, and ending with a portrait of Minnie Lindsay, the implied compiler. "Mrs Arthur Lindsay" and "St. Catherines" have been pencilled in by someone else, someone who knew that the other pictures on the page had been taken in England, but could not remember the subjects' names.

Mrs Lindsay no doubt knew them all, but her internally committed recitation has not come down with her album. Only its hierarchical logic survives in the breadth and order of presentation. Studio stamps indicate groupings by location (*adjacency*) or *kinship*; the groupings were organized page by page. Thus brought to life, Mrs Lindsay's album is a "chronotope" – a fictional fusion of space and time.[10] Commentary imbedded in the content and sequence of the pictures creates a dream place of reception at court (*analogy*) or a procession from the upper levels of society into Mrs Lindsay's circle (*subordination*). Her portrait at the end of the album represents both her signature and the inventive storyline of a backward look.

LIVING CURIOSITIES

Mrs Lindsay's imaginary procession was designed to stop at her door. Other albums of the same period wanted only to pause, before proceeding down the social or racial scale. The pretext was scientific, and we can see in these collections the gradual renovation of the cabinet by natural history. A strange hybrid appears as The Royal Album, a kind of visual *Debrett's*, merges with the Book of Nature.

The Ogilvie Album (MP 032/81), signed by W.W. Ogilvie in 1868, is a paper museum of humankind. Two hundred cartes-de-visite, from studios in London, Edinburgh, Glasgow, Paris, Vienna, Trieste, Florence, Cairo, Washington, and other far-flung cities, form an exhibit of celebrities and national types that begins with members of the royal house of Britain. Their portraits are followed by the current rulers and leaders of Prussia, Egypt, Austria, Italy, Russia, Abyssinia, and Greece. A fifth of the way through the album, these notables become increasingly generic, as in "Hungarian Prince" or "Bedouin Sheik." And so on down the line of ethnicity and trade; the lower the status, the more colourful the type, as in "Egyptian water carrier," "Russian Monk, Jerusalem," "The Sultan's Dwarf Clown," "Papal Zouave," and "Greek Brigand." British aristocrats and officials are identified by name, European ladies and actresses likewise, where possible. Halfway through the album, British royals, aristocrats, and politicians begin to mix with the lower orders, such as "Syrian friends." A few of Notman's Montreal characters elbow their way in. Jockeys, photographed in Brighton, model their hand-coloured silks. A Circassian slave, haughty and in control of her divan, hints at the existence of more wanton odalisques. The album concludes with a curtain call of favourites, including royals, Roman peasants, and silly Scottish girls.

The album, impeccably preserved, makes a stunning impression, fourteen hand-coloured cartes-de-visite adding immeasurably to its charms. There is much more to the album, of course, and its encoded arrangements are key. On the one hand, subjects are clustered according to status, nationality, race, occupation, and gender. Naming and labelling – these images are almost all carefully captioned – divide people from human specimens. On the other, the standard format of the carte-de-visite has its usual levelling effect. Ogilvie, in his way, is an objective encyclopedist; he is also a man of his times.

Nineteenth-century attitudes toward nationality and race were conflicted, to say the least – shaped by competitive interests and visually ambiguous. If Ogilvie appears somewhat eccentric in his world-making use of the album, he is in learned company. Roslyn Poignant describes three albums of cartes-de-visite, superficially "within the social frame of a Victorian family album," that were compiled in the 1870s by the Racial

Alma Dancing Girl

Syrian Girl

Egyptian Woman

Committee of the British Association for the Advancement of Science to illustrate the human composition of the British Isles through comparative physiognomy. In Album C, which includes Teutonic types from England, Scotland, France, and Germany, "The total effect is of Teutomania superimposed on Cartomania to provide a composite view of a supposed highest plane of Victorian Society."[11] The context of such projects, according to Poignant, was anthropology's rejection of a typological approach to racial diversity in favour of a Darwinian developmental model that was essentially hierarchical.[12]

Poignant's evocation of the typical Victorian album as a closed, hierarchical system (from Queen to royal family to men of rank to family in genealogical order to servants)[13] throws Ogilvie's private atlas into relief. Working like the Racial Committee from commercial photographic stock, he took an approach that was less rigorous, even stubbornly unscientific. His presentation proceeds neither from the top to the bottom nor from the general to the particular, but rather, meanders as a traveller whose attitudes are sometimes expanded, sometimes reinforced through strange encounters. Pictures with such captions as "Syrian friends" are pregnant with stories, the compiler's versions of *The Thousand and One Nights*. An uncaptioned carte-de-visite, tentatively identified as Ogilvie and a male companion in Arab costume, reinforces this Romantic fantasy.

Edward Said's definition of scholarly Orientalism is not impertinent to Ogilvie's somewhat disorderly world view. The album's stock characters and photographic tableaux turn the Orient into Said's theatre of Orientalism, "a closed field, a theatrical stage affixed to Europe."[14] Ogilvie, of course, casts a much wider net; he is in effect more liberal in his condescension. All the world's a stage, as the plump Venetian gondolier teeters with his flag on a photographic studio's mock craft, a wicker chair.

If Ogilvie's inclusiveness seems to play to authority, another aspect of his album hints at a different program, unruliness by intent. His collection is bound between tartan-patterned covers that feature a medallion portrait of Bonnie

Prince Charlie. He breaks the collection's contemporaneity only once, by including a photographic copy of a painted portrait of Mary Queen of Scots. What can this anachronism mean? Heinz and Bridget Henisch have explained that photographic studies of national dress, or symbolic bits of the landscape, could be interpreted as seditious in countries dominated by foreign powers.[15] In the Ogilvie Album there is a picture of a Georgian soldier that matches their criterion. Perhaps Ogilvie's interest in stereotypical national symbols was an expression of pride in his own Scottish heritage.

Yet again, if Ogilvie wanted to honour Scotland's distinct society, he seems sometimes to undermine himself. Near the end of the album, a carte-de visite from the J. Beckett studio in Glasgow depicts "A Scotch Washing," two uncapped maidens standing together in a washtub, their striped skirts raised above their knees, their oblique expressions cast in melodramatic abjection. The models' traditional costumes mark them as fisher lassies from Newhaven, an ethnic community of Huguenot descent.

The Newhaven folk are famous in nineteenth-century photography because of their thorough documentation in the 1840s by the Edinburgh partnership of David Octavius Hill and Robert Adamson. Colin Ford explains that the photographs were part of a public campaign to improve the safety of the fishing fleet. Still, it was not long afterwards that the Newhaven women's traditional costume came to be identified with loose morals.[16] Ogilvie's album contains two other cartes-de-visite of Newhaven fisherwomen, straightforward displays of the type. But the young women posing provocatively in their washtub boat are more complex creations, embodying nostalgia, prejudice, and illicit pleasure. Scottish Others, these women stand close to the sea and not so very far from their sister odalisques.

MIXED COMPANY

The Ogilvie Album represents the first enthusiastic wave of photographic world-making. Since then, ethical and scientific

A SCOTCH WASHING

Kate Kearney's Granddaughter

Constantinople Sedan Chair

Venetian Scissor Grinder

considerations have complicated and enriched the task. The ethnologist-collector of photographic specimens has gradually learned to consider the conditions and motives operant on both sides of the camera and how these invisible factors alter cultural identity and self-presentation. Michael Taussig envisions a prismatic mirror of representation that captures the recorder, the recorded, and the cultural inflection of the recording instrument. Struck by photographs of Cuna women and men, he points to their choices of costumes, the women in a radically traditional costume, the men in Western-style dress: "photography concentrates to an exquisite degree the very act of colonial mirroring, the lens coordinating the mimetic impulses radiating from each side of the colonial divide."[17]

The syncretic results of cultural confrontation are well illustrated by the work of two men, Fred W. Berchem and G.E. Mack, naval officers employed by the Hudson's Bay Company in the first quarter of the twentieth century and assigned to ships in the Arctic. The two men knew each other; in 1927 Berchem seems to have served on the *Nascopie* under Captain Mack. Though they worked under identical conditions, their approaches to compilation are informatively different. If Mack was a photographer, he also collected the photographs of others, while Berchem's albums are clearly the well-ordered work of a photographic collector from life.

The Captain G.E. Mack Album II (MP 598) has been indexed by the McCord under five headings: polar bear; Eskimo costume and igloo; Hudson's Bay posts, settlements, ships, and officials; Laplanders' costumes; and reindeer from Norway. A curious episode glimpsed in this album is the landing of imported reindeer in the Canadian north. The introduction of the herd was an entrepreneurial innovation in northern development; the Lapp herdsmen, their traditional handlers, were there to ease the transition. These "rare" (and richly syncretic) moments invariably come up in discussion of the Mack albums and are considered its highlights.[18] The pictures are indeed scarce, even within the albums in question, which dedicate far more space to the regular supply duties of the Hudson's Bay Company ships. Both Mack and Berchem were concerned above all with the interests and property of the company, including the people, or types of people, who served it. Their collections show that the knowledge and skills of the Inuit were greatly valued in negotiating northern waters, hunting the polar bear, and increasing the harvest of seals. In exchange, the Hudson's Bay Company brought modernization and "opportunities" for adaptation. In the Fred W. Berchem Album 1922–1924 (MP 128/84), we find a picture of an "Eskimo" pilot at Lake Harbour, as well as a snapshot of three Inuit men listening through headphones to radio, both pictures taken in July 1922.

Berchem seems the very image of a sober and careful documentarian: his photographs are sharp and uncluttered; his captions are legible and succinct. The occasional outburst of private feelings is therefore surprising, though less so when one considers his age and experience. In 1917 Berchem was a fifteen-year-old apprentice on the ss *Baytigeon*, sailing the Indian Ocean. By September 1919 he was watching the unloading of stores at Fort Chimo. The earliest album by Berchem in the collection, that for 1920–21, is a study in first contact, vacillating between received opinion ("one of the H.B.Co's best hunters") and the most puerile jokes ("Venus and Adonis. Two typical natives of the regions around Chesterfield Inlet. These two are man and wife."). The first caption is attached to a full-length portrait of an Inuit hunter, and the second to pictures of two elderly people who have innocently posed for the camera. The same album includes snapshots and newspaper clippings that bring Berchem close to a northern drama: the story of "Ouangawak the Eskimo murderer and the woman whose husband he killed," captured by the Royal North West Mounted Police. The final episode – Ouangawak's escape and death – is eventually recorded in equally broad strokes. Judging from his captions, Berchem is no more excited by his own kind. In a later album (MP 127/84) one photograph of the *Nascopie*'s 1927 sealing expedition shows the hunters fanning out from the ship and swarming over the ice. The ambiguous legend reads, "'Onward Christian

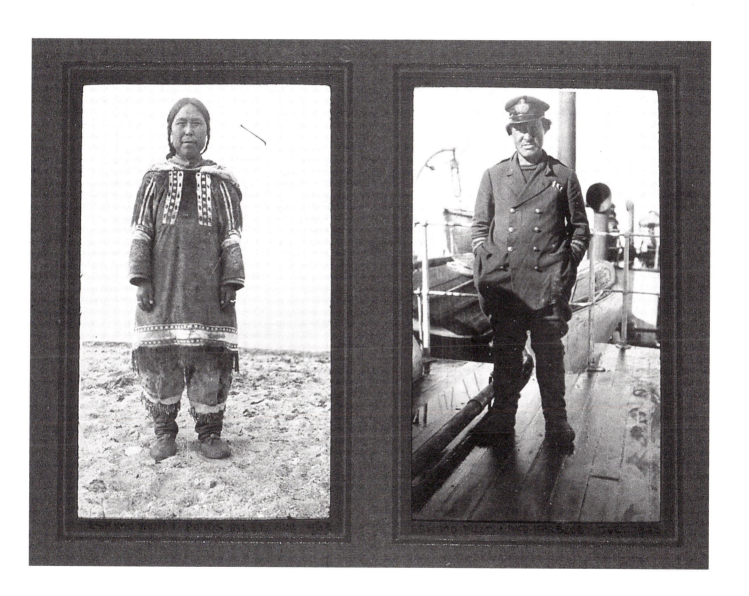

Fred W. Berchem Album 1922–1924 (MP 128/84), 14

soldiers'?" His photographic expression is more sociable; from the same expedition comes a sympathetic portrait of one Jack Cook, crouching beside a "whitecoat," a harp seal pup whose birth coat is the goal of the spring hunt.

Berchem's photographs of Inuit men and women are patently not portraits but blunt physiological reports, made, labelled, and sorted by human category and circumstance in relation to the compiler's prime focus, the ship. A group of women, children, and elderly men are simply identified as "Eskimos living in Nascopie's forehold, Season 1926." The results of interracial breeding are noteworthy to Berchem and an explicit theme of Mack's album (MP 598), which includes multiple views of one large family, the father apparently of European descent and the mother Inuit. Their children are closely studied. We have some indication of the comments that would have accompanied these images in the McCord Museum's accession book of 1947. The album was donated by the captain's wife, Mrs R. Mack, and described then as containing photos of "Eskimo and mixed breeds, costumes, tents, igloos, hunting scenes, RCMP and HB Co. officials."[19] The children of an interracial marriage were looked upon as one more subject category of Arctic exploitation – indeed, one of its most interesting types.

BOOKS OF BEAUTY

Quite another type of typological album – its portraits unquestionably transactional – is the Becket Actress Album (MP 189/78), compiled by Hugh Wylie Becket in Montreal after 1872. In the scrapbook idiom of the fan, the Becket album is dominated by celebrities, mainly actresses, whose portraits are mounted on hand-decorated pages. The actresses' names or their most famous roles are inscribed in whimsical vignettes, heraldic banners, and laurel leaves. Dates are attached to two names: Croisette, 1876; Judic, 1876. Only one male actor is included, his full-length portrait cut out and inserted as a figure in a painting displayed on an easel. The name "Faure" is inscribed below. Royal personalities include Queen Victoria, 1873, and copies of portraits of historical figures such as Marie Antoinette, Mary Queen of Scots, and Catherine de Medici. Apart from royals and thespians, three sport clubs are represented: the Montreal Gymnastic Club (including one Robt. A. Becket), the Montreal Baseball Club, and the Toronto Lacrosse Club, all from 1872, the year the album was started. Quite soon, it seems, actresses and women of power usurped the local heroes, offering the compiler more scope for embellishment.

The handwork of the Becket album leads us to another scrapbook, or sketchbook, the Emily Ross Album (MP 107/82), presented to the compiler by her brother on 1 January 1869. This album illustrates the integration of photography into the established avocations, intellectual pastimes, and displays of "ornamental skills" that suffused the Victorian home.[20] An example of the type was described by a British writer, who recalled an evening with two elderly sisters: "she placed in my hands an Album, containing a number of water-colour sketches of flowers and of seaside resorts painted by her sister and herself during their earlier years, together with old Valentines, coloured prints, Baxter and otherwise. There were also steel engravings from long-neglected 'Books of Beauty,' pressed flowers, leaves and seaweed; quoted verses written in delicate penmanship and wreathed in floral borderings; and many other suchlike garnerings from the scythed fields of Time."[21]

The Ross album is unfinished. Changes in style and quality – the signature of one "Lizzie" – suggest that the scrapbook was shared or changed hands. Still, its collages of photographs and painted vignettes form a cohesive group. The photographs appear to have been lifted from cartes-de-visite. Their presentation on the page is enhanced by framing devices that contextualize the images in different ways. Some photographs are enclosed in "frames" decorated with lyrical floral (female subject) or geometrical (male subject) motifs. These images are creative proposals for the display of photographs; they intensify the image by sealing and beautifying

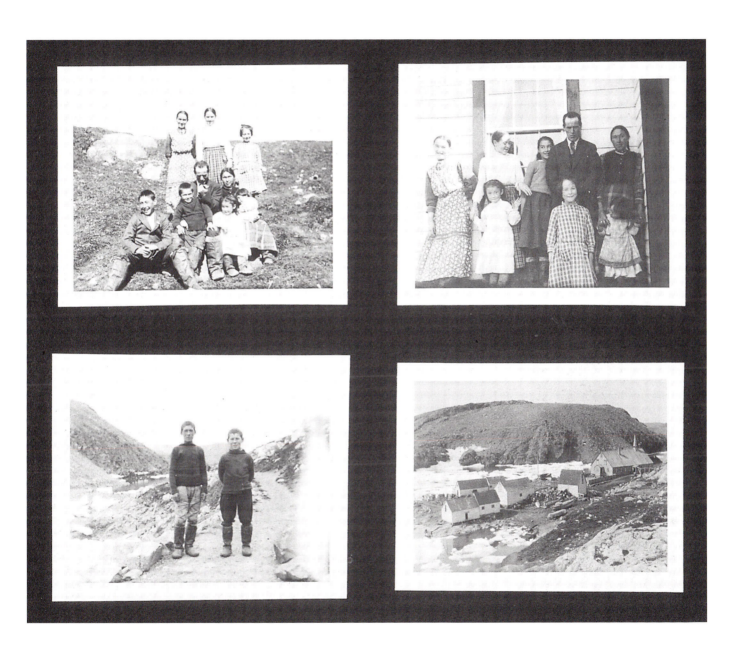

Captain G.E. Mack Album II (MP 598), 3

Emily Ross Album (MP 107/82), 32–3

its edges; they are functional, aesthetic designs. Other images contain more of the personality of the artist and an inkling of her yearnings. In one case, five portraits are mounted on the vanes of a fan. Though nicely done, this was probably not an original idea. Miss Ross had no doubt heard of Miss Stevenson, whose photographic dress, camera hat, and photograph-and-feather fan were recorded by William Notman in 1865.[22]

A fourth collage, the most interesting, inflects the interpretation of the rest by breaking the boundaries of the enclosure. The carte-de-visite is shown falling out of an envelope, which is rendered in realistic detail, postmarked Kingston and Montreal, and personalized with a monogrammed seal. The envelope as drawn has been torn open; the photograph, a portrait of a man, falls out of it sideways toward the bottom of the page. In this case, the Romantic vignette achieves full narrative potential by shifting the static image into continuous, pleasurable rediscovery. The motif of the letter pierces the framing device and penetrates the walls of the domestic cloister, thus proposing an unfinished tale.

Charles Rosen and Henri Zerner have defined the Romantic vignette as an emanation from the narrative centre. Hilary Thompson has further suggested that the effect of narrative closure afforded by the Romantic vignette is of a moral order.[23] If so, the mixed message of this mid-century album accords with the colliding influences of the period, as reflected in the world of children's fiction.

The crisis is explained by Daniel T. Rodgers, who sees American children's stories of the mid-nineteenth century as surrounding "Northern middle-class children ... with a set of socializing pressures and interlocking moral injunctions critically different from those impressed upon children before them ... the 'semi-mechanical' virtues of industry and regularity – drummed in by the regular discipline of schools and school-modeled homes, reinforced by didactic storybook example." As the century ends, Rodgers perceives a shift from "a code of restraints to one of heroic impulse." Female storybook figures "found themselves confined by a set of emotionally constricted, often much too hard-working paren-

tal surrogates whom they won over to their purer, more sentimental creeds of spontaneous love."[24] With its metaphoric tokens, the Ross album communicates similar fantasies of individual and societal transcendence. The photograph literally bursts the bounds of the regulating Victorian frame.

COMPILING THE VIEW

Becket and Ross were enthusiastic amateurs who used photography to reinvigorate and personalize an established artistic form. Another survival of the pre-photographic world was the print collector's album, a more precious and serious tome. "Amateur" here refers to knowledge and passion. Private circles and amateur societies, such as exchange clubs, were the engine of photographic experimentation until the end of the 1850s, when commercial sources of supply and popular demand quickly changed the nature of production. Grace Seiberling and Carolyn Bloore have shown that the function of photographic albums evolved over the 1850s from specimen books of prints to collections of images by type.[25] Still, the print itself was a type of mastery, and until the snapshot ruined things forever, the amateur photographer retained an aura of dignity.

In 1865 Canadian landscape photographer Alexander Henderson, himself a member of the Stereoscopic Exchange Club, published his work for the first time under the title *Canadian Views and Studies by an Amateur*. Independently wealthy, Henderson was a self-employed commission merchant. He was also an amateur of art and the founding president of the Art Association of Montreal, a group of twenty-three artists, politicians, professionals, and businessmen (William Notman among them) who came together in 1860 to encourage fine arts in the city.[26] Within two years of his first publication, Henderson had opened a studio in Montreal, where he specialized in architectural, urban, and landscape views, supplementing his activity with portraits; still, the status of his work remained in flux. In the studio, Henderson did

not discriminate between his amateur and professional stages, transferring and inventorying his pre-1866 plates as needed.[27]

Despite Henderson's self-identification, his published album of 1865 cannot be considered the work of an amateur. But like Notman and other nineteenth-century professionals, he did make significant contributions to amateur projects. One of the many albums that have come to the McCord from the Molson family of Montreal is a compilation commissioned from Alexander Henderson by May, Hattie, and Ethel Frothingham and presented to their uncle, John H.R. Molson, on 1 January 1879. Photographs: Canadian Scenery (MP 1452) is a lavish presentation of 189 albumen prints, organized geographically, by town, waterway, and region, and complementally, according to theme, season, and photographic interest. The panorama extends from Truro, Nova Scotia, to Niagara Falls. Descriptive views of the colonized landscape denote prosperity and expansion, traditional occupations, feats of engineering, natural resources, and wonders. Understandably, almost all the images are Henderson's, but breaking the flow are five composite photographs from the Notman studio, inventive accounts of Montreal social life and sporting pleasure. They seem out of place until the album's commissioners are taken into account – an original and fun-loving family of photophiles. Other photographs and albums from the Frothingham connection – the Louisa Davenport Frothingham Album, given to her in 1876 by her two older daughters, the Frothingham/Benson Carte-de-visite Album, and Ethel's turn-of-the-century album, the Benson Family Album – chronicle the Frothingham family's enduring enthusiasm for photographic tableaux. In the case of Canadian Scenery, the inclusion of Notman's flagrant artifice underscores the tension between "artificial" and "natural" effects that inflects much of Henderson's own work. Drawn to such challenging subjects as snow, ice formations, and waterfalls, Henderson was prepared manually to enhance the effects. His own depiction of tobogganing, combining studio and outdoor exposures, formed a bridge between art and nature. Still, by comparison with Notman, Henderson was a purist.

Out of the mouth of babes … the Frothinghams' amateur compilation makes his artfulness more apparent.

Another album of scenic views, this one entirely composed of Hendersons, is nevertheless also marked by the desires of its commissioner, David Ross McCord. Of the forty-eight albumen prints in the McCord Red Album (MP 139), the first nine are architectural views of three McCord houses. Henderson made these photographs on assignment around 1871, then or later turning the plates over to his client. They are now at the McCord Museum, their value secure since Henderson's descendant threw away the rest of his plates. The prints would be interesting in any case because of the message they bring to the album.

Henderson photographed not three but four McCord houses: two ancestral homes on the Nazareth Fief, the Ross house on Champ de Mars, and the McCord family seat, Temple Grove, built in 1837 by John Samuel McCord.[28] The Champ de Mars house predated Temple Grove as a family monument. It was built in 1813 by David Ross, David Ross McCord's maternal grandfather. Neoclassical in style and richly appointed, the Champ de Mars house was much admired. David Ross McCord commissioned Henry Bunnett to draw the house, inside and out. Nevertheless, he left Henderson's photographic view of his maternal grandfather's house out of his album.

McCord's omission redefines his album as an architectural genealogy. Samuel McCord had died in 1865, his wife five years later. But the unexpected and significant factor was the death in 1866 of David Ross McCord's older brother, John Davidson McCord.[29] Although David Ross McCord would not take over Temple Grove until his marriage in 1878, it was as master of the house that he commissioned the photographs of the exterior. His stance between the columns of the porch affirms his possession and sense of destiny. Henderson's views of Temple Grove are followed in the album by twelve blank pages, some with abrasions and traces of glue. Whatever the missing prints were, the Henderson prints that follow constitute part of McCord's photographic collection

Photographs: Canadian Scenery (MP 1452), 92

and his preservationist mission. Henderson's treatments of nature, especially rivers, lakes, waterfalls, woodland, ice fields, and snow, have been organized for visual interest and private contemplation. The sequencing of the prints is more loosely associative than the album created for John Molson. Blank pages indicate that these families of images were supposed to grow.

Susan Stewart has argued that the material souvenir, shifted into the realm of the collector, leaves its maker behind, generating a myth of origins that is the "narrative of the possessor."[30] Following Thorstein Veblen's *The Theory of the Leisure Class*, she equates the narrative of possession with a genealogy. Just such a transformative conflation takes place in the Red Album, which predicts the museum in the making. McCord's collecting activities were driven by his constant awareness of cultural disappearance and perhaps even his own, for he lived by a terrible motto. Everything he touched was an imminent souvenir. Such an elegiac dynastic myth germinates in the proprietary preamble of the McCord Red Album and stretches to the nation as a whole through McCord's photographic purchase of the Canadian landscape.

McCord looked forward and struggled against the void. Other collectors looked back through the lenses of landscape, architecture, and legend to keep history alive in the present. The descriptively named Green Album (MP 010) includes photographs from the Montreal studios of Notman, Henderson, and Barnes (possibly Wilfred Molson Barnes, whose establishment existed from 1900 to 1940).[31] Purchased prints are combined with snapshots, maps, photographic copies of paintings and drawings, and a pressed botanical specimen. Of disparate sources and spanning up to ninety years, photographs and other visual documents gathered into the album seem to have been chosen for their representation of Quebec's colonial and military history, especially the Seven Years War and the War of 1812. Twentieth-century maps and copies of nineteenth-century military engineers' plans are distributed throughout. Subjects of obvious military and colonial importance are punctuated with landscapes of no apparent signifi-

cance. The photographs are organized neither geographically nor chronologically; rather, they are amassed in a private museological survey of visual culture.

The Green Album reflects a lifelong passion for history, and the feeling is contagious; its views of anonymous burial grounds and ordinary meadows are sown with what-ifs, the discoverer's theories, and the thrill of the chase. The more specialized and sombre Cannon Album (MP 1993) is comparatively remote. Made in Vienna, the album takes its name from a prominent brass cover motif, though it could be a curatorial pun, since the album contains 198 cartes-de-visite (or carte-sized prints) of historic European sites, buildings, and canonical works of art. Many such photographs now exist as enlarged reproductions, but this vintage piece is a fascinating window into mid-nineteenth-century reception.

The carte-de-visite formula that turns commoners into kings is less flattering to works of art. All monuments, big and small, are reduced to manageable proportions, and their systematic display, four to a page in pockets, is dry. Inscriptions in English, French, and Italian are relegated to the back of the mounts, and while some include page references to Murray's guidebook, no traveller's tale or flowery description lifts the pall of paper-museum fatigue. To understand the appeal of the Cannon Album, we need to be reminded that, in the nineteenth century, engraved illustrations of artworks were not so abundant; that foreign places and monuments dwelt mostly in the imagination from textual description.[32] Thus for the armchair traveller, adult or child, compilations of artworks reproduced in miniature combined canonical instruction with intense, sensory stimulation. Looking was allowed, even on a Sunday, when most other distractions were forbidden.[33] Victorian rationers of pleasure underestimated the power of these portable museums, their generation of questions and fantasy. The Cannon Album is a catalogue of contemplation. The yearnings of the compiler are arrayed in this photographic diaspora, whose meaning depends on the illusory nature of collection, especially the collection of souvenirs.

Cannon Album (MP 1993), 32

The souvenir, according to Susan Stewart, is a trace of authentic experience that is always incomplete, a metonymic reference "impoverished and partial so that it can be supplemented by a narrative discourse, a narrative discourse which articulates the play of desire." Stewart understands the photographic souvenir as utterly dependent on its story, which itself becomes the object of nostalgia. Every element of her model album goes through a transformation from the public to the private by absorption into the lore of the possessor. She fortifies her argument by distinguishing between souvenirs of exterior sights (purchasable visual representations) and souvenirs of individual experience (mementos). Objectively speaking, these may be one and the same, but the memento-type souvenir attaches to a life history; it is the material sign of an abstract referent that is transformation in status.[34]

Stewart admits only the memento to her archetypal album, and her discussion of this point signals her strong literary bias – the blind spot in her vision. Her model compilation seems to be based on a closed autobiographical text – closed to the constant revision of performative re-presentation and surprisingly closed to fantasy. The substance of that text is external reality: "events that are reportable, events whose materiality has escaped us, events that thereby exist only through the invention of narrative."[35] Her definition disregards the motility of photographic experience; it slights the imagination; it reduces the image to a mnemonic hook. Stewart locates the memento-souvenir in a structure of longing, a fixed referential gap between past and present, a cradle of narrative. That gap must remain open. She insists that past and present cannot meet.

As in an album of photographs or a collection of antiquarian relics, the past is constructed from a set of presently existing pieces. There is no continuous identity between these objects and their referents. Only the act of memory constitutes their resemblance. And it is in this gap between resemblance and identity that nostalgic desire arises. The nostalgic is enamored of distance, not of the referent itself. Nostalgia cannot be sustained without loss. For the nostalgic to reach his or her goal of closing the gap between resemblance and identity, *lived* experience would have to take place, an erasure of the gap between sign and signified, an experience which would cancel out the desire that is nostalgia's reason for existence.[36]

But performative contemplation of an album closes the gap, remoulds it, and opens it again. The storytelling nature of an album constitutes *lived* experience (real and imagined) that neither erases nor cancels sites of longing, but continuously revisits them in a moving present. This actualization of the past – its blending in the present – is illuminated by an album-collection that is the very picture of longing.

The John C. Webster Memorial Album (MP 198/81) is a compendium of photographs and newspaper clippings that chronicle the life and accidental death in 1931 of a distinguished Canadian flyer. It was donated by the second husband of Webster's widow sometime after the woman's death. The compiler is unknown and, despite the source of the gift, seems unlikely to have been Webster's young widow. There are no wedding pictures, no sentimental views of courtship or early marriage. The bride, who was also a flyer, joins her husband only in a group on the airfield. The biographical sweep of the album, from baby pictures to newspaper reports of the fatal accident, suggests that it was compiled by Webster's mother, though the very nature of collecting would nurture that view. Susan Pearce explains, "We feel about our collections as if they were part of our physical selves, and we identify with them: loss of collections brings the same grief and the same sense of deprivation which accompanies other bereavements. Collections can be used to construct a world which is closer to things as we would like them to be, and the colloquial use of 'things' in a phrase such as this is revealing."[37]

The album fits into a pattern of bereavement that Colin Murray Parkes explains as a form of selective, visual searching: "Searchers carry in their mind a picture of the lost object."

The restlessness of searchers is insoluble because driven by the impossible goal of finding the person who is lost. In their grief, searchers are preoccupied with thoughts of the deceased and the specific events that led up to their loss. By dint of intent, their memories are photographically clear: "maintaining a clear visual memory of lost people facilitates the search by making it more likely that they will be located."[38]

The photographic album preserves the life story of the departed within a concrete and bounded report. The telling of the album perpetuates the search, which is additively transformed by each experiential narration of its keeper. Time has arbitrarily stood still for the lost object, but it will not wait for the keeper, whose endless search, embodied by the album, will be gradually expanded to include not only the departed but a person much altered by loss and recovery, the searcher herself. And if, as Christian Metz has argued, the photographic image has helped the mourner to love the departed *"as dead,"* this transformation in the nature of feeling itself marks a chapter in the mourner's life, a profound experience that will be relived and recounted, changing over time.[39]

The memorial album reconciles mourning and adjustment as a progressive and expansive redefinition of the self in concert with the departed. Ivan Illich and Barry Sanders explain: "In oral cultures, one may retain an image of what has been – yesterday, at the time of the full moon, or last spring, but the person then or now exists only in the doing or the telling, as the suffix comes to life only when it modifies a verb. Like a candle, the 'I' lights up only in the activity and is extinguished at other times. But not dead. With the retelling of the story, the candle comes to glow again."[40]

The album as a private collection, whether social, anthropological, historical, museological, or biographical, domesticates a vast and unpredictable universe, setting its pleasures and terrors into a pattern of knowledge and experience inextricably linked with the self. The compiler-spectator is absorbed by and into the visible world through tangible possession of its photographic emblems and the waking dream work of the imagination. How shall we remember Johnny Webster? Collectively, for he is no longer one, but with a chorus of I's, an endless round in the retelling:

I gave birth to him.
I flew; like Icarus, I fell.
I gathered up the photographic pieces.
I kept them until I died.
I keep them. I am looking at them now.

MEMOIRS AND TRAVELOGUES

REMEMBER ME?

All compilers appeal in some way to the future. Collectors make their stand in thoroughness and patience; they amass their messages to posterity; they hole up; they wait. Autobiographers are more disposed to action; they ride out to meet mortality with their own special version of events. Solipsism is risked; indeed, it is required of the autobiographer, who must saturate even hindsight with the alert and prescient self. An autobiographical album keeps its main protagonist alive and in wilful engagement with the now.

In this chapter we consider two types of autobiographical albums, the memoir and the travelogue. A memoir is a person's account of the incidents of his or her life – the figures, transactions, and movements that have affected it. A journey might qualify as an incident, though the memoir really needs no excuse – it can be sparked by the simple desire to reflect. Having taken photographs during a particularly active phase of one's life, or simply having gone through an active phase of taking photographs, might be reason enough for a compilation, to bring order and tellability to the photographic hoard. Or the album may have been decided on in advance, and a camera made part of a carefully planned adventure. This certainly applies to most of the travellers and at least

one of the soldiers. A travelogue conventionally takes the form of an illustrated lecture or descriptive film; I am borrowing the term to capture the semi-public nature of the traveller's album, its veneer of objective reportage.

In each of these albums, one voice – the compiler's – rises above the hum of interesting conditions. That does not mean that every memoir or travelogue is an original. On the contrary, each of these albums is representative of many, each of them no doubt assembled by an individual with something to say and someone to say it to. An autobiographical compiler understands his audience and assumes that its members understand him. The pretext of an autobiographical album can be anything that shows off to advantage its *somebody*; the audience remains small (and understanding) unless the lead role expands, some chance or mischance turning the compiler into an extra on the world stage. None of the albums that we will examine give any indication that the compiler expected such to be the case; the wartime albums are ironically compelling for that reason alone.

Discovering these personal albums in a museum of social history raises certain expectations of social relevance and historical import that will not be denied. We want to situate their incidents in the larger picture. We also want to know what separates these accounts from others, not just other albums but other autobiographical texts – letters, diaries, and journals – to which they are frequently compared. Photographic autobiography *is* different for all kinds of reasons. Its intelligence is visual, contained in an all-over description that is sometimes pointed by a caption, sometimes opened up by a few terse lines. As personal narratives, albums are retrospective, selective, and coded. Memoirs and travelogues correspond closely to the lives of individuals. Maddeningly, compulsively, they are no more decipherable than the people we know.

PICTURE PERSON

Hand Pepys a camera instead of a pen, and picture this:

A-bed late. In the morning my Lord went on shore with the Vice-Admirall a-fishing; and at dinner returned.

In the afternoon I played at nine-pins with my Lord; and when he went in again, I got him to sign my accountts for 115*l*: and so upon my private balance, I find myself confirmed in my estimate that I am worth 100*l*.

In the evening in my cabin a great while, getting the song without book, *Help, helpe Divinity* &c.[1]

What an impossible day! (It was chosen at random.) The movements of the lord and the vice-admiral needed to be photographed while Pepys slept. The signing of the account book and Pepys's mental calculations were nothing to see. A self-portrait working up the song might have been good, though without sheet music or an instrument, somewhat enigmatic. The most photogenic event was the game of nine-pins, though it would have taken a very clever photographer to capture Pepys's sense of his own importance as he played games with the lord.

A visual diary is not the equivalent of a text, nor is it necessarily a life's work. We are dazzled by the output of the pseudo-amateur Lartigue, whose albums, diaries, and paintings were his primary occupation.[2] But diarists, according to Thomas Mallon, come in many forms: chroniclers, travellers, pilgrims, creators, apologists, confessors, and prisoners. Only the chronicle pretends to full autobiographical coverage as "carrier of the private, the everyday, the intriguing, the sordid, the sublime, the boring – in short, a chronicle of everything."[3] Chronicling is both a method and an incentive for writing; the results can be dense and scratchy; the reader must take what she can. Mallon offers two painful examples: an entry in the diary of zoologist Philip Gosse noting in strict order of occurrence the birth of his son and the delivery of a new specimen (we suffer for the son); Virginia Woolf explaining the pretext for her diary as the basis of memoirs that she will write when she is sixty (we suffer for ourselves).[4]

Pictures are chronicles of everything that can be pictured. Photographic memoirs may be based on pictures, but they

follow the fundamental rules of personal narrative. Adaptable by nature and communicative at cause, they carve out segments of their compiler's life for re-presentation. Personal narratives are stories predicated, according to John A. Robinson, on "tellability," admitting the remarkable, the commonplace and the shameful, and "the point," excluding no possibilities between forceful instruction and vulnerable self-analysis. Much depends on the listener. Robinson explains personal narrative as a form of conversation, shaped by its varied modes of expression and interactional protocols. Conversational patterns include association, problem-solving, interrogation, and clarification of misunderstanding; the optional perspectives of storytelling, whether as spectator or participant; and diverse styles of dialogue, such as presenting, sharing, matching, polarization, and sociable legend.[5] Conversation's complex and fragile ecology provides a flexible model for the album whose express subject is the self. Only one quality is essential: an appropriate and consensual discursive pattern that begins as an interior dialogue. The personal photographic compiler must feel as Albert Camus did: "I am happy to be both halves, the watcher and the watched."[6]

Prefiguring Camus's reflexive gaze is the work of an avid amateur photographer whose Anonymous Amateur Album (MP 586) and negatives came to the McCord Museum prior to 1973 as an anonymous donation. The album, which contains 169 snapshots, can be dated only approximately to the 1910s and early 1920s. The photographer appears to have lived in or around Montreal; sojourns in Winnipeg and Ottawa are also recorded. The album manifests three compulsive interests, the first of which is formal or technical, that is, purely photographic. The epigraphic image is a sun breaking through the clouds. There are complementary cloud studies, then as now, standard photographic exercises; genre pieces, such as a newsboy hawking his papers on the street; and a journalistic self-assignment, the story of a fire destroying a row of houses. Experiments solve problems of exposure – timing and motion – rather than composition. Portraits and self-portraits are taken under testing conditions and presented in clusters for comparison.

A second interest anticipates the Social Landscape movement of the 1960s as an idiomatic treatment of early-twentieth-century urban life. Choices of subject are as individual and timely as the photographic language. Signs are no more than interjections, disconnected and visually blunt: a star of David, the Commercial and Technical High School, the Dorval Jockey Club, and movie marquees – The Province, now showing the Keystone Cops and Charlie Chaplin in *Cruel Cruel Love*. But behind each static facade, we can hear wheels turning, for this photographer is not simply a recorder. He is storyteller, in his way, and a dreamer. A recurrent motif is the train: views of a Grand Trunk Pacific rail yard, train stations at Redditt, Vaudreuil, and Ste-Anne, trains moving through the landscape, and informal portraits of conductors. An extended trip to Winnipeg is a stream of impressions that ends with the landmarks of the city. The photographer's tendencies are thus both realist and romantic. The album participates in a form of social realism as an ongoing report gathered by an observant, peregrinating citizen. The modern city, a heterogeneous expression of progress and continuity, is transformed photographically into a place of self-discovery and self-assertion. The compiler's name has been lost and his precise circumstances are unknowable, but his movement in and out of the archetypal city is a way of being, and of shaping identity, that others have employed. Lewis Fried found in the memories of Lewis Mumford a similar blend of city and country that culminated in his utopian vision. "The city represents and *is* the plenitude of human nature: so Mumford argues. The city is a human project: man making his self. As such, it is an encyclopedia of man-in-general."[7]

A modernist, metaphoric fusion of man and city forms the third theme of the album: a series of self-portraits that is fitted in throughout. Identification has proceeded from one key image: a portrait of a man dressed in sombre business attire sitting in a wood-panelled room beside his camera, which exposes the scene through reflection in a mirror. This

carefully considered and serious self-portrait is mounted on a page with an outdoor portrait of a man and two women, three favourites who figure elsewhere. The residential street has been double-exposed, layering a second ghostly view of houses and light standards on top of the beaming trio. The snapshot, which might have been rejected, instead is well placed to comment on the photographer's endeavour. The contrasts in this single pair of images – interior and exterior, dark and light, solitude and sociability, precision and accident, preservation and dematerialization – encapsulate the binary oppositions of this very photographic album. The album carves out an urban habitat for the modern "man-in-general," a safe house between self-absorption and assimilation to the whole, a station stop between private and public.

A PRESENT FROM HIMSELF

James M. Cox makes the intriguing point that the birth of autobiography – its emergence from preceding forms of confession and memoir – coincided with the French and American revolutions, "when the modern self was being liberated as well as defined." Combining confession and memoir, the autobiographical relation "bared the inner thoughts" and "recounted the career."[8] Compiled after 1862, the Birch Album (MP 2160) would have fulfilled both functions in presentation by its compiler, Richard J.W. Birch.

A self-made modern man is announced by the inscription "Richard J.W. Birch, Oct. 13th 1862 / A present from himself." The album is a collection of forty-six cartes-de-visite, focusing, though not exclusively, on Birch's military service with the 30th Regiment at Quebec City. Coincidentally, though of no small import to the McCord, the Birch album encapsulates the union of the founders' collections: a portrait of Miss Voss as a Normandy peasant refers to the famous Notman composite *The Skating Carnival, Montreal* (1870), while a carte-de-visite of Ensign Robert Arthur McCord is a piece of McCord family history. Nothing, of course, could

have been further from Birch's mind; the album, as he says, is to him, from him, and about him.

The majority of the subjects are men, some in uniform, others in civilian clothes or studio-supplied costumes. No captions are visible. Birch has inscribed the names and ranks of his companions on the mounts, but he has not transferred this information to the page. The portraits are anonymous unless the cartes are pulled out, and even then Birch has left insoluble riddles of association or economy: the portrait of Lieutenant Monroe has been cut down and mounted on the back of an invitation card issued to Birch by one Lady Cope. Peeking at the hidden notations reveals that some photographs predate the purchase of the album; the cartes-de-visite are not in chronological order, nor were they arranged in order of receipt. For all this confusion, the appearance is very neat. With colleagues on parade and all gathered intelligence tucked out of sight, Captain Birch controls the story, whose pleasure in the telling is compressed into one secret annotation: "Lieut Clower 30th Regt / Nuckle headed monster." The photographs inscribe the career; these few words hint at the inner thoughts. Birch sends his version into the future as a message in a bottle.

SUSPENDED BODIES

In the Birch album, tellability obtains at the most basic level: the point of it all is the uniqueness of the compiler. What tells within the museum, however, is Birch the nonentity, a junior officer of the 30th Regiment, the instrumental observer of his times. Most autobiographical compilers share this fate, their albums bobbing in the wake of titanic histories. The First World War was very productive of written memoirs, ordinary myths nurtured on classic myths, as Paul Fussell has shown.[9] Photographs and photographic albums were no less plentiful and heroic; we shall look at four.[10] Their young compilers, two men and two women, were to varying degrees affected by the war. Their photographic

Anonymous Amateur Album (MP 586), 35

Birch Album (MP 2160), 10 (detail). "Lieut Clower 30th Regt / Nuckle headed monster"

memoirs recount their experiences, which, unfortunately, were not unique except, of course, to them.

The William Hilliard Snyder Album (MP 016/92) belonged to a soldier from Vancouver who died in action near Amiens. The album covers Snyder's last days in Canada, April to October 1916. His snapshots of family and friends in Ottawa, Edmonton, Lake Louise, and Vancouver are interspersed with pictures of Camp Hughes in Manitoba, where he trained as a recruit. The album, which is accompanied by letters, keepsakes, and other contextual material, is very affecting as a first-person account.[11] Hilliard Snyder's excitement as he embarks on this tremendous adventure – his generation's war – is palpable throughout.[12] He knows that he will want a photographic record of his experiences; that is all he knows for sure.

Many young recruits carried cameras to training camp, or so we might gather from advertising campaigns directed at them and their anxious families.[13] But Hilliard's fascination with photography was of long standing. In the first group of letters held by the McCord (1910–12), he is writing from school, asking for family pictures and inquiring, "How do you like this picture of me. Morris the boy from Peterboro' took it. It is not so bad when you think it was a time-exposure of one minute."[14] In 1916, writing from the Château Laurier in Ottawa, Hilliard is the same mechanically minded boy, though thoroughly enjoying the social benefits of his training at the Canadian School of Musketry in Rockcliffe. "On Wednesday evening I had dinner at the Almans', and left about eight thirty to go over to a sort of garden party which *the* girls of Ottawa are having to help to soldiers, well I can't start to tell you what I did there, any way a girl called Miss Boy (Marian) & muh! a Mr Graham and a Miss Saunders painted the whole place red." Four pages of snapshots are dedicated to this interlude, not telling exactly but certainly communicating its blissful rush. Turn the page, and the album settles into a detailed description of the Colt and Lewis machine guns.

Knowledge of its awful ending skews my reading of this album. For Snyder, the project is exhilarating and open to the sky. His album has not one title but two. The first, on the fly-leaf, is the certainty of beginning – his name, the date, and place of the acquisition, 2 April 1916, at home in Vancouver. The second, added to the inside front cover, eclipses the first with a nobler calling and a historic site – the 195th Battalion and Camp Hughes. Solidarity and purpose snap the album into focus, and two paired snapshots are symbolic of the moment: on the left, the hieratic portrait of an erect, somewhat forbidding officer; on the right, four friends in civilian clothes laughingly forming a human wall by balancing on each other's shoulders. Like these bodies, Snyder's album is poured in arrested anticipation of life in and after the war. As L.L. Langness and Gelya Frank suggest, unfulfilled expectation is fundamental to autobiography. "From a Heideggerian point of view, our lives always have within them something still outstanding which has not yet become realized."[15]

Snyder's album was finished, although he did not know it, when, on 9 October 1917, he wrote the following to his sister, from "Somewhere in France": "After a long and somewhat rough journey we have finally arrived at our destination mid the awfullest rain you ever saw in your life. The first night we were in a very nice billet, you could not want for better, but to-night I am just contemplating whether to sleep in the bed provided or on the floor as there seems to be a pitched battle going on there at present." On 25 March 1918, still somewhere in France in the mud and waste, Hilliard Snyder was shot through the head and died instantly.

Cox states plainly that the autobiographer cannot write about her or his own death. Like any historian, he or she is obliged to construct an arbitrary and fictive framework, the "exit and entrance" that bracket the tale.[16] Beginnings and endings make personal narratives possible, while tipping the hand of conscious and unconscious intention; they tell us what the album is about. The Cynthia Jones Album 1917–1923 (MP 079/86) is ostensibly about the First World War. The compiler, Miss Holt at the time, served as a nurse in England and France, accumulating a scrapbook of snapshots, purchased photographic postcards, and cartoons. Snapshots

W.O. REID. 114th Batt..CEF.

LANCARA B.S.

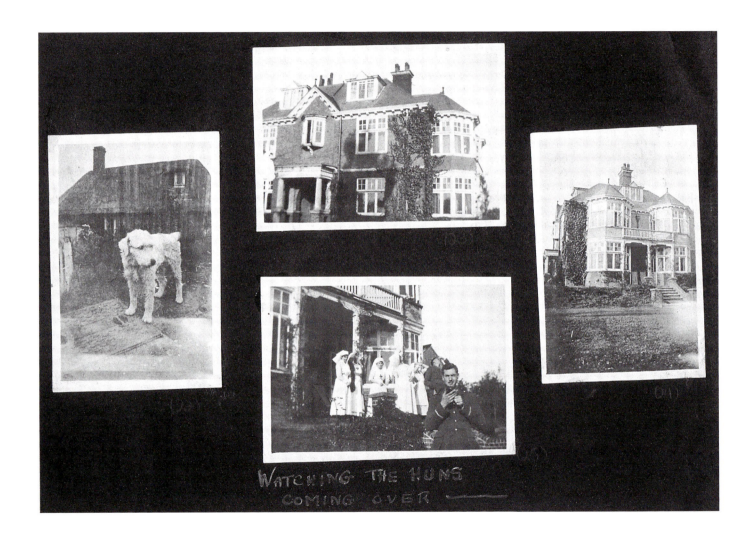

Cynthia Jones Album 1917–1923 (MP 079/86), 8

record her September 1917 departure for Europe on the American troopship ss *Adriatic*. A purchased view of the Officers Rest Home at Broad Oak Lodge in Sturry, Kent, situates the snapshots of patients and nurses that follow. One of these is captioned, "Watching the Huns coming over." Holt's universe becomes a theatre of Huns and patients, and she is far too busy to take pictures. Her chronicle of service in France is supplemented by picture postcards of Canadian field hospitals, including Étaples, which is shown in ruins after the bombing raids of May 1918. Cartoons lampoon the agonies inflicted by nurses on patients in "The Chamber of Horrors" and "The Electrical Ward."

The album continues after the war with a trip to Europe (1922) and ski vacations at Ste-Marguerite and other resorts (1922–23). Jones was not immune to the horrors that she had experienced overseas – far from it – but the extension of her wartime memoir into the twenties suggests that she viewed the war and its aftermath integrally, as a coming of age, before her life of marriage and children demanded its own separate account. Classification by subject threatens to cover over Jones's "exit and entrance." Consequently, her later album of 1928–31, while very much the viewpoint of Mrs Jones, is likely to be classified as a family album, while the memoir of Miss Holt melts into the pictorial history of the Great War. The actuality of experience is distorted in the process and its true lessons are suppressed.

Another woman's wartime memoir, the Wagner Wartime Album (MP 033/80), also fits within a chronicled life as the earliest of four albums donated by the compiler. Mrs Wagner was a keen-eyed photographer – an amateur journalist – who navigated with ease between individual, social, and historical cycles, blending them into her compilations. The settings of this album include Beaupré, Kamouraska, Valcartier, and Halifax. Some places, dates, and names are supplied; captions otherwise consist of wisecracks, initials, and rhetorical prompts: "Some 'nun' eh what!?" (a young man clowning in a nun's habit). The ritual washing of a girl's long hair and the marking of a tennis court are innocent pleasures, darkly mirrored in the

donning of military and nursing uniforms, the masking of faces in bandages, the recording of ships in Halifax Harbour.

Western autobiography's presumed "'spatiotemporal' orientation"[17] is easily upset by the memoirist's reconstructions after the fact. Mrs Wagner did not serve overseas, so the framework of entrance and exit in her account is less easily perceived than in Miss Holt's. Nevertheless, the structure is in place, though multiple and distributed throughout the album as a pattern of fissures in the present, ostensibly made by prescience and suspense. The concentrated display of troop and supply ships on a page annotated and dated "21/9/17 ... Halifax" impresses her account with the full weight of history by foreshadowing the massive explosion that occurred in December of that year. Oddly disorienting, the chronological order of this album seems at once predictive and retrospective. Across its pages, courtships are pursued, culminating in informal wartime weddings. A little boy in a sailor suit is embraced for posterity by a seaman.[18] Bathing beauties, knitting sisters, the hearty, the blinded, and the maimed cluster before the camera as the future narrator prepares to explain, "This is how it was before this happened and it was different." Distant in space, present in time, the European crisis is the stuff of an initiatory ritual gone wrong.

Likewise, the D.M. Murphy Album (MP 163/77) could be dubbed "The Education of a Canadian Soldier." The album is a composite of Canadian outdoor life, including snowshoeing, skiing, canoeing, rowing, foot-racing, soccer, horseback riding, camping, courtship, military training, and photography.[19] The album spans nearly twenty years, from 1901 to 1919. The organization of pictures is not chronological, and for all the liveliness of the snapshots, a caption such as "The future H.M. Geo V in Ottawa 1901" steeps this album, like Wagner's, in conscious reconsideration.

The album is divided generally into themes – episodic, geographical, and categorical – which are neatly summarized in the first few pages. The design of the album helps to order the tale since each page holds only five pictures in decorative combinations of round, oval, square, and rectangular apertures.

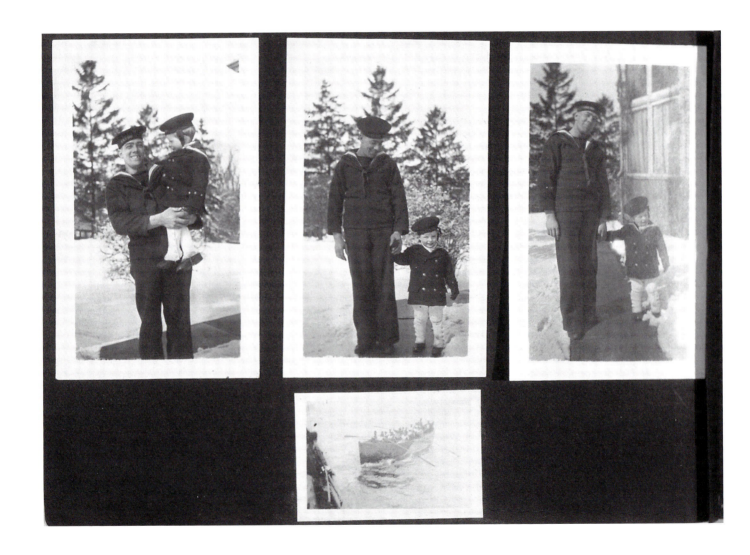

Indeed, the album seems the portable offspring of the Victorian parlour table, whose parentage is acknowledged in a photograph on the album's first image: a densely populated whatnot is virtually anthropomorphized in a group portrait that also includes a man, a woman, and a lapdog. The same page presents an urban view of Montreal-type row houses and informal portraits of two young men and a young woman.

Its family history complete, the album concentrates on the activities, interests, and accomplishments of a young middle-class male passing from nineteenth-century childhood to twentieth-century adulthood through the phase now commonly referred to as adolescence. The moment of this pre-war adolescent memoir is doubly fascinating since it coincides with the recognition of adolescence as a distinct life stage, a theory propounded in 1904 by G. Stanley Hall in *Adolescence: Its Psychology and Its Relations to Physiology, Anthropology, Sociology, Sex, Crime, Religion and Education*.[20] The Murphy album was compiled as late as 1919 in a society by then attuned to the special nature of adolescence and the institutions needed for its protection. The album by its very existence immures and validates those sentiments: the turbulent adolescent years are deemed by their survivor to be precious and worthy of preservation.

The individual photographs, on the other hand, seem of a different program, enthusiastic, declamatory, and heroic – admitting nothing but the perfect outward self. In the Murphy album the self-conscious and romantic adolescent is enlisted as the biographer of an aggressively visible proto-adult, the man that Murphy-child was brought up to be. For many historians, the Victorian era ends with the First World War, but the Snyder and Murphy albums suggest something different, at least for the boys: the artificially extended adolescence of a new era that was not allowed to play out, but was abruptly stopped and pushed back onto the previous generation's values. Joseph F. Kett acknowledges the period's shifts and dichotomies:

It was ironic that the trumpeting of manliness and will power in late 19th-century success tracts should have become one of the impulses behind the establishment of institutions for adolescents, since the adolescent was a stranger to manliness, at least insofar as manliness meant intellectual and spiritual maturity. Middle-class values at the end of the century downgraded maturity and intellectuality in youth while upgrading physical prowess and perpetual becoming. The word "manliness" itself changed meaning, coming to signify less the opposite of childishness than the opposite of femininity.[21]

However secular and progressive in outer appearance, the boys' work that occupies Murphy and his friends is the evergreen legacy of nineteenth-century Christian manhood. One seeks its roots in the writings of Charles Kingsley, Thomas Hughes, and other Victorians whose valorizations of physical and metaphysical prowess formed the notion of "Christian manliness" or "muscular Christianity." Donald E. Hall's history of muscular Christianity traces its label and definition to a literary review of 1857 by T.C. Sandars: "[Mr. Kingsley's] ideal is a man who fears God and can walk a thousand miles in a thousand hours – who, in the language which Mr. Kingsley has made popular, breathes God's free air on God's rich earth, and at the same time can hit a woodcock, doctor a horse, and twist a poker around his fingers."[22] The Murphy album is illuminated by Donald Hall's explanation of the pedagogical program of muscular Christianity – its metaphoric shaping of a male body that was inseparable either conceptually or physically from the body of the British Empire. On its fictional playing fields, in the panoramic outdoors, tenets of physical and moral strength are gulped down as pure oxygen, "free air," infected with bias and risk. Hall is justifiably wary of such intoxicating metaphors. "As both literary and social history has shown ... when words are made flesh, they often form the bodies of soldiers."[23]

Bodies suspended in the adolescent state of "perpetual becoming" are the stock characters of a parallel orality – songs of self-discovery meant to be sung again and again. The Snyder, Jones, Wagner, and Murphy albums communicate far more than *their* war. Shaped to the compilers' individual

needs, they function as conversations earnestly conducted in what Robinson has called the "heuristic mode."[24] Discoveries are made even in wartime, even as the exploration bogs down in the rhetoric of slaughter. War then reveals itself as an illusionary backdrop to the real adolescent plot.

DOMESTICATIONS

A different war and an informed view to containment frame the Chambers Red Cross Album (MP 040/90), a scrapbook-memoir of the Second World War. The compiler was Mrs W.D. Chambers, commandant of transport service for the Woman's Voluntary Service Corps of the Red Cross. A veteran ambulance driver, Mrs Chambers had earned her post. In the First World War, as Evelyn Gordon Brown, she had served with the First Aid Yeomanry Ambulance Convoy, earning the Military Medal. Her album tends to be short on particulars, but some of the photographs are numbered, leading to the Canadian military files at the National Archives of Canada. From the captions, we learn that Mrs Chambers served in Sicily and North Africa, a fact that places her among "the first Canadian nursing sisters to serve in territory wrested from the enemy."[25]

Mrs Chambers's album was plundered prior to its donation to the McCord, but the forty-seven pictures remaining suggest something of its original quality and focus. The basic ingredients of this album are not unlike those of the Snyder or Jones albums, but Mrs Chambers's selection is more disciplined. Nothing before or after the war distracts from its unifying purpose; nothing beyond Mrs Chambers's personal experience is allowed to intrude. The album combines ordinary snapshots with the official "human interest" shots of the military photographer: "In the Canadian Red Cross Tent, Lieut. C.A.B.O. McGill, an artist from Vancouver, B.C., had the misfortune of losing his right arm in Sicily. Undaunted, he is learning to draw with his left hand ..."[26] Mrs Chambers is sometimes an actress in these scenes, which are optimistic

visual narratives of Canada carrying on. Her own pictures tell the same cheerful story of friends and family in service, important visitors, colourful characters, recuperating patients, and herself.

Deliberately, or so it seems, the European theatre has been shrunk and placed in a familiar photographic container. The album's snapshots of a mobilized nursing sorority could easily be transposed into a family album; even the military photographs are designed to defuse anxiety and bring the global tempest to domestic teapot scale. The positive nature of the album is strategic, finding strength in the fictive framework of beginnings and endings: this war, like the last one, must end. Conditions admittedly are unusual, but on the evidence of this album, not so much frightening as testingly foreign: "At the kitchen door on the seafront, Mrs Chambers, M.C., Montreal, with the help of her staff and a lot of sign language buys tomorrow's lunch. Fresh fish – but expensive."[27] The Chambers wartime album wants us to forget the horrors of the war. It compares with the traveller's journal, a document initiated in the belief that something worthy of future consideration is about to take place and should be stored, "as an antidote to the familiar."[28]

Unfamiliarity – the osmotic condition of the stranger – has inspired many apotropaic tales. Views / E.M.W. (MP 2360) is a composite view of the Yukon, compiled by Miss E.M. Wright around 1910. Like the Chambers album, the Wright album bridges the genres of reportage and autobiography, and subcategorically, the memoir and the travelogue. Imbued with the rugged romance of the northern frontier and punctuated with nostalgia for the Canadian south, it seems at first the album of a visitor – the photographic record of a spatiotemporal shift. The sojourn, however, is purposeful and extended. Miss Wright, it transpires, is the relative of a Presbyterian minister whose parish is the Klondike just after the gold rush. Party to his calling, she is an inside-outsider, a minor figure in the evangelical plot.

The Wright album combines snapshots with purchased views, including civic and religious celebrations such as

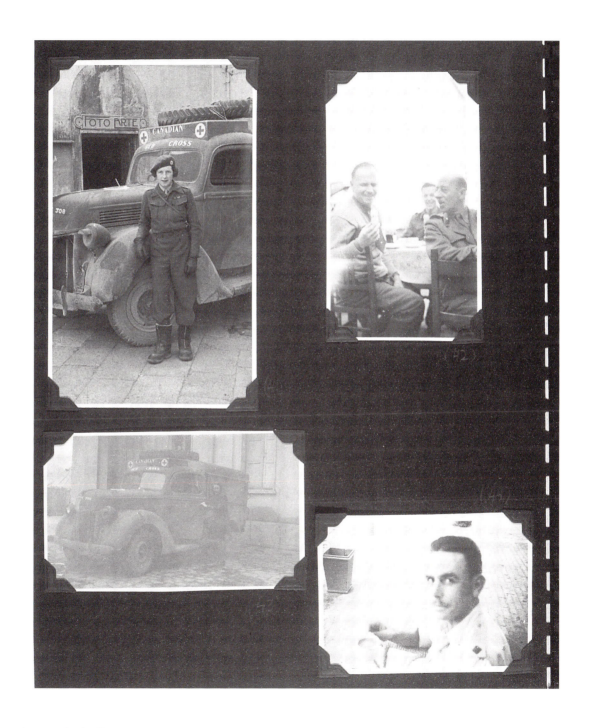

Chambers Red Cross Album (MP 040/90), 18

George Washington's birthday (1900), a pageant in aid of widows and orphans of the "War with the Transvaal" (1900), the funeral of Frank H. Reid, and Presbyterian church services at Tagish Post (1898) and Whitehorse (1900). Contrasts between wilderness and civilization are the compiler's stock-in-trade. Souvenir photographs are infused with the spirit of a new frontier typified by "The First Baby Born in Dawson" (a donkey photographed in front of a studio backdrop) and "The house that was froze in and the people that was froze out" (a family perched on the roof of their snowbound dwelling). Snapshots include general views of the area and some interiors, especially meeting halls and churches.

Within the terms of a photographic study, travellers can be categorized by the way they see. As John Taylor says, "Travellers practice the gaze, which is contemplative and penetrative; tourists glance, which is accumulative but shallow; and trippers see everything (if they see at all) in disconnected blinks, blurs or 'snaps.'"[29] A traveller's collection may confound the photographic indexer by displaying all three, and in the Wright album, seeing is balanced by having been seen – of having become pictured and storied characters in the community. In the album's second image, a commercial photograph from Larss and Ducloss Photos, Dawson, depicts a bundled, half-frozen figure, "Rev. Mr. Wright on Evangelical Tour in the Klondyke on a bycicle [sic] at 40 below zero." This comic outdoor tableau appears more than once, as does its intimate indoor counterpart, a grainy snapshot of the minister working at his makeshift desk under a single source of light. Miss Wright's "Views" are very much a singular view that winds immediacy around the past and the distant present. Lively, situational tales of the north are shot through with longing, symbolized by the recurrent image of a flower-covered Peterborough gravesite and culminating in pastoral views of southern fields and pastures.

Miss Wright's approach to the north can be compared with the different tacks of the two Hudson's Bay ship's officers, Berchem and Mack. Berchem's albums, as we have seen, are very orderly and restrained in their selection of pictures,

which are sequenced or gathered into groups, then neatly captioned. His photographic essay on sealing is a complete exposition, showing the dynamic group action of the men as they set out for the herd and return to the ship. Berchem wanted the appearance of typical sealers, as well as their prey; the hunt was recorded from beginning to end. His production can be divided cleanly between extended essays (March–May 1927) and general views (1921–27). Captain Mack, on the other hand, took and collected pictures (it is tempting to say) continuously over his twenty-two-year command of the SS *Nascopie*. One of his two albums (MP 597) literally defies description, bulging with over five hundred snapshots, his own and others', taken on land, ice floe, and sea. No one could make narrative sense of this avalanche; the buried stories are his alone to relate. What Berchem and Mack share, however, and what separates them from Miss Wright, is quite visible in their albums: displacement is not a temporary condition but the norm. Ironically, what this means for the men is a single point perspective, Mack's being the company's and Berchem's the ship's. In Berchem's album of 1921 to 1927, the ship becomes a huge floating camera; it is his only vantage point on the world. This two-stage sublimation (body by camera, camera by ship) is rather poignantly understood; for Berchem, a ship has meant "home" since he was little more than a boy.

Home for Miss Wright is definitely somewhere else, but she connects to the people around her in ways that Berchem and Mack cannot. She has no recognized authority, of course, and no particular allegiance, save to God, country, and the Reverend Mr Wright. Caught in the Yukon experience, she is nevertheless secure within her role as the proverbial witness to ready-made sights. She is a tourist no doubt, but one with a powerful sense of *who* she is (who she is not) and *where* she is (where she is not). She carries, in other words, what Lucy Lippard and others have recognized as an authentic "sense of place."[30]

Tourism and its images operate on many levels. Taylor's three manners – "gaze, glance and blink" – are workable

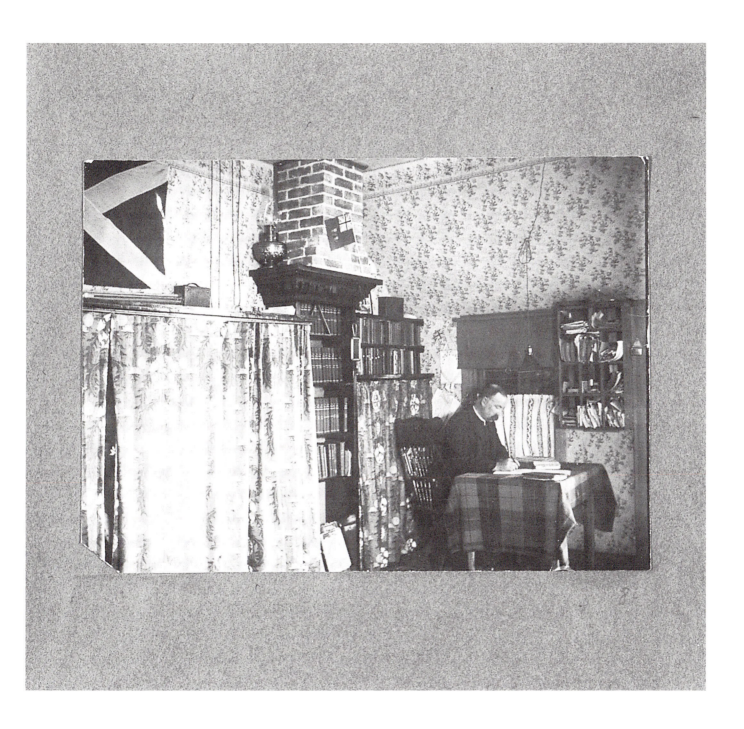

RETURNING ABOARD. (85)

RETURNING ABOARD (86)

SCRAMBLING "HOME." (87)

HAULING AND PANNING SEALS. (88)

metaphors for the cognitive habits and mechanical options of modern tourists with cameras. Immerse their products in an album, however, and the categories begin to blur. The album itself is a protracted gaze and an extended experience, however short its component vignettes; it is itself a journey. Following Georges van den Abbeele, Nancy Spector has seen in the album an archetype of self-discovery, suffusing the travelogue with actuality and symbolism, part of the life chronicle and a synecdoche for the life cycle.[31] In effect, the day tripper's "blink" is metabolized by the photographic corpus into a pause or a digression that comments on the compiler's life as a whole: Miss Wright's flashbacks to the Peterborough grave seem somehow to anchor and validate her existence in the north.

HOMEWARD BOUND

Most of the albums that we have examined so far include some reference to travel, and we shall see that family albums, like novels, use travel as a spurring narrative device. But an album dedicated to travel and related from a traveller's perspective is something quite different. The truisms of heightened awareness and clarity are, to a degree, valid, but travel albums also perform a rather interesting reverse operation that most of us have noticed affecting the characters of our fellow-travellers (and occasionally our own). A gradual hardening of the attitudes seems to develop along with the film, and an album that is about being elsewhere among others tends to close in on the familiar. Simon Gikandi has recognized this circular pattern in the travel writing of the nineteenth century as a necessary step in the forming of national identity. "It is primarily by rewriting the colonial other along the traces and aporias sustained by the trope of travel that the imperial travelers can understand themselves and their condition of possibility; it is in that space linked to England by a dialectic of difference and identity that the Victorian sages can gaze at themselves and hence evolve a system of knowledge through the textualization of alterity and negativity."[32] We shall see in one Edwardian travel album how the desire to sustain that space of knowledge plays out on the return trip.

Against these harmful habits are the lesser sins of self-indulgence, the amateur traveller's romantic impulses, egged on by the examples of professional travellers – poets, novelists, painters, and photographers – whose images are not only remembered but often remade in reverential performance that guarantees authentic experience. Taylor muses over this slavish tourism, and its perfect example can be found at the McCord in another of Mrs Wagner's albums, which combines purchased views of the Gaspé with her carefully constructed imitations.[33] Such a project has less to do with getting away than getting back to where the images can be presented side by side and their painstaking recreations admired. Other travel albums, Mrs Wagner's included, are more adventurous, but the opposite poles of escapism and capture, excitement and restraint, originality and emulation, demarkate the journey, and the ultimate destination remains the same. The travel album, like the traveller, is bound for home.

Prescriptive travel need not assume the loftiness of a grand tour. Souvenirs of a Few Pleasant Summer Days, 1898 (MP 028/89) chronicles a nine-day holiday of sightseeing and cruising the St Lawrence River and its adjoining waterways. The photographs, which are objective and crisp, record what the compiler saw on a carefully orchestrated visit. She apparently made the album as a gift to her hostess, who is pictured in the doorway of her home. Views of Montreal and Quebec City are firmly picturesque, dominated by popish architecture and military statuary, excavated by narrow streets, and unspoiled by the growing population. Only authentic Quebec staffage, such as monks, street peddlers, and urchins, are allowed into view. The cruise, which took up most of the nine-day visit, is recorded from the rail of the steamer, whose modern amenities are not documented at all. We see the steamer *Carolina* tied up at Tadoussac, but with no indication that this is the travellers' vessel; it simply forms part of the landscape. The album is a historiated slice of a mobile and

Light-house in Lake St Francis July 28.

Couteau Bridge July 28

Couteau on the St Lawrence July 28

Couteau Rapids July 28

Souvenirs of a few pleasant summer days 1898 (MP 028/89), 16–17

rapidly industrializing society that is manifest only by deduction from signs of prosperity and modern ease.

The framing of the photographs lends itself to illusion; they are shot from the mid-body, an angle that increases the proportion of foreground, sweeping the viewer into the frame. The visual effect is consistent, both within this album and without. Ann Thomas has speculated about the influence of photographic views on late-nineteenth-century Canadian landscape painting, seeing through the stereoscopy of Elizabeth Lindquist-Cock a similar plunge into space.[34] All that to say that the emptiness of the foreground, somewhat radical to our eyes, might well have pleased our photographic artist. Time and again, the traveller's gaze skims across untroubled surfaces into incalculable atmospheric depths that invite exploration. Indeed, these still images are full of movement. The compiler's dedication lyrically invokes the sensation of memory as a "backward rush ... like fragments of a dream." Literally and figuratively, the tourists seem to have been transported through space and time across the surface and into the optical field.

POOP-POOP

The MacDonnell European Travel Album (MP 2151) of 1904 is equally caught up in the romance of travel, though it grapples more cheerfully with the new. Of its forty-eight views, almost a third comment on the latest industry, tourism, burgeoning in Britain at that time in the form of rail service, luxury hotels, motor cars, and guidebooks. The motor car is the dominant motif, though it is always the MacDonnells' car that we see, signalling their will to adventure. Travel by steamship and rail was far more common and comfortable; the Automobile Association would not produce its first touring guide until seven years later.[35] A photograph of the stoic compiler and her grandchildren sitting in a car surrounded by curious and polite bystanders, "Felton England, Aug. 1904 – '14 Punctures in one tire in one day,'" sums up the condition of the roads.

Progressive ideas set the tone of this album, making staunch moderns of its Edwardian protagonists. In this green and pleasant land, they find not a single pastoral landscape. Sheep do not graze on Scottish hillsides; they cluster inconveniently on narrow Scottish roads. The English Lake District, romanticized by Wordsworth, Coleridge, and Southey and adopted as his own by Ruskin, may have been recognized by the children as the quintessential English landscape in miniature – Farmer McGregor's garden in Beatrix Potter's *Tale of Peter Rabbit* (1902).[36] The rabbit, however, is nowhere on the scene. The *genius loci* of this ribboned landscape is another anthropomorphized figure, Kenneth Grahame's Toad of Toad Hall, doomed on first contact to an illicit passion for the motor car. "'Glorious, stirring sight!' murmured Toad, never offering to move. 'The poetry of motion! The *real* way to travel! The *only* way to travel! Here to-day – in next week tomorrow! Villages skipped, towns and cities jumped – always somebody else's horizon! O bliss! O poop-poop! O my! O my!'"[37]

For the McDonnell party and its motor car, parked before the luxurious Prince of Wales Lake Hotel, the poetry of motion is the same: "Nothing but a drink on Lake Windermere" before returning to the open road.

AN ENGINEER'S PROGRESS

Bloemfontein to London. Via East Coast, Egypt and the Continent / M.C.B. and C.J.A. / Feby to May 1910 (MP 2152) is the inscribed title of a third travel album, an orderly compilation of 176 luminous prints. Its main characters are a man and a woman. The use of initials can be interpreted as a meaningful gesture on the part of the compiler (M.C.B., a woman), whose affection and respect for her travelling companion (C.J.A., a man) is evident throughout. The exact nature of their relationship is unclear.

The album was occasioned by the return of this pair to England from Bloemfontein, Orange River Colony, a journey

Tender Ireland taking passenger from
the Campania for Queenstown, Aug 1904

Old England Hotel on Lake Windermere,
Bowness, England, Aug 1904.

Nothing but a drink on
"Lake Windermere," Aug 1904.

Sutton, England, Aug 1904.
"14 Punctures in one tire in one day"

that took place at a significant historical juncture. As a British dominion, the Orange River Colony was terminating a three-year period of colonial self-government (1907 to 1910) and becoming the Orange Free State, a province of the Union of South Africa. Royal proclamation of the Union of South Africa was given on 2 December 1909 and took effect on 31 May 1910.[38] In Bloemfontein, C.J.A. had occupied the post of district engineer from 1907 to 1910. The album marks his leaving.

A cog in the imperial wheel, C.J.A.'s role in South African affairs has ended, and as we follow his progress northward, back to England, we share a particular kind of tourism, an engineer's progress through fields of colonial endeavour in East Africa and Egypt. The "pre-texts" that Gikandi expects to find at the bottom of colonial travel writing are discoverable here, though their authority is somewhat diminished by the "backward rush" of the moment as conditions in Africa change and the minor colonialists pack up for home.[39]

The album suggests that this journey was dressed in fun, so comparison with contemporaneous travel literature seems appropriate. Charlotte Cameron's *A Woman's Winter in Africa* (1913) helps to clarify the itinerary and brings out some of the nuances of the pictures. The album's first five pages cover goodbyes and the departure sequence through "Jo'burg" and the Rhodesian anchorage at Beira. The sixth page is spent on Mozambique, which Mrs Cameron speaks of as a Portuguese penal settlement, unhealthy, uninteresting, and not recommended.[40] Our travellers pause respectfully before the gates of the fort, the harbour, and the British consulate. The next stop, Dar es Salaam, German East Africa's largest port and, according to Mrs Cameron, a place of numerous attractions, is confined to three photographs in the album. They are combined on one page with a view of the Zanzibar Railway at Clove Plantations, reportedly beautiful and regretfully missed by Mrs Cameron: "Ninety per cent of the world's supply of cloves comes from Zanzibar."[41] On the streets of Zanzibar, a multicultural city of picturesque ruins and colourful natives (says Mrs Cameron), M.C.B. is shown with different British officials, among them the commissioner of police.

Mombasa is then approached through the harbour at Kilindini, the terminus of the Ugandan Railway. The album records Mombasa's hybrid mode of transportation (the *ghari*, a cross between a rickshaw and a trolley pulled by a native), as well as British government offices. Styles of colonial, transient, and native accommodation, sharply contrasted by Mrs Cameron, are passed over by our travellers, who photograph the stations, railway yards, steamship, and landing on the way to Uganda.

Mrs Cameron's itinerary did not include Uganda, but this part of the Bloemfontein-to-London album is illuminated by another contemporary memoir, *The Baganda at Home* (1908) by C.W. Hattersley of the Church Missionary Society (CMS). Indeed, Hattersley might have served as the travellers' guide, so closely does their vision of the colony match his outlook and priorities. The album includes views of the Botanical Gardens, the CMC Mission Hospital (showing a victim of sleeping sickness, a problem to which Hattersley dedicates a full chapter), and the impressive Namirembe Cathedral. There are several snapshots of the young Bagandan *kabaka*, Daudi Chwa (1897–1939), who poses with his tutor. As Hattersley explains, "The King was under the tuition of some of the leading chiefs, assisted by pupil teachers trained in the C.M.S. school at Namirembe, until he was eight years of age. Now he has a private tutor, appointed by the Colonial Office, and is being carefully brought up in much the same style as a European prince."[42]

God and mammon alternate in colonial Uganda. Hattersley makes the point that European settlers are few, perhaps 450 in all.

Whether it is that the Government has not offered sufficient inducement to [settlers] to take up land, or whether their means have been insufficient, is uncertain, but very few have been able to make a living, and comparatively little land has been taken up by them; nor do I think there is much prospect of people without a large capital making a success of life in Uganda. A few "wasters" keep turning up from the Cape, and prove to be no credit to either their country of origin or the home of their adoption, though others may merely have had, as they say, bad luck.[43]

The mode of locomotion in Mombasa

Government Offices, Mombasa

Principal Street and Gov. Offices
Mombasa

M.C.B. on Ghari Mombasa 1910

Some of the lucky ones are pictured with the travellers on a picnic at Ripon Falls or making up shooting parties on the various estates. The album then makes rather a jump from the shores of Lake Victoria Nyanza to the coast at Aden. The monumental and the picturesque appear for the first time in Egypt, though not without pressure from the much admired, much documented Suez Canal. The travellers' invisible guide to the antiquities seems to be Thomas Cook, whose tours of Egypt and the Holy Land had been operating since 1869.[44] One of Cook's steamers is pictured on the Nile. All together, the Egyptian sojourn takes up thirteen pages of the album. Individual images are less pointed at progress, tending to linger on the culture. There are market scenes, donkey rides, atmospheric views of the cities, and sailboats on the Nile. In Egypt the travellers seem very much at ease. After all, as a Thomas Cook pamphlet explained, Cairo was "no more than a winter suburb of London."[45]

Elements of a grand tour, spotty and unfashionably out of season, bring the album almost to a close. The last few pages are reserved for the funeral of Edward VII. Visual references to his death – the end of the Edwardian era – first cropped up in Florence dated 6 May 1910. The flags on the piazza are flying at half-mast. A fortnight more of tourism in Venice, Charlottenburg, and Potsdam, and by 20 May the two travellers have reached London in time to witness the funeral procession of the king.

To summarize the album in this way deprives the viewer of its interesting extremes, from impenetrable personal messages to the most predictable photographic clichés. Nevertheless, the album lends itself to a linear reading and entertains delusions of closure. Its apparently seamless chronological and geographical organization enables the viewer to visualize a map. It is only when the trip is actually plotted on that map – the map of Edwardian colonialism – that gaps and concentrations of interest begin to appear. Was C.J.A. scouting the continent for a new engineering post? What aspects of Western advancement mattered to him at that moment, a professional disruption coinciding with the last burst of British imperialism?

To these questions, the album, as *aide-mémoire* to an oral recitation, pieces together a reasonable answer. Its continuous vacillation between private and public agendas is a clue. The travel album is generally assembled after the fact, but unlike the retrospection of the memoir, a certain lack of reflection in the travel album gives it value as a closed system of attitudes and symbols, an itinerary predetermined and fulfilled photographically. In this case, the death of the king is a surprising climax to the travellers' return. In psychological terms, we have in this intersection of historical and personal events a classic illustration of the "flashbulb memory."[46] The album transforms the travellers into historical personages playing on an imperial stage.

In his influential study of tourism, Dean MacCannell went back to the turn of the twentieth century as the "first moment when modern mass tourism and its support institutions were fully elaborated as we know them today." His taxonomy of attractions closely matches the interests of our compilers: establishments, groups, occupations, transportation networks, vehicles, and public works. Work itself, claims MacCannell, has been transformed over this period into "an object of touristic curiosity." Even the pyramids have been secularized and detached from their historical context to be presented (in Marxist terms) as "monumental representations of 'abstract, undifferentiated human labor.'" This observation informs MacCannell's ethnological critique of post-industrial modernity – a hardy mixture of social performance and semiology that has percolated through the literature of tourism as his theory of staged authenticity. The nature of curiosity when labourers gaze upon labour and the diversity of roles that tourism creates are keys that unlock the traveller's album. These will bear fruit in subsequent discussions of typology, where MacCannell's candour will also be of help: "It is intellectually chic nowadays to deride tourists."[47] His comment could be applied to Susan Sontag for her much copied sketch of the guilt-ridden vacationer, working at taking pictures to appease his anxiety over having fun.[48] Sontag's idea of fun seals tourists' albums in

aphorism, but as any travelogue shows, to "gaze, glance and blink" is also to point at things – the unexpected things – that matter.

On the cusp of twentieth-century modernity, memoirs and travelogues exhibit Victorian society's fascination with progress, whose representation is doubled in instrumentality, mirroring back the modern self as its photographic embodiment. In the same breath, modernity's promise and volatility are foretold – steamships, motor cars, *gharis*, and guns – every stitch and tear in the Frankenstein monster. Memoirs insist on the moment by laying claim to posterity. "Here today – in next week tomorrow" commingled in Victorian and Edwardian travelogues, rushing as motifs into the albums of the next generation.

THE IDEA OF FAMILY

THE IDEA OF IDA

One of the strangest objects in the photographic collection of the McCord Museum is a black morocco adjustable album containing approximately 263 amateur photographs, featuring a core group of people repeatedly depicted under similar circumstances over several decades – a family album. The Langlois/Gélinas Album (MP 145/84) was donated to the museum by Mrs Judy Yelon, who found it at a garage sale in Montreal. Its particular appeal to the museum rested on a tidy group of black and white gelatin silver prints from the early 1900s to 1925, many taken in the Charlevoix region of Quebec, around Baie-St-Paul and La Malbaie. Somewhere in the area was a much loved summer hotel; its destruction by fire is recorded over a number of views. Two young women, Ida and Euzebie, are featured in the album; their names are scratched in pen on the surfaces of the prints, rather spoiling the overall effect. "Ida" comes often and easily, but uncertainty over the spelling of "Euzebie" raises suspicions of a later hand.

The album is divided into two parts, the first already described, the second running from the back of the book, upside down. Colour snapshots are mixed in with the black and white; the prints are crudely stapled in, overlapping, curling, and cracking as the paper becomes more brittle. The

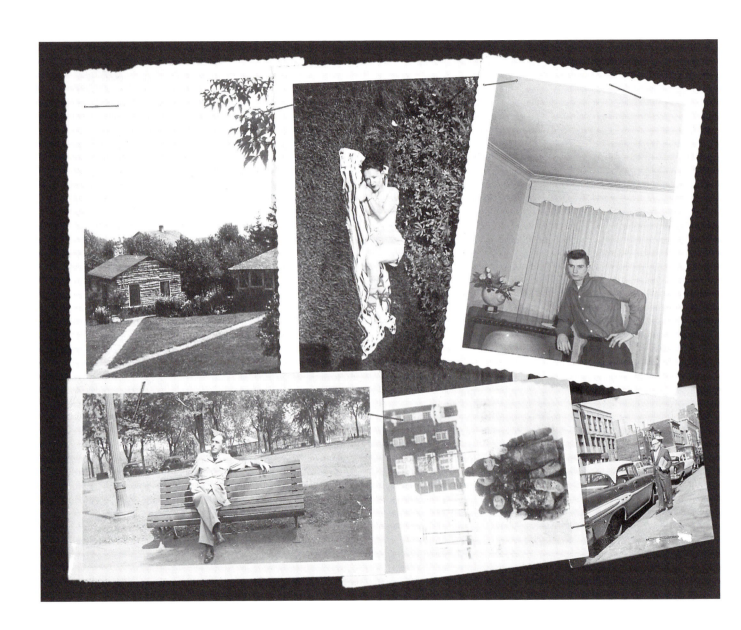

Langlois/Gélinas Album (MP 145/84), part 2, 18

second period spans approximately thirty years, from the forties through the sixties. Two documents, an "In Memoriam" card (dated 1952) and an undated newspaper obituary appear in this section.

The obituary of Nelson Gélinas of Shawinigan, Quebec, is the source of the album's constructed title. Gélinas, born in Detroit, came to Grand-Mère, a town north of Shawinigan, at the age of fifteen. He resided in Shawinigan for most of his life, working for thirty-five years at Shawinigan Chemicals. He married Ida Langlois and they had seven children. So the provenance of the album is a line through the Gélinas family to Ida Langlois, *jeune fille*. One of her descendants may have put together the second part as a way of keeping Ida's unorganized prints. How the album ended up in a Montreal garage sale is anyone's unhappy guess.

The first section of the album documents the halcyon days of the Chamard Hotel, as well as its major characters, Oncle Bill Chamard, the motherly Gessy, Ida, Euzebie, and a parrot named George Washington. Many of the photographs are taken on the porch, where it is curious to find a young man reading Edith Wharton's *The House of Mirth*. The subjects are generally aware of the camera; their own snapshot cameras appear at their sides. Performers in the lounge or on the grounds of the hotel are caught unawares. Ida and Euzebie pose in fancy dress for a costume party or pageant, creating an authentically Canadian *tableau vivant*.

The second half of the album seems the antithesis of the first, though it is really its logical extension. The rolling hills and open meadows around the Chamard Hotel have simply been replaced by suburban backyards and campgrounds. The population of the album explodes, with servicemen, sunbathers, and toddlers jostling for space on each crowded page. Fading colours amidst the black and white; the insertion of photographs upside down and sideways; candid, unflattering, and clownish snaps; the rusting staples – this anti-aesthetic presentation only increases the emotional charge. Stability rises from the chaos: conversation groups migrate seasonally from lawn chairs to dinettes; an elderly man shows off his

new car; a smiling woman poses coquettishly with her mop. The pictures peter out and the album will disappear, but the pleasures of family life seem destined somehow to continue. Is this the true shape of the "faithfully visited gravestone?" Unquestionably, yes.

The *idea* of family dominates the album collection of the McCord. In fact, many compilations that we have seen thus far under the categories of collection, memoir, or travelogue are designated by the museum as family albums, and the label, while partial, is not incorrect. Treatments of private life are generally influenced by the family plot; sometimes, as in life, they are infected by it: those are the albums that we will call "family," the ones that will concern us next. As in the last two chapters, we will define this type of album in terms of its origins, intentions, contents, and reception, a discussion that challenges with more-specific examples the paradigmatic *idea* of album that we have visited before. Addressing (or redressing) the possibilities of the family album brings our contextual study of the album full circle. We have already cleared away a lot of the bush and made a number of discoveries. The family album will help us to finish the job, revealing this photographic construction as fully as possible before we see (or hear) what else can be restored through orality.

THE BIBLE BEGOT

Many theorists trace the family album to the family Bible. Halla Beloff, for one, places the album in what she sees as a bloodless, Christian tradition: "At one time the Family Bible contained the record of the members' lives. Truthfully, austerely, and without comment, it stated the facts of the rites of passage and the coming and passing of relationships. Each event, christening, confirmation, marriage and death was given equal weight." The family album is supposed by Beloff to have replaced the family Bible: "The family milestones are still recorded, and the arrangements of their photographing in an album brings order and progression to the fragmentary

and jumbled impressions and memories of events in daily life." But the album introduced "selection ... varnishing of truth ... omission ... liveliness and informality, and a wealth of information and possibilities for memories and nostalgia that was unthought of before."[1]

Tying the family album to the family Bible – the Image to the Word – imbues even the silliest family album with solemn, ancient authority. Biblical lineage entails a literary bias which insists that the album be read as a book, as the Book. The connection seems logical. Colleen McDannell's history of the family Bible proves that it predated the album. Used as an instrument of record, it sometimes included photographs. The popularity of the family Bible did peak after the Civil War, at which point the album was well established. But the encyclopedic ambitions of the family Bible as a central source of spiritual and temporal information were not all passed down to the album. If the album tore a page from the family Bible, it was the "family record," which, if the family was pictorially inclined, was predicted more visibly by framed effigies of ancestors hanging on the walls or clustered on a table in the parlour. Ironically, if the family Bible is to be invoked as the precedent for the family album, its sentimental associations and hidden lacunae make the strongest arguments.

As McDannell explains, the emergence of the family Bible coincided with a shift in Victorian religious practice. In the ideal Victorian home, the mother replaced the father as the reader of the Bible and the spiritual teacher of the child; her image resonated in sensory associations of touch and voice. This archetype, as we have seen, followed the photographic album in the person of the mother-compiler. In less-than-ideal circumstances, the album has succumbed to the same human frailties that flawed the authority of the family Bible. McDannell has found instances of omission from family Bible records – in one case, by loss of enthusiasm as the children kept coming, and in another, by righteously angry deletion when a child went astray.[2] Snapshots by the roll of the first child, dwindling to a Polaroid for the last; subtle elisions and brutal beheadings of disgraced relatives – these are the fingerprints of the compiler. In proof of love and damnation, the family album and the family Bible functioned much the same. But their transcriptions of family history were substantially different in form and ultimate effect.

The nineteenth-century album as genealogy was seriously delimited by the newness of the invention. Photographic portraiture formed a thin ancestral crust: there was literally nothing to put between arrivé and arriviste. Health and luck holding, two, possibly three, generations might have been photographed. Daguerreotypes, if possessed, lived apart from the album; tintypes could barely fit in. There are examples in the McCord of compilers' attempts to glue these metallic, framed objects into their albums – thick description indeed.

There could be no visual equivalent for a list of begats, except by allusion. Adopting the conventions of portraiture, cultural identity and family lore could be encoded in the symbologies of costume, attribute, and bearing (a tartan, a locket, a thrust of the chin). But visual codes are not automatically decodable, as Richard Brilliant has observed. "Social roles, however enacted, are like masks or disguises, carefully assumed by individuals in order to locate themselves in a society conditioned to recognize and identify these forms of representation in practice and in art. If there were nothing more than that, then representing a person in a role, defined by society, would not be a disguise to conceal some uniquely private kernel of being, because there would be nothing to conceal, no inner reality that the portraitist would be obliged, somehow, to uncover or express."[3] The nineteenth-century album represents two layers of wilful disguise and/or self-representation through portraiture: the complicity between photographer and client; the re-presentation of the self through strategies of compilation.

The album as social positioner, inserting the ordinary family into a vertiginous hierarchy, has already been discussed as a collection, illustrated by the Arthur Lindsay Album (MP 2146). Representation of one's national background and racial status might be achieved, as in the Ogilvie Album (MP 032/81), by symbolic packaging and the inclusion

of a national icon. The architectural suite in the McCord Red Album (MP 139) plots its symbolic genealogy from possession and place. That same line is more brazenly drawn in the McCord album of family portraits.

The McCord Family Album (N 060) is an orderly presentation of 10 cabinet cards and 105 cartes-de-visite or half-stereos, compiled sometime after 1874. It is organized to reflect blood ties, connections by marriage and association. Pride of place is given to John Samuel McCord (1801–65), whose portrait appears on the first page and on the second in smaller format, where it is accompanied by portraits of his daughter, Eleanor Elizabeth McCord (1836–63), and son, David Ross McCord (1844–1930), along with a half-stereo of a graveyard. On the facing page are photographs of the McCord brothers, John Davidson, Robert Arthur, and David Ross again. In this establishing spread, the compiler has found room for John Samuel in reprise, David Ross twice, and a view of a cemetery, but the mother and two living McCord sisters are conspicuous by their absence.

David Ross McCord was the fourth child and second son of the family. As already explained, his older brother, John Davidson McCord, a medical doctor, died in 1866. His younger brother, Robert Arthur McCord, an officer in the 30th Regiment, died in 1882. David Ross also outlived his three sisters, Eleanor Elizabeth, Jane Catherine (1838–1914), and Anne (1848–1929). He gained control of his father's estate and inherited his mother's predilection for collecting, marrying those legacies in the content and structure of his family album. A number of cartes-de-visite must have come from Anne Ross McCord's personal collection since they are inscribed to her; other entries postdate her death in 1870. The find version of this compilation must therefore be assigned to David Ross, whose genealogical statement, here as in the Red Album, is transparent. He presents himself as the anointed head of the family.

The first priority of his family album is to stake his patrimonial claim, which he does on the first three pages, setting the tone for the rest of the album. Likenesses of sisters, relatives, friends, and acquaintances from Canada, the United States, Scotland, and England fill its pages, along with a few copied paintings and engravings that represent his mother's taste. Anne Ross McCord haunts this album: friendly salutations and messages of love hidden on the backs of the cartes-de-visite are mainly dedicated to her. But those private sentiments are concealed. One can imagine this family album on display in the parlour of Temple Grove, for it is very much a public document that sublimates the ambitions of its compiler to the greater glory of family.

Hoping, dreaming, and less praiseworthy thoughts are in all family albums; even the most stolid nineteenth-century exemplars are upheld by flesh and blood. For those who see only their austerity and factuality, Victor Turner's discussion of the Sturlunga Saga offers an illuminating parallel. He notes that Icelandic historical writing evolved very differently from the European development of annals into chronicles and chronicles into written history. Icelandic history instead interwove with fictional writing. Turner explains that "thirteenth century Icelanders were still innocent of the later attempts to conform historiography to positivistic notions of 'objectivity,' 'evidence,' and 'documentation.'" Their "'narratives' are value-laden." His terminology rings photographic, and more so as he continues: "One of the most conspicuous features of Icelandic saga-writing, however, is its famed stylistic 'objectivity' – its sober, matter-of-fact epic authority. Yet since the 'objectivity' is stylistic, made up of carefully calculated artistic effects, and not of substance, one cannot regard sagas relating even contemporary or near-contemporary events as straightforward records, but rather as aesthetic restraint the better to stress the violent passions described so soberly."[4]

The family album is also objective, evidential, and formulaic: family photographs are what one expects to find, and however styled in flattery or spontaneity, such photographs are invested with authority. Julia Hirsch has defined the family photograph as a portrait of at least two people who seem to be related; she insists on visual evidence of a blood tie.[5] Richard Chalfen introduces "two characteristics of

kinship groupings, namely people who live together as a residential unit, and relatives who are grouped in a pattern of contemporary (or horizontally related) kin relatives." In the Japanese-American families that Chalfen studied, "vertical continuity," or communication between past, present, and future generations, is patterned on Japanese custom and quite literally reproduces it in photographs of rituals honouring the dead.[6] Jaap Boerdam and Warna Oosterbaan Martinius classify family photographs by subject and social environment, including pictures of family members and those kept by family members because of their familial associations: "interiors, friends of the family, 'the car,' a former house, domestic pets, etc."[7] Each significant other or object adds to the profile of an individual member and elaborates the description of the family as a whole.

At this point, we can situate the family album somewhere between the genealogy and the saga, the first schematic and suggestive of a family tree, the second formulaic and embroidered with lore. Taking something from both, the family album amounts to an expression of identity.

WHO DONE IT?

Whose identity? That is the question. A family album is not by a family, but about it and its reasons for continuance. The album synthesizes those reasons; a member of the family synthesizes the album. John Kouwenhoven's pleasure in his family's snapshots is tied up in his recognition that he is "a member of the first generation in human history whose awareness of the past comprises a multiplicity of unarguably real informal images of our parents' childhood worlds as well as our own." The pictures he goes on to describe have been taken by one of his mother's older sisters, "one of the Philadelphia maiden aunts who dutifully but not joylessly 'kept house' for their widowed mother, my Quaker grandmother."[8] Through the album, Kouwenhoven sees his family from the "unarguably real" perspective of his aunt, inseparable in his

mind from the family ethos but perhaps not in her mind and certainly not in ours. The family compiler may be the daughter to one woman and the sister to another; she lives, and not solely through the lives of others; her voice could never be objective or omniscient, however neutral or complete her album's overall effect.

The activity of compiling sets the doer apart in a role that has its own lines of visual articulation. A photographic album, the *very type* of cohesiveness, may in fact exist in parallel with, or in retreat from, the dominant culture of its subject-family. Photography was, and continues to be, an isolating hobby; isolation can be productive; it can certainly be a relief. For the family photographer, home life may offer a compelling subject, a smokescreen for self-projection, a pretext for a hobby, or all three at once.

Two albums acquired by the McCord in 1977 from Mme France Langelier (MP 183/77 and MP 185/77) each combine the functions of family album, diary, and creative pastime. According to a cataloguer's notes, the albums depict the Langelier family and their life somewhere near Mattawa, Ontario. The name sounds French, but the captions in the Langelier albums are all in English with the exception of "Nos Amis," an inside title inscribed on a page of novelties, photographic portraits imitative of postage stamps. Though the albums are quite different, they treat the same themes and draw from the same archive: hunting, hiking, canoeing, camping, shorelines, woods, and pastures describe the wilderness, while civilization is represented by Victorian interiors, amateur theatrics, sophisticates in evening clothes, and Montreal and New York streetscapes. The romance of nature is expressed in pictorial conventions such as figures gazing over water or leafy archways formed by fallen trees. The photographer's evident rapport with his Native neighbours is recorded with no more explanation than his relationship with his mother. Small settlements and evidence of natural-resource exploitation are likewise noted without visual or textual comment. Captions tend to be brief, either lyrical or witty: they convey no information; rather, the compiler exults in a sense of

"Nos Amis" Langelier Album (MP 183/77), 8

communal knowledge and possession. Each image seems to fit within an annual cycle of events held on familiar territory and greeted ceremonially with the same utterances, the sighs of satisfaction, the old private jokes. Hunting scenes are captioned "How to be happy tho' single" and "The first of the season," while an outdoor tea party, occasioned by an expedition to a "fort," is in one album entitled "Five O'Clock. Philistines of the Wilderness" and in the other, "Ships that pass in the night and speak to each other." This doubling of images – their reprise and reinterpretation in the other album – confirms what the eccentric arrangements suggest – that this lucid bunch of pictures is mostly off-limits; that the compiler is working from a private and enigmatic script.

The second Langelier Album is signed by the compiler; on the first page, a portrait of a mustached young man in his twenties is inscribed "ME." The same sentiments are expressed – and the same contrasts – but generally with more flourish and humour, especially in the captions. "Lest We Forget" is a spread of pictures dedicated to home, hearth, and happiness, including a display of trophies hammered to an outside wall, deer heads as familiar to us now as "Nos Amis." Further on, a Native family group and a very dignified portrait of a Native woman identified as "Maggie" are combined with formal portraits of two dogs posing before a monogrammed curtain, one captioned "'Waggles' now defunct barbarously murdered 1903 by Miss Nepton [?] and her associates." The timelessness of familiar faces and places is punctured by this journal entry, a reminder of the observer's personality and place in time.

The layouts of both albums follow the creative direction set by mid-nineteenth-century scrapbooks, such as Emily Ross's or Hugh Wylie Becket's. In the Langelier albums, there are no hand-drawn vignettes; manipulation of the image takes place in the darkroom. Experimentation extends to the shapes of the pictures (hearts and maple leaves) and to their decorative borders (scalloped or indented). The edges of pictures are not cut to shape but masked in the printing; the images have a thin white border. The layouts of rectangular prints are also done with flair, setting photographs at angles to the page. There is a time factor here as well, the incalculable hours of darkroom work, editing, sequencing, and mounting that taxed the compiler's sociability. While "ME" was out tramping in the woods, making self-portraits, looking up verses, or rocking trays, family life was going on apace. His continuous narrative is a fiction.

In the collection held by the McCord, there are family albums compiled by all the usual suspects, even the English nursemaid. The question generally posed of a family album – who is this family? – must therefore be expanded – or rather, prefaced – with the following: who is the presenter of this family? why has he or she taken on this role? "ME," for example, seems to relish every mannerism of his outwardly normal kin while carving out his niche as bystander and beneficiary of their habits. Quite a mix. Interrogating the family album in this way also spotlights its fictive entrances and exits, underscoring the point that the album is only a fragment of a larger family history, definitive (if at all) temporarily.

Families come in all shapes and sizes, and so must albums; thus we get albums of nuclear families, extended families, or single-parent families, and we know just what they are. But status is not stasis, and as Tamara K. Hareven explains, *family* research (or say, *family album* research) that uses "the 'snapshot' method" freezes the family unit at a moment in time. Hareven would like social historians to go further. Her style of family-cycle analysis does what a single snapshot cannot do: it acknowledges the vagaries of family life. As she points out, "individuals live through a variety of patterns of family structure and household organization during different stages of their life cycle ... families and households evolve different types of organization, structure and relationships."9 Albums as extended portraits and comparative visions are well suited to the documentation of a growing or changing family, but what about family crisis, some sudden or accelerated change? A photographic album formed in a crucible of instability may by intent seem *more* normal than any other family album, and its vision will be just as enduring.

maggie

"Maggie" now defunct

The Small Molson Album (MP 1768) illustrates this paradox of eternalized transition. It can be dated to the first marriage of John Thomas Molson (1837–1910) to Lillias Savage (1839–66). A cluster of portraits expresses their union, a family of two increased by the only issue of this marriage, a daughter named for her mother. The death of the first Mrs Molson forms a natural break in the album, but does not bring it to a close. On the contrary, portraits of the second Mrs Molson, Jennie B. Butler (1850–1926), and the first children of this marriage continued to be added. This family album can only be understood as a private photographic sanctum, which, though unsigned, must have belonged to John Thomas Molson. The memory of his first wife, Lillias, is maintained in the fullness of his affection for the second. Still, as Molson's second family continued to grow, the combinatory album did not. It appears to have served its compiler through the complexities of happiness, loss, adjustment, and transference. No larger than a prayer book, such an intimate object was never intended for public display. The album articulates a definition of family that is both touching and removed from our times; in Molson's life and times, it was his alone.

The perspective of the J.T. Molson Family Album (MP 2359) is quite different. It is probably that of Jennie B. Butler Molson. There are no portraits of the first Mrs Molson, but Lillias, Jennie Molson's stepdaughter, eventually figures as part of an extended family of children, aunts, and uncles from both sides. The dominant figure is John T. Molson, photographed several times in Montreal and while travelling in Scotland and Italy. Daughter Naomi also travelled and was photographed with a friend in a London studio. All this would have required some verbal explanation. A carte-de-visite taken at Fratelli d'Allessandri in Rome might otherwise be indistinguishable from its North American counterpart – just another picture of Father – but knowledge of the source changed its meaning completely. Any armchair tourist could acquire a collection of views, but having one's portrait taken while travelling formed the basis of a story and gave proof of authentic experience. In the Molson family album, the hidden stamp of an Italian studio perpetuated the eighteenth-century dilettante ritual of commissioning one's Italian portrait, while foreshadowing the evidential function of a tourist snapshot. This spirited compilation meets the criteria of a family album primarily by its function as a self-defining instrument – the family talking to itself and to others.

We hear much now of redefining the family, but "family" has always begged explanation, and the "family album" does too. Private life is not the direct equivalent of family life and never was. For all our interest in individual experience, we tend to subordinate its accounts to the greater social orders of family and community, effectively rebuilding the walls that the informant has broken through. In a chapter called "The Family Chronicle," Alan Thomas attends to the psycho-social conditions of nineteenth-century female compilers.[10] His discussion of the Emma Hoyle album illuminates her passage from girlhood through courtship to adulthood; the album ends shortly after Emma marries and has a child. If this is a family album, its outlook on marriage is pretty bleak. What the album seems to be about, what Thomas helps us to see, is a vanishing moment of in between (in-between families, to be sure). The point is not to quibble over categories but to express Thomas's implicit recognition of the separate identities that he bundles into "family." Isolating our compilers' lives, seeing them, and seeing how they see themselves within family and society is an extensive project. Hareven makes one of its stages quite clear: what historians really need is a method of isolating and synchronizing individual time, family time, and historical time.[11]

INTIMATE CIRCLES

Some family albums seem the very product of this synchronism. At the McCord the Lafleur Album (MP 2155) marks the intersection of private lives, family life, and public histories. The album, compiled between 1880 and 1900, seems to have come from the family of the Reverend Theodore Lafleur (1821–1907), who was a Baptist missionary active in

Small Molson Album (MP 1768), detail (original placement unknown). "Mrs J.T. Molson," 1866

J.T. Molson Family Album (MP 2359), 16–17

Longueuil and Montreal and closely associated with the Grande-Ligne Mission, founded in 1835 by Swiss and French evangelists. Lafleur was from Napierville, Quebec, but studied between 1841 and 1850 in Geneva, where he probably met his French wife. His brief institutional history, *A Semi-Centennial Historical Sketch of the Grande-Ligne Mission, 1885*, recounts the highlights of his career and offers some clues to the identity of figures in the album.

The Lafleur family's connections were widespread. In 1837 and 1838, religious persecutions in the wake of the rebellion had forced early Quebec converts to Protestantism to seek refuge in the United States. Those links were maintained by Lafleur's and other missionaries' collecting tours; they are reflected in the sources of pictures in the album: studios in Connecticut, Massachusetts, Rhode Island, and New York. Closer to home, an 1887 portrait of Daniel Coussirat, affectionately dedicated to "Monsieur le pasteur T. Lafleur," connects his activities to the school of theology at McGill University, where Coussirat taught. A key figure in the evangelical movement was Mme Feller (1800–68), whose portrait, copied in the cabinet card format, is the second image in the album. The copy was made by the Notman studio in the year of her death, no doubt for commemorative distribution. The Notman studio index provides other names: Professor Darcy, 1874; Charles Childs and a lady, c. 1880; and Reverend J.L. Morin, 1894.

Family history forms a part of this family album. Mme Lafleur maintained contact with her French relatives; greetings to the children (Henri, Alice, Paul, and Eugène) from their Parisian aunts (Mathilde and Elise) are inscribed on views of the city. Alice Lafleur, age fifteen, posing with her schoolmates, adds a younger generation, whose names are all listed. The Lafleur family is the nucleus of many concentric circles, and the album, for all its modesty, wants to make those dimensions clear.

Social synchronism is a delicate condition, easily thrown out of whack. Separating the album from the compiler means a loss of individual time, a temporary inflation of family time, and the inevitable eclipsing of both by a generalized historical time, drained of all specific meaning. A fourth temporality lost is performance time, the real time of presentation that weaves through a fixed photographic sequence, making sense of the impossible surplus of photographic lives. Personal habits of attention are part of this temporal equation: How long should we stay? What kinds of questions should we ask? Is it polite to pry? Performative viewing imposes certain limits on telling and listening: the family album is restored to its original form as a durational work (in this respect, like a play, a piece of music, or a film).

By raising this point, I mean, in a very limited way, to compare the experience of looking at a family album to watching a film. Technically, the film exists within a temporal framework of speed (frames per second) and duration (one hour, fifty minutes). One can stop the film and scrutinize a key frame for all of its messages, enlarge a piece of that frame, or amplify a scrap of sound, but it is intolerable and ultimately senseless to consider doing so to the whole film.[12] A photographic historian, left alone for hours in the vault of a museum, tends to get bogged down in the details, looking for a key that will unlock the family album as a whole. This is necessary work, heroic and tragically flawed because it completely distorts the album's reception, something like seeing an altarpiece in a museum instead of a church, but arguably more damaging to an ecology of givens and gaps.

Consider, for example, the Wardleworth Estate Album (MP 006/74), probably compiled around 1880, comprising 7 cabinet cards, 113 cartes-de-visite, and 1 tintype. These are all portraits, except for 4 fine-art reproductions. A number of the photographs are inscribed on the back by the sitter, one a portrait taken at Béziers, France, of the Louis W. Koester family, "To Mr D.W. Ross, Montreal, for kind remembrance, the 14th April, 1873 ..." The cartes-de-visite come from near and far – Quebec, Ontario, Vermont, Maine, New York, New Jersey, Pennsylvania, Michigan, Wisconsin, Iowa, England, France, and Russia. Inscribed dates range from 1869 to 1877, but tracing 36 Notman studio photographs through the index still in use at the McCord widens the range of dates from 1864 to 1880, approximately sixteen years.

Lafleur Album (MP 2155), c. 1880–1900, 2–3

Sixteen years! Stop for a moment and think back sixteen years. Then run through the names and personal histories of 120 of your family, friends, and acquaintances. Change roles. Imagine yourself in a parlour, leafing through an album of portraits compiled by your host. You recognize some faces; for the sake of argument, let us assume that you recognize everyone photographed at the Notman studio – the Ross family, the Allen family, the Allan family – you know all of them, and your memory has been prompted by the compiler's arrangements by kinship and association. Do you look at the album for ten minutes? Half an hour? Do you interrogate your host as to the names, addresses, and occupations of the figures you do not recognize? Are you a policeman? Or do you converse in a manner that confirms your guesses and draws out the highlights of the album (according to your informant): father's business associates, the Iowa branch of the family, or "Beat's me. Ask Mother."

The Baker? Album (MP 2147) is another good example, a nearly anonymous collection of cartes-de-visite. The compiler never completed the index page. The name of the donor has been lost. At some point, while the album was still in the family, someone other than the compiler tried to identify some of the portraits. The concentration of relatives – mother, sister, uncle, brother – confirms that this album came from a family, tentatively identified as "Baker," a name that comes up more than once and in different locations. A handwritten note enlarges certain figures, offering the barest whisper of the missing commentary. Gazing on her dour formal portrait, one would certainly need to be told that Aunt Eliza Dunning was "very witty," and the informant's wittiness, not Eliza's, would be the living proof.

MUTATIS MUTANDIS

The hand of a compiler is a firm one, but not necessarily the dealer of linear, objective truths. In her typological reading of family photographs, Julia Hirsch gives us three fictional responses to the same image: the doting niece's, the prodigal son's, and the stranger's. Each is imbedded in a personal, oral account which, as Hirsch says, "usually has more texture and complexity, reaching far beyond the scope of the picture itself." Not one of these accounts is reliable, however, nor does Hirsch trust the absent captioner of the picture, but only the evidence before her eyes: "Family photographs themselves do not change, only the stories we tell about them do."[13]

Family albums, on the other hand, do change. At least, the possibility of alteration is a reasonable pretext for a story, and food for thought for the photographic historian. In "Photographs and History: Flexible Illustrations," James C.A. Kaufmann discusses a short story by Lee Zacharias, written from the perspective of an adolescent girl about her grandmother's death and the family album.[14] In the story, the girl-narrator is consumed with the album, especially pictures of herself, and she has become its compiler. The grandmother is confined to hospital for what the family knows is the last time, and she asks the girl to bring her the album. After the grandmother's death, the album returns, and eventually the girl takes it out to remind herself of what her grandmother looked like. The album has been pillaged, leaving only a single photograph of the grandmother, young and beautiful. The girl surveys the destruction that has swept away everyone in the grandmother's frame: "Mother, Mary Lou, and Grandma, Christmas, 1968. Four more photo-mount corners, one torn loose, hanging by a pinhead of glue."[15] Three generations have been eliminated at a stroke; a personal photographic file is wiped clean, right back to the grandmother's own self-absorbed teenage years.

Kaufmann is struck by the instant authority of the remaining portrait: "clearly not the whole truth, this single photograph attains the power of history by the default of the other visual historical documents." He sees the grandmother's de-compilation as a symbolic effort to deny death. "The material reality of her slow decay is erased, and she becomes instead an image – fictionally specific, but historically incomplete. Though the visual documentation of the grandmother's life

is deficient, it becomes the substitute image for the sum of a life. History becomes a photograph."[16]

A less radical form of revisionism caught the attention of sociologists Boerdam and Martinius in a study of a young couple, engaged to be married and looking for the first time at the family photographs on both sides. Recitations of the respective genealogies were summarily brief. Mostly, the young people swapped stories, "adjusting the two individual pasts to form a joint memory ... a process of reinterpretation of the separate pasts from the common present."[17] We can imagine that certain characters and family legends gained strength in the process, while others faded away from lack of appeal or possibly shame. What was at stake was the fittingness of the family chronicle to travel with the individual into the next life-stage.

Being in control of one's own life story is no guarantee of that fittingness or its impermeability to change. One album in the McCord starts out as a celebration of one type of social group and ends up in the hands of another. Certain changes have to be made along the way. The Natural History Picnic Album (MP 582) is a collection of snapshots datable by the few inscriptions as ranging between 1900 and 1908. The photographs could be classified mainly as informal group portraits. Most of the subjects are young, and those who are not are likely to be surrounded by young people, a zany group of men who are the album's main characters. Their interests are displayed within the album and are largely social, ranging from card parties to marriageable women. Most of the photographs could be described as conversation pieces. There are relatively few single portraits, with the notable exception of cats, photographed individually on lawns, loafing in baskets, performing tricks for a young woman, or posing against plain backdrops. Passages of scenic views mark trips ("1000 Islands 1900"), special events ("Duke of York: Visit Sept 1901"), noteworthy incidents ("Thos May Fire Jan 1901"), or temporary situations ("Military camp, Three Rivers, Q. June 25. July 6, 1901"). Echoing the sociability of the contents, individual photographs are gathered into generous bunches by subject, location, and occasion. Indeed, the classificatory tendencies of the compiler are contextualized within the first few pages, which contain photographs of young people on natural history picnics. These are scenes of leisurely self-improvement, as Carl Berger explains: "The fad of natural history was most evident in the fashion for making one's own collection of natural history objects. The materials were accessible and the equipment minimal, and everything had a place within the orderly Linnaean system of classification in which each item was described by two names – one referring to the family, the other to the particular species." Berger also notes some degree of social evolution: discouraged before 1880, young women increasingly were welcomed on these walks and became the majority after 1900.[18] The group pictured in the album is gender-balanced, and the photographs, staged in a rustic setting, seem more about courtship than science.

The anonymous compiler has left tantalizing clues in the album: one name ("R.W. Sterling Toronto July 1907") on a page of young men's group portraits, as well as three street addresses that Lovell's Montreal directory assigns to J. Boyd Dunlop, shirt manufacturer, Thomas Brethour, contractor, and F.W. McKenna, surgeon dentist, and Walter G. Penny, commercial traveller. Those names appear nowhere: friends would never be forgotten; landlords are of little account. The rooms or houses are remembered as havens of great conviviality. In these smoky interiors, the camera acts as a theatrical spotlight, prompting extravagant gestures – mugging and swaggering – completely unlike the restive poses assumed by both sexes on their nature walks outside.

The album can be compared with the pre-war "memoir" albums examined earlier, an exercise that underscores its distinctly collective ethos. In the early twentieth century, families and their pastimes were changing by degrees, patterned on the conventions of the Victorian era.[19] Divisions by generation and gender are apparent in this album, which also gives evidence of continua through new rites of passage. Courtship rituals were moving to different settings, but as Peter Ward points out and the album confirms, the Victorian cult of

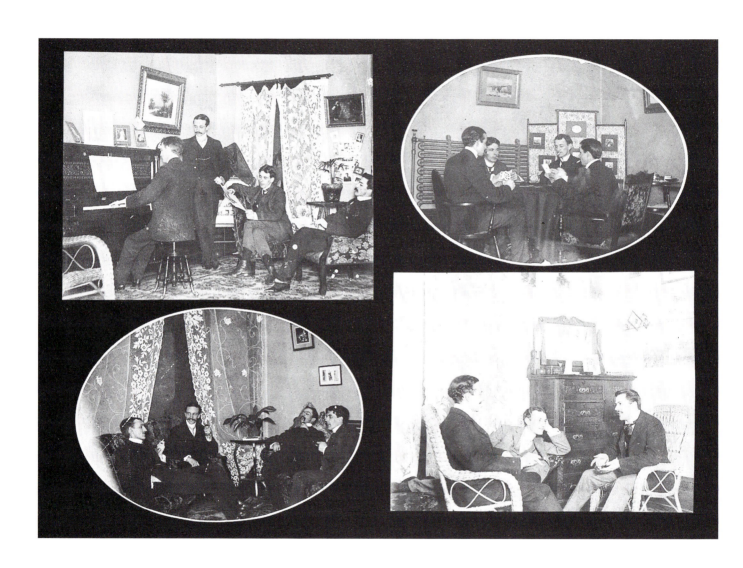

domesticity still held sway: "In 1900, then, women courted in familiar as well as unfamiliar places. By moving into the domain of men they had broadened their opportunities for male friendships. But when the prospect of marriage arose women found security in their own traditional province."[20] Accordingly, this "natural history of man" concludes in a leisurely survey of a turreted house and picturesque garden. Everything comes into the light; the smoky masculine domain dissolves into the comfort of the family porch. But the album contains the traces of its retrofit for the future: pictures torn out, certain pages removed altogether. A family of sorts, comprised of five young men, is being replaced by a family of the right sort, symbolized by home and hearth. The family plot thickens into ...

THE LOGICAL ORDER OF SOCIAL MEMORY

The albums examined thus far illustrate a variety of family-type compilations that seem to accommodate both anomalies and courses of change. Having insisted on the impossibility of Bourdieu's *idea*, it would seem appropriate now to confirm that no such album exists, at least at the McCord. That in fact is true, but two albums in the collection come very close to the sociologist's platonic form.

The Charles-Philippe Beaubien Album 1903–1908 (MP 042/90) was donated to the museum by Gretta Chambers, granddaughter of the photographer and compiler. This album is one volume of an extensive series now spread among the grandchildren, depending on whose parents appear in the photographs. Charles-Philippe Beaubien was born in 1870 to a prominent Montreal family whose history to 1914 is outlined in his uncle Charles-Philippe Beaubien's *Écrin d'amour familial: Détails historiques au sujet d'une famille, comme il y en a tant d'autres au Canada qui devraient avoir leur histoire*. Charles-Philippe the amateur photographer was by profession a lawyer. His biographical entry in *The Canadian Men and Women of the Time* (1912) cites his education, marriage

to Gretta Powers, religion, club memberships, and reputation as "A powerful speaker."[21] In interview Mrs Chambers characterized her grandfather as a passionate amateur photographer who believed in keeping a "running commentary" of his life. He travelled regularly for business and pleasure, often starting an album with an important journey.[22]

This album begins about 1903 with an Atlantic crossing and a trip through Europe, on which he was accompanied by his wife and child. After their return, the album continues with pictures of the family in city and country, gathering for group portraits or absorbed in their pastimes, swimming and sailing at their country estate on Lac Nominingue. The porch at Nominingue becomes the gallery for a command performance of an itinerant troupe of dancing bears. More journeys follow in the order of occurrence, including a trip to the American west coast. Compilation follows a pattern of openings and closings: visions of the distant, outside world are kept in balance by images of home and family. Nevertheless, symbols of transport – boats, buggies, cars, ladies carrying a lady in a voluminous woven basket – never disappear from this account. They are distributed among signs of ease and stability – houses, grandparents, siblings, and babies.

As a photographer, Beaubien was remarkably consistent and painstaking in his work. The best vantage points are considered and reached with some physical effort. Sublime landscapes are carefully organized, from *repoussoir* to deep space in which his companions stand patiently for scale. It is interesting to compare his subjects with the emblems of authenticity gathered by others travelling at that time in England. Working against the grain of nostalgia, Beaubien demonstrates little interest in "Shakespeare land," in snapping or staging the natives in genre scenes. He disdains, or is innocent of, the prescribed list of ancient and natural charms.[23] His pictures of England, the Continent, and even the American west are romantic in a different, more optimistic sense, rooted in an eternal present. As an educated man, a connoisseur, he associates himself photographically with what he judges good and lasting: geological formations,

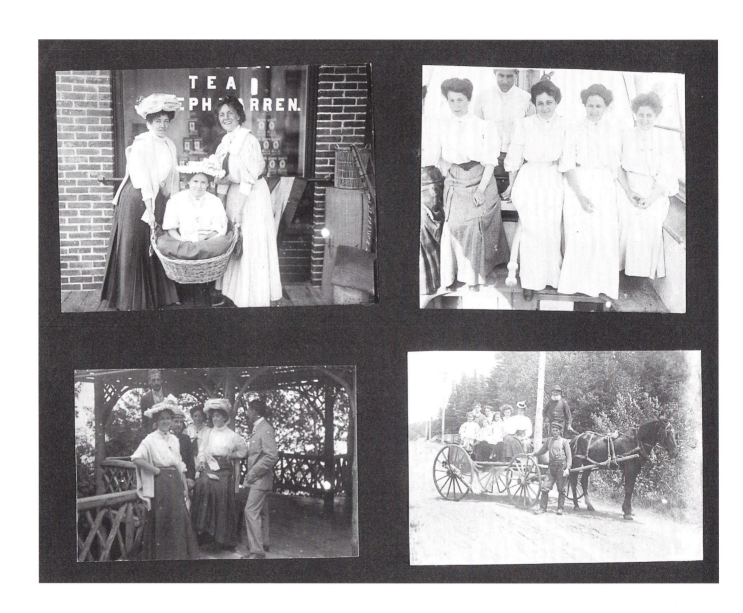

picturesque ruins, architectural monuments, sweeping boulevards, and formal gardens.

There are no captions or dates on any of the pages. Mrs Chambers's reconstruction of the narrative hinged on her recognition of the figures, her recollection of the family tree, and her identification of milestones, such as visits or trips, impressed on her mind in the retelling. Looking at the photographs prompted stories – affectionate family secrets. As a child, she had been shown the albums. She recalled one occasion, just before the Second World War, when her grandfather showed her pictures he had taken of German architecture and gardens. He urged her not to judge Germany by the ugliness of the present moment. The album contained his faith in the redemptive power of art. His family and his charming recordings of family were an integral part of his vision. This album, which tells us so much about family life, was expressly conceived and clearly understood to be one person's instrument of self-knowledge and expression.

The Benson Family Album (N 007/86), the album of Etheldred Norton Frothingham Benson, aspires to completion and internal logic. The photographs, all studio portraits, date from the 1870s to the First World War. The Frothingham family loved to be photographed. An earlier Frothingham/Benson album of cartes-de visite (N 005/86) is the product of countless trips to the studio, where family members posed and played before the camera. As young mother, Etheldred attempted to extend the photographic experience to her children. She began the album with pictures of her own childhood. In a Notman composite, Etheldred and her two sisters are depicted tobogganing with their father; on the facing page she appears as a debutante.

In the next picture, Etheldred is married; she and her husband share a picture spread. Her portrait appears on the left, and on the right is George Benson. With respect to photography, Etheldred appears to have married the wrong man. Indeed, she may have been misled since there is evidence that George did take the time to sit for a portrait before they were married. His carte-de-visite appears at the end of the Frothingham/Benson album, paired with a portrait of his fiancée. The portrait of George Benson as husband, awkwardly inserted in Etheldred's family album, is an extract from *Who's Who in Canada*. This Who is quite the foil to Etheldred's play-acting father. The clipping spoils the chronological flow of the album since the text mentions the two sons and one daughter who have yet to appear in the narrative.

As the album continues, Etheldred attempts to restore the photographic lustre of her family. The arrival of her children is marked one by one. Her daughter is photographed at the same studio where Etheldred was photographed and in much the same style. But her husband appears only the once as an alien visitor from the world of business. Etheldred was unable to persuade him to *get with it*, to participate in her photographic genealogy. The flaw in her self-presentation speaks volumes. Appropriately, the last item in the album marks the dissolution of the closed family unit, as her oldest son, George, departs for military service in Europe.

MIRRORING OTHERHOOD

The family construct in the Benson album is wholly dependent on children. The album has a storybook quality: Etheldred is a child who grows up and has children of her own. As babies come along, they are displayed in their christening dresses to the camera, first cradled in their mother's arms, then propped up in a first attempt at independence. Eventually, they must have wailed and been taken away. By whom, one wonders? Few albums answer that question, though nurses and maids were certainly part of even the middle-class family until the 1930s. The Louisa Davenport Frothingham Album (N 006/86), compiled by Etheldred's mother, includes pictures of Sarah Campbell, a.k.a. Growler, the Frothingham family nurse, as well as a group portrait with servants Sarah and Nancy forming a backdrop to visitors at the family's summer home. But the Benson Family Album is almost exclusively concerned with Bensons. As we shall

GHF + Harriett March 12th 1865

LDF + ENF

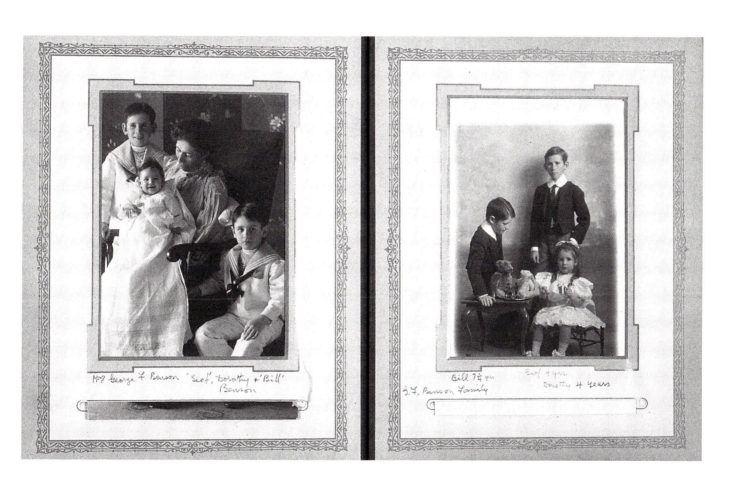

Mrs George F. Benson "Geof", Dorothy & "Bill" Benson

Bill 7½ yr. Geof 9 yr.
G.F. Benson Family Dorothy 4 years

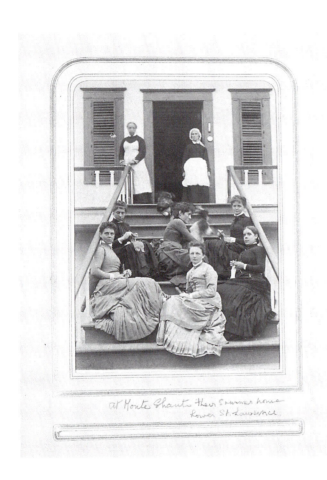

at Monte Shanti their summer home Lower St. Lawrence.

Monte Shanti - Rivière du Loup

see in the next chapter, the relationship between mother and child has been simplified and pictorially strengthened to meet the ideal of maternal love popularized in Etheldred's day. Other photographs in the McCord collection demonstrate how those ideas might be changed. Cynthia Jones, for example, took pictures of her children from 1928 to 1931, several of baby Maureen in the arms of a nurse and more of a toddler playing with a maid. Mrs Jones, it will be remembered, was a nurse in the First World War; perhaps she felt some kinship with another woman in uniform. Whatever the case, her family photographs of servants and children in tender and playful engagement are intriguingly rare.[24]

More unusual still is an album that explores the life inside a life in service. The Annie Craven Album (MP 039/76) is an expression of personal identity bound up in a broad definition of family, her own and the ones she serves. This is a sad, fragmented document, valued by the museum for its japanned cover and printed fabric pages. Annie Craven was an Englishwoman, born in 1880 in Wakefield, West Yorkshire. She was nanny to a Canadian family that donated her album to the McCord. The album includes photographs of her relatives in England, her charges in Canada, and the royal baby, Prince Charles. These images, scattered over place and time, comprise the attachments and associations of a life in service. The album is an incongruous container, a gift, one is tempted to think, from her employers. Exotic and feminine, its pockets should have been filled with a more refined collection, but Annie Craven's photographic trove everywhere feels awkward and out of place. She tucked a poem in one of its pockets, "Nocturne" by Hazel Marion Shaughnessy, whose turning point, between dusk and dawn, is a sudden invasion of confusion and loneliness; dawn comes too soon to solve "the mysteries of the night."[25]

Two portraits that Annie Craven kept of herself are fascinating to compare. In the first, she presents herself to the camera as a forthright, determined, and comely young woman. The photograph was taken in Stanley, England, at some distance, therefore, from Wakefield. Perhaps Miss Craven was already in service. This photograph, or one like it, may have been her presentation piece to potential Canadian employers. Her costume is simple and without pretension, a full white blouse lightly trimmed with lace. She gazes forcefully at the camera, her seriousness only slightly undermined by a dark ribbon choker tied in a flirtatious bow. Why not? she must have thought. The reception of her portrait would in any case have been conflicted, her employers wanting a girl who looked well enough but who would not run off and get married.[26]

In the second portrait, she is stamped as a nanny, probably to Andreas and Melville Bell. Dressed in uniform, Annie Craven is with her charges and part of them. Her eyes are focused on the camera, but her head is turned toward the baby who sits on her lap, distracted, no doubt, by an animating assistant. The most self-possessed of the trio is the young male child who stands behind Miss Craven and the baby, with his arm around the nurse's neck.

The history of this album adds to its curiosity, for it came to the museum as part of a donation from the descendants of Annie Craven's charges. It had returned, if only briefly, to the family at its core, to the children she had helped to raise. Through Annie, and symbolically through her album, those children are forever linked to her family – Aunt Lizzy, Uncle Will, and Cousin Florie in England – to Baby Tommy Beauclair, who died at forty-six, to the royal family, to the mysterious glamour girl from Birmingham. The stories of those lives, like Annie's arms, encircled the babies Bell because, while Annie was with them, they possessed her stories as their own.

The character of the servant-narrator dominates the plot of works such as *Gil Blas*, *Jane Eyre*, and *The Turn of the Screw*, but this literary trope also creates temporary powers, as Bruce Robbins observes. "In addition to all of these, we can count the minor servants, featureless and perhaps even nameless, to whom the author nevertheless chooses to give the floor at some strategic point, who emerge into ephemeral being in order to deliver messages, commit indiscretions, impart family secrets, administer consolations, emit prophecies, make recognitions, and so forth – through whom, in short,

Annie Craven Album 1900–1963 (MP 039/76), 9

Annie Craven Album 1900–1963 (MP 039/76), 2

the business of divulging decisive information is largely carried on." A combination of literary traditions and substantive conditions gives the servant-narrator a very strange mixture of impotence and believability. In plays, Robbins tells us, the servant colludes in his or her asides with the audience, while in certain novels the reader can either accept the word of the servant or put down the book.[27]

In a photograph the servant presence is both a sign and a conduit; it mirrors the beholder's invasion of the domestic sphere. The servant who is seen and not heard (like the child) has in fact heard a great deal; the servant body is an aural instrument of record. The memoir of a career in family life, the Annie Craven Album is imbued with objective authority, as though her witnessing of the family were its guarantee of fact. Generations were raised by this rule, children turning to the servants for the facts, as well as for the myths of their family. In *Ritual in Family Living*, Bossard and Boll noted that "servants who had remained in the family for generations kept the family past alive, often through stories told to children at bedtime."[28] The Annie Craven Album throws the orality of an album into relief. While the servant does not always figure in photographs of the period, what the servant knew, and told, may well constitute the album's recitation of family life.

Reflective of the same time, place, and social stratum, the Beaubien, Benson, and Craven albums are three very different definitions of "family" and compilatory agency. Charles-Philippe Beaubien operated within an orderly universe that gave space to his artistic instincts. He honoured the family – his family – as he honoured the achievements of Western civilization. Etheldred Frothingham Benson was born and bred to maintain a Victorian sector, the domestic protectorate within the masculine empire.[29] She is not the photographer but the impresario of a photogenic family of performers. Annie Craven raised other people's children, puzzling together her family and her album as an inside-outsider. Neither mother nor father, all her stories told, she resides now in collective memory as the eternal observer, a creation of her own family souvenirs.

The role of observer is not, however, strictly reserved for some biological other. Mrs Charles W. Wagner's wartime memoir and travelogue are complemented by a third snapshot album. The Wagner Gaspé Album, 1928–1933 (MP 032/80) is a woman's record of domestic life on the Gaspé peninsula. The Wagner family appears to have been living in a lumbering and fishing community year-round. House, car, clothing, and leisure time confirm the prosperity of the family. Mr Charles W. Wagner is clearly of the professional class.

For Mrs Wagner, there are fishing parties, sugaring-off parties, walks by the sea with little children and puppies. Mrs Wagner is a stranger to this environment. She and her visitors "make strange" in a number of images, even as she quietly explores the rugged beauty of the landscape. These visions are often juxtaposed. In one photograph a woman and a man pose with a large dead bird held up between them. The man grins impishly. The woman, caught at an oblique angle, looks slightly demented. She appears to be talking her way through the experience. On the same page is a pictorial landscape of road and misty mountains. The album alternates between candid shots of outdoor activities and respectful views of the environment. The Gaspé seems a very nice place to live and bring up a family.

Suddenly this idyllic vision is interrupted by a sequence of pictures taken on a ladies' charity mission. The essay, which begins with views of shacks and the arrival of a car, goes on for several pages. The living conditions and unhealthiness of the charity recipients are appalling. The women's bodies have ballooned from child-bearing and malnutrition. Their gawking, barefoot children suffer from hunger and disease. Almost as shocking is the integration of this photographic adventure, which ends as abruptly as it begins, the album returning to the family's normal program of comfortably roughing it in the bush.

Taking into account the values of another time, the charity mission can be interpreted as a discrete autobiographical chapter within the larger memoir of the family, itself a discrete segment of an upper-middle-class life. Or, less generously,

Wagner Gaspé Album 1928–1933 (MP 032/80), 81

ulterior motives for the mission can be supplied. After the First World War, charity work was considered women's work, absolved of nineteenth-century suspicions that too much activity outside the home would threaten traditional family life.[30] Still, charity work functioned as an outlet for its participants. Isolated in a rural community, Mrs Wagner was completely encircled by tradition. More than a hint of frustration is embedded in her pictures of grown-ups at play. As her accumulation of albums shows, the photographer-compiler was an avid amateur whose personal ambitions were contained by her choice of motherhood and her acceptance of societal expectation. Her essay on poverty in the Gaspé is bracketed by the same sets of conditions.

The essay fixes an aspect of Mrs Wagner's self-image in a retrievable, presentable form. For her children and others who were not present, it is a visual prompt for the showing and telling of a sharp break in her normal life as wife-mother-friend-hostess and official photographer. Filling in the void, do we hear grief, nostalgia, apology, or triumph? This specific episode lives within the continuous present of family life as a vivid flashback – more past somehow than the continuum of the normative context. Within the Wagner family saga, Mrs Wagner's narrative digression has its own clear voice.

AS I WAS SAYING

The private album takes direction from a variety of sources, and it changes direction in performance. The photographic notations of a tourist, for example, may fulfil different needs, from awakening pleasant memories to guiding the ploughshare and the sword. Historians of the family album say, Look to the genealogy; the portable portrait gallery is the descendant of the family Bible. But no family album is so prescriptive or hieratic. Theories of collection suggest another, much older precedent, one with rhetorical and mnemonic functions, the album as cabinet. This model illuminates the others, even as the cabinet's epistemology is leavened by the narrative digressions of a diarist, traveller, or intimate observer. Here, as anywhere, analogies are helpful, but a taxonomy of albums based exclusively on extrinsic models exposes a variety of forces that structurally will not hold. Thematic partitions are porous and unreliable. They have served this study as temporary corridors from the particular to the general, from the album as object to the very nature of compilation. But something basic to that nature is still missing. Orality is the key, as an analysis of its motifs and presentational patterns will show.

ORALITY AND PHOTOGRAPHY

CLICK

Click the shutter. Click the mouse. However you choose the frame, however oiled the apparatus, there is a click (a noise, a vibration) that marks the conjunction of stimulation and decision which has taken, or made, the photograph. The act is, and then it is over.

Sound, like the photographic moment, is fugitive. Its utterance coincides with its disappearance. Recitation revives the original utterance, bringing it into a continuous present, just as the making and viewing of a photograph create a continuum with the past. Orality invests power in naming, which photography also does by the modern authority of mechanism. These resemblances are striking, but they take on real substance when the photograph is inserted with others in an album. There the roots of orality run deep, and intertwining with photography's, they shape experience into memories whose formations in the album are the permanent, visible trace.

I have said this often enough, and my discussion of collections, memoirs, travelogues, and family sagas has been shot through with glimmers of the conversations that upheld those projects in the past. It is time now to detail the links between photography and orality and, more importantly, to demonstrate that the recognition of an album's oral structure and interpretive

performance will bring us closer to understanding the photographic work. I propose to do so in four ways, beginning by laying down the groundwork of oral tradition in terms of vestigial structure and content, reviewing as well arguments for the specificity of oral consciousness. Then I will read back through photographic and cultural studies that relate to albums and correlate those findings with the characteristics of orality. Those areas of agreement, features of the oral-photographic alliance, will expand our reading of albums that we have already seen. Finally, we will take up where we left off in the introduction, resuming the story of the sisters' album and extending its analysis (to this point, largely descriptive) through contextual, visual, and oral interpretation. Oral culture, photographic theory, and illustrations from the albums will be interwoven through this chapter. The sisters' album, "Photographs," will constitute a chapter of its own.

Hearing from the Past

The study of orality began as a study of text. This methodological inversion has a peculiar logic, however curious the results. The exegete, the Homeric scholar, and the ethnographer were literate folk working with what they had, the vestiges of oral composition in an ancient text. Transformative in its reproduction, the later work of art had extended the life and altered the memory of the old. An illuminating trope is the ekphrasis, illustrated by Keats's "Ode on a Grecian Urn," whose lines are all we know of the inspiring object. Transcriptions or recordings of modern oral performance were no more faithful to the original; how could they be? Like the translation of a private album into a public museum (or reality into a photograph), the effort to preserve and understand oral culture was always in some way deleterious, the provisional aspects of orality tending to disappear behind the permanence of writing or the prestige of a rare recorded version.

The difficulty persists, so that however attuned we may become to the importance of oral tradition, the written word still stands as gatekeeper to the utterance. Extending our literary bias to photography as visual literates or *readers*, we have erected the same structure in front of the album. Meanwhile, the oral/literary divide is an ongoing debate, now heated by the glow of a digital world, then chilled by statistics on illiteracy. As students of the photographic album, we have to pinpoint that divide and set up there. The photographic album is very much the product of a literate and industrialized society, and we have seen its visual adaptation of literary modes, such as the memoir. Orality seems nevertheless co-present, a possibility that recourse to the literature of oral tradition will confirm. But we cannot forget that the first language of the album is photographic, a visual language, distinct from others in a number of ways, including its relationship to the real. Our divide begins to look more like a traffic circle, the meeting of three epistemic and mnemonic axes – orality/literacy, literacy/visuality, and visuality/orality. Visual and textual modes have conditioned our reception to this point; let us now turn to the oral.

Scholarly interests in oral tradition can be identified under numerous headings: the Finnish historical-geographical method, tracing the spread of archetypes; comparative philology and mythology, examining Indo-European roots; psychological analysis, Freudian and Jungian; direct correlations between oral arts and society; Marxist and feminist perspectives; structuralist, post-structuralist, and narratologist readings; the "oral theory," stressing formula and process; and the "ethnography of speaking," observations of human artistry in social performance. Ruth Finnegan, whose survey is the basis of this list, underscores the pluralism of oral studies, and in her summary of current trends, she reports increased attention to human agency – "individual voices, repertoire and creativity."[1] Material culture can be visited under several of these categories by accepting the condition of a finished work as one of continuous process.

In a comparative discussion of epic and novel, Bakhtin writes of the hardening of genres that have completed their development. "All these genres, or in any case their defining

features, are considerably older than written language and the book, and to the present day they retain their ancient oral and auditory characteristics."[2] Students of orality ironically depend on the stability of textual survivals, on typical patterns of phraseology, theme, and development, beautifully trapped like flies in amber.[3] Axel Olrik was one who pioneered this approach in his "Epic Laws of Folk Narrative," a checklist of genetic markers outlined in such terms as the laws of opening and closing, the law of three, the law of twins, the law of the single strand, and the use of tableaux.[4]

Still today, the application and extension of oral-formulaic theory (the Parry-Lord theory) is concerned, according to John Miles Foley, "with the interpretation of style and structure as evidence of a work's oral traditional provenance."[5] Important considerations always are the technical problems of retention and transmission of an oral composition. Jack Goody's studies of present-day West African orality contain numerous observations that, he would argue, apply equally to Homer. He insists, first of all, on the coexistence and reciprocal influences of oral and literary tradition. On the question of memory and its sustaining formulations, Goody's observations in the field dictate broader definitions: "the concept of sameness may be much looser; it may refer not to verbal identity but to some kind of unspecified structural similarity."[6]

The scent of orality can be pursued in many ways. To each of Finnegan's theoretical headings, methods of detection, indicators, and specialized terminology can be attached – myth, legend, archetype, reflection, doubling, codes, bundles, functions, intertexualities, narrative, spin-storying, and performance – terms that are duplicative, complementary, or mutually antagonistic in use. Photographic discourse already shares much of this language; examples of its application to albums fill the previous chapters with paradigms and analogies. Our direction from here is considerably more specific. If the album, or some part of the album, belongs in a continuum of oral tradition, then stylistically and structurally, orality should have left its trace on albums in the collection of the McCord.

Folklorists and sociologists (Chalfen, Kotkin, Musello, Ohrn, Greenhill, and Boerdam and Martinius) have consistently made the point that the album is unlocked by storytelling. Michael Lesy, Marianne Hirsch, Stanley Milgram, and Roslyn Banish, among others, have analyzed the themes and archetypes that have emerged from their face-to-face interviews with respondents (Hirsch interviews herself). Archivist Lorraine O'Donnell makes a direct connection between family photography and storytelling, allowing that the positive image constructed by the album may be tarnished by a family member's oral account.[7] But in a public collection, we have neither respondents nor guides. No one is shaping these albums into digestible narratives; no one is filling in or glossing over their lacunae or "intertextual" references. This, as I have stressed, is a loss. At the same time, the total absence of oral accompaniment (its virtual silencing) is precisely what allows the oral framework of the album to resurface.

A framework against which the orality of the album can be tested was set out by Walter J. Ong in *Orality and Literacy: The Technologizing of the Word* (1982). Building on Milman Parry, Albert B. Lord, Eric A. Havelock, Jack Goody, Marshall McLuhan, and others in, or intersecting with, linguistics, sociolinguistics, anthropology, and communications, Ong cast a wide scholarly net. He came to this work via the history of rhetoric, having concentrated on the dialectical order of Petrus Ramus. Drawing on his research in mnemonic systems and psychology, Ong set out to explain the content and structure of oral composition in terms of human consciousness. Aspects of the problem had been addressed earlier in *The Presence of the Word: Some Prolegomena for Cultural and Religious History* (1967) and *Interfaces of the Word: Studies in the Evolution of Consciousness and Culture* (1977), where Ong had applied his theory to a study of "wordless" communication, the pure sound described in "African Talking Drums and Oral Noetics."[8]

Ong's work naturally recommended itself to an interdisciplinary project involving classification, memory, and oral presentation, but its relevance to the photographic album

exceeded normal expectations. His description of the oral condition – his "psychodynamics of orality" – elicited in me what can only be described as a shock of recognition. The rhetorical tradition that adheres to the cabinet of curiosities – a rather obvious model for any collection of objects, including pictures – suddenly found its place in a family of oral compositions. Ong's framework, as applied to the organization of an album, helped to clarify the desires of individual compilers. Their "illogical" procedures began to make sense. A vague notion that orality and photography were related seemed suddenly verifiable, and more interesting still, it could be shown that the older mentality was still driving the new. Discovering structures of oral tradition imbedded in a snapshot album put claims of the Kodak revolution into perspective and cast the photographic industry and its customers in a more sensible light. "The camera as storyteller" had touched a chord that was already there.

Nothing new in that thought, but the idea that photography reactivated a condition dormant in Western consciousness, that it invaded the structure of literacy and made books – photographic books – systematically based on oral formula had not been considered before. Ong's approach to the problem of orality opened that possibility because of his insistence on the specificity of the oral condition. He champions it, in effect, against what he perceives as the hegemony of writing. His essential argument for attending to the "psychodynamics of orality" is that its conditions are radically different. Ong's attention to difference – his distillation of a purer orality – facilitates comparison with other patterns of consciousness. Application of his framework to albums does not turn photography into a text, recited or written, nor does it demote photography to illustration. On the contrary, it illuminates the particular qualities of individual photographic experience – its own psychodynamics. The complementarity of photographic theory and Ong's orality is unfailingly surprising, and it would perhaps surprise Ong, whose diverse scholarly interests barely touch on the visual arts.

Orality and ... Visuality?

An intellectual biography of Ong and a substantial critique of his work would be another book, which has in fact already been written. A biographical portrait and selected bibliography were part of an Ong festschrift in *Oral Tradition* (1987).[9] Bruce E. Gronbeck, Thomas J. Farrell, and Paul A. Soukup have edited a collection of essays that explore Ong's thoughts under three headings, media, consciousness, and culture, extending his field of psycho-cultural studies to post-Freudian analysis of the mind-body split (Ruth El Saffar) and to the displays of individual and social character emerging from the medium of television (David Payne).[10]

In *History as an Art of Memory*, Patrick H. Hutton summarizes Ong's contributions to cultural studies, looking specifically at *Orality and Literacy*'s history of the changing modes of communication. As a historiographer, Hutton is intrigued by Ong's historical breakdown, which Hutton likens to a mnemonic scheme, linking each communications stage (oral, chirographic, typographic, and electronic) with "a different historical perspective on memory: orality with the reiteration of living memory; manuscript literacy with the recovery of lost wisdom; print literacy with the reconstruction of a distinct past; and media literacy with the deconstruction of the forms with which images of the past are composed." Hutton builds his argument from a variety of materials – philosophical, linguistic, sociological, and poetic – but he returns to Ong in a conclusion that calls for the reawakening of the historian's imagination.[11]

Ong's readers also include detractors, among them Martin Jay, who situates Ong's work in a history of anti-ocular discourse. Jay extracts most of his proofs from *The Presence of the Word*, a book in which Ong argues from a defensive position to reclaim some territory for the oral. Jay calls Ong's, Goody's, and Donald M. Lowe's theories of culture "grandiose."[12] Disparaging William M. Ivins's discussion of Plato, he notes its influence on Ong. Jay challenges Ong's assertion that medieval stained glass was more decorative than instructive.

Generally, his view of Ong is inseparable from his opinion of Marshall McLuhan, who was Ong's teacher; Jay thinks both are prone to hyperbole. At the same time, he builds on their ideas regarding the invention of printing.

Jay has many other fish to fry, which is probably why he overlooks another passage from *The Presence of the Word,* in which Ong really lets loose on visuality: a critique of John Locke's famous comparison of human understanding to an image formed by light and fixed in permanence (essentially a photograph). As interested amateurs of the photograph, we had better hear Ong out as he literally fumes: "Locke assimilates the entire sensorium to sight and converts consciousness into a *camera obscura,* a hollow into which and through which light rays play. The visual simplicity of Locke's model is matched only by the naivete of his assumption that the model is adequate to the real state of affairs."[13]

Most of us would agree that an adequate explanation of consciousness would entail more than the substitution of one sense for another; the problem for Locke and for Ong is communicating clearly a point of view that they see others losing sight of. (My phrasing here is a perfect example of the visual habit.) Despite the "and" in *Orality and Literacy,* Ong, like many scholars, can be accused of constructing his arguments in apposition. As Ruth El Saffar says, "Dualism is a byproduct of script culture."[14] Ong and his readers are products of that culture. While, as El Saffar rightly says, "Ong suggests that consciousness is moving beyond the need for opposition, which grows inevitably out of the metaphysical binarism that has dominated Western thinking since Plato,"[15] his arguments for the "recovery of oral culture" have often depended on demonstrating the *lack* in what is referred to as "hypervisualism."[16]

Whenever Ong mentions literacy and orality, or seeing and hearing, he privileges the oral/aural as his topic and his predilection. For example, when he considers the psychosexual stages of the child, he does not glance into the Lacanian mirror. Rather, he conceptualizes the child's coming to language in terms of flow and constriction (orality and literacy).[17] What feeds Ong's discontent with the visual nourishes his pleasure in the oral. Sound for him is "the special sensory key to interiority," proceeding from one interior to another, revealing the interior "without the necessity of physical invasion."[18] Ong seems never to have *entered* a painting or a photograph in the way that Michael Fried, for example, understands the experience of spectatorial absorption running through into eighteenth-century representations of reading, listening, preaching, drawing, reciting, or blowing a bubble – subjects simultaneously representing "engrossment in the act of painting" and anticipating "the absorption of the beholder before the finished work."[19] One of the texts that instructs Fried is Abbé de La Porte's commentary on a genre scene by Jean-Baptiste Greuze, *Un Père de famille qui lit la Bible à ses enfants* (Salon of 1755), a painting that describes the family's nearly seamless absorption:

The little boy, who is making an effort to grab a stick on the table and who is paying no attention whatsoever to things that he cannot understand, is perfectly true to life. Do you not see how he does not distract anyone, everyone being too seriously occupied? What nobility and what feeling in this grandmother who, without turning her attention from what she hears, mechanically restrains the little rogue who is making the dog growl! Can you not hear how he is teasing it by making horns at it? What a painter! What a composer![20]

For his part, Ong says, "Sound situates man in the middle of actuality and in simultaneity, whereas vision situates man in front of things and in sequentiality."[21] Jay is not wrong in his detection of bias in Ong; there is productive bias in both. Jay's rehearsal of ocularcentrism is a valuable backdrop to any discussion of the sensorial partition of experience. Perhaps Ong truly is closed to visual experience – an oral/aural being to the core. Or perhaps he shares the opinion of novelist Flannery O'Connor, who explained the violence of her stories as a means of persuasion: "to the hard of hearing you shout, and for the almost blind you draw large and startling pictures."[22] This, in any case, characterizes Ong's contribution

to this study, which is a search for an *adequately complex* compilatory model. His shouting voice has been immensely useful in freeing the album from the empoverishments that *silent reading* ironically helps to impose.

In our increasingly computerized and alarmingly illiterate First World technocracies, we find new arenas of Ongian debate. Henry S. Sussman reads in Ong a form of nostalgia or "longing" for an oral order. He is also struck by the religious rhetoric that he finds in studies of orality (Ong is a Jesuit priest) and ponders the connection between orality and theological propagation.[23] Sussman wants Ong on side against illiteracy, which of course Ong is, within the context of his own program: "Orality is not an ideal, and never was. To approach it positively is not to advocate it as a permanent state for any culture. Literacy opens possibilities to the word and to human existence unimaginable without writing."[24]

The printed page is, after all, Ong's medium for the delicate reconstruction of oral consciousness. Sussman's assessment of Ong's achievement in this area is unreservedly positive:

the constellation of oral behaviors, skills and attributes that he assembles throughout the main part of his book constitutes a major contribution to the theory of linguistic behavior. Within Ong's scenario, orality and literacy do not so much threaten as condition, extend, and in some cases stimulate each other. Some of Ong's ongoing concerns about writing, such as its impact on memory and memorization, may have been shared by Plato, but the research that he marshals to support his profile of oral traits is a good deal more recent. Ong's fascination for his subject has enabled him to explore a wide range of its conditions – physical, temporal, cognitive, logical, social psychological, and metaphysical.[25]

Conditions and Categories

What then are orality's conditions, and how do they relate to the photographic album? In *Orality and Literacy*, Ong begins his chapter on psychodynamics by exploring the nature of sound: "It is not simply perishable but essentially evanescent, and it is sensed as evanescent." Sound relates doubly to power: its source, potentially threatening, is dynamic, and naming in magic (or science) is an act of empowerment. In oral culture, knowledge of the problem-solving kind depends on memory. The recipe is simple: "Think memorable thoughts." And those are "heavily rhythmic, balanced patterns, in repetitions or antitheses, in alliterations and assonances, in epithetic and other formulary expressions, in standard thematic settings (the assembly, the meal, the duel, the hero's 'helper,' and so on), in proverbs which are constantly heard by everyone so that they come to mind readily and which themselves are patterned for retention and ready recall, or in other mnemonic form." The practical necessity of retention shapes its mental organization: "In an oral culture, experience is intellectualized mnemonically."[26]

Ong's inventory of characteristics then divides into nine categories, some cast from the duality of his title: additive rather than subordinative; aggregative rather than analytic; redundant or "copious"; conservative or traditionalist; close to the human "lifeworld"; agonistically toned; empathetic and participatory rather than objectively distanced; homeostatic; situational rather than abstract.[27] Relating these traits to the album, I have reordered Ong's list under three facets of compilation: patterns of inclusion, patterns of organization, and patterns of presentation. Certain aspects of these traits belong in more than one section: aggregates, for example, which are organizational patterns (groupings of photographs), are made up of aggregative particulars (photographic formulas), which are analyzed under inclusions. Consecutive in plan, all sections are also contiguous, in the sense that effects, consciously or unconsciously, are rehearsed in anticipation. Predictably, these compilatory phases correspond to the first three canons of rhetoric: finding or researching; arranging or organizing; and fitting one's material to audience and context. Performance and memory, the fourth and fifth canons, shape any discussion of the album in use.[28]

How do memorable thoughts become elements of oral compositions, and what form do they take in albums? According to Ong, the elements of orality are conservative or traditionalist, close to the human lifeworld, and situational rather than abstract. Images are formulaic, epithetic, or proverbial, casting individuals or scenes in absolute clarity. The oral world is populated by heavy or ceremonial characters.

The conservative or traditionalist orientation of oral culture derives from its methods of storing knowledge; the past needs to be repeated lest it be lost. Originality consists in reshuffling formulas and themes, introducing minor variations to engage the audience or even major ones to accommodate political or religious shifts. Syncretism in small doses is the key to perpetuating old stories in changing contexts. Information that needs to be transmitted – histories, genealogies, methodologies – cannot be ordered as objective records or instructions. Ong's example is the *Iliad*'s vast catalogue of ships, leaders, and territories, which he defines as an account of human action from which procedures and commands can also be absorbed, almost by example, as occurs under apprenticeship: "An oral culture has no vehicle so neutral as a list."[29]

Conceptual thinking in oral systems follows the same general rule, meaning that it adheres very closely to real-life situations. Ong's discussion of this point draws heavily on psychological research conducted by A.R. Luria in the 1930s, though first published in its original Russian only in 1974. *Cognitive Development: Its Cultural and Social Foundations* was the title of the English translation, which followed two years later. In terms of visual studies, Luria is an intriguing source because he tested literate and illiterate subjects using geometrical figures and drawings, which the respondents were asked to name or classify. He found substantial differences in thought patterns, noting his oral respondents' indifference or resistance to abstraction. A circle, for example, might be identified as a plate or a moon. Asked to eliminate one dissimilar object from the group of hammer, saw, log, and hatchet, the oral respondent took the situational path; it seemed logical to eliminate one of the three tools since without one the log might still be put to use. Deliberation based on experience dominated categorical or syllogistic constructs. Concrete examples provided the best, meaning the most useful, definitions.

The formulation of thoughts and descriptions in reliable verbal clusters is a boon to retention and unambiguous characterization. Ong shows how "antitheses, epithets, assertive rhythms, proverbs, and other formulas of many sorts" create heavy or ceremonial characters: "The hero is always a type character, a kind of elaborate personalized formula, such as wise Nestor, wily Odysseus, furious Achilles, a weighted, standardized figure hung with appropriate cultural values or antivalues." Formulaic phrases also contribute to the flow of performance: "the oral poet who feels a tree surfacing in his imagination has an abundance of options for maneuvering the tree gracefully into his metric current: aged tree, living tree, native tree, goodly tree, withered tree, and so on."[30]

Formulas and themes, real-life situations; reliable verbal clusters – these elements should be visible in an album. Figures and situations should be types sketched in broad, reproducible strokes that unambiguously amplify character and circumstance. The compositions of characters and scenes should be logical within a functional, situational construct. Symbolic relations should tend to metonymy in close mimetic connection to the real world.

Wise Nestor and Aunt Sue

Types abound in photography; the album is a litany of clichés. Interest in this phenomenon has tended to focus on the snapshot, as though Kodak liberated the average man and woman to be just like everybody else. Conversely, and despite the efforts of many historians to map the fault lines in Victorian conformity, we tend ahistorically to see the carte-de-visite as the emblem of Victorian repression and the snapshot as the spontaneous Edwardian response. Grouping albums by

intention instead of technique does away with some of the confusion, but what we need to understand better is the allure of type and the adaptation of nineteenth-century typology to photography.

Categorical studies of snapshot albums leave us awash in statistics. People inevitably leads the list of subjects (59.6 per cent of Timm Starl's photographic stocks); holidays are favourite themes (42.1 per cent, according to Starl). The typical "album of snapshots" compiled by Brian Coe and Paul Gates includes people, leisure, the seaside, the townscape, work, interiors, and events. Starl would add parties (3.3 per cent) and military themes (10.4 per cent); under subjects, he divides cities (5.6 per cent) from villages (1.6 per cent) and counts buildings (11.2 per cent), sights (1.6 per cent), transport/technology (3.5 per cent), and animals (2 per cent).[31]

Such categories have their limitations, for they are plainly subjective and frequently overlap. Sociologist Bourdieu throws a statistical wrench by reporting that vacations constitute the high season of family life.[32] We are dealing with photographic clichés, and the greatest cliché of photographic literature is that photographs convey different data at different times. The most formulaic class picture can suddenly become amazing when sometime later Adolf Hitler and Ludwig Wittgenstein are found to have practically shared the same bench![33] But even in the moment, a photograph runs deep with informational currents. Mrs Wagner's wartime album includes an outdoor gathering of young people whose dress and behaviour tentatively suggest an informal wedding. The same photographs could be classed under people, party, ceremony, family reunion, landscape, transport, or military, depending on the priorities of the cataloguer.

Graham King divides the photographic hoard into three distinct groups: material assets (home, automobile, pets, power lawn mowers, vacation homes, and garden furniture); achievements (trophies and their recipients, marking graduation, hunting, and fishing); and snippets of satisfaction (parties, picnics, and holidays).[34] Objects are interpreted as status symbols, milestones, or marks of a memorable event. Chalfen catalogues the same drives ("conspicuous success, personal progress, and general happiness"), which he plots on a human timeline, naming subjects that typically are photographed (children crawling) and those that are not (breast-feeding) and explaining how photography is experienced at each stage of life. Individuals, he insists, have the power of selection, yet their inclusions and omissions are conformist and resolutely positive. "Snapshot collections manifest a pride-filled movement toward adult life."[35]

Other experts would tend to disagree. Objects have a variety of symbolic attachments, as Csikszentmihalyi and Rochberg-Halton have explained in terms of psychology, anthropology, sociology, and mythology. "Just as depth psychologists immediately interpret a person's relationship to an object in terms of sexual symbolism, sociologists tend to look at the same relationship in terms of status symbolism."[36] In sociological readings of albums, a recurrent piece of material evidence is the car. Certainly, we have felt the importance of the motor car in the MacDonnell European Travel Album; it is everywhere pictured. The car also figures in the Wagner Gaspé Album 1928–1933, but functions very differently there. The charming motif of English village folk solemnly posing around the MacDonnells' beleaguered car is grotesquely mirrored in a picture from the Wagner charity mission that shows the wretched beneficiaries flocking around. The Wagner car gives the women independence and protection as they venture forth on their mission. It announces their arrival and fortifies the barrier between rich and poor. The MacDonnell car is also an expression of distinction, but one rooted in nineteenth-century progress. The family is endowed with a certain sense of power which, here again, is not purely symbolic, but derives from the symbolic object in use. Csikszentmihalyi and Rochberg-Halton take from Clifford Geertz the concept that "symbols can be both 'models of' and 'models for' reality. In the first sense, they reflect what *is*; in the second, they foreshadow what *could be*; and thus they become a vital force in determining cultural evolution." The car enhances the physical energy of the owner: "He or she, like

the car, can be auto-mobile, literally self-moving."[37] In a photographic album, a picture of a car can function as an epithetic prompt, summoning the energy, adventure, or acquisitiveness of its owner in the linking of a picture with a phrase. In the chaotic second section of the Langlois/Gélinas Album, a car becomes the attribute of one man; it transpires – or rather, suggestions accrue – that it is his last car after a lifetime of auto-mobility. The man, slightly stooped, and his car are faithfully recorded, and the extended portrait is stapled into the album beside another man's "In Memoriam," as though both men were simply getting ready to drive off.

The repertoire of photographic types includes persons, objects, places, and occurrences. A vast composite array opens up under the umbrella of daily life, photographs of people whose portraits are cast in the familiar light of habits, hobbies, and mundane affairs. Such subjects are the stuff of chronicles because they suggest a pattern of regular notation. We see this in the Anonymous Amateur Album's images of urban facades and trains, the *effect* (I have to stress) of daily rounds and schedules duly logged. The context of a family album changes the meaning: types may be tinged with ritual and invested with a certain sense of occasion. In the Charles-Philippe Beaubien Album, portraits are made of people sitting on the porch because it is typical of family members to do so; they gather there regularly under the matriarchal rule of relaxation. They also take walks, boat, bathe, and play tennis. Of course, they are on vacation, but to their dedicated chronicler they are really on display. A day in the country brings family and friends into the light, their inner beings released as specimens in a natural habitat. Beaubien's portraiture is occasioned by social patterns that have formed him as a child, that he perpetuates as an adult, that he both kindles and records by his photographic participation. What Gadamer calls "occasionality" (the connotative weight of intention) is complicated by the mirror effect of Beaubien's social and creative roles. Brilliant, following Gadamer, expects "occasionality" to amplify the expression of individuality, *not type*, which both believe to be the essence of the portrait.[38]

But an individual may aspire to be a type; the grip and manifestation of that desire may constitute his or her self-image.

The personal album's typologists have tended to concentrate on the snapshot since it is supposed to reflect most directly the desires of its users; snapshot trends are thus measured as social, ideological, and psychological indicators. Conversely, the nineteenth-century studio photograph is deemed more programmatic. Its types are largely assumed to be products of technological limitation, commercial expediency, and long-standing pictorial convention. Julia Hirsch traces nineteenth-century studio practices to Renaissance notions of decorum: "the formal photograph must avoid being a visual confessional, and must shield subject, viewer, and photographer alike from passionate engagement."[39] But just as we have learned to interpret the codes of patronage behind the conventionalized works of Renaissance and Baroque portraiture, we need to consider the nineteenth-century client's photographic act and the means for self-presentation at his or her disposal. As Hillel Schwartz has found, the desire to be doubled was intense. "Photoportraits took on the properties of the miniature: repetitive, recursive, revisable, phantasmic. Each time people changed stations or partners, they rushed to romance the camera, sitting for new portraits as they adopted new personae."[40]

Performing to Type

Nineteenth-century types were not born in the studio; they came to the operator in a mature state, prepared as for a social or business call.[41] Both the formal call and attendance at a photographic studio required foresight and training, and in Erving Goffman's sense of self-presentation, they are closely related public performances.[42] Richard Brilliant divides the population into those who occupy the public space in a significant way (celebrities) and those who do not (private citizens).[43] Knowing who is who is crucial to reception, for even under Andy Warhol's fifteen-minute rule, famous and

unknown are absolutes. But individual self-perception is different. Every person, however unassuming, partitions the world into public and private. If anything, this distinction was more keenly felt in the nineteenth century, when position (station or *place*) was so clearly demarcated, even in the domestic sphere. Social calls, which took place in the *public* rooms of the *private* home, involved visitors and hosts in short performances, generally no longer than twenty minutes.

"Through the portière, a theatrical curtain, every entrance became an occasion," writes Grier.[44] Novelists such as Henry James have lifted the curtain to show us the stress and tedium of the at-home, but on stage the rules of performance held sway. All but the most intimate friends retained their outer wraps; hostesses, costumed to receive, stopped whatever decorous task they were about and looked alert. The same proscenium, costumes, props, and gestures feature in performances for cartes-de-visite, and in the Arthur Lindsay Album we find the whole repertoire. On a single page, a woman stands gazing into the camera, hands clasped; a woman sits, pausing in some work, looking up as though to greet her caller; Mrs Arthur Lindsay models a voluminous lace shawl, posing in profile to the camera; another woman, also draped in a luxurious shawl, reads a letter. In the iconography of nineteenth-century manners, the image of a woman reading, rather than conversing, suggested that she was in the intimate company of family or friend. Cartes-de-visite were messages meant to be understood; a properly performed carte-de-visite would strike the right balance between public and private personae.

Deciphering these codes of behaviour is far from a science, and the strangeness of the photographic environment would have rattled anyone's sense of decorum. As Henisch and Henisch explain, early studios were often set up outside, with painted backdrops giving the illusion of a parlour; indoor studios were often decorated to look like outdoor scenes.[45] The operator might assume the role of stage director or social adviser if the client chose to listen. In 1863 one bemused patron reported that he was given the option of holding or wearing his hat.[46] A visit to the photographic studio was the opportunity to play-act before the camera, and some curious performances were recorded. But as any large collection of mid-nineteenth-century photography proves, the most popular role, far and away, was the public self.

"Yes, the wise man too speaks, and acts, in Formulas; all men do so. And in general, the more completely cased with Formulas a man may be, the safer, happier it is for him."[47] Thus wrote Thomas Carlyle, whose ideal Victorian male, according to Herbert Sussman, was a typological construction enshrined in a bible of industrial manhood, *Past and Present* (1843). As Sussman explains, "In seeing heroic manhood as a timeless, divinely sanctioned pattern manifested through human history, in the past as in the present, the text naturalizes, even sacralizes, male superiority and presents patriarchy itself as the realization through time of divine Will." Following Richard Sennett's *The Fall of Public Man*, Sussman shows that reserve – the strong, silent concealment of one's inner life – is the essence of Carlylean masculinity. "Public life became focused not on individual expression or theatrical presentation of the self, but ... on the heroic leader who acts out the emotions of less manly men."[48]

For Victor Turner, such cultural performances rise above the theatre of everyday life; however circumspect and restrained, they are active, rather than reflective, "agencies of change, representing the eye by which culture sees itself and the drawing board on which creative actors sketch out what they believe to be more apt or interesting 'designs for living.'" Turner's social drama arises out of conflict or crisis, passing over the threshold (*limen*) to resolution.[49] On a domestic stage, at a point of individual and family crisis, we have seen such a transition in the Small Molson Album, a captain of industry, John Thomas Molson, rehearsing the manly exterior of mourning in serial self-presentation.

Usefully, Sussman points out the strains and contradictions in nineteenth-century male models and the dilemmas that they pose for their students: "the problem of power and patriarchy calls for a double awareness, a sensitivity both to

the ways in which these social formations of the masculine created conflict, anxiety, tension in men while acknowledging that, in spite of the stress, men accepted these formations as a form of self-policing crucial to patriarchal domination."[50] What we find, to paraphrase George Orwell, is that all creatures are typical, but some creatures are more successfully typical than others. Annals of colonialism in the McCord collection – the Ogilvie Album, Bloemfontein to London, the Captain G.E. Mack Album 11 – need to be approached in an awareness of types predictively generating types, a conundrum of almost unbearable complexity when the role of local "culture brokers" is taken into account.[51]

Snakes and Ladders

As the first popular outlet of photographic performance, the carte-de-visite licensed movement in any advantageous direction, up, down, or diagonally across the social scale. Margaret Homans has shown that a process not unlike the colonial phenomenon of mimicry took place at the heart, or hearth, of the Victorian reign as the queen cooperated in a pictorial program of regal domestication: "She helped her nation to become powerful and prosperous by helping it to see itself as a middle-class nation, just as she smoothed the transition to a wholly symbolic monarchy that would have taken place with or without her in the nineteenth century."[52]

The spectacle of royalty, sprinkled throughout albums of cartes-de-visite and snapshots, contains within its popularity the seeds of transformative consumption. A cat may look at a king, and the average cat still wants to. Only now, the onstage image of the king or queen must resemble a backstage image.[53] While electronic media have accelerated the process, the displacement of the ceremonial character into the situational or human lifeworld can be traced to the sequencing of albums as a procession of royals, lesser aristocrats, accomplished commoners, foreigners, and intimates. Nothing except knowledge of the principals distinguishes the carte-de-visite of Sarah Campbell ("Growler") and May Frothingham in the family album of her mother, the Louisa Davenport Frothingham Album, from that of Queen Victoria and Princess Beatrice in The Royal Album. In the Natural History Picnic Album, the Duke of York's visit to Canada in 1901 is given no more space than the antics of kittens. The same momentous occasion is bundled into a trip to Ottawa in the D.M. Murphy Album. The funeral of Edward VII, which concludes Bloemfontein to London, is absorbed into the travellers' itinerary and partially eclipsed by the colonial plot.

The will to type – to be a type, to see the world as a composite of types – extends the Christian doctrine of prefiguration to the temporal world. The typological method of Carlyle was overt and highly orthodox, drawing directly on the scriptural figure of Samson to fashion his nineteenth-century man. Carlyle's modern nemesis must be Griselda Pollock, who has audaciously essayed a feminist prefiguration. Beginning with the story of Naomi and Ruth and situating her exegesis in the context of what she calls a post-biblical and post-colonial era, Pollock succeeds typologically in projecting "an astonishing act of *woman-to-woman* covenanting" onto her own memories of a family servant and awakening resistance to the territorialization of desire.[54]

Pollock's example inspires one to consider the typological underpinnings of the Benson Family Album in light of a study by Jan Lewis into the nature of "mother's love." Guided by the teachings of women's magazines, Lewis develops an image of nineteenth-century motherhood as the instrument of Protestant moral instruction. The mother was to teach the child by example, by inspiration. "The children of such a mother would come to 'revere her as the earthly type of perfect love ... they cannot but desire to conform themselves to such models.'" Such love would be eternal because preserved in the children's memories and reincarnated in the children themselves as "an almost corporeal part of themselves." Lewis finds myriad examples of this pious injunction: the mother is to reproduce herself in the child, "'a mental and moral daguerrotype of herself'... 'a fragment' ... 'a mirror.'"

Louisa Davenport Frothingham Album (N 006/86), 10–11

As a model, a mother must conform to type, internally and externally, for "the face was the '*index and agent of the soul.*'" Mothers were exhorted to make themselves look like Christ, and mothers' reading, both advice and fiction, assigned them the role of dying so that their children might achieve eternal life. Lewis cites one correspondent to *The Mother's Magazine*: "'the example and counsel of a living mother could hardly equal in power, upon the filial heart, the silent but thrilling preaching of a departed one.'"[55]

Etheldred Benson was spared the typological sacrifice of premature death, but in every other way her image conforms to the type of motherly love. Her album is a catechism for her children, and she makes its teachings very clear by including pictures of herself as a little girl. As her own babies arrived, they were presented to the camera, held in their mother's arms with her gaze upon them. The little ones often look back at the camera, but they are gazing, as Etheldred understands, at themselves in the future, gazing back at this icon of motherly love. Their condition is hopeful, predictive, and prescriptive. In one family photograph (fatherless, to be sure), Etheldred and the children are pictured as a group in the "Notman outdoors," though not on a tricked-up toboggan, as Etheldred was with her father and sisters, but formally posed in their outdoor clothes before an atmospheric backdrop. This is a public presentation of the Benson family, the last in the album, before the children, the mirrors of the mother, splinter off into the outside world. In the event, Etheldred's immolation is more Marian than Christlike, since it is not she but her first-born son who is offered up to the European conflagration.

Understanding of nineteenth-century typology is deepened by Paul J. Korshin's discussions of abstracted and natural modes, literary forms that Korshin accommodates within a strict understanding of typology as Biblical, predictive, and consciously so. Typology as exegesis and as classification came to intersect when seventeenth-century theologians began to compile types into typological handbooks. These would ultimately facilitate the extension of typology, first to other inspired texts, then to "natural phenomena, historical events, and ultimately, all aspects of human experience."[56] The continuous presence of divine inspiration is captured in a phrase, "the Book of Nature," perpetuating a sixteenth-century system of knowledge that Foucault has elaborated in terms of semiology and hermeneutics. "The great metaphor of the book that one opens, that one pores over and reads in order to know nature, is merely the reverse and visible side of another transference, and a much deeper one, which forces language to reside in the world, among the plants, the herbs, the stones, and the animals."[57] The Book of Nature lost none of its authority to progress; revelation was adapted to complex metaphors of the pastoral and the sublime.[58] As Korshin says, "natural typology had become so common by 1800 that there was no longer any *reason* to mention it."[59] But John Ruskin, for one, felt otherwise; his writings would insist on what Mike Weaver has defined as "a code that had been evolved through a thousand years of Christian art, reflecting the accumulated feeling of ages, always different in terms of changing pictural styles, but constant to the pictural meaning of the doctrines which had engendered its types."[60] Tractarian traces in the biblical and modern moral subjects of the Pre-Raphaelites are only the most famous examples of a consistent thread.

In his study of nineteenth-century photographer Roger Fenton, Weaver finds theological predisposition in the man and typology in the work, still lifes and landscapes that include Fenton's documentation of the Crimean War.[61] Fenton's use of Christian figuration in his view of Balaclava Harbour fits within the terms of a modern crusade. A rising tide lifts all boats; Fenton's typological strategy also shifts his documentary photographs of an ongoing campaign into the discourse of history painting. Then as now, stark realism was considered incompatible with the depiction of heroic action, and realism was something that photography could not shake. But as Edgar Wind showed in relation to Benjamin West's *Death of General Wolfe* (1771), realism could be "*mitigated*" by applying a rule first argued by Racine: "Distance of country

compensates in some sort for nearness of time."[62] West had instinctively corrected for the realistic touches in his painting by appealing to exoticism and religious iconography. The same instinct can be felt in Fenton's photographs and likewise illuminates the European conventions of New World photographic landscape with a spiritual sense of predestination.

In the twilight of Victorian imperialism, in the dominion of Canada, an Old World topography seemed to have predicted the New.[63] In 1905 Henry J. Morgan and Lawrence J. Burpee surveyed the Canadian landscape from the imagined perspective of "the first white man who set foot in America," sketching the picturesque from east to west as a composite of European types: dike lands and marshes from Holland, landscapes from rural England, fjords from Norway, mountainous wilderness from the Alps; the pastoral and the sublime are contiguous in a typological panorama, "from dainty bits of landscape to scenes almost appalling in their grandeur and immensity."[64] Historian Keith Bell has observed that photographs of the Canadian west used in immigration and colonization campaigns were carefully cropped to resemble European farmland, a falsification with the best of intentions – that the attraction of European farmers would make the illusion come true.[65] Within Canada, popular historic and geographic illustrations propagated ideological constructs – myths of identity – that nationhood projects would aim to fulfill.[66]

Typology with a pragmatic twist flavours Alexander Henderson's Photographs: Canadian Scenery, commissioned, as we remember, for John H.R. Molson. The album opens on awesome views of a New World city, including some wintry scenes showing the beauty of a fresh snowfall and its management in a bustling urban enviroment. The spring breakup, a mountain of ice surmounted by men with poles, signals the reopening of the St Lawrence to commercial navigation, a significant part of the Molson fortune. Penetrating the interior, loggers and Natives are the staffage of unspoiled beauty and resource development. A living past and future profits are thus conflated in nature, an amalgam expressed in the natural and artificial effects. All types listed by Weaver are binomial;

Niagara Falls, by this rule, would represent both Deluge and Salvation.[67] Henderson's pictorial interest in contrasts and extremes was quite compatible; the dual meaning of falls, rocks, trees, and other natural elements would surely have been sensed, if not precisely decoded, within his dual economy. Providence not only predicts progress; it naturalizes it within a familiar order of discovery and transformation.

Real Tall Tales

Photography's fabrication of heavy or ceremonial characters is encapsulated in a report from the photographic album project of the Smithsonian Institution's Family Folklore Program. Kotkin relates a story, based on a single photograph, that was told to her by a woman about her great-uncle Max. The photograph of Max in his cowboy hat and chaps, described from memory in interview, had generated an ironic epithetic title: "One Gun Blum, The Jewish Cowboy." On the basis of a single photograph and a catchy phrase, a man who spent most of his life as a tailor in Newark, New Jersey, had gone down in the annals of his family as a cowboy. The life of the photograph had been extended by folkloric ekphrasis, for the woman had spun from its memory the epic of Max the Cowboy that she had passed on to her children.[68]

Ong's mixture of "antitheses, epithets, assertive rhythms, proverbs, and other formulas of many sorts" that grow into the heroic figure can actually be seen in the Klondike ministry album, Views / E.M.W.. The hero of this album is the Presbyterian minister, the Reverend Mr Wright, a living legend who bicycles on his evangelical rounds at 40 below zero (Fahrenheit), mounts prayer services in the Railway Dining Tent, and serves his flock of rugged parishioners at the outer edge of "CIVELAZITION." The tale is embroidered by ironic views of characters and situations, most cast in an exaggerated objectivity as *tableaux vivants* not unlike the "Tableau representing Great Britain and Her Colonies at a Concert Given in Aid of the Widows and Orphans Created by the

TABLEAU REPRESENTING GREAT BRITAIN AND HER COLONIES. AT A CONCERT GIVEN IN AID OF THE WIDOWS AND
CREATED BY THE WAR WITH THE TRANSVAAL. PALACE GRAND FEB. 15TH. 1900.

FLASHLIGHT PHOTO BY
LARSS & DUCLOS
PHOTOS.
DAWSON.
2568.

War with the Transvaal, Palace Grand, Feb. 15th 1900," which is a tour de force on any scale, photographic, political, or musical. Photographs in the album do not chronicle Wright's Yukon period in any rational way; rather, they cause it to bubble up in legends that connect circumstantially to his life. At the same time, the album documents his implantation in the struggle and camaraderie of an improbable community. This is what photography can show: small victories in the now that point inferentially to the future.

The banal practicality of the Chambers Red Cross Album is a model in its attachment to real-life situations, to Canada carrying on. Such responses to crisis are both reflective and reflexive, notes Barbara Myerhoff. "As heroes in our own dramas, we are made self-aware, conscious of our own consciousness. At once actor and audience, we may then come into the fullness of our human capability – and perhaps human desire, to watch ourselves and enjoy knowing that we know.[69]

Typology is not separate from real life – quite the contrary, for experience itself is predictive. As Korshin suggests, we interpret signs and anticipate outcomes based on a typology of conscious and unconscious memory. "One might describe the mixture of psychology and semiology whereby the human mind predicts – whether rightly or wrongly – such conclusions as the psycho-typology of everyday life."[70]

Whether nested in a system of codes, figures, conventions, myths, tropes, or archetypes, however relational and provisional its meaning, photography's mechanical and mimetic nature hooks it *experientially and performatively* into the real. Philippe Dubois has justly attended to the epistemology that arises from the indivisibility of the photographic "image-act," and he has fixed labels to the combination of factors that define the relationship of image to referent at the moment of production ("moment de la 'prise'") and the moment of reception ("moment de la reprise").[71] The spectatorial experience arising from that dual nature must be one of fusion and re-enactment; "to see the picture is to see through the lens is to be there taking the photograph," as I (or Gertrude Stein?) once described the spectatorial rush of photography.[72] This is how we see the photograph; we are taken up in the seeing, just as sound penetrates us to the very core. The extraordinary aspect of photography is the "ordinariness" that makes it matter now, that makes it memorable later. Photographic historian John Roberts follows the literary critic Raymond Williams to the "ordinariness of culture" and comes up with this definition: "The photograph is not simply an effect of dominant power relations, or evidence of the optical unconscious, it is also a form of *practical* knowledge, an inscription of, and an intervention in, a socially divided world."[73] A plate is always a plate, even when it serves as a circle or a moon. Photography is conservative in that sense.

PATTERNS OF ORGANIZATION

In an oral culture, how will the elements of a recitation be arranged to facilitate retention and presentation? First of all, by deliberate *repetition*: not only are formulas typical, but they are constantly recycled within the same oral composition. Redundancy, or copiousness, serves the speaker in several ways, amplifying important ideas, restating points that may have been missed, and gaining him time in which to marshall his thoughts. Both repetition and elaboration serve to communicate praise *or* vituperation. In African drum language, nicknames are expansions of praise formulas; in certain regions a program of glorifying kings and chiefs can take over the drums completely. Conversely, a campaign to rid a village of an undesirable person can be a steady and unbearable drumming out of insults. Between clans or villages, sound can become a contested site alternating between efforts at praise and at blame.[74]

What Ong calls the 'noetic economy' of orality is agonistically toned – shaped by intense engagements between characters whose merit or worthlessness must be clear. He stresses the exteriority of orality's narrative crises, in contradistinction to the interiority of literary forms. The polarities of good and bad, brave and cowardly, or noble and ignoble

must be *shown* through the actions of heroes and villains. As Ong points out, "Enthusiastic description of physical violence often marks oral narrative."75 Orality draws pictures in the air.

By comparison with written language, the syntax of oral composition is simple. Parts of sentences are strung out in succession, rather than woven together in subordinate clauses. Ong's example of the *additive* oral style is the creation narrative in Genesis 1:1–5. He compares the Douay version (1610) with the New American Bible (1970), finding the older version still steeped in the pragmatics of oral presentation and the current one recast into the syntactical structures of narrative writing. The Douay version contains nine introductory *and*s, of which there are five in Genesis 1:1–3: "In the beginning God created heaven and earth. And the earth was void and empty, and darkness was upon the face of the deep; and the spirit of God moved over the waters. And God said: Be light made. And light was made." The same passage in the New American Bible reads as follows: "In the beginning, when God created the heavens and the earth, the earth was a formless wasteland, and darkness covered the abyss, while a mighty wind swept over the waters. Then God said, 'Let there be light,' and there was light."76

Ong's points of comparison are essentially structural, though other qualities emerge when the two versions are read aloud. The introductory *and*s of the Douay version create spaces of bodily rest and mental re-collection; they separate phases of creation and states of consciousness – the different messages that come from seeing, feeling, and hearing.77 The compound structure of the American version smooths the successive impressions still recoverable from Douay by unifying the experience – formlessness, darkness, and wind are transmitted in a rush. Breaks in the passage are closed, and the sensorial shifts between sight, touch, and sound disappear with them.

For the photographic album to echo these patterns of organization, there should be signs of deliberate repetition. Photographic description should be overdeveloped, the subjects' qualities driven home through praise or blame that accrues to excess through reiteration or exaggeration. Finally, the photographic elements should be discrete, organized in a structure of linkages that, like train cars rolling through a crossing, do not constitute a narrative, but exhibit narrative potential as a chain of signs and freight.

Echoes and Reprises

Orality's requirement for repetition is well served by the mechanical nature of photography. At the simplest level, a photograph can be produced in multiple copies and used more than once in the same album. In the McCord Family Album a cabinet-sized portrait of John Samuel McCord dominates the first page, establishing his position as the head of the family. The same portrait, in the form of a carte-de-visite, is mounted on the very next page, creating a cluster (father, son, daughter, graveyard) that legitimizes the claims of David Ross McCord.

In the Klondike album, Views / E.M.W., the insertion of a Peterborough gravesite among the lively pictures of the Yukon suggests remoteness and yearning. The re-presentation of the same photograph some twenty-three pages later introduces a group of pastoral landscapes that are assumed to come from the same general area of southern Ontario. The arrangement tints the houses, fields, and roads with nostalgia and associates them with home.

Repetition is a simple device, though we should not pass over it too quickly, but stop for a moment and consider its effect. The first time we see the gravesite photograph, in a context of Klondike strangeness and colourful excess, it may not make much of an impression. Clearly, the image is from another place and time, but its significance to the compiler is unclear. The reappearance of the image confirms its importance, literally by giving *place* to it again and experientially by translation to the beholder, who recognizes the photograph because she has seen it before. The compiler's doubled act of remembrance will be revisited (in thought and probably in

action) in an emulative act of remembrance sparked by the second image of the site. A place of memory is thus imaged; but more significantly, the condition of memory, or something that reminds us of memory, is figured and absorbed through repetition.[78]

The duplication of images in an album occurs with surprising regularity. More common still, though easy to mislay under cliché or type, is the repetition of a formula: the same subjects photographed together again and again – the same place, the same pretext, and generally the same facial expressions. Repetition is used to Chaplinesque effect in the William Hilliard Snyder Album. Just before Hilliard goes off to training camp, "Muh," as he calls himself, and his friends horse around with a camera on a site identified as the North Arm, Vancouver. The photographs are mounted at the four corners of a page. The formula is again very simple: two or more figures at the centre of a vertical frame, bracketed by long receding lines that meet the horizon roughly at their waists. The effect is of a stage (it is a pier), and the subjects ham it up. Three of the photographs are very closely matched – same general location, same flamboyant poses, with the protagonists switching places. In the fourth photograph, bottom right, the formula is slightly altered – there are more figures, and the bottom of the frame is invaded by the shadow of the photographer – but the scale is the same, and "Muh" is much the same, so that the four miniature tableaux lead the eye through a flickering "cinematic loop" that brings the party and especially its central character to life.

In the Natural History Picnic Album, multiple images of the five main characters celebrate the virtues of male friendship. Photography is part of their routine; planning pictures and posing is done with great relish, and the results are posted in the album. One pair of photographs, mounted on a vertical axis, appears to have been taken on the occasion of a nature walk. The season could be early spring; the location could be Mount Royal. The trees are bare and the ground is dusted with snow, but the men seem quite comfortable in light clothes. For the more formal group portrait, they dangle like crows on a wire, sitting or leaning on a rustic railing. For the other, they have removed their hats and jackets, draping them like military trophies on a single tree that rises behind their bunched heads. Relaxed, physically entangled, they are lolling on the grass.

The men are repeatedly photographed, and their photographs are also repeated in ways that emphasize their positive traits. The railing portrait reappears in the album on a full page of men's group portraits, the second time masked in the printing into a circular medallion that eliminates the surroundings and intensifies the all-important fraternity of the group. Introduced to these men through their proto-family album, and following up every possible lead to determine their family names, we have to accept that, barring some fortunate accident, the album will remain an anonymous compilation of anonymous subjects.

But what do we not know? Attention to what is shown, and repeatedly shown, tells us rather a lot about these men. By their own lights, they are handsome, vital, dapper, witty, urbane, affectionate, generous, industrious, adventurous, creative, faithful to family and friends, close to nature, kind to animals, and comfortably well off. The album has been designed to support this litany of praise.

Vituperation is harder for the neutral stranger to assess, though one can surmise quite a bit from people's reactions to amateur photographers and their albums. The critics' refrain, the song of conformity, is hardly kind to people who have invested time, energy, money, and ego in expressing their uniqueness. Private opinions freely offered in words or pictures can be even worse. One would like to say that people are hardest on themselves, but there is little photographic evidence to support that claim.

Fame and Applause, Blame and Derision

In 1971 Ralph M. Hattersley asked the readers of *Popular Photography* to consider "family photography as a sacrament,"

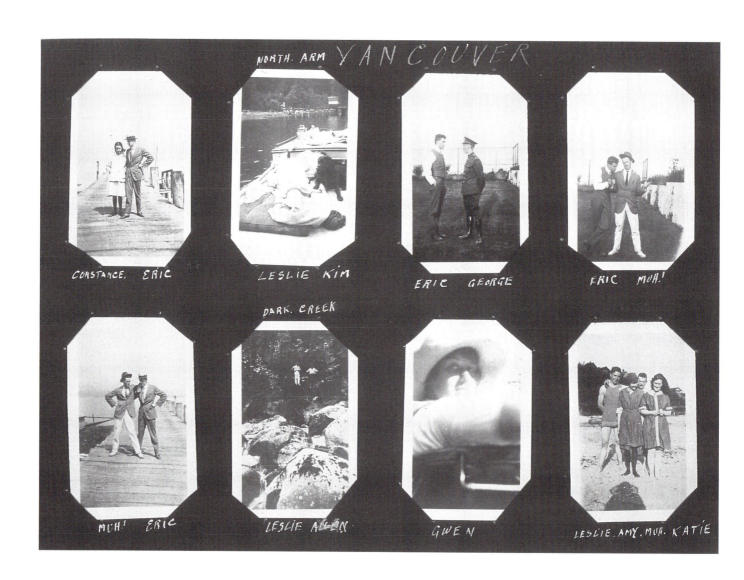

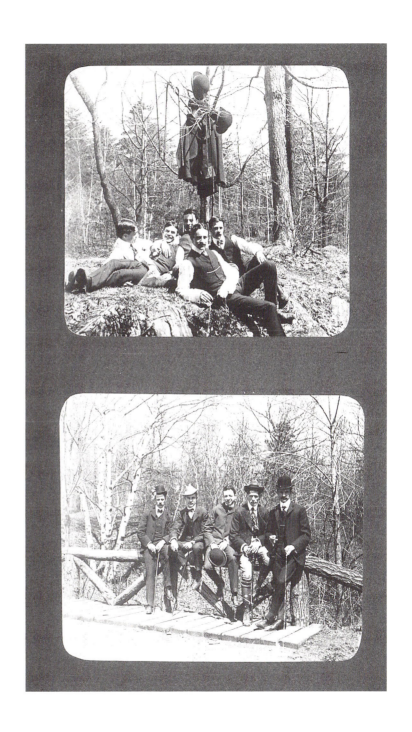

offering little prayers as needed to produce loving and pleasure-giving pictures. His underlying point was clear: "Respect the fear people have of being photographed, and resist strongly any temptation to be a bully with your camera."[79] The artist Duane Michals vividly recalled his grandmother's resistance to being photographed, concluding rather harshly that she was "vain."[80] And yet she *was* photographed, Michals forever associating the site of that photograph with some insensitive remark she made to him. The photograph in its tactless reproduction carries equal quotients of praise and blame, and shifts between states. The most beautiful image of a young and vibrant creature will be full of reproach for its aging subject. A "before" picture that once dismayed may become the evidence of a triumphant metamorphosis in the "after."

In the public sphere, sensitization to the rights of others to control their own image has inspired a number of social documentarians to incorporate their subjects' verbal responses to the portrayal in a collaborative work. These texts establish the consensual nature of the photographic bargain, revealing how the subjects feel about the process and sometimes how they feel about themselves.[81] In the early seventies, photographer Roslyn Banish and social psychologist Stanley Milgram undertook a similar project to demonstrate the layers of response to a family photograph. Reporting in *Psychology Today*, Milgram wholeheartedly approved of Banish's portraits, though some of her subjects did not. They were disappointed by symptoms of age, sickness, disunity, and inconsequentiality seen in their relatives and themselves.[82]

According to Christopher Musello, there are three approaches to family photography: idealization, natural portrayal, and demystification. The last may include "people vomiting, asleep, half nude, strangely dressed, and so on. They may catch the embarrassing or ludicrous, and serve ultimately to demean, tease, or otherwise present the person as silly, funny, or in their least ideal image."[83] The second section of the Langlois/Gélinas Album is full of unflattering snapshots, including an older couple at their dining table flashlit from a low vantage point, a buxom figure crouching down to some task by the shore, a sleeper in a deck chair, and a middle-aged woman caressing a mop. These snapshots are among those added to the album with a stapler, the very opposite of deletion, one could say. Musello says that demystifying photographs add depth to the family collection and are cheerfully received. His data is of course accumulated from the survivors, since we have all seen pictures torn up on the spot; still, some apparently defamatory images are not.

In an adult literacy workshop that I animated using albums from the McCord, the participants were given disposable cameras to make their own photographic albums. In the process of editing and arranging their photographs, not a single photograph was discarded. I was surprised. "One learner whose adult son had caught her on the telephone unawares was a little displeased with the results, but encouraged to do what she liked with the picture, she included it. The subject was her and the photographic ambush was obviously pure him."[84] Her son had violated her privacy and made a mockery of a project that she held very dear, her first journal. But censoring the photograph would have censured the son too severely; there was too much finality in such an act, and the woman may have sensed that orality would take care of it. The demystifying photograph initiated discussion between those who would praise ("What a terrible picture! You're much better looking than that") and those who would blame ("See how Bill snuck up on her. What a terrible guy!"). The format of the album allowed this woman the choice of engaging with her son or simply turning the page. The son's photograph in no way contaminated the rest.

A Dialogical Plan

The organization of photographs in an album is based on the photographic integer, which is mounted image by image, page after page, by episodic or thematic cluster. Photography affords views from many perspectives, built up in close-ups, wide-angles, sequential exposures – photographs that *say the*

same thing in different ways. What appears initially to be a general theme in an album often turns out to be a single subject – a person or an occasion – revealed in as many dimensions as the compiler can muster. Pictures of a type may form complementary and adjacent groups, or they may be spread throughout the album as recurrent motifs. As numerous examples in the previous chapters showed, subjects are developed through multiple encounters, each adding something of detail or expression. The extended self-portrait of the Annie Craven Album is a limited case; the D.M. Murphy Album seems a more conscious attempt at positive self-representation.

A very succinct example can be found in the Charles-Philippe Beaubien Album, six photographs on one page. The top register consists of four prints, vertically framed and mounted edge to edge. They are all concerned with sailing. The first photograph, shot down the boom from the stern, sights the direction of the boat through the eyes of a figure who leans against the mast looking out over the water; an older man, he is correctly attired in yachting costume and cap. Everything is normal, but there is an awkwardness to the photograph just the same. The horizon line has not been levelled, and there are two distracting elements. One of the passengers is curled up on the roof of the cabin; all may not be well with him. A third figure is cut off at the right edge; his arm, stabilizing his body, and a bit of his torso intrude into the image.

The second photograph has also been taken on the water, but perhaps closer to the point of departure. Five people are pictured, four men and a boy. Charles-Philippe Beaubien is part of the group, though set apart by his attribute, the morocco camera case, from which the instrument has been removed. This photograph is more carefully composed; the group is tightly framed and mostly unified, although the arm of the boy has been cut off, oddly echoing the severed arm of the first frame. Three of the men look directly into the camera; one has his hand on the shoulder of the boy. The fourth man, the older yachtsman, stares off at an oblique angle as he smokes his pipe.

The third photograph features the photographer. Jacket and hat removed, legs braced, face concentrated, he appears to be dealing with a line; the pose is vigorous, handsome, self-consciously heroic. The image is light overall, keyed to the surrounding water and sky. The boat does not feature in this photograph; nothing is really solid but the man. Beaubien's head, hands, and trousers are the graphic counterpoints to the atmosphere, expressing the total engagement of mind and body, the powerful self-sufficiency that paradoxically separates him from his all-male group.

The fourth photograph in the row represents a timeless seafaring type, a man portrayed without vanity in his rough woven clothes and fisherman's cap. He is on the boat; he is perhaps *of* it in a way that the holidaying sailors are not. Across the register, different types and relationships are portrayed as extracts from the flow of shared experience.

The two photographs on the bottom have no obvious connection to the top and no physical contact with each other. On the left is an image of a horse-drawn carriage before a columned porch. A party that appears to include Beaubien's wife and daughter sits in the open carriage. On the bottom right is a small group portrait, composed before a leafy backdrop, that includes Beaubien's mother and his wife, Gretta. These photographs reiterate the main themes of the album, family and place, the earthly harbours that nurture one's fleeting evasions by water. The upper register does not include Gretta Beaubien, but likely would have charmed her. According to her granddaughter, she was an avid sailor. Elsewhere in the album, she is pictured being carried across a beach to a moored boat. The portrait of her husband, a hero in this sailing frieze, expresses shared and mutual passion.

The internal structure of an album preserves the step-by-step reconciliation of a distinct photographic unit with other like units within an oral structure and a bookish design. How are decisions made? Alan Trachtenberg's close study of the opening sequence of Walker Evans's *American Photographs* offers a concise model of Saussurean-type analysis. Reviewing the critical reception of the book, Trachtenberg notes a

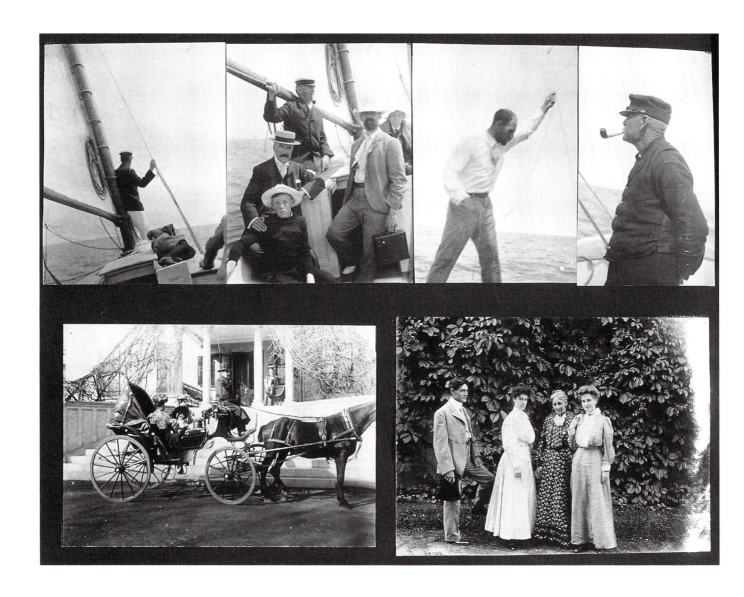

Charles-Philippe Beaubien Album 1903–1908 (MP 042/90), 50

tendency to see the work as transcriptive, as a list. He himself sets out to *read* the photographs as a text, but something very exciting intervenes. He is hooked by William Carlos Williams's suggestion that the photographs are talking and that they have plenty to say. Trachtenberg begins to conceive the photographs as speech; his mode of reception becomes aural.

Evans's photographs speak in relation to each other: "Each picture completes itself only in the complete work, its voice returning to it as an echo of the whole." Trachtenberg hears echoes in a pattern of pictorial relations: inside and outside views; juxtapositions of style and anti-style; art paralleling the vernacular; the device of a frame within a frame; craft over the machine. "We partake, then, not only of a list that has been prepared, but in the making of that list, in the preparation itself, the ordering of images." This sounds like the *Iliad*'s list, not a list but an apprenticeship, and in fact, what Trachtenberg gains from it all is Evans's "pointed discourse on the photographic image." The opening sequence of the book makes its craft visible; the camera is shown to be "inscriptive," not "transcriptive." That is what the photographs have to say. If Trachtenberg ultimately abandons the oral and insists on the picture book as a *text*, he nevertheless has to pass through the oral to break out of a documentary reading, to take *American Photographs* into the realm of fiction.[85] That reading of Evans is audacious enough, and Trachtenberg is absolutely right. He is still dealing with a book, an example of secondary orality perhaps.

In the mounting and presentation of amateur photographic albums, the relation between vision and voice is considerably more solid and direct. There are reminders in the albums of the influence of amateur theatricals, in which representations are neither transcriptions nor inscriptions but encryptions in a collectively accessible visual code. In the Langlois/Gélinas Album, for example, there are several photographs of two young women, in costume, one in a lavish Victorian gown, the other in Native dress, complete with braids and feathered headdress. On one page their separate portraits in costume are incongruously combined with photographs of the burning Chamard Hotel, one of the key sites in the album. Some thirty photographs later, the personifications, at least, are partially solved as the tableau is re-enacted for posterity: the Native maiden kneels before the European woman; Canada pays homage to Britannia. The thirty-image delay creates a little theatrical suspense.

In the nineteenth and early twentieth centuries, costume parties, entertainments, and parlour games trained the amateur in associative and participatory viewing.[86] Players acted out phrases that were hidden from their audience; solutions to the riddle were shouted out. The D.M. Murphy Album offers a compiler's variation. Of five photographs on a single page, four are devoted to athletics, mainly running: a sprinter ("Hans Homer"), captured in the starting position; runners on the streets of Montreal; recruits in physical training at militia camp; and the likely compiler, "D.M. Murphy," in his track suit. The first photograph on the page is the puzzler: a bolt of lightning in the dark sky, "Park Ave July 1900." The same scene, identically captioned, has already appeared in the album, so this is a repeat. But on this page the photograph functions as a spark to idiomatic language: "lightning speed", "quick as lightning". Speaking the picture makes the allusion shine.

The photographic game of latent language never loses its appeal. It is interesting to find references in American critic Max Kozloff's analysis of Cindy Sherman's and Eileen Cowin's self-directed tableaux to the vestigial magic of stories projected through the arrangements of bodies and flashing eyes. "Dare I go further and say that such a graphic device, or rather insight, tells as much as it shows, that the activity of telling and of showing are fused in this aspect of the scenario? I cannot 'see' anything like it as I read a text, but the carnality of it in the photographs is brought to me by virtue of another sort of text, the mental concept that underlies the degraded charade of the image."[87] It is not polite to shout in an art gallery, but Kozloff's visceral reaction to these contemporary tableaux nevertheless seeks some outlet in an image of wordplay, the degraded (orally unconsummated) charade.

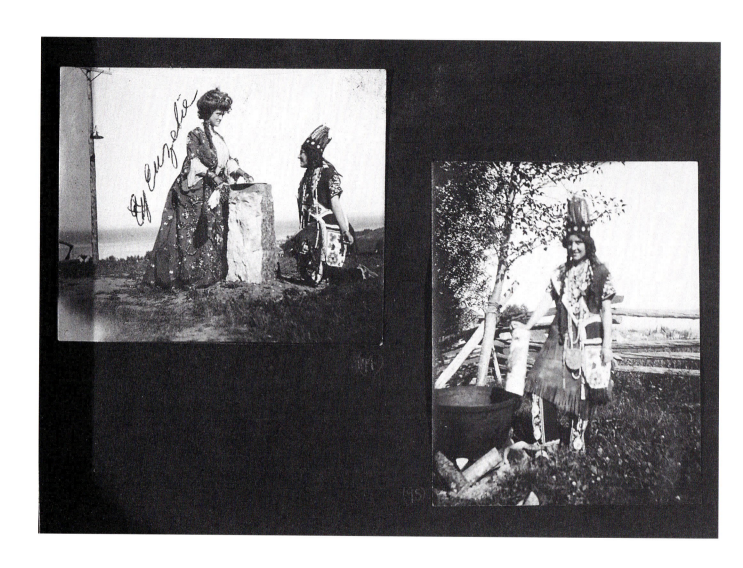

Langlois/Gélinas Album (MP 145/84), part 1, 21

An album offers a succession of distinct and physically separated impressions, the "and … and … and" of dialogical looking – a pattern of "and this is …" "and who (what, where, when, why) is this?" "and this is …," and so on. The order and spacing of elements has been determined by the compiler; each photograph has been placed to advantage. In albums of cartes-de-visite the allusion to an architectural space, a portrait gallery or sculpture court, leads the spectator through a series of virtual encounters. The scrapbook albums of Emily Ross and Hugh Wylie Becket set their photographs in *trompe l'œil* frames, the Ross album encouraging a desire to touch and the Becket delineating a worshipful distance from its actress-idols. Any notion that the spontaneity of the Kodak exploded that orderly space will itself be exploded by the recollection of a modernist framework, John Szarkowski's division of American photography from 1960 to 1978 into two types, mirrors and windows.[88] Whether his assignments have held, or whether they made very much sense at the time, is here irrelevant. The point is the persistence of this architectural motif. Seeing a photograph as a spatial construction – a window out of space or a framed reflection that interiorizes space – fits into the compilatory impulse and extends the art of memory. But, as museum studies have shown, visitors like to wander. They do not follow the curatorial map; they browse; they hunt and peck.[89] In an album, things are no different. The solidity of a spatial framework is the very thing that licenses a spectator's capriciousness. One can always return to objects that are fixed on the wall or on the page. Looking back to front, browsing, and skipping are encouraged by the fragmentary, yet continuous, nature of the album. The spectator feels free to pursue the themes or stories as she finds them.

Additive patterns of compilation derive from and reinforce the separateness of each element, a photographic separateness of temporality and space, of another person's dip into the real. What has been *cut* through consciousness and dimension as radically as Philippe Dubois describes the act of taking a picture does not melt back together by the mere fact of adjacency.[90] The *impression* of a linear, or horizontal,

narrative can nevertheless be achieved, as the Wagner essay on poverty shows very well. That episode is delivered bit by bit: the car arrives and is surrounded by the needy; the houses are inspected from a distance, then approached; the miserable inhabitants are documented, some grinning as people before a camera are wont to do; single-figure studies are made of the most grotesque cases; the houses are penetrated by the visitors, and a sampling of the interiors is recorded; the departure is signalled by a backward glance at the shore. From the compiler's perspective (the way she *tells* it), the story is unified and closed: the story ends. The series' multiple cuts into the lives and memories of the participants leave it rather more jagged and unpredictable in its long-term effects.[91]

But even when the compiler works within the envelope of domesticity, as does Mrs Benson in the Benson Family Album, her closed narrative structure contains the seeds of its own destruction. Any photograph can be at cause, for any photograph is a potential *kernel story*, a discrete, catalytic reference to a longer story that is teased out and expanded in conversation. Building on Roman Jakobson's theory of speech performance, Kristin Langellier and Eric Peterson explain the kernel story's context and structure:

The kernel story, to focus on metonymic relations, is both part of the conversation in which it occurs and the conversation is part of the story. As a result, the story develops slowly and gradually shifts in a curvilinear or spiraling direction. In this context of spiraling from story to conversation to story to conversation, a kernel develops in the connections made by participants substituting similar experiences for aspects of the story in their conversation. A kernel story, to focus on metaphoric relations, is shared as everyone's story and functions to promote group solidarity. Once a story becomes part of the group's repertoire, it can be referred to or told by any participant.[92]

For an album to pass, as many writers feel it doing, from individual to communal possession, for the album ever to partake in the logical order of social memory, this transformative

assimilation of discrete metonymic and metaphoric objects must continuously be rehearsed. Oral tradition shows how this is done in presentation.

PATTERNS OF PRESENTATION

Following Havelock, Ong describes orality's transmission and retention of knowledge in terms of empathy *and* participation. In fitting idiomatic style, he talks about "getting with it," a surrender to, or absorption into, the pooled experience of the community. A kind of objectivity results (really a non-subjectivity) which is not the text's separation of "the knower from the known" but the storyteller's separation from himself. The individual is "encased in the communal reaction." Ong's choice of words here is somewhat unfortunate since communal encasement, as he explains it, is not *shielding* but *yielding* as an embryonic medium of growth and change. Ong repeats an observation made by editors of *The Mwindo Epic*: the performer of the epic identifies so strongly with its hero that he slips into the first person, not just when recounting the hero's exploits but also when addressing the researchers who are transcribing the performance (he calls them scribes!). "In the sensibility of the narrator and his audience the hero of the oral performance assimilates into the oral world even the transcribers who are de-oralizing it into text."[93]

This story leads directly to Ong's next point, which is largely based on the work of Jack Goody and Ian Watt.[94] Oral societies, he suggests, "live very much in a present which keeps itself in equilibrium or homeostasis by sloughing off memories which no longer have present relevance." This is not a case of Nixonian erasure or the disappearance of records, for there is nothing to wipe or shred. But what Ong calls "triumphalism" is operant nonetheless in the way that current conditions or exigencies reach back through time to adjust genealogies or even sacred myth. Examples of homeostasis include the shedding of archaic words and expressions, a process not unknown in literary societies, where it is nev-ertheless possible to preserve disused vocabulary in the lexical museum. More arresting occurrences are those in which traditional recitations of family history appeared to have been revised to support modern claims. Questioned by the literate recorders, the oral performers seemed oblivious to the change. What had always been true remained true, according to the rule of situation; the genealogies, however altered, were the same because their real regulating function was the same. The effect of what J.A. Barnes called "structural amnesia," as reported among the Gonja by Goody and Watt, has been the recasting of constitutional myth: when there were seven states, the mythic founder had seven sons; when the country was redivided into five states, two sons simply disappeared from communal memory, preserving the group's connection with the past by allowing it to eliminate and forget what had become irrelevant to the present. "The present," concludes Ong, "imposed its own economy on past remembrances."[95]

This economy of remembrance is by no means total, according to ethnohistorian Jan Vansina, who stresses the evidence of archaisms preserved, and who prefers under the heading of "congruence" to think of "tendencies toward homeostasis, not of homeostasis as a radical process."[96] Goody and Watt refer to the "homeostatic tendency," though their nuanced examples show clearly that this common characteristic, while central to their differentiation of literate and non-literate cultures, is plural in the sense that it conforms to the needs of each distinct oral society.[97] In the combination of storytelling and photography that is the literate society's album, radicalism can be seen to re-enter the picture as an image that is not in the first instance made to be adaptable, but becomes so within the life of the object.

The same adaptive process was at work during Western culture's long transition from orality to literacy. Tracing the effects of alphabetization, Illich and Sanders have examined its impact on the definition of truth. "In the realm of orality one cannot dip twice into the same wave, and therefore the lie is a stranger. My word always travels alongside yours; I stand for my word, and I swear by it." The lie, or fictional

narrative, depends on a conception of thought as "the silent tracing of words on the parchment of my memory," in other words, on the perception of my memory as a text. In the Middle Ages, truth became an inscription on the soul, and moral judgment followed suit as a reading of the accused person's conscience. The emergent metaphor of divine authorship made the liar into a usurper of God's authority. Illich and Sanders find that in a world *"contingent on God's authorship ... a [thirteenth-century] cleric who writes down stories has to state that he is not the story's actual source (fons ejus), but only its channel (canalis)."*98 The same disclaimer will unknowingly be parroted some seven centuries later in exhibition and book titles, *the camera as witness*.

Ong summarizes the conclusions of Randall M. Packard, Claude Lévi-Strauss, T.O. Beidelman, Edmund Leach, and others in his statement that "oral traditions reflect a society's present cultural values rather than idle curiosity about the past."99 When we consider this point in light of the previous one, it is easy to see how the performer's identification and audience's participation (or vice versa) combine to keep an essentially traditional vehicle of self- and communal expression in a productive state of responsive and inclusive flux. Interpretation, advises Ong, must take account of ongoing adjustments, a discursive process that begins before a sound is made.

I need conjectural feedback even to formulate my utterance. Speaking of a given matter to a child, I am likely to say something quite different from what I say in speaking about the same matter to an adult. Your actual response to what I say may or may not fit my earlier conjecture. In either event, it enables me further to clarify my thought. Your actual response makes it possible for me to find out for myself and to make clear in my counter-response what my fuller meaning was or can be. Oral discourse thus commonly interprets itself as it proceeds. It negotiates meaning out of meaning.100

For the photographic album to fit within this progressive framework, its vitality must somehow be renewable; typolog-ical predictions and the promise of performative ritual must be attainable within the changing conditions of the present. "Feedback" nourishes a developing situation, a two-way street between tradition and innovation, as Vansina has shown.101 The photographic album must shift from the absolute solidity of material culture to a state of in-between, fully realizable only in performance.

Plays without Scripts

The path to understanding such a visual object has already been blazed. Drawing on the theories of Victor Turner and Henry Sayre, Dwight Conquergood has argued persuasively that textile artworks, *story cloths*, made by the Hmong refugees from Laos fit within the notion of performance as "culture-inventing, self-performing, and transforming." Embroidered cloths as a medium have a long history of performative function in Hmong celebrations and liminal rituals marking birth and death. The refugee experience has introduced a new transformative crisis in need of mediation. The story cloths, which are treated as artworks in the West, are narrations of wartime experience: "The embroidered escape narratives are a strategy for rescuing 'the said from the saying' of the oral tale. They fix but do not freeze meaning. Instead, they prompt spoken narratives, like that of Yee Her, that give voice and personal nuance to the *pa ndau* patterns. They stimulate memory and provide a context for people to perform their own personal history."102 The story cloths are continuous narratives that combine traditional motifs with a literally invasive military presence – helicopters, planes, and bursts of gunfire. As instruments of orality, they are, of course, repetitive, copious, situational, tragically homeostatic, and infused with vestigial magic power.

In light of this example, I would return to André Bazin's comparison of photography with the Egyptian cult of the dead. The analogy between photography and death is a pillar of photographic theory; Bazin's essay has often been cited to illuminate

the dichotomous relationship between perpetuation and finality (the photograph that "embalms time"). Those flies in amber that he mentions are plainly, transparently dead, but his recourse to Egyptian mythology undermines that certainty, filling it with more provisional implications. The ancient performative ritual that Bazin translates to photography is not about finality at all; rather, it is predicated on the belief that corporeal existence is continuing in an unknown world. Bazin recognizes this hope in the persuasiveness of the photograph and its almost irrational immediacy on reception.

In spite of any objections our critical spirit may offer, we are forced to accept as real the existence of the object reproduced, actually *re*-presented, set before us, that is to say, in time and space. A photograph enjoys a certain advantage in virtue of this transference of reality from the thing to its reproduction. [Note to the text:] Here one should really examine the psychology of relics and souvenirs which likewise enjoy the advantages of a transfer of reality stemming from the "mummy-complex." Let us merely note in passing that the Holy Shroud of Turin combines the features alike of relic and photograph.[103]

Bazin, as already noted, draws close to the family album in elucidating his metaphysical theory. Dubois, building on that theory, sustains only the briefest descent into the "trivial mode" of the family album, just long enough to construct his semiological framework. Any claims for the aesthetic qualities and material value of the album are dismissed as naive. Dubois fixes the album in the shadowy channel between absence and presence, placing all importance on the indexical nature of the album's photographs: "the fact that they consist of actual physical *traces* of particular individuals who once were there and who have a special relationship with those who are looking at the photographs."[104] Like Susan Stewart, Dubois seems incapable of imagining something that might fill that chasm other than a mixture of sentimentality and inchoate desire. Strange, because he is so close. He has held the answer in his hand – an equivocal answer, to be sure, since it is Barthes's.

In *Camera Lucida*, Barthes maintains to the end that he cannot penetrate the reflective surface of the photograph, and yet he does. He scripts and choreographs the Winter Garden portrait of his mother and uncle (the one spoken line is given to the photographer). He projects on the typological portrait of a little girl the face that he knows of motherly kindness. As spectator, he tries to do what Étienne-Jules Marey and Eadweard Muybridge have done with stop-action photography, to break the image down into temporal bits and scrutinize it. He plays the game of concomitance (who is alive? who is dead?), recognizing as he leafs through his collection of mental images that all the pictures, in a metaphysical sense, are about him.

The date belongs to the photograph: not because it denotes a style (this does not concern me), but because it makes me lift my head, allows me to compute life, death, the inexorable extinction of the generations: it is *possible* that Ernest, a schoolboy photographed in 1931 by Kertész, is still alive today (but where? how? What a novel!). I am the reference of every photograph, and this is what generates my astonishment in addressing myself to the fundamental question: why is it that I am alive *here and now*?[105]

Barthes's technical deconstruction is a failure; he sees nothing more in the photograph than the grain of the material. But he *hears* himself, crying out in the voice of Golaud, because the picture will not speak.[106] Barthes speaks. He fills the void with his intimate literary performance. His outpouring is always surprising, and here it is illustrative of a fundamental point: the Winter Garden photograph (the portrait of his mother that he describes and refuses to show) is complete in itself. There is nothing lacking in it but Barthes's intense reaction, a phase of his maternal mourning; and there is nothing lacking in his book, despite the absence of the Winter Garden photograph. *Camera Lucida* (Barthes's ekphrasis) simply inverts the fate of the dispersed album, which too survives in the co-presence of absence – in the absence of the voice.

Performance Rites

The oral condition of "getting with it" seems to resonate in Henry Sayre's proposal that contemporary criticism – Barthes is his example – be seen "as a kind of performance in its own right."[107] Carol Mavor's *Pleasures Taken: Performances of Sexuality and Loss in Victorian Photographs* takes up this suggestion in an interpretation of three nineteenth-century corpora. She has been struck by the inherent contradiction that a still photograph can also be "performative." Guided by Barthes's correlation of photography, theatre, and death, sanctioned by his spectatorial state of *punctum* (delight and/or pain), Mavor erects her own framework of oscillation, a theatre in which she seeks the female protagonists of Lewis Carroll (Alice Liddell), Julia Margaret Cameron (Mary Hillier), and Arthur Munby (Hannah Cullwick) and in a very real sense, appropriates them. "We perform a dialogue with these special photographs (and it usually has nothing to do with the original intentions behind the taking of the picture). What is no longer there performs upon us and we perform upon it. It bereaves us and we bereave it."[108]

Mavor's project is interesting on many counts, particularly in the way that it defines and assigns the roles of photographic performance. Even in Hannah Cullwick, whose willing participation and deep responses to being photographed are recorded in a diary, Mavor finds an "imperfectly conscious performer." Nor are the motives of Cullwick's Svengali, Arthur Munby, completely resolved. In the end, she states that neither photographers nor sitters "can be said to be playing the leading role of director; rather it is a drama performed by a cast of subject-objects."[109] Central to Mavor's reading is her inclusion of herself in that cast; inspired by Barthes's *The Pleasure of the Text*, she wants to write aloud. Her book is a series of imagined encounters between the figures in the photographs and herself as a curious, sometimes aroused spectator. The contract to perform is transactional, depending to an appreciable degree on Mavor's sense of the subjects' agency in activating her desire. She intensifies her critical performance by imaginings of mutual ardour, metonymic tokens, and the maidenly blush.

The theatre of *Pleasures Taken* is both provocative and perilous, for it stretches the notion of performance almost beyond meaning, and certainly to the edge of its application here. Performance or self-presentation through photography derives, even when it deviates, from social and cultural convention. The photographic image is its basic and interesting starting point, but the notion of performance, cultivated in a medium of conformity and impulse, extends much further than the pictured subject, incorporating all aspects of presentation (soliloquy to gossip) to audiences, real and imagined, as well as their participatory reception.

Photographic performance is hardly a complex term, but its meaning shifts through a variety of applications and needs to be elucidated carefully in terms of intention and effect. Mavor is a little shaky on this point – I think intentionally so – but *anticipation* of ongoing dialogic performance by the makers of these albums is crucial to my argument here, so I will bear down on what may seem a rather moot point. A performative image or utterance cannot be created out of innocence; the promissory aspect of performative expression demands some small perch on intentionality. According to communications scholar and folklorist Elizabeth C. Fine, a performative metaphor used in preaching, for example, is designed to excite an audience to action or performance. As in the saying, so in the doing: the audience becomes involved in "an immediate verbal and physical response to the call."[110] An erotic image may be interpreted performatively, as Mavor does, but it does not follow that the person performing in the photograph is in any way complicit in the promise, especially if that person is a child.[111] Mavor's performance as a critic is actuated by her vivid sense of the subjects in *re*-presentation; her original contribution to photographic inquiry is an application of feminist and psychoanalytic theory to a controversial site of intertwining subjectivities. But her sense of entitlement to appropriation is greater than mine, or that is my conceit. There are empathetic ways of reviving a heuristic

conversation without leading it, though as Turner reminds us, many factors need to be taken into account:

Postmodern theory would see in the very flaws, hesitations, personal factors, incomplete, elliptical, context-dependent, situational components of performance, clues to the very nature of human process itself, and would also perceive genuine novelty, creativeness, as able to emerge from the freedom of the performance situation, from what Durkheim (in his best moment) called social "effervescence," exemplified for him in the generation of new symbols and meanings by the public actions, the "performances," of the French Revolution. What was once considered "contaminated," "promiscuous," "impure" is becoming the focus of postmodern analytical attention.[112]

Using the voice as a medium of interpretation reinstates the oral pattern that first brought the visual hoard to order. We do not need to know the names of the soldiers and ladies gathered in the Birch Album, but we must know, and acknowledge in the looking, that Birch knew them and could *rhyme them off*. The album describes the man and his stature in the interdependent hierarchies of military and civilian society. For Captain Birch, coursing through the album meant uttering the names, ranks, and regiments of his fellow officers, information hidden from the viewer but saved on the mount for the time when eyes or memory failed. Then whom would he forget (Oh, how could I forget ...) from this close community? The "Nuckel headed monster"? Would Lieutenant Clower's written epithet outlive the memory of his stubborn, oafish ways? Highly unlikely. We are haunted by our Clowers; they set our standards and patterns of expression; they are the final arbiters of our performances, as Edward T. Hall relates. "Harry Stack Sullivan, a very great contributor to psychiatric thinking in this country, once described his own attempts at writing by saying that the person who appeared before him as he wrote and who appraised his sentences as they were coming out was a cross between an imbecile and a bitterly paranoid critic!"[113]

Even in compilation, Birch's album would have begun its dialogic progress, with each carte-de-visite changing from a simple token to a questioning reminder of sworn friendship, staunch character, physical endurance, or prettiness in bloom. The visual aggregate by which Birch defined Birch was programmed to fracture into a composite of past visions and revisions, current conditions, and speculation about the future, all present and always truthful in the telling.

Family Secrets

The recording of Gretta Chambers's presentation of the Charles-Philippe Beaubien Album is remarkable in many ways. Like the album itself, it holds together a family of powerful individuals. Mrs Chambers's grandfather was a talented and dedicated photographer; the photographs that brought us together were descriptive of an amusing, storybook age. Many of the observations and details that came out in our meeting have already informed this study. What I want to convey here is the quality of the meeting itself. It was brief and focused, yet somehow loosely conversational, questioning and confidential on both sides, digressive and informative. The transcript is full of incomplete thoughts and hesitations; we seem constantly at cross-purposes, yet we are both listening, and the Beaubien album, up to that moment in its history, receives a full account. Our conversation was as Langellier and Peterson have evaluated cooperative storytelling: "What seems at first glance a tangle of interruptions and overlaps is upon closer observation a web of strategies to tell this story together."[114] Mrs Chambers and I sought common ground by sharing insights and personal anecdotes. We compared notes on our mothers. Yet we never left the album. When I listen to the tape of our discussion, it is clear that we have accommodated ourselves and each other to a familiar presentation pattern.

The making of the album had been exclusively her grandfather's, and while he was alive, he seems to have controlled

its presentation. At the time of his death, the telling was passed down as a collective responsibility. Looking at the photographs, Mrs Chambers identified people, places, and things that she had never known anything about, or had possibly forgotten, but she associated those gaps in her memory with members of the family who might be able to fill them. Those associations led to stories about them, stories that went some distance and time from the situations we were ostensibly reviewing. As Mrs Chambers pursued these leads, she framed some of her stories as confidences, indicating that there were things she had known which her siblings had not, and vice versa. This partitioning of knowledge had not created divisions in her family, whose members seemed to know where the secrets were kept. On the contrary, the fact that the weight of family folklore had been shared among the children seemed to draw them closer together. Many shoulders were carrying the stone. The art of memory in this case was remembering who might remember, and the album, as one of many albums, held some of the keys.

The stories that Mrs Chambers told me must have been authorized family favourites; I was, after all, a perfect stranger. I also sensed – and this is pure intuition – that the same stories would have come up in the presentation of another album, for they often seemed generic, relating only tangentially to the pictures at hand. Beaubien family lore had created its share of heavy or legendary characters, and Mrs Chambers distinguished herself in the telling. But it was the simplest thing that was truly moving and deeply informative about the album as her grandfather had conceived it. Her utterance of the names as she turned the pages and recognized the figures was to me unforgettable. This was not because of the emotion in her voice. Mrs Chambers was touched by what she saw, often by its aesthetic appeal, but throughout our meeting, she remained very composed. No, it was simply the frequency with which certain names came up. Presenting the photographs in this album – hers from her grandfather's legacy – Mrs Chambers uttered her names for her mother, her grandmother, and other great figures in her universe again and

again. Her voice stroked the memories of her extended family. There is no other way to describe it.

By contrast, we can begin to understand the uneasiness that grows when a photograph in a family album is passed over in silence. Deborah Kurschner Clarke provides a particularly wrenching illustration from her own family history:

A small black-and-white photo tucked away in one of our family photograph albums reveals my father on this day 50 years ago. As a child endlessly poring through old family pictures, I was always slightly puzzled by this picture of a gaunt boy, a week shy of 15, sitting on the ground in a compound with two other haggard boys dressed in what looked like baggy striped pajamas. Behind them are two wooden barracks draped with large pieces of material showing the star of David. I did not think to ask how my father came to be in such circumstances, though even as a young child I found the picture incongruous among my father's many photographs of healthy family members and friends doing regular things like playing at the seaside, sightseeing or simply posing and smiling for the camera. I also did not ask why most of the people pictured in my father's album were dead.[115]

The photograph snapped at the liberation of Buchenwald, the botched job of plastic surgery that replaced the numbers on her father's arm – these were the mysteries that haunted the margins of Clarke's small-town-Ontario family life. As the third and youngest child, she had no doubt absorbed the taboos that prohibited her questions, that stopped them from even surfacing in her. The story that spins out from her memory of the photograph was not actually given to her because of it. She and her siblings were told about their father's experiences in the camps because of a television documentary that the family watched together – orality returned her to the album.

Clarke's childhood memory of not understanding the photograph is as meaningful to her as the history that she has learned from her father and other witnesses, from television, and from books. Memories of the unspeakable are powerful

indeed. When Clarke was a child, the reality referenced by the photograph was not some atrocity (not yet) but a strange, dumbing silence, a barrier between her and her father. Silence informed her understanding of the album as no explanation could have done. But the explanation was eventually given, replanting one kernel story in the album, one among many still to come. For Clarke, there will be other conversations that will include both the knowing and the not knowing in her presentation of the picture. She and Marianne Hirsch would probably talk long into the night.

The psychodynamics of orality are reflected in the content and structure of the private photographic album, scripting the halting, serpentine dialogue of its interpretation. In the evanescent flow of visual information, there is comfort in seeing what others are seeing, and there is also forgiveness for the breathless interpreter. Illich and Sanders explain: "The question 'What did he say?' contains the request 'Tell me what he is trying to tell me.' We do not expect our companion to have understood word for word; we only want to understand what *he* has understood. This understanding of explanations, coupled with the ability to explain what one has understood, is basic to oral discourse."[116]

The "web of strategies" woven through this chapter proves that there is a real affinity between orality and photography. The characteristics of photographic compilation and oral composition are remarkably well matched. Attention to the oral framework of compilation is complementary to contextual analysis, and performative interpretation is an appropriate method of deepening and communicating understanding. Teasing out the patterns of inclusion, organization, and presentation in an album means that more, not everything, will be revealed. To argue that an oral framework has to be reconstructed to understand fully the meaning of an album is not the same as arguing that it can. We do not expect our companion to have understood word for word; we only want to understand what she has understood. This is what I hope we can achieve as we return to the sisters' album and revive their suspended conversation.

"PHOTOGRAPHS" 1916–1945

SISTERS

They are two. We do not know their names, their addresses, their parish, whether they worked, when and where they were born, or when and where they died. What do we know, and how?

Fundamentally, we know that at least one of these women was an avid amateur photographer who pursued her interest during the thirties and early forties. We also know that the women lived in the province of Quebec, or at least spent holidays there. We know that they were Roman Catholic and that they spoke French. We know that they were people of moderate means, able to access photography and a motor car, though unmoved to document their houses and other possessions and rather attached over the long term to certain articles of clothing. They seem practical rather than showy, though they certainly liked to show off for the camera. Their holidays centred around cottages and lakes, and they seem to have enjoyed the outdoors, especially sunshine, though they are far from woodsy. Their attachment to nature and rural culture is sentimental and was possibly mediated by pictures, since they went to some effort to pose in rustic settings for the camera. We see that they were fond of each other, that they resembled each other, and that their

relationship went back to girlhood. We assume therefore that they were sisters.

Is this a collection? Based on its contents and what we know so far of its organization, I would say yes. We have already seen that the photographs are not in chronological order, but arranged according to theme, resemblance, or affinity. Many of them appear to have been made in pairs or groups. Photographs that predate the album have been collected and preserved in its pages; though mainly filled with snapshots, it also holds school pictures, postcards, first communion pictures, and a newspaper clipping, as well as an "In Memoriam" card.

Is this a memoir, or is it travelogue? Again, yes to both questions, based on the inscriptions that emphasize place and date, and also denote a great number of excursions by car and train. Weighting the balance toward memoir is the mood of the album, which is saturated with retrospection; the last photograph is literally a backward look. Conversely, none of the women's activities could be ascribed any historical significance; no one seems to have a message or a career. Travel is visibly important, but should their journeys be taken metaphorically (as life passages), as vacations (as the high season of family life), or as a very photographic combination of both?

Is this a family album after all? Well, yes, after a fashion, though only by the inclusive definition that we have already worked out, for the *idea* of family is nowhere to be seen. No one is born; everyone simply is, in these snapshot slices of life. Kinship seems an important factor, though not for its own sake, but for the sake of individual lives that are sustained by intimate associations, both physical and metaphysical.

We have seen that each category encourages its own habits of attention: the notion of collection alerts us to motifs and social values; memoir, to pertinence, to the point; travelogue, to distance over place and time; and family, to yearning and affection. Faced with as intricate a document as this album, we need all the help we can get. So let us remain open for the moment and place "Photographs" in the general category of life history. Much of the official record is missing, but between gaps, there is a great deal of compelling visual evidence that invites both contextual and oral interpretation.

The first way of working might be called a reading of the album. By studying and comparing the photographs, by interpreting motifs and gestures, by measuring the importance of the main figures, by marking the comings and goings of secondary figures, and by relating the conditions acknowledged or displayed to the state of the world outside, we can learn quite a bit about the lives of these women. We can create a parallel account that supplements the documentation at hand and comes very close to the level of knowledge and insight that the sisters' audience would have brought to the album. Since this is life history, our written account will be in chronological order, beginning in 1916 and ending in 1945.[1]

The second way of working might be called a recitation of the album, and it takes us a good deal further. For bear in mind that to *read* the album as a historical document is figuratively to tear it apart, to extract by force of reason its hidden progressive account. This is an important first step, because having read and digested the facts, we are prepared for the real work of the album, which is (because it always was) to get inside them. Consider me the compiler. When we sit together in my home and look at my pictures, I do not tell you that I am a spinster who lives with her sister, that we are Roman Catholic, French-speaking, working-class, or other facts of my life. These things are obvious, just as the photographs are visible. Instead, I tell you how I feel about these things by sharing what I recall, or choose to recall, from my past and how it relates to the present and my perspective on the future. That is how the album works. Recitation of the album builds on its intrinsic relations and allows us to approach the compiler or compilers through the evidence of their intentions. To construct a recitation, we will enter the sisters' album through the oral-photographic framework that was outlined in the previous chapter: patterns of inclusion, patterns of organization, and patterns of presentation.

The very first photograph in the album is dated 1936. It shows a little girl standing beside a rocker. We know that she is not one of the sisters because many pictures depicting them as mature women are dated 1933. The earliest inscribed date is 1924 on a very small picture of a woman whose eyes are thrown into shadow by the brim of her hat. That picture is on page 14.

To begin our biographical reading, we are looking for the earliest picture that we can date securely, and we find it on page 7. It is a school picture stamped "Art Studio 48 St. Catherine Street, E. Montreal." The Art Photo Studio is listed in the Lovell's Montreal directory of 1915–16. Art Studio or Art Photo Studio is not listed in previous directories, and by 1916–17 the studio had been sold or changed its name to Français Photo Studio – Morency Frères, which maintained the same location.[2]

The school picture can thus be dated 1915–16. The girl appears to be in late adolescence or early teens, so we can reckon her year of birth to be around 1900. Unquestionably, this girl is the elder of the two sisters, who by 1916 must have been finishing her formal schooling somewhere in the Montreal area. Finding her among her chums, boys and girls posing for snapshots in an open field behind an urban row of houses, we can assume that the girl was not a boarder in a Montreal convent, but that she lived in the city and quite possibly in the east end.

Her younger sister is not part of this lively group, nor does she appear among the seven girls on the ferry boat or in related pictures from the twenties. She does not feature in any of her older sister's boat trips or excursions. One assumes that she was just too young, that the gap between them had not yet closed. Building on that assumption, we want to look more carefully at a picture on page 21.

Another school picture features a girl of seven or eight. Her high forehead, dark eyes, side-parted hair, somewhat prominent nose, and straight mouth identify her as the younger sister. The lower edge of the print is tucked under a snapshot of the older sister, who sits meditatively on a rocky shore. This layering of photographs is unique in the album. Held there by black corners, the arrangement cannot be explained as a vestige of earlier compilations, so it must be intentional. A symbolic expression of caring is one possible meaning, the younger sister figured as being in the thoughts of the elder. At the same time, the puckish younger self appears as a guardian angel, looking out for her older sister. The page in its totality encourages this double reading. On the right is the pendant to the portrait of the older sister – the younger sister photographed on the same rocky shore. Her costume is sombre, with white accents at collar and cuff. The little schoolgirl is similarly uniformed. The positioning of the two photographs is clever, for the younger woman's oblique expression, her eyes turned up to her right, forms a warm complicity with her younger self on the page.

The shoreline pictures were taken in the summer of 1932. At least seventeen pictures can be dated to that year, including an image on page 21, "14 Août 1932." That photograph depicts the older sister standing in a cemetery, looking down at a grave. She is wrapped up in her thoughts and her physical surroundings. The framing of the photograph envelops her in markers and plantings. One cross rises above the flowering bush in the foreground. It is emblazoned with a monogrammed heart.

In pursuing the earliest photographs in the album, we have leapt from the teens to the thirties, skipping an important group of small snapshots from 1926. Some of these have been mentioned already, being part of a wedding suite of single and group portraits that first appears in the first six pages of the album. Their format and poor condition immediately set them apart.[3] As well, the figures tend to be photographed against similar backdrops, favouring the smooth stone facade of an urban dwelling. These pictures, we can assume, were family photographs and important ones since the negatives were preserved and remained accessible to the compiler in later years. In the album we find that other

14 Août 1932

photographs from the same group were reprinted. Two pictures of small, dark-haired children under the age of ten (four children in one photograph, two in the other) appear later in the album, one on page 25. They are larger than the vintage prints and made with the decorative borders that characterize the snapshots of the late twenties and thirties.[4] And there is a third reprint from the negatives of the twenties, a portrait of a middle-aged woman and two of these children that has been enlarged to the format of the bigger St-Ours portraits, the first of which we saw on page 9.[5] This portrait of a mother and children is the only enlargement in the album that does not depict one of the sisters. It is presented on page 12, paired with the St-Ours shoreline picture of the older sister.

The resemblance between the woman with young children and the older sister is remarkable. A generation separates them in age. The portrait of the older woman has been accorded special treatment and a place of honour in the album. All this adds up to the conclusion that the woman is the mother of the two sisters. Immediately, one is struck by the fact that they are never photographed together, but only placed together in the album. That combination occurs here and on page 9, where the older girl's school picture is accompanied by two pictures from 1926, one of children and one of a couple, the mother and her spouse. I do not say "father" because this man makes only a fleeting appearance in the album. Conversely, the four young children reappear as a group around 1929 (page 6). Their numbers have been swelled by a child of about two, and they are sitting in a row outside the house that we associate with the older woman, Rachel.

Children can be hard to identify from small, faded snapshots; parents frequently say this, even about their own. To confuse things even further, there is another small snapshot in the 1926 series that depicts a couple with small children; we never see those people again either. The four children may be siblings, half-brothers and half-sisters, cousins, or very young aunts and uncles. We cannot know. Still, with regard to their place in the album, a few conclusions can be drawn. First, the sisters are not among these subjects, and yet one or

both of them had access to the prints and negatives, as well as the desire to include the series in the album and to feature three of its images. The 1926 pictures were important to them, and later pictures of the same children were just as important. It is noteworthy that the 1929 photograph of the children does not represent any special occasion. Dressed in everyday clothes, the children are significant in themselves. Likewise, their home means something to the sisters. Comparing the bannister and mouldings, we realize that the picture on page 2 of the teenage girl standing on the outdoor stairway was taken in the same location.[6] It is the home that we associate with Rachel, for her 1929 portrait was made in the doorway of that house (page 23).[7] The same doorway frames a portrait of another woman from 1924 (page 14). Almost certainly, it is the mother, making the later picture of Rachel its pendant. The girl pictured on the stairs is the younger sister.

Most telling, however, in this album of recurring figures is the disappearance of the mother after 1926. I think that she died, possibly in childbirth. The sisters, who are quite a bit older than the five children, were probably from her first marriage. Their mother had been widowed and she remarried. The absence of the sisters in pictures of their mother from the twenties suggests that they lived apart, not uncommon for the issue of a first marriage, especially if the eldest was beyond her teens. Their mother's death left the sisters without parents, but with a large extended family in which Rachel figured prominently. She, I think, took charge of the younger children. The two sisters formed a tight unit of protection and affection, which they commemorated with photographs.

Without undermining this premise, for I think it is correct, I want to pause and evaluate its importance. None of this lineage is recorded precisely in the album, nor is the sisters' family history its central theme. Their background signifies principally as a conditioning context. We do not see death; we see mourning. We do not see separation; we see togetherness. We do not see absence; we see presence. What can be shown, or borne, is what the sisters want to show; we should not automatically tether their pictures to symbolism

"Photographs" 1916–1945 (MP 035/92), 12

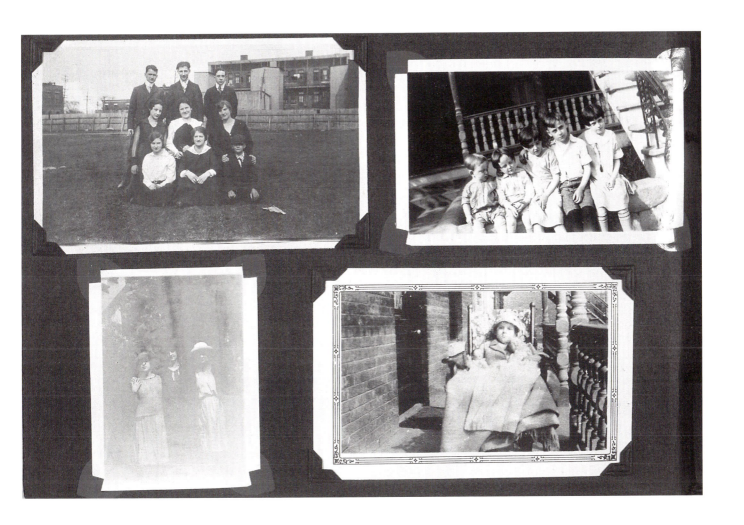

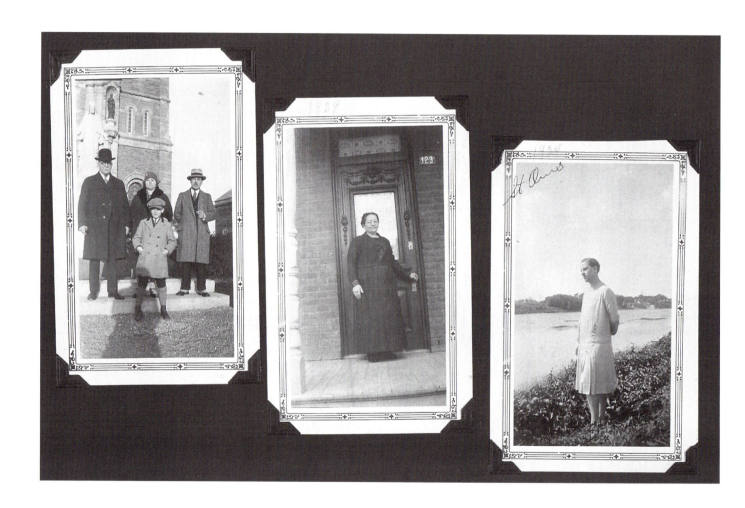

"Photographs" 1916–1945 (MP 035/92), 23

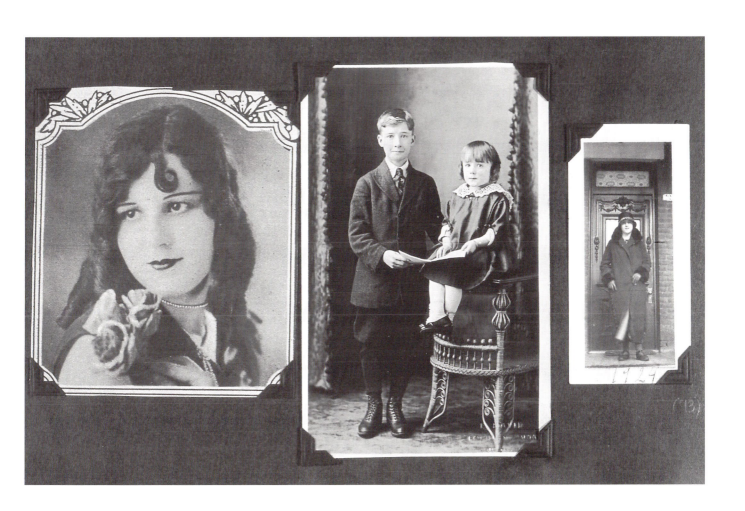

"Photographs" 1916–1945 (MP 035/92), 14

by insisting on the hidden facts. The images are veiled representations of the past and transparent presentations of the moment. We observe the subjects in different situations. We see clear and consistent expressions of feeling. Whatever we might have heard from the sisters by way of explanation, whatever we might conjecture, the photographs present a positive picture of their life together. The album is a celebration, not a lament.

CYCLES AND MOTIFS

The sisters' family, like many families, had enjoyed taking pictures on occasion. The heart-shaped photo corners suggest that they had inherited an incomplete album, perhaps their mother's. One or both of them took up photography, though this did not happen right away. No photographs in their collection are traceable to 1930 or 1931. In the early thirties, in the wake of the stock-market crash, pocket money was fairly scarce. The sisters were also still dealing with the loss of their mother.

In 1932 someone felt the urge to take some photographs and began one Sunday. The photograph in the cemetery on page 21 was taken on Sunday, 14 August 1932. The following Sunday the sisters photographed more spontaneously in the countryside around Rigaud and Beaconsfield, reaching as far west as highway 17 in Ontario.[8] Most dates given in the album are Sundays, with a few interesting exceptions.

One photograph, clearly dated 31 August 1932, is a portrait of the older sister, who poses with a concrete lion in an entrance. That day was a Wednesday, though not just any Wednesday but the day of a full solar eclipse. The newspapers were full of excited preparations for watching and recording. The daily newspaper *La Presse* had been building excitement with detailed instructions, photographically illustrated, of how safely to take part. As it turned out, the skies were overcast and there was nothing to see except huge crowds of people – "L'attente anxieuse dans les rues," as *La Presse* con-

cluded its coverage. Judging from the portrait of 31 August, our sisters were completely oblivious to the event or to any other earthly concerns, such as temperature and humidity, reported by *La Presse* as the continuation of a heat wave – "Chaleur collante qui embuait toutes choses." The older sister is wearing her dark Sunday coat with a fur collar. Can this be possible? Perhaps not. The compiler may have been confused over dates. Two likely companion pictures are also dated. It is impossible to tell from one if the date is 21 or 31 August; the other is assigned to September. Our compiler is not infallible on dates or places, as we shall see. Such an important day as 31 August 1932 may simply have stuck in her mind, though losing its connection to the stars, being eclipsed by matters more personal.

Regardless of the precise date, we know that in the late summer of 1932 the sisters were photographing each other and having themselves photographed together with regularity. Most of the pictures are sombre; a number are set in cemeteries or on shorelines. We recall the montage on page 21 that knits those two settings together. It appears that the women were emerging from a period of mourning and that the first pictures they took were memorials. They then turned to the reconstruction and reanimation of their lives. The cornerstone has been laid in a portrait of 1932 in which the sisters, darkly and formally dressed, pose sitting in the grass. They are both very well; the older sister smiles affectionately at the younger, whose typically oblique look is modified with a grin.

After 1932 the sisters seem less cloistered in their mutual support and affection. On pages 3 and 5 we saw photographs of picnics at Baie Georgia and St-Donat. There were many such picnics at that time, cementing relations with a particular couple and their boy. In all likelihood, these are relatives; the man may be their cousin or even their brother. The connection seems to be through him; he is sometimes photographed alone, while his wife is always depicted in company. Furthermore, she bears no resemblance to the sisters. To the boy, the sisters must be aunts or adopted aunts; it hardly matters – they are bound to each other in a way that we would like to

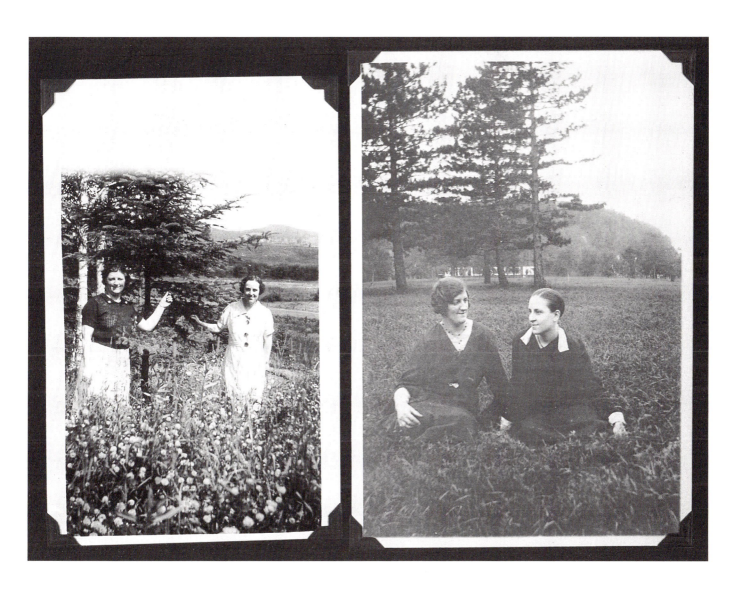

associate with family. Their outings as a group mark a delightful period, very interesting photographically because of the communal nature of the record. A spirited desire to get everyone into the picture results in cinematic sequences that are broken up and sprinkled throughout the album, one form of cohesion paradoxically sacrificed to another.

Much centres around the car. In 1933 there was a lot of hard driving, though probably not as much as the album's inscriptions would lead us to believe. According to the compiler, one Sunday, 27 August, the quintet called in at St-Donat, Ste-Agathe, St-Maurice, and St-Esprit. This is literally impossible, and by her own hand, the compiler's confusion or lack of interest in the facts is proven once and for all. One of the pictures is inscribed "St-Donat 27 Août 1933" on the back and St-Esprit on the front. In the same year the party was also sighted at Terrebonne and Ste-Julienne. Again, the inscriptions seem somewhat doubtful when other factors, such as clothing and surroundings, are taken into account. The third woman is a useful guide in these matters since she varies her costume (even her apron!) quite a lot. The least helpful is the younger sister, who was plainly devoted to her printed dress with the leafy collar. It is a very photogenic dress, and from the great number of pictures in which she wears it, she recognized its qualities on sight.

The photographs in the touring and picnicking genre are very charming and accessible; they are open to the spectator in a way that the rest of the album is not. This impression depends largely on a participatory photographic process and tends to mislead in its welcoming effect. Performing for the camera, these actors are performing for one of their group; the insular company of two has expanded to an intimate society of five, but no further. At this stage of life, they display very little interest in the outside world. Although they travel, they tend to seek similar situations to make their pictures; waterways, fields, flowering bushes, fence lines, and leafy groves are their specialties. Even decorative settings are kept to a framing formula; well have these snapshooters learned the Kodak lesson to get in close. When they break the rules

and reduce themselves to ants before a monument, it is not without meaning. One is caught by their group portraits at the base of the statue of Baldwin and Lafontaine in Ottawa, before a church steeple at St-Donat, and at the tomb of Kateri Tekakwitha (1656–80), the "Lily of the Mohawks," at Caughnawaga. The patriotism and religion that peak in these pictures saturate this album as worthy sentiments, deeply internalized and automatically expressed through meditative portraits and pastoral views. Another cultural signpost is the Rigaud group portrait taken by the boy on 21 August 1932, which captures the four adults holding sheaves of wheat. Other signs of attachment are more episodic and obscure.

On 27 April 1934 Roméo Labelle, son of J.E. Labelle and Eva Clément, died in Montreal at the age of twenty-seven years and four months. This information and a photograph of the deceased comprise his "In Memoriam" card, one of very few non-snapshots in the album. A search through *La Presse* turned up an item on 28 April notifying mourners of the funeral to be held on 30 April at Notre-Dame du [Très] Saint-Sacrement Church, followed by burial at the Côte-des-Neiges cemetery. The procession was to begin near the church at the home of J.E. Labelle, 4382 rue St-Hubert.

A slim lead to the identity of the compiler, the St-Hubert address matches none of the houses pictured in the album. Lovell's Montreal directory indicates that the father had not lived very long at that address; he moved or died shortly thereafter, leaving one Paul Labelle, machinist, at the St-Hubert flat. Tracing Roméo to his apartment proved equally fruitless. One Roméo Labelle, clerk, who lived at 1569 de Bullion in 1928, was no longer there by the following year.9 So the deceased, who is pictured in military uniform, may have worked as a clerk. That is about all we know.

Roméo Labelle must have meant something to the sisters, for there are no other "In Memoriam" cards in the album. But if he features in any pictures before 1934, I have failed to identify him. Born around 1907, he would have been about the age of the younger sister, but there are no secondary male figures of that age. The inclusion of the card is an unsolvable

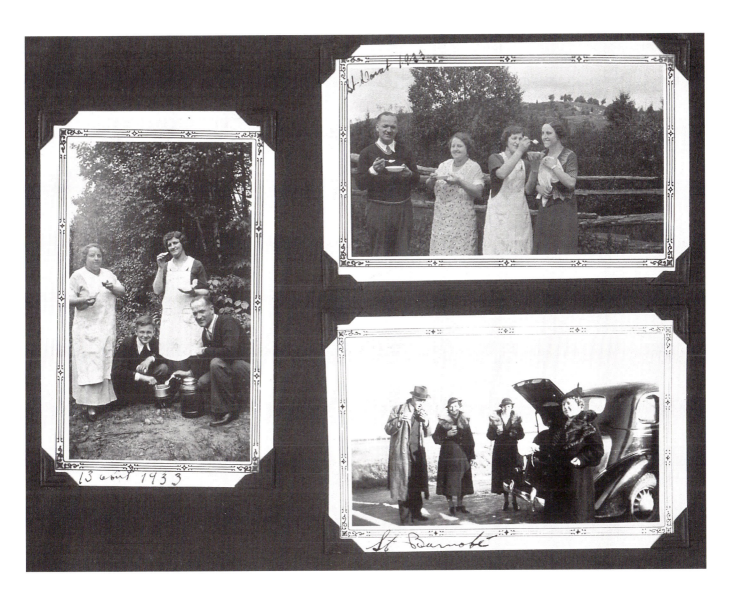

mystery. One element in a crowded page, it sits in the middle of the top row. On the left is a group picture of sixteen girls. The older sister *may* be among them (fourth from the left in the back row), but this is a tentative identification. To the right of the memorial card is a wallet-sized picture of a butcher in his meat cooler. The same man appeared in a group photograph on the steps of a church, possibly taken in the twenties (page 23). The bottom register consists of three views of lake and countryside taken in August 1940, probably at Lac Noir. The tracing and contextual reading of the picture are inconclusive, but we can measure the impact of this young man's death from two factors: the presence of the card and the fact that no other elements in the album can be ascribed to 1934 or 1935. It may be coincidental, but a certain style of touring, picnics, and pilgrimages was suspended for two summers. Perhaps the Labelle connection ran through the sisters' companions, the couple and their boy, for they are slow to return to the album. In July 1936 we find the sisters on their own or in the company of other women, staying at the Pension Ducharme near Ste-Adèle (page 36).

How might the sisters have recounted the next few years? Differently, for their audience would have changed. After 1936 more people had a share in their memories, an extended family and a circle of friends. If my broad reconstruction of their history is correct, a new crop of siblings was beginning to mature. Two photographs from 1936 feature a girl in her mid to late teens who may be the eldest girl; she looked to be about seven in 1926. The girl resembles the younger sister a great deal, but with a wider mouth and an almost flirtatious smile. She is also slimmer and taller, perhaps slightly self-conscious about her height since she suffers a bit from bad posture. She appears once in a photograph at Ste-Adèle, posing by a split-rail fence with the older sister and again with both sisters and a fourth woman, praying at a religious shrine (page 64).

Around this time, the format of the pictures changed from the curlicue to the deckle-edged borders. The reprints from the twenties were therefore done no later than 1937, and

probably before, as a way of bringing the past forward into adult relationships. The compilers may have begun to conceive the album around that time and to photograph with some kind of goal in mind. Gradually, the photographs filled with new, somehow familiar faces. The sisters took part in events such as first communions and family reunions, and they photographed the devoted group around Rachel.

Their hobbies and experiences also seem to have expanded, though just a bit and with some caprice on their parts as they tried certain things just once. No other pastime exerted the fascination of photography, though boating seems to have come close. Beginning in 1938, they puttered around in rowboats, a diversion that continued to please well into the forties. In 1939 someone photographed the motorcade of the royal visit; one print constitutes their foray into public events. Some things were tested and abandoned. In 1940 there was a hike up the Pain-de-Sucre mountain at Lac Noir. In most of the pictures, the sisters look hot, tired, and fed up (page 53). Interestingly enough, this is one passage in the album that is concentrated and sequenced into a narrative. Pictures of the party on the trail and clowning at the lookout are amplified by postcards and snapshots of the natural environment. Three album pages constitute a full documentary report, as though the sisters wanted to preserve the memory, vaunt their endurance, and put the whole miserable experience behind them.

The rest of the 1940 Lac Noir holiday follows the normal pattern of distribution across the album (these pictures are easily identified as the products of wartime shortages – there are many of them, but they are small). Cottages and fishing trophies are displayed; the sisters pose for each other in their long summer dresses. One or the other has begun to experiment with hand colouring. There are completed prints, as well as *aides-mémoires* on the colours of a cottage (scribbled on the back of a print: "Haut jaune pâle/Bas grillage brun pâle").

Life winds on through real and metaphysical journeys. The cycles and rituals gradually evolve. In 1939 we find the sisters once again in the delightful company of the couple

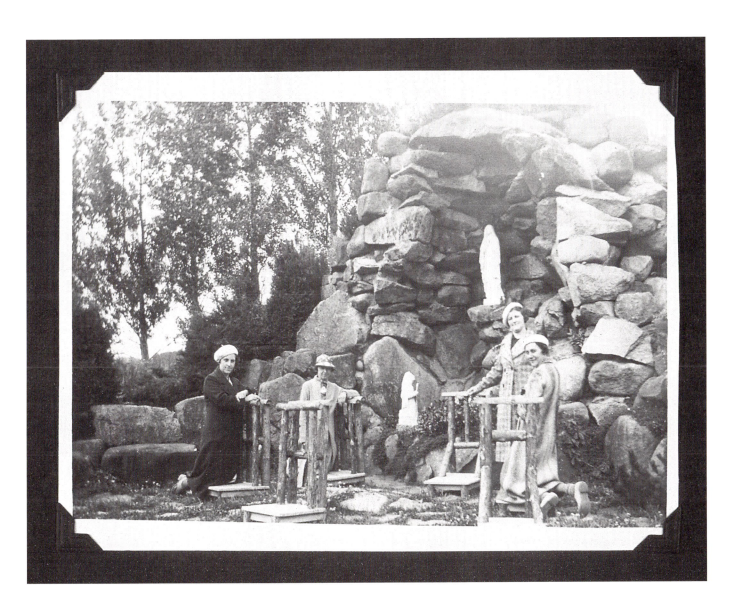

"Photographs" 1916–1945 (MP 035/92), 64

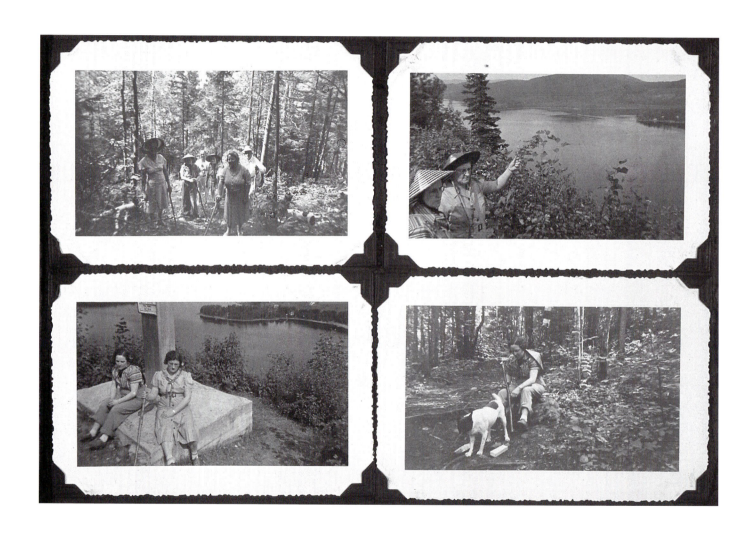

and their boy, but something significant has changed that group dynamic, for they are all five standing before the camera (detail, page 41). Who is taking this picture? Possibly the boy's young wife, for he has grown up. He is now smoking and wearing a wedding band. The core group's last car trip had taken place in 1938, a fitting climax to the genre, complete with leapfrog by the road and a tailgate picnic. But the unit that was them has been invaded. Adjustments will have to be made and new ideas accommodated, things like hiking. A young woman who is probably the bride is pictured on the 1940 hike, her mother-in-law's arm linked through hers for the photograph. Perhaps the Lac Noir cottages of 1939 and 1940 are connected to this turn of events as a way of bonding. The atmosphere is congenial, but the sisters eventually return to Ste-Adèle and the last summer scenes are set there.

A sharp contrast develops in the last years of pictures between the bustle of family and the solitary soul. These women are not old in the forties, but their place is now in between the aged and the young. Their sense of stability in this shift comes as always from each other. Their habits and haunts hold true. They were still living in Montreal in the forties; they patronized Photo L'Écuyer, which was in business between 1941 and 1946 on Mount Royal East (between St-Hubert and St-André). Ste-Adèle had become their favourite vacation spot in the Laurentians. They spent the day there taking pictures on Labour Day, Monday, 1 September 1941. The date is arresting: the war in Europe had been raging for two years, but there is little sign of it in this album.[10]

On this peaceful day the sisters visited the Ste-Adèle Lodge. They photographed each other demonstrating the resort's amenities, including its modern swimming pool. The older sister, fully dressed, poses on the ladder, her image reflected in the still water. This picture, hand-coloured, was perhaps intended to be framed, for it is loose between the covers of the album. An enlarged photograph of the younger sister standing on the steps of The Red Room constitutes the last photograph in the album.

But the sisters' affection for Ste-Adèle was not fading. In 1945 they went back there on the train, a sentimental journey divided between quiet walks and happy reunions. They photographed each other boarding the train; the album contains two such pictures of the older sister and one of the younger (page 57). This doubling of portraits, now in its fourteenth year, doubles again with the inclusion of the train-yard portraits of two younger women, the photographs that open the album. Those portraits, we realize, were taken on the same trip because others in the series bring the older and younger women together. Joyful feelings of adventure and community give life to the album, but always arranged to illuminate facets of the sisters, their shared experiences and mutual affection, the quality of their life together.

So simple a story, so transparent are the events and emotions of these lives. But our reading is reconstruction; it is the parallel text of the chronological storyboard. Structurally and emotionally, this resumé bears little resemblance to the album as compiled. Each entry in this chronicle has forced me back to the album to reconsider its photographic arrangements. Each episode has been a nagging reminder that the album's presentation of these lives defies literary convention. And yet these are very conventional lives.

Orality offers another way into the album by illuminating its mysterious structure. Recognizing the possibility of an alternative narrative form instills confidence in the compiler and controls the urge to explain digressions, redundancies, and other irregularities away. Some of these characteristics have already been explored, but there is still more to be gained from a systematic application of an oral-photographic framework. The psychodynamics of orality are fully manifest in the inclusions, organization, and presentation of this photographic album.

PATTERNS OF INCLUSION

A traditional or conservative approach to accumulating the photographs in this album presents the sisters' changing

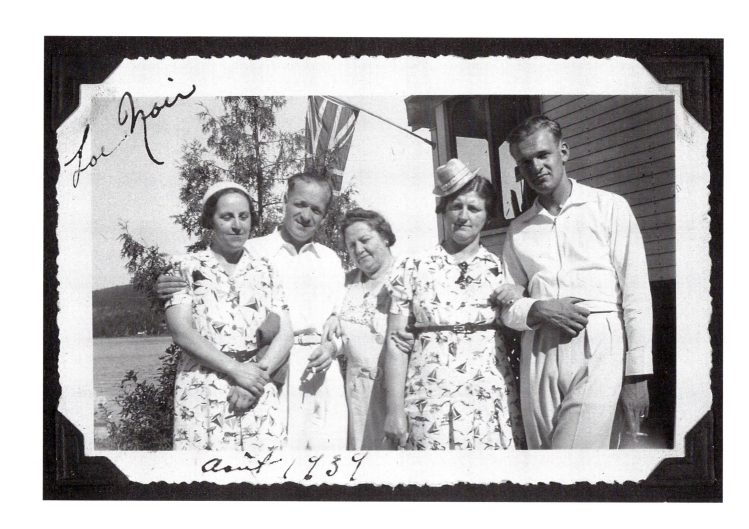

"Photographs" 1916–1945 (MP 035/92), 41 (detail)

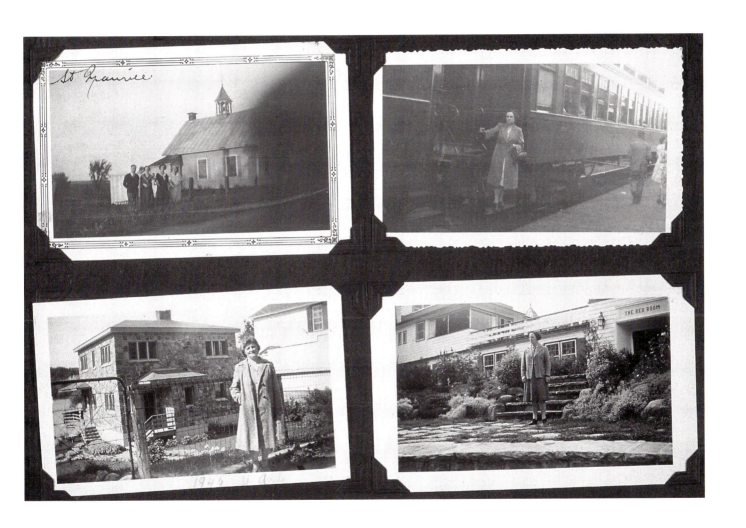

circumstances within a cycle of recurrent forms. Each phase of their lives ties another knot of togetherness, the album's specific message; but the manner of marking or acting out events fits into a repertoire of types or patterned behaviour. The index is predictable – family, ceremonies, trips, townscapes, cottage country, and Quebec farmland – and the manner of self-presentation within this repertoire is formulaic as well.

The album is replete with emblems of the theatre; doorways, staircases, verandas, and gates are its entrances and exits. These backdrops have been chosen by the photographers, but the subjects can be no less conscious of the game when posing is so demanding. People are forever climbing up on things – trains, rocks, platforms, stairs, trees, carriages, windowsills, bandstands, diving towers, lookouts, and podiums. In choosing locations, they are inspired by the Book of Nature, whose bounty is mimed in a variety of ways, by reclining in tall grass (page 22) or by blissfully inhaling the perfume of a tree. Each pose is a little performance, sometimes mimicking the act of public speaking. The man is especially rousing, with histrionic gestures borrowed from vaudeville or the newsreels (page 25). Another man plays the orator on the hike.

The improvised stages of this album are outdoor versions, or vestiges, of the parlour's *portière*. Changing the vantage point, they also serve to uplift and emblematize the act of looking. The younger sister presents herself in this manner, sometimes engaging with her recorder in a direct gaze (page 72), sometimes fixing on the horizon as a sculpted virtue of visuality (page 4). A composite of setting and type is a portrait of the younger sister on the edge of the shore, likely near Rigaud. A giantess standing on a rock before a backdrop of water and sky, she turns to her right, sighting something in the distance as she raises a pair of binoculars to her eyes.

Archetypes and a typological framework cast the older sister as a surrogate mother. This is a deliberate effect of one double-page spread (pages 12 and 13), where the four chosen pictures have been printed in the same format to be presented as a group. As earlier explained, the first pair (page 12) establishes two different female characters as mother and daughter. The middle-aged madonna sits gazing serenely into the camera, with a toddler on her lap and a little girl standing, draping her arm over the back of the chair. In the accompanying print, the older sister is stamped as a daughter by the childlike fashion of the twenties and the modest pose of a convent girl.[11] The placement of these prints on the page and the tilt of the younger woman's head seems to direct her gaze at the mother. At the same time, the daughter's oblique look of resignation as she stands on life's shore communicates a sense of loss.

On the opposite page, two photographs of the older sister restate the same themes (page 13). The first picture records her in dark winter clothes standing with a child in a white snowsuit. This image is from a suite of six photographs made on the same occasion and distributed over a spread of eight pages in the album (page 13). The suite forms a complicated detour, looping through several apparently unrelated episodes and back through time. The child appears alone in two of the series, at the rink and in front of a stone entrance that closely resembles the facade of the 1926 family photographs (the setting is strictly a visual reminder, for it is not the same). The child's parents are invisible throughout. Each of the sisters is individually portrayed, maintaining the pattern of mirroring poses. Finally, the older sister is pictured twice with the child.

The picture on page 13 is the more formal of the two sister-and-child-in-the-snow scenes (neither could be called candid). The older sister gazes steadily at the camera, one hand touching the shoulder of her charge. Unusual in this album of paired portraits, there are no corresponding pictures of the younger sister. The pattern, as we shall see, has been broken for a reason.

The second picture on page 13 appears to have been taken on a summer day in the late twenties. The older sister, wearing a dark outfit, pauses on a city street. Composition and

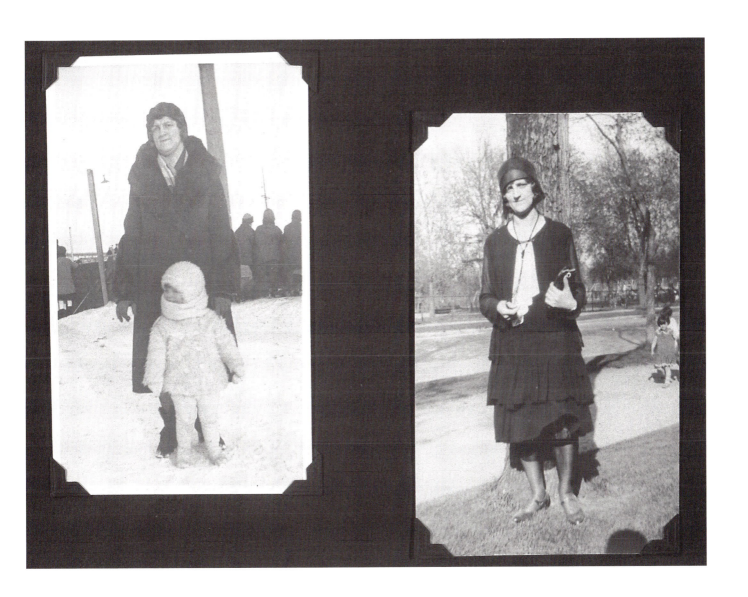

expressive elements tie this portrait to the rinkside portrait with child: the pole is echoed in the tree; the brilliance of the snow matches the sunshine on the street; the woman's expression is identical in both pictures.

Over a decade separates these two portraits of the older sister; the picture on the right carries the viewer into the past. If the mother died in the late twenties, the portrait on the right would be concurrent with the older sister's assumption of the maternal role. Here then is the spread: mother and child, 1926; daughter, 1929; older sister and child, c. 1939; sister-cum-mother, c. 1930 – time shifts continuously through this typological montage. Past, present, and future are co-represented as the mantle of motherhood is transferred to the older sister.

Orality insists on repetition. In this case, another set of photographs elaborates the maternal motif. From the rinkside series, one might assume that the younger sister did not care to be photographed with children, but that theory is disproved by an earlier pair of portraits, each sister posing in a park with the same baby. The older sister reclines on the ground, fully absorbed in an angelic child, who is partially screened by the tall grass. The younger sister sits on a log, bracing the restless child and smiling at the photographer (page 22).

If we consider the photographic act as part of the image, each picture can be schematized as follows. The younger sister as photographer looks at her older sister, who is looking at (looking after) a child. The older sister as photographer looks at the younger sister, who looks directly back at her. The baby, however appealing, is little more than a living doll, a metonymic expression of the link between the sisters.

Copious representation creates a number of "heavy" or heroic characters using stock combinations of figures, attributes, poses, and situations. The older sister appears most often; she can be recognized in 115 photographs, half the prints in the album. The photographic act functions as a praise formula, an expression of worthiness. By sheer numbers, she is established as a constant, reassuring presence.

Her gaze is forthright and friendly; she is composed and self-confident; she is companionable and fun-loving; she is thoughtful and pious. The younger sister appears in approximately 88 photographs. Often posing in the same situations as her sister, she presents a different set of characteristics. Her expression is sometimes veiled, her head averted from the camera. When she addresses the camera, she does so with energy. Her body oscillates between restraint and exaggerated heroism. In short, the older sister seems a more passive, cooperative photographic model, conscious of feminine traits, such as warmth and serenity. The younger sister experiments somewhat more with her identity. She strikes poses rather than holding them.

Each woman's framing of the other expresses her attitude and formulates a type. In comparable situations, the older sister is placed higher in the frame than the younger. The older sister shoots down; the younger shoots up (compare, for example, the St-Ours shoreline portraits, pages 12 and 23). A very slight difference in height or vantage point amplifies the psychological conditions of their relationship. There are religious connotations as well in the link between heaven and earth formed by their paired portraits.

The three main secondary characters in the album are the sisters' touring companions – the man, the woman, and the boy. Each is depicted more than twenty times with little variation. The man presents himself as a steady character, a bit of a clown, and a lover of simple, predictable pleasures. His wife is a plump, good-natured, and affectionate woman who enjoys her creature comforts, even in the woods. The boy is their sunny offspring, warm and dutiful to his parents and his two aunts. All three are keen photographers, the boy especially, affording the sisters many opportunities to pose together in an adult family group. What is unusual and immediately attractive about this series is its camaraderie. Relationships, as pictured, are on a very equal footing, so equal that, on cursory examination, determining the connections between the four adults and the child is quite impossible. This would seem to contradict orality's requirement for

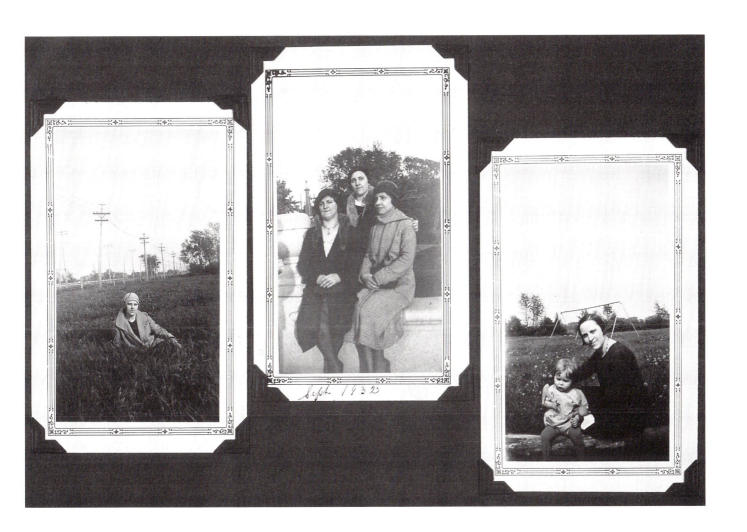

explicit formulations; motherhood at least should leap to the eye, especially in a *family* album. And motherhood does, according to the compiler's definition.

What is remarkable in this album is the dearth of conventional family units – mother, father, and children. The sisters rarely took such pictures; the ambiguous example on page 1 is unusual in every respect, including its clumsy composition. The only family portrait of their three travelling companions treats the mother as a child by placing her on a swing between her husband and the boy (page 25). But even that maternal icon has its counterpart in the sisters' repertoire. Predictably, the older sister swings while the younger sister pushes her from behind (page 36). Tradition is not abandoned; it gives birth to more useful formulas. This extended family created its own photographic rituals that substituted for the pictorial conventions of family life. Surrogate mothers and daughters are copiously described and praised within the formulas of this particular album. Their characteristics are displayed within conventional situations, or *situations that have been made conventional*, through ample reiteration within the typological structure of their creation.

PATTERNS OF ORGANIZATION

The organization of the album forms a chain of repetition that is visible in several forms: temporal/situational (the distribution of pictures made on the same occasion across the album), emblematic (the treatment of certain kinds of pictures as motifs), formal (the design of the page or montage), and actual (the multiple presentation of a single image). Interrupting the chain are items that precipitate questions or digressions: conspicuous kernel stories (the life and death of Roméo Labelle) or inconspicuous kernel stories (the life and death of the laughing girl, third from the left).

Fragmentation is most obvious in the treatment of the picnic sequences from 1933. Pictures from that series are spread over the first half of the album (pages 3, 31, and 36

are examples). Another serial group portrait, this one shot on the beach at Lac Noir, is also broken up across three widely separated pages, first on page 28. There are many more examples; the rule in this album is dispersal. It is interesting to compare this approach with Hilliard Snyder's concise and jumpy cinematic sequence. Both methods are intended to animate and amuse, but the narrative program of our sisters is best served by a generic image, somewhat disconnected from place and time. The moment is thus abstracted and extended into never-ending pleasure; such a basic desire seems subconsciously to have affected the dating of the picnic series, some of which is manifestly incorrect.

The picnic and the lakeside series are not the only examples of happiness stretched over time. The rowing pictures of the late thirties and early forties take up where the picnics leave off, combined on a single page, halfway through the album, then rowing taking over and continuing almost to the end. The sociability of the picnic years is gone. Most of these pictures are photographs of the sisters alone or together in rowboats. Snapshots mounted across from each other, on pages 70 and 71, offer perfect examples of the mirroring portrait; the women here are wearing matching halter tops and occupying the same position in the boat. From the bow, they photograph each other sitting in the stern. In other words, conscious of themselves as twinned, they have taken some trouble, scrambling around in the boat to make matching portraits. These are dated July 1943; they are quite likely to have been taken on Lac Rond at Ste-Adèle. Once again, dates seem to blur on the following page, where suspiciously similar photographs are identified on the back as "1944." The compiler's memory floats these images in a continuum.

In the layout of the album, symbolic clusters seem to form around certain kinds of images. In the first third of the album, pictures of little children, alone or in pairs, crop up a similar manner, unattached to parents and often in the centre of the page (pages 9 and 25). As described earlier, the St-Ours pictures are separated on the page by a small snapshot of a little girl, probably taken much later in Montreal (page 9).

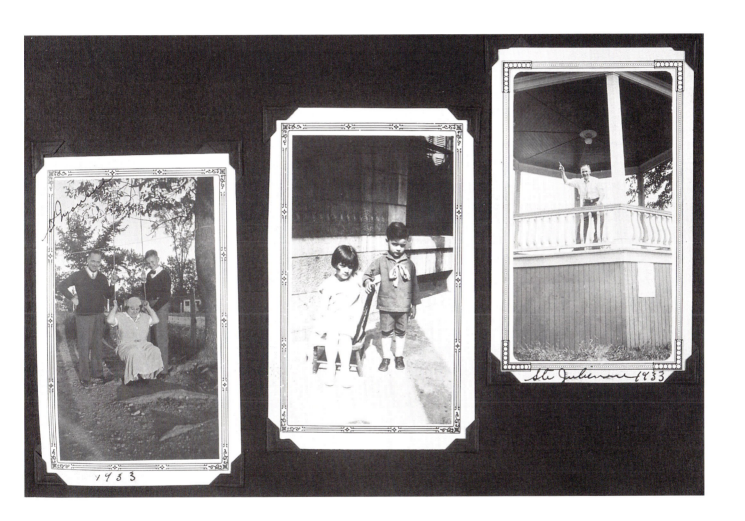

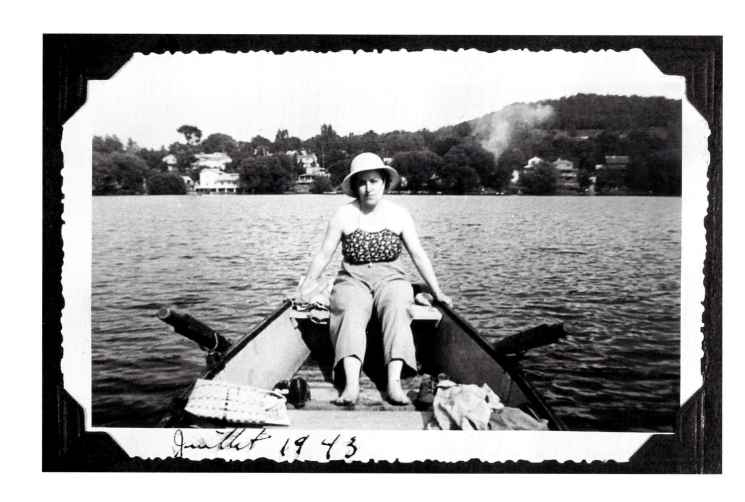

Juillet 1943

"Photographs" 1916–1945 (MP 035/92), 70 (detail)

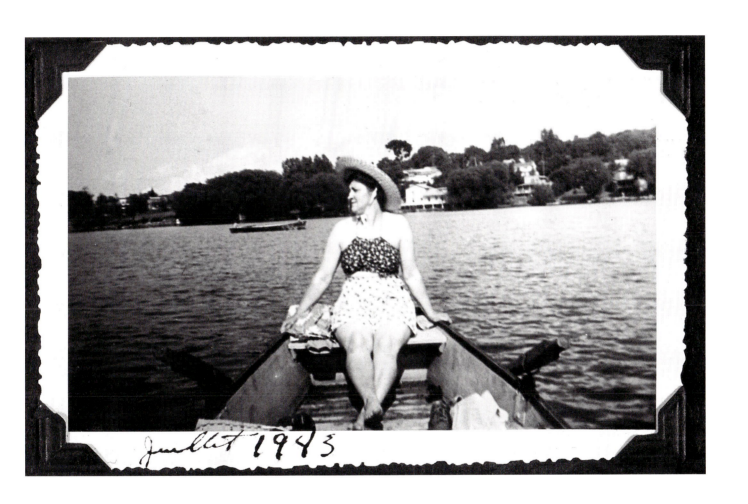

"Photographs" 1916–1945 (MP 035/92), 71 (detail)

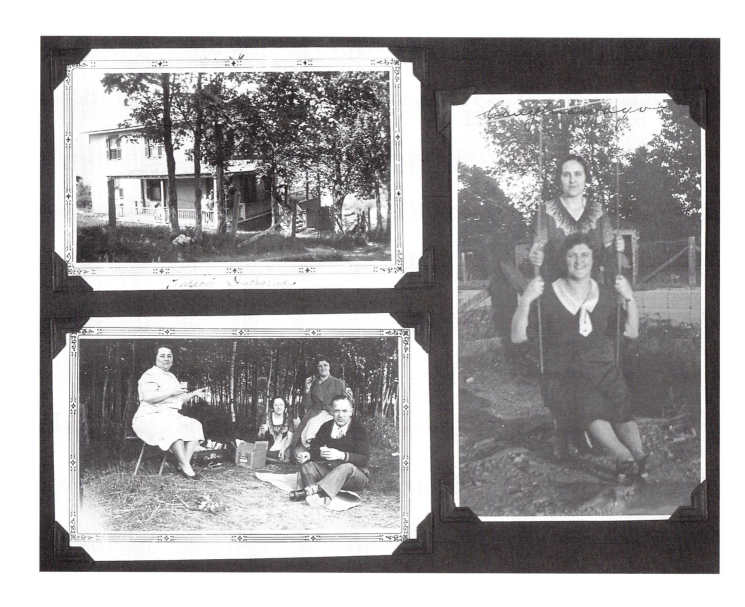

The child in the white snowsuit, sitting in his stroller in front of the stone entrance, separates two rinkside portraits of the sisters. On page 25 the family group from St-Maurice (mother on the swing) and a picture of the father (declaiming from the Ste-Julienne bandstand) are divided by a picture of a girl and a boy (a reprint from the 1926 series).

We have already looked at the layered treatment of the younger sister's school picture on page 21. The use of the gaze to make associations between photographs can be seen elsewhere in the album; one effect is to heighten the integrity of the page. The tilt of a head, the curve of a back, or the angle of a body may function as a visual *repoussoir* or express correspondences. This is an album of corporeal expression and allusion. On page 11 a picture of a twenty-year-old boy lying on the grass, smoking and grinning up at the photographer, would be unidentifiable without the adjacent picture, the Terrebonne portrait of the boy and his smoking father. Fusing their faces – stripping years from the father, aging the young boy – makes up the features of the reclining youth. Incidents plucked out of space and time are unified by intrinsic and extrinsic associations; they unify the page. An extension of this formula unifies the album overall.

There are two cases in the album of actual repetition – the same image used more than once, just as Views / E.M.W. doubly presented pictures of the Peterborough gravesite, among others. In the sisters' case, one of their rowboat portraits, taken at Ste-Adèle in August 1938, is first presented as an enlargement, then ten pages later in its original, dated snapshot form (page 75). The older sister rows the boat and the younger sits in the stern as passenger. Neither waves or smiles. They are both looking straight at the photographer, the younger with something like directorial intensity.

This dual portrait comes off very well. Within a landscape format, the lake fills half the frame, rising to a level horizon, the opposite shore dotted with cottages. Compositionally, the scene is reassuringly contained: another rower pulls in from the left edge of the picture; the right edge is defined by a line of boats bobbing at their moorings. The women and their boat are thus surrounded by water and immersed in a humane landscape. The other members of their party are unaccounted for, although logically we know that someone is pressing the shutter. But the contentment and self-sufficiency of this pair seems almost to be willing the picture into being.

On page 65 the enlargement of the 1938 rowboat portrait is accompanied by a single portrait of the younger sister taken sometime between 1941 and 1945 on a deck or a lookout. Arms folded, leaning back on the railing, she projects a kind of rueful satisfaction, grounded in the realities of middle age. The boating picture shares page 75 with a snapshot of three young women – two previously seen hanging off the train – riding a horse and buggy, a photograph taken in 1945 at Ste-Adèle. Facing these images is the odd trio of page 74: the young woman on the tracks, Rachel being read to in bed, and the party with balloons in the dinghy (the older sister in the twenties). In the cluster formed by pages 74 and 75, the repetition of the rowboat portrait eases the exchange of happy memory and fearful anticipation.

In the second case of repetition, the snapshot first appears on page 57 in a cluster of images mainly connected with Ste-Adèle. The 1938 holiday is represented, as are the shorter visits of 1941 and 1945. The anomaly in this display is a photograph of the four adult day trippers at St-Maurice, "27 Août 1933." It is one of the boy's long views, here blotted by the sign of the amateur, the shadow of a thumb. On the bottom right is a picture of the younger sister, dressed as we first saw her on page 4, her look as severe as the cut of her clothes. Now she is standing on the steps leading to The Red Room of the Ste-Adèle Lodge. Bracketing the forward-looking figure on page 4, this woman looks back, a clear message reinforced by the second, more emphatic use of the same image.

An enlargement of the same "Red Room" portrait is the last item in the album. Isolated and mounted with an asymmetrical flourish, the portrait is endowed with the authority of a signature. Should we trust this one piece of textual evidence and ascribe the album to the younger sister? We can, because the repetition of this photograph is only confirming

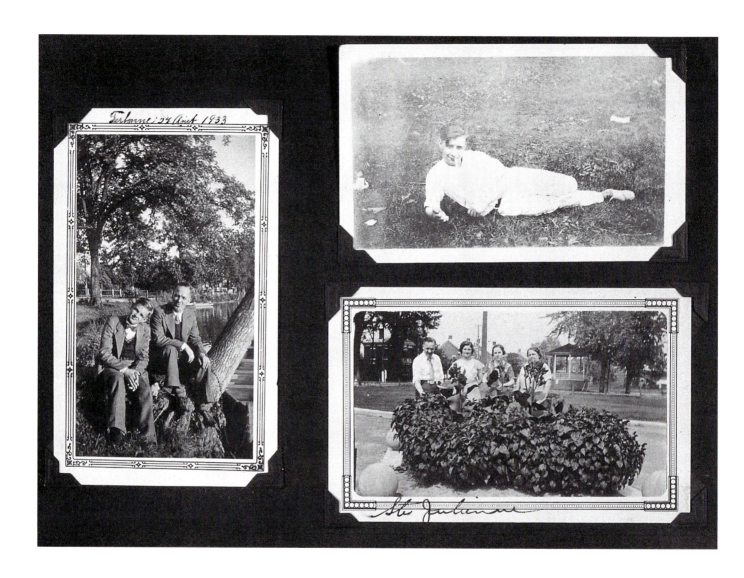

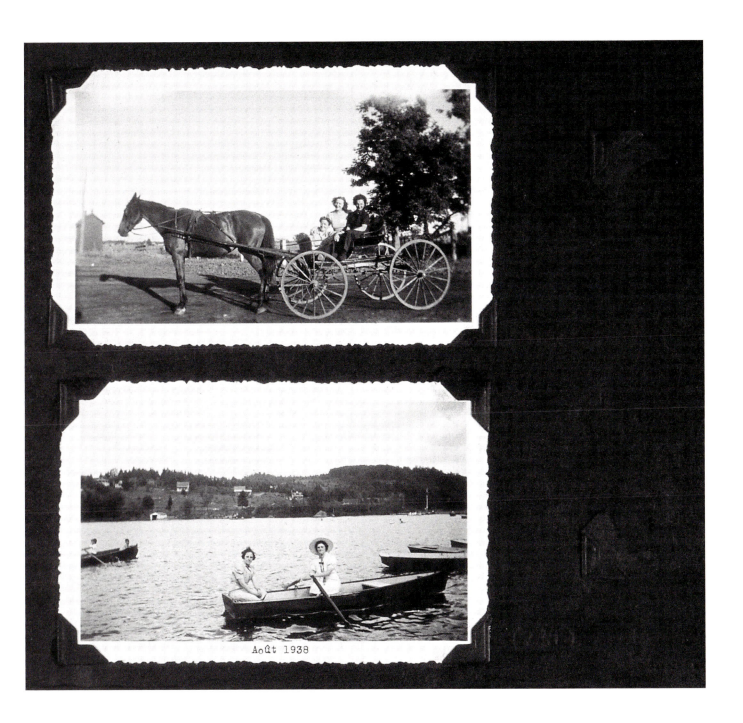

Août 1938

what we have already learned about the sisters from the vestigial orality of the album.

Imagine the younger sister showing you the album. She is going to use the name of her sister, or some phrase that describes her sister, 115 times. Imagine the tenderness in her voice, for she clearly loves her sister and does not tire of thinking about her. The character of her sister will be drawn by the roles you see her playing in the album, and by the same caress that we heard in the voice of Gretta Chambers. And the younger sister's character will also be exposed, as the primary observer of this small world and our partner in conversation.

PATTERNS OF PRESENTATION

The organization of the album flies in the face of chronology, so we are not surprised to find photographs from 1944 and 1945 mixed in with those from other periods. The beginning and ending of this album is conceptualized in other ways – most importantly, in terms of relationships. Placing the 1941 portrait at the end of the album is a form of homeostasis, substituting a symbol of steadfast devotion for the reality of impending loss. The backward look, the refusal to say goodbye, is an antidote to the four photographs on the previous two pages, which are all about goodbyes.

Three of these photographs are rather dark and closed. In this album of lakes, roads, open fields, and mountains, one is suddenly confronted with three interiors, a dining room, a living room, and a bedroom. The sisters' world is shrinking. In the dining room a crowded group photograph marks what was no doubt a very happy occasion, a formal dinner blessed by the presence of a priest and a very elderly Rachel (page 76). On the opposite page, Rachel is unquestionably the main figure, posing with family and friends in a living room. The last photograph in the spread is a portrait of Rachel propped up in bed, reading the newspaper. She has grown old. Soon she must disappear.[12]

Completing the spread is a photograph of the older sister, who poses meditatively before the Ste-Adèle church; she is covered up to her shoulders in flowers and framed by the lancet-arched doorway of the church – her arbour, her rowboat, and her coffin all in one. The younger sister's worst fears are displayed across these pages, but her pain is eased by their placement within the album. Turning finally to the Ste-Adèle outing, seeing herself through the eyes of her older sister as strong and independent, restores her sense of presence and well-being. Responding to what was and what inevitably must be, the younger sister prepares for the retelling: the candle comes to glow again, ignited by her art of memory.

Throughout the album, photographs have been organized by association into echoing patterns that can be heard in presentation. Specific sessions and photographic habits have created series of images that are fragmented and spread throughout the album, multiplying their internal and external references. Each "and" in this procession of discrete visual narratives lends another angle to the characters' lives. Each page also forms an aggregate that may be mirrored on the opposite page or reiterated elsewhere in the album.

One effect of this structure in presentation is to dismantle the workings of time. The picture of the boy, his mother, and his two aunts playing leapfrog on a country road is a perfect metaphor for this process (detail, page 40). The past is always relative; on each page, the criss-crossing of dates confronts the distant past with the recent past and mixes the present with the future. The way it is told, nothing ever ends (except, *Dieu merci*, the hike). The picnic or the boat ride is continuously narrated, then, now, and forever. The fragmentation and repetition of such events prompt feelings of déjà vu that are more actual than empathic. Memories are imminent; stories are latent. Visual reminders form cycles of prediction and actualization, memories brought sharply into the present by the telling of the album, the imaginal dialogue of spectatorial re-enactment.

The unaccompanied album requires of its viewer both interrogation and performance. Each of us must play the dual role of teller and listener. To understand the album, we need to hear it. To hear it, we must risk a little madness, a little ridicule, and speak it in a chorus of voices.

"Photographs" 1916–1945 (MP 035/92), 40 (detail)

Page 27, three photographs: a couple embracing by the side of a country road; three women and a man standing at the back of a car, with one woman pouring from a thermos; a woman standing inside a gate, her elbow resting on a post as she gazes into the distance. That photograph is inscribed "St-Maurice, 27 août 1933." The compiler says:

That's my brother and his wife. That's Jean-Paul and Marie-Jeanne. He's a character, that Jean-Paul. He retired last May. They're in Florida now. So here we are, going to St-Maurice. We stopped at a farmhouse for a picnic. There was nobody there, so we just stopped. We took a lot of pictures because the farm was so nice and old-fashioned.

Did you know the people?

No, no, and we didn't go near the house. We just stayed close to the road. I remember a swing attached to a tree. We took turns taking pictures on the swing.

That's your sister.

Yes, that's Pauline, leaning on the fence. There is another picture of Pauline and me together with her sitting on the swing. I have it somewhere in the album.

We were just looking at it, weren't we? Oh no, that's your brother and his family.

That's right. Now you see that picture in the middle, that comes much later. Jean-Paul bought that car years later. Our nephew, André, took that picture. That was our last trip all together. We must have been going to visit André's fiancée's family at Lac Noir. I don't know. There were many picnics before Roméo died, but not so many at that time, so that must have been it. Yes, we look like we're in a hurry to get somewhere, and Marie-Jeanne is wearing a good dress and white shoes.

But that's a very good picture because we have Pauline, and Marie-Jeanne, and Jean-Paul, and that's me. I'm pretending to pour coffee from the thermos. So it looks more like a picnic.

I turn the page, to find the same couple playfully embracing or pretending to dance by the shore (he is smiling at the camera, clenching a cigarette in his mouth; she is finding her footing and looking down at the ground) – "Lac Noir." In the middle picture, four tiny figures stand on the steps of a church – "St-Donat 1933." On the right, three women and a man, all formally dressed, stand in a line to be photographed by a man whose shadow creeps into the bottom of the frame – "St-Barnabé." Now we hear the boy:

Oh yes, we were all brought up Catholic. My aunts, they were very religious. My mother too, but it was okay. We used to go for long drives on Sunday after mass, all of us in the car. My father loved to drive. My mother cooked. My aunts took pictures. My parents – my father – were real clowns. We used to go to Ste-Adèle – they made a whole album from the pictures – but after we got married, it seemed like we should go to my wife's family's place, and then with the kids and the job, well.

Do you take a lot of pictures of your kids?

My wife does.

Now, two women are playing ball across a country road. "Beaconsfield. Vraie partie. 1933," they say, but it's really make-believe for the camera.

This was a very nice day in the country. You see, we are playing catch. That must be André's ball. We are out in the country, somewhere. Well, it says "Beaconsfield," so that must be it. We went to Rigaud on that trip and all the way to Ontario. There's a picture somewhere of the two of us with a sign that says "Ontario." We didn't get very far, but that was a long drive in those days. Another time, we went to Ottawa.

The two sisters, in their darkest Sunday best, are teetering on the edge of a river. I recognize Terrebonne, or what the compiler remembered as Terrebonne, 1933, when she inscribed the companion picture of the man and the boy.

That was the same spot, very pretty with the tree hanging over the water and the boat. André looks so much like his father now. That picture that he sent us where he's lying in the grass. I still can't believe he's married. Well, here we are in Terrebonne. There was a lovely park there with flowers and a cannon. André especially liked the cannon. I took their picture and then André took this one of Pauline and me in the same place. It's not as good. He took it before we were ready and he wanted to get the whole thing in, the tree, the boat, the building. He was just a young kid.

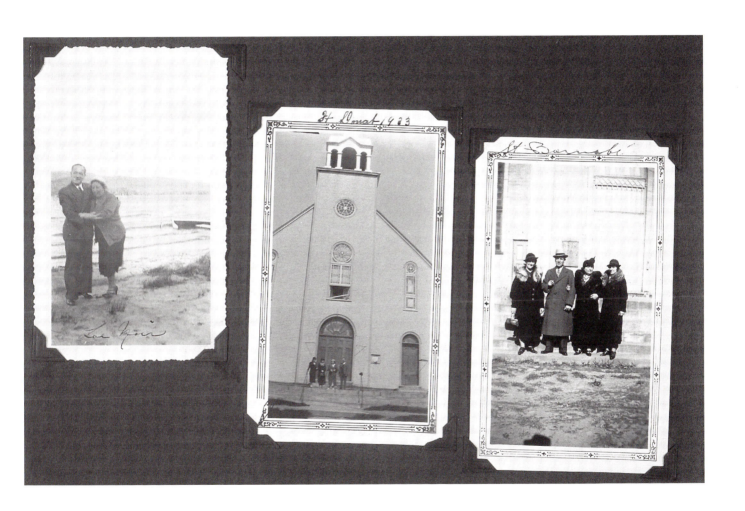

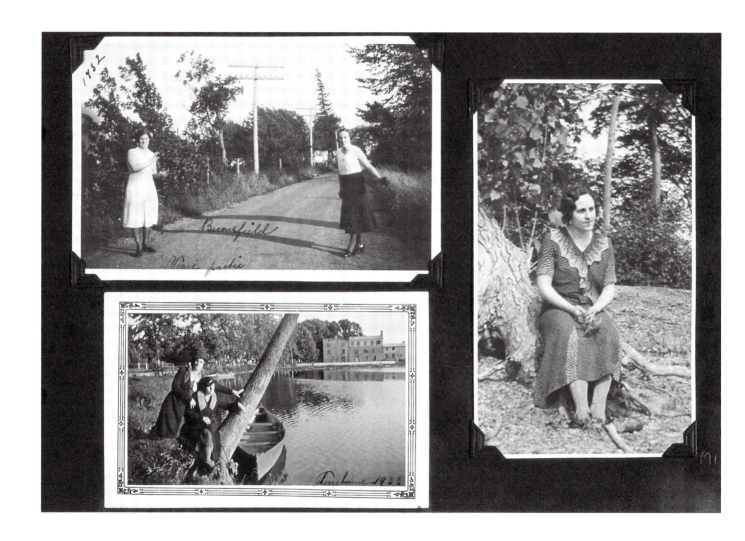

And here she is, sitting quietly in a woodsy setting, our lady of the printed collar.

I wore that dress a lot. I liked it. It was very loose and cool and I liked to wear it for our Sunday drives.

This is not a family album, in the abstract sense of a chronological account or genealogy, but an album about family. Its compiler is a woman who tells and retells her devotional tale, who gives praise in a multiple tableau of family lore, who asks us to remember everybody in this small universe of sisters, the elder in her constancy and the younger in her evergreen patterned dress.

CONCLUSION: REMEMBERING TO TELL

Orality lingers in the depths of photographic consciousness, silently petitioning for critical recovery. Yet so vital is the link that the merest suggestion is sufficient reminder; allusions to photography and orality can be caught like butterflies in a net. It was Alfred Appel, then professor of English at Northwestern University, who first captured the beautiful Joycean specimen that opened this book. His particular interest in the photographic memento mori was piqued by a snapshot of his own mortality, his understandable reluctance to be translated into a "grave image" before his time. Reflecting on Lee Friedlander's homage to Walker Evans (1903–75), a view through a window down onto a Cambridge street that included a postcard reproduction (a souvenir?) of Evans's 1930 photograph of a Boston row, Appel remembered passages from Nabokov, Hemingway, Wright Morris, Kafka, Joyce, and others that similarly evoked "our basic call for photographs," the desire to speak to their elegiac presence.[1]

Like Appel, we are fascinated by these shades, though more than a little anxious to follow Bloom out through the cemetery gates and get away from the stillness that the grave without the gramophone seems to represent. The photographic album, *the faithfully visited gravestone*, is a monument to memory. Granted, but let us render to memory what is proper to memory, its life-sustaining function in the present.

We can begin this process by reopening our analytical minds to a pattern that we instinctively know: the vestigial oral framework shaping the contents, structure, and meaning of the photographic album.

As a tool for collection research, the oral-photographic framework has tremendous potential, expanding contextual readings and reinstating the album in its raison d'être, its relevance to an audience. On the basis of orality, the specific and heretofore maddening aspects of an album can be restored to their communicative functions. The utility of repetition and clichés now explained, it should be impossible to ignore the epithetic nature of echoing portrayals, or to neglect the predictive conflations of typologies. The aggregate structure of the album then becomes anything but random; meaning is nested in clusters and adjacencies that leap to the eye. Sounding out the arrangements of elements, to hear (the better to see) the compiler's devices, finally makes use of the disused notion that the album was compiled by an individual for presentation in discursive spirit – a conversation held by the album in suspense.

The case for orality has been made on the basis of a public collection, but complete anonymity may not be the most severe test. Albums that remain in private hands are no less mysterious, and the oral-photographic framework can be used to break the codes of family lore and family secrets. The amateur sleuth still reigns superior, for the main thing is to develop an empathetic relationship with the compiler of the album. Patience and perseverance work wonders.

Public collections present other difficulties. To "get with" the jargon, priorities will have to be adjusted. Albums cannot be catalogued in a hurry; habits of attention and recording practices will have to be changed, effectively breaking the cataloguer's dependence on the written word. For while it goes without saying that an album should never be dismantled or tampered with, imaginative reconstruction is another matter. An album is a classic example of a horizontal narrative shot through with vertical lines of both epic and anecdotal dimension; these entry points (the album's myths and kernel stories) are valued differently depending on the narrator and the moment in time. The said and the unsaid are twin sentries evadable only by craft, luck, and readiness. So an album must be entered again and again, and yet again in different company. Its description in the museum's catalogue should mention the doors that are still unopened.

Is every album worthy of this effort? Considering the younger sister's album, what practical gains have we made? We may feel that we understand the sisters better, that they have transcended ordinariness, namelessness, and their temporary relegation to the dust heap, to become folk heroines of sisterly affection and the capacity to dream. On the social-historical side, the album offers an alternative perspective on family life and reminds us of its particularities in an abrupt paradigm shift. The sisters were childless. Daughters, nieces, cousins, they buried their relatives, remembering everybody as best they could; but when the last sister died, no one was there to claim her album as an heirloom. Perhaps unmarried aunts and uncles – those without the blessings and burdens of children – are the compilers whose histories of family life end up in public collections. Finding such an album in a museum, we must consider the possibility that our vision of family life comes, not from the source or the centre, but from the margins of observation and construction. The younger sister elucidated a very moving family *idea*, and we shall remember her for that. Can we remember as well the receptiveness and complexity of this ordinary woman's vision and apply it to our own public exhibitions of human experience? I wonder.

As important as it is to remember everybody, the recognition of an affinity between oral tradition and photographic compilation has other implications. Ong's psychodynamics of orality give shape to memory by explaining its transmission within the conditions and exigencies of oral consciousness. Photography, too, is concerned with memory – some would say it inscribes it – but the accommodation of photography within a mnemonic system that leaves no tangible inscription has something else to say about the nature of photography, its relationship to memory and language.

We must recall the fundamental point that the features of orality which have enabled us to make the correlation with photography have been derived from transcriptions of recitations. They are the likenesses of telling and listening – hard copies of things transitory and provisional to their incorporeal core. Photography draws from the same well of evanescence because (like other art forms) it is concerned with transitory human experience and because (unlike other art forms) it can simulate its qualities. The cluster of expressions that accrue to an impression of devotion in the older sister flickered across her face under specific conditions and were gone. The camera caught them and turned them into an observable feature of material culture. But they are no less ephemeral for all their permanence on the sheet. Cataloguing their recurrence should not obscure the fact that photographic images are tokens of irrecoverable experience. But there is no loss, no cause for keening, when the process of remembering reactivates the image and leaves its own experiential trace.

Through Ong, we have examined a number of features that distinguish orality from literacy. According to Goody and Watt, a crucial difference resides, not in the way that societies remember, but in the way that they forget. The homeostatic organization of culture in a non-literate society provides for the assimilation of the past into an active present. The process is dynamic in the sense that irrelevant memories and the language that preserved them are shed. Goody and Watt do point out the existence of certain "mnemonic devices ... which offer some resistance to the interpretative process. Formalized patterns of speech, recital under ritual conditions, the use of drums and other musical instruments, the employment of professional remembrancers – all such factors may shield at least part of the content of memory from the transmuting influence of the immediate pressures of the present."[2] We could now add the photographic album to their list. It is also a mnemonic device and a fine example of congruence between tradition and society in its adaptation of oral consciousness to modernity's literary guise.[3]

The pleasures of provisional meaning and performative engagement are hardly unknown in literary theory. A single essay by Wolfgang Iser contains striking parallels to the features and conditions discussed in this study as oral and compilatory. Terms such as "concatenation" and "gaps of indeterminacy" are transferable without comment to the additive structure and dialectical reception of a photographic album. Iser refers also to the reader's tendency to group things and fill in the gaps in an effort at harmony, an illusory exercise that belongs to the reader alone.[4] In a similar vein, Gillian Beer invokes Tzvetan Todorov's "'perpetual present' of narrative," which allows "fresh participation on each occasion of reading," each experience admitted to memory, to "mingle, forming networks of allusion with other reading and other experiences of time."[5] The underlying message is simple: works of the imagination require the workings of the imagination to be received. To the appreciable degree that we imagine history, the same observation applies to and covers the genres of life history that we have been examining: the collections, memoirs, travelogues, and family sagas that impress themselves into our déjà vu as realities.

Our sense of reality is what is at stake. A photographic album is made up of photographs, the democratic traces of the real. An Atget may point, as Szarkowski has proposed,[6] but his photograph points in many directions at once. What tiny detail will assert itself later, and on whose watch? As invitations to re-enactment, photographs cover themselves again and again in fresh recollection. They are revisionist by nature.

The album applies the strategies of orality to bring this propagation to order. It treats both remembrances and remembering. Its function as an *aide-mémoire* is not just literally or figuratively to present everything that is to be remembered but also to prepare and activate the mnemonic condition. "In an oral culture," says Ong, "experience is intellectualized mnemonically."[7] Our photographic culture is flooded with memories – information new to us that needs somehow to be received in a state of remembrance which will allow us to receive it again. The album exhibits a wise solution.

Its oral-photographic framework greases the wheels of retrieval, reinstating and expanding the repertoire of remembrance as the images are seen and heard in a rolling present. It is remarkable, I feel, to be able to see so clearly the dynamic process of memory being husbanded through transmission – remarkable especially in an instrument so often assigned to moribund convention.

Having met the hopefulness of Lieutenant Snyder, the encyclopedic ambitions of Ogilvie, the wickedness of Birch, the searching of Johnny Webster's mother, and the tenderness of the sisters, we have passed twice through the cemetery gates. There are lessons for image-makers, critics, and curators in the winding structure of these photographic albums. There are lessons for us all in their resonant tales.

APPENDIX ONE
A Note on the Photographic Collections
at the McCord Museum of Canadian History

"Everybody keeps a photographic album," wrote John Towles in 1864, and his observation still holds true, though not everybody knows it.[1] In museums and archives, everyone's albums are held in public trust. In Canada the collection of albums held by the McCord Museum of Canadian History is a splendid example. Not only does it trace the history of amateur compilation from the beginning, but it also records different attitudes to albums over an exceptionally long term. The McCord's initial acquisitions in this area anticipated the involvement of most other museums by some fifty years. In family albums alone, the McCord Museum offers remarkable opportunities to compare the products of two and three generations. Many of the collection-type albums that are the focus of chapter 2 have been part of the museum since its creation.

The McCord Museum is the legacy of a nineteenth-century lawyer and landowner, David Ross McCord (1844–1930), whose somewhat alarming motto, "When there is no vision, the people perish," summarizes the urgency of his quest.[2] McCord's lifelong interest in aboriginal and colonial history is more positively expressed in a collection of artifacts and documents held by his namesake museum.[3] These include photographs and photographic albums from Montreal families. McCord himself was a compiler and he also commissioned photographic compilations, most notably from the

Montreal landscapist Alexander Henderson. In 1919 McCord succeeded in his campaign to give his collection to the Royal Institution for the Advancement of Learning, better known as McGill University. Two years later, the McCord National Museum was officially opened in downtown Montreal.

The initial deed of gift was for fifteen thousand objects related to all aspects of Canadian history; these holdings were only the beginning, and as the collection continued to grow, so did the need for proper housing and display. In 1971, under the direction of Isabel Barclay Dobell, the McCord Museum opened in its current location on Sherbrooke Street in Montreal, a building that was subsequently renovated and expanded, reopening in 1992. Many more albums, including the McCord family's, had come to the museum since its establishment, and the photographic collection had come into its own with the arrival of the Notman Photographic Archives.

The Notman Photographic Archives preserves the legacy of an earlier nineteenth-century photographer and businessman, William Notman (1826–91). His bustling Montreal studio, the cornerstone of a small empire, was the source of some 400,000 images alone. Founded in 1856, the studio remained in the Notman family until it was sold in 1935 to another commercial concern, the Associated Screen News, which divided the operations into the historical division, run by Charles Notman, and the commercial studio, Wm. Notman & Son. Business continued in this way for nearly twenty years until the death of Charles Notman in 1956, when the company was reorganized and the historical section and the commercial studio separated. The historical division's glass-plate and film negatives, prints, and documentation were donated to McGill and assigned to the McCord, creating a department known as the Notman Photographic Archives, under which the museum's entire photographic collection was gradually consolidated. The reputation of the Notman Archives grew, and its holdings were enhanced by donations and purchases that reflected a general interest in photographic experience and the enlightened, grassroots approach to social history of the Notman Archives's first curator of photography, Stanley G. Triggs.

This public collection developed as a private person's might, by watchfulness and waiting, through unexpected acts of generosity. Albums initially were acquired because they contained photographs from the Notman studio or could be related somehow to the firm's activities. Such albums might include the work of other professional studios, as well as the typical snapshots of Canadian families. Of particular interest are the Notman family albums, which, like any ordinary family's, trace an evolution in the source and style of the contents, from studio portraiture to the snapshot. But the McCord family's passion for photography was no less important, or infectious. For generations, the McCord Museum was considered the "attic of English Montreal." Accordingly, many of the albums in the collection have simply been transferred from one attic to another, often part of larger donations of private papers and works of art. The McCord "family" has grown and criss-crossed linguistic and social divides. Local collectors have been inspired by the museum's mission to preserve Canadian heritage; they have scouted for the McCord at flea markets and remembered the museum in their wills.

The McCord is not an art museum but a museum of social history. The albums are therefore valued more for their illustrative potential – the subject matter of component images – than for the aesthetic value of the photographs or the album as a whole. Nevertheless, the museum recognizes that the intentions of the compiler are intrinsic to the meaning of the object and thus to its place in social history. The photographic collection, famous because of Notman, also serves the other interests of the museum, complementing its holdings in costume, textiles, ethnology, and decorative arts, as records of the objects in situ. The collection is much consulted by historians, curators, art directors, and the general public in search of visual records and atmospheric illustrations.

The merging legacies of nineteenth-century philanthropy, artistry, and commerce have resulted in a diverse group of photographic albums, records of private life and compilatory

tendencies from 1860 to 1960. The collection of the McCord Museum now contains over two hundred and fifty personal photographic albums, tens of thousands of photographs in all. This rich environment was the seedbed for my discoveries in photography and orality.

Between 1992 and 1997 I had unfettered access to the collection, where I examined about 230 personal photograph albums, all acquired before 1 January 1993. This large group formed a reference collection whose parameters and strengths guided the selection of works for a study collection, now the basis of this book.

In characterizing this collection, the first thing we can say is that personal photographic albums are made of photographs acquired for personal reasons. Those photographs were not necessarily taken by the compiler; they may have come from anywhere. The album is an amateur album, in the sense that an amateur has compiled it. Within the reference collection, the breakdown between albums made up of studio photographs and those composed of amateur photographs is roughly half and half. There are almost as many albums of cartes-de-visite, cabinet cards, and tintypes as there are snapshot albums, even though the golden years of studio photography (1860 to 1890) represent less than a third of the period in question. The museum's concentration on nineteenth-century photography flows from the two founding collections. A strong emphasis on studio portraiture, especially of family and friends, also marks this period. Images derive from studios in eastern and central Canada, the northeastern United States, Britain, Europe, and sometimes further afield. Montreal-area families predominate as both compilers and subjects, though their albums are also visited by the famous and the unknown, whose images they purchased or exchanged. Within the studio period, we also find scrapbooks of photographic portraits combined with drawing, painting, and decorative design, albums that belong to the pastimes of collection and display.

As well, there are albums of purchased pictures that touch on travelling and reminiscence. Within those genres, we find print collections of landscape and architectural views, as well as albums of cartes-de-visite dedicated to art reproductions, celebrities, and peoples considered "exotic" at the time. These thematic volumes, while individually impressive, form a very small part of the McCord's nineteenth-century holdings, a reflection perhaps of their early desirability on the photographic market. The McCord's photographic collecting has not exerted much influence on that market, nor has its collection been much shaped by collecting trends. In expanding its collection of albums, the McCord has relied mainly on donations. Ironically, the museum's enforced dependence on its "family" of supporters has increased the value of its album collection to a researcher by reducing the likelihood of creative tampering by a dealer.

In the snapshot world of the reference collection, the highest proportion of family-type albums is from 1900 to 1920; there are approximately half as many from the 1920s through the Second World War. It stands to reason that few amateur albums from 1945 to the present have come to the museum; the exceptions are either memoirs or anonymous albums. Little representation from the fifties and sixties means very little colour. Most snapshot albums are comprised of gelatin silver, black and white prints made in commercial laboratories. Some snapshots have been printed in amateur darkrooms; some have been masked in the printing or trimmed into novel shapes, such as ovals, diamonds, or maple leafs. Some privately or commercially printed images have been hand-coloured.

Personal albums dedicated to travel represent a small, though interesting component, clustered around the turn of the century. Travel is a constant secondary theme of other albums, whether they are family or individually focused as diaries or memoirs. Personal photographic memoirs are also present, often bracketed by dates and consistently energized by a certain sense of urgency in the moment. Typically, they stop when normal life is restored. Still another framework for the snapshot is the thematic collection; a number are constructed as scrapbooks, some with encyclopedic ambitions.

Overall, albums of social relations dominate the reference collection, accounting for nearly two-thirds of the objects. Thematic albums on subjects other than family represent little more than a third of the collection, though their presence seems larger. Documentary projects tend first of all to be bigger than family-type albums of the same vintage. Some thematic albums extend to several volumes; they are voluminously detailed. In a concise history of the Notman Photographic Archives, Stanley Triggs signalled the importance of a group numbering over 6,000 photographs, "taken in the High Arctic between 1865 and 1960 ... snapshot albums compiled by officers of Hudson's Bay Company ships who made the long voyages from Montreal to supply company trading posts on the Arctic Islands and Hudson's Bay."[4] As records of service, industry, national expansion, feats of engineering, and urban renovation, a number of thematic albums are comprehensive and accomplished, complementing the legacy of the Notman studio. Access and timing – the amateur's luck – elevate their status in the collection.

This note on the McCord album collection is based on sources listed in the bibliography, as well as on documents on file at the museum and information provided by the archivists. For a recent overview of the collection as a whole, I recommend Stanley G. Triggs's 1996 article for the *History of Photography*. Triggs has written and collaborated on a number of publications, catalogues, and articles about Notman and his family members and associates and about Alexander Henderson, which have informed this book. In addition to the entries listed under Triggs and the McCord Museum of Canadian History, see the bibliography under the Art Gallery of Ontario (1985); Roger Hall, Gordon Dodds, and Stanley Triggs (1993); and J. Russell Harper and Stanley Triggs (1967).

APPENDIX TWO
The Photographic Albums Illustrated in the Text

All the albums are from the Notman Photographic Archives of the McCord Museum of Canadian History. Listing follows accession numbers by year within each series. Three series are coded: MP, M, and N. The MP series (museum photograph) is the current numbering system. Adopted in 1973, this system encodes the year of acquisition in the last two digits after the slash mark. Albums acquired prior to 1973 have been assigned numbers in the MP series without an accession year. The M series (McCord Museum accession record) has been replaced by the MP series. M numbers are shown in parentheses after the MP number to facilitate retrieval of registration data from the McCord accession books. An N series (Notman) number means that the album contains mostly photographs from the Notman studio. Entries in the N series may be cross-indexed with the MP series – MP for the album and N for some or all of its contents. In this case, the N number follows the MP number in parentheses.

The album titles are either inscribed by the compiler (I) or constructed by the museum or myself (C). The dates of most albums are the estimated dates of completion; they generally correspond to the last datable photograph in the group. In some cases, the compiler has signed the album or dedicated it; these dates are given as either start dates or end dates, depending on the sense of the inscription. The photographs in the albums have been attributed, titled, and dated on the

basis of inscriptions or other secure documentation, such as the Notman index. The titles of commissioned or collected photographs, such as cartes-de-visite or postcards, are provided where known. All inscriptions, front and back, are also given, with the caution that they are not necessarily the compiler's but may be later additions by a relative or an unknown party. Inscribed, or documented, titles copy the spelling and punctuation of the original; they are enclosed in quotation marks, while constructed, or descriptive, titles are not. Terms such as "untitled," "unattributed," or "undated" have been omitted.

Measurements of albums closed are given as height × width × depth; measurements of prints as height × width. The standard format of a carte-de-visite is approximately 11.5 × 6.5 cm; the print itself is somewhat smaller. A cabinet card measures about 16 × 10 cm. Exceptions are noted, and other prints sizes are as given.

Numbers in parentheses at the end of each album page description refer to pages in this book.

MP 010. Green Album (C), c. 1940(?). Expandable album with green cloth cover (31.5 × 42.7 × 5.5 cm) containing 147 albumen and gelatin silver prints, 22 printed maps, 5 photographic copies of drawings and historical documents, and 1 botanical specimen, items related to the colonial and military histories of Quebec.

– Page 41. Two views of unidentified site with trees and rubble; two gelatin silver prints, each approximately 10.5 × 12.5 cm. Photographic copy of "Plan of Mount Johnson. Showing the land purchased by Sir John Johnson ... William Sax, Land Surveyor, 1805"; gelatin silver print, 14.2 × 17.8 cm. (59)

MP 139 (formerly M 13578). McCord Red Album (C), compiled by Alexander Henderson and/or David Ross McCord between 1871 and 1878, with possible later additions. Red leather-bound album (54 × 36 × 4.5 cm) containing architectural and landscape views by Alexander Henderson (59 albumen prints).

– Page 8. Alexander Henderson, Temple Grove croquet court (D.R. McCord), 1872. Albumen print, 11.5 × 19.3 cm. (57)

MP 582. Natural History Picnic Album (C), c. 1910. Black cloth-covered Gilson Adjustable album (18 × 29.5 × 5.5 cm) containing snapshots and studio portraits (131 gelatin silver prints), mainly taken in Montreal from 1900 to 1910.

– Page 11. "On Mount Royal, April 28, 1901." Two gelatin silver prints, 9 × 10 cm and 9 × 10.8 cm. (143)

– Page 13. "2297 St Catherine. Nov. 1900." Four gelatin silver prints: 9 × 11.3 cm; two oval, each 10.5 × 7.6 and 8.6 × 10.9 cm. (108)

MP 586. Anonymous Amateur Album (C), c. 1920. Black leather expandable album containing multiple portraits of family and friends, self-portraits, landscapes, urban views, and reportage (169 gelatin silver prints).

– Page 35. Self-portrait; gelatin silver print, 7.9 × 13.4 cm. Group portrait (double exposure); gelatin silver print, 7.6 × 13.1 cm. (68)

MP 598 (formerly M 20107). Captain G.E. Mack Album II (C), 1905–1927. Black cardboard expandable album (26 × 34.3 × 3.2 cm) containing snapshots of Hudson's Bay Company interests and Inuit communities in the Canadian north (227 gelatin silver prints).

– Page 3. Captain G. E. Mack(?), Northern family and buildings, c. 1920. Four gelatin silver prints, each 8 × 10 cm. (51)

MP 1452. Photographs: Canadian Scenery (I), 1879. Red leather-bound photographic album (43.5 × 34 × 5.8 cm) containing mainly landscape and architectural views by Alexander Henderson, as well as 5 works by Notman & Sandham (189 albumen prints). The compilation was commissioned from Alexander Henderson by May, Hattie, and Ethel Frothingham as a gift for their uncle, John H.R. Molson.

– Page 92. Alexander Henderson, "Under Table Rock," albumen print, 20.3 × 15.5 cm; "Under Table Rock," albumen print, 15.3 × 21 cm. (56)

MP 1768. John Thomas Molson(?). Small Molson Album (C), c. 1860–1875. Black leather-bound album for cartes-de-visite (12 × 9 × 3 cm) containing a personal collection of family portraits dating from J.T. Molson's first marriage to Lillias

Savage and continuing after her death in 1866 into his second marriage to Jennie B. Butler.

– Detail (original placement unknown). William Notman and John A. Fraser, "Mrs J.T. Molson," 1866. Hand-coloured carte-de-visite, 8.5 × 5.5 cm. (100)

MP 1993. Cannon Album (C), c. 1878. Brown leather-bound album (35 × 23 × 7 cm) containing cartes-de-visite and other photographic images of French and Italian cities, monuments, and works of art (198 images).

– Page 32. "Tableau synoptique des Papes Depuis Saint Pierre jusqu'à Pie IX"; Sommer & Behles (Naples & Rome), three photographs of marble sculptures from the Vatican collection. Four albumen prints, each approximately 9 × 5.5 cm. (60)

MP 2146. Arthur Lindsay or Minnie Lindsay (née Marion Kiefer). Arthur Lindsay Album (C), c. 1866. Black leather-bound album (23 × 18.3 × 5.8 cm) containing a private collection of 102 cartes-de-visite.

– Page 26. Top row: J. Beattie, Clifton, England; J. Egan, London, Ontario; bottom row: J.E. Mayall, London, England; Maitland, St Catherines, Ontario, "Mrs Arthur Lindsay, St Catherines." Four cartes-de-visite. (43)

MP 2147. Baker(?) Album (C), c. 1876. Brown leather-bound album (16.5 × 14 × 3.5 cm) containing 29 cartes-de-visite or albumen prints of the same size.

– Pages 22–3. Notman & Sandman, Montreal, "Aunt Eliza Dunning" (22979-II), 1876; Field, Montreal, "G. papa's mother." Four cartes-de-visite. (106)

MP 2151. MacDonnell European Travel Album, c. 1904. Grey cloth-bound snapshot album (26 × 20.5 × 2.5 cm) tracing a family's tour of Britain by motor car.

– Pages 4–5. "Tender 'Ireland' taking passengers from the Campania for Queenstown, Aug. 1904"; "Nothing but a drink on Lake Windermere, Aug. 1904"; "'Old England Hotel,' on Lake Windermere, Bowness, England, Aug. 1904"; and "Felton, England, Aug. 1904, '14 Punctures in one tire in one day.'" Four gelatin silver prints, each 9 × 14.8 cm. (84)

MP 2152. Bloemfontein to London. Via East Coast, Egypt and the Continent. M.C.B. and C.J.A / Feby to May 1910 (I), c. 1910. Brown suede-bound snapshot album (19.7 × 25.4 × 1.9 cm) recording the journey of a woman and a man from Bloemfontein, Orange River Colony (now part of South Africa), to England (176 photographs, most captioned by the compiler).

– Page 10. "C.J.A./M.C.B./The mode of locomotion in Mombasa"; "Government Offices, Mombasa"; "Principal Street and Gov. Offices/Mombasa"; "M.C.B. on Ghari, Mombasa 1910." Four gelatin silver prints, each 5.5 × 7.8 cm. (86)

MP 2155. Lafleur Album (C), c. 1880–1900. Brown leather album (25 × 20 × 6 cm) for cabinet cards compiled as a private family history within the Baptist evangelical movement of Quebec, as chronicled by Théodore Lafleur in *A Semi-Centennial Historical Sketch of the Grande-Ligne-Mission* (1886?).

– Pages 2–3. W. Notman, Montreal, "Copy of portrait of Mme Feller" (31900), 1868; portrait of a unidentified man. Two cabinet cards. (103)

MP 2160. Richard. J.W. Birch. Birch Album, begun 1862. Dark green leather-bound album (15.5 × 22.5 × 3.5 cm) containing a collection of portraits of Richard J.W. Birch's friends and acquaintances during his military service (46 cartes-de-visite).

– Detail, page 10. W. Notman, Montreal, "Lieut Clower 30th Regt / Nuckle headed monster," 1864 (13160). Carte-de-visite. (69)

MP 2162. The Royal Album (I), c. 1862. Brown leather-bound album (15.3 × 13 × 3.5 cm) containing 18 cartes-de-visite: 14 portraits of the British royal family by J.E. Mayall and 4 unidentified cartes-de-visite from studios in New York, Brussels, Copenhagen, and London.

– Page 2. J.E. Mayall, "The Queen and Princess Beatrice," c. 1860. Carte-de-visite. (133)

MP 2359 (formerly M 19322; N 057). J.T. Molson Family Album (C), c. 1875. Dark brown leather-bound album (15.5 × 12.5 × 5.2 cm) containing 24 cartes-de-visite, a private collection centred on the family of John Thomas Molson and Jennie B. Butler Molson.

– Pages 16–17. Fratelli D'Alessandri, Rome, "J.T.M."; W. Notman, Montreal, Toronto, or Halifax, "J.T.M.," c. 1872. Two cartes-de-visite. (101)

MP 2360. E.M. Wright, Views/E.M.W. (1), c. 1910. Brown suede-covered snapshot album (24.5 × 31 × 5.5 cm) containing a collection of purchased views and amateur snapshots depicting daily life and community gatherings in Dawson City, Whitehorse, Tagish Post, and other locations in the Yukon (112 photographs).

– Page 27. Larss & Ducloss Photos, Dawson, "Tableau representing Great Britain and Her Colonies at a Concert Given in Aid of Widows and Orphans Created by the War with the Transvaal, Palace Grand, Feb. 15th, 1900" (flashlight photo 2568). Gelatin silver print, 15.2 × 20.5 cm. (138)

– Page 60. Larss & Ducloss Photos, Dawson, "Rev. Mr Wright on Evangelical Tour in the Klondyke on a bycicle at 40 below zero" (2570), c. 1900. Gelatin silver print, 16.5 × 21.5 cm. (137)

– Page 67. E.M. Wright (?), Reverend Wright working at a table. Gelatin silver print, 11.7 × 16.8 cm. (79)

MP 006/74 (N 011/74). Wardleworth Estate Album (C), c. 1880. Green leather-bound album (30 × 22.5 × 7.5 cm) containing a private collection of 7 cabinet cards, 113 cartes-de-visite, and 1 tintype, all portraits, except for 4 fine-art reproductions.

– Pages 22–3. Page 22: (top left) Morgan McAyres (carte-de-visite dedicated to D.W. Ross, Esq., Feb. 1872); and unidentified portraits from Dupee & Co., Portland, Maine; James Inglis, Montreal; and W. B. Burke, Milwauke, Wisconsin. Page 23: unidentified portraits from Bradford studio, Brooklyn; James Inglis, Montreal; Baldwin, Keeseville, New York; and James Inglis, Montreal. Eight cartes-de-visite. (104)

MP 039/76. Annie Craven. Annie Craven Album 1900–1963 (C). Black painted and japanned photographic album (27.5 × 22 × 7 cm) containing photographs of an English nanny, her family, and her charges (16 photographs and postcards; one poem).

– Page 2. Annie Craven and Melville and Andrea Bell (?). Gelatin silver print mounted on card, 14 × 9.6 cm. (117)

– Page 9. Stanley Studio, Stanley, England, Annie Craven, c. 1900. Card photograph, 13.1 × 9 cm. (116)

MP 163/77. D.M. Murphy Album (C), c. 1920. Burgundy cloth-covered album (20.7 × 26.5 × 2.5 cm) containing 89 snapshots and 1 postcard depicting a young man's family, friends, hobbies, and sporting activities.

– Page 13. "Park Ave July 1900"; runners in the street; "D.M. Murphy"; "The R.S.M. P.T. at Camp. Recruits"; "Hans Homer." Five gelatin silver prints, 5 cm. in diameter to 6.7 × 9.3 cm. (149)

MP 183/77. "Nos Amis" Langelier Album (1/C), c. 1905. Black cloth-covered Gilson Adjustable album (18 × 29 × 5.5 cm) containing 120 snapshots, mainly portraits and picturesque views.

– Page 8. "Our Afternoon at the Fort"; "Five O'Clock. Philistines of the Wilderness." Two gelatin silver prints, 9.3 × 11.5 cm and 11.5 × 9.3 cm. (96)

MP 185/77. Langelier Album (C), c. 1905. Black cloth-covered Gilson Adjustable album (28.2 × 21.2 × 5 cm) containing 128 snapshots, mainly portraits and picturesque views.

– Pages 54–5. Page 54: Native families by canoes, gelatin silver print, 9.2 × 11.5; dog before monogrammed curtain, oval gelatin silver print, 9.2 × 11.5. Page 55: "Maggie," gelatin silver print, 10 × 8 cm; unidentified child, gelatin silver print, 5.5 × 3.8 cm; "'Waggles'" now defunct barbarously murdered 1903 by Miss Nepton [?] and her associates," scalloped gelatin silver print, 9.3 × 11.5 cm. (98)

MP 189/78. Hugh Wylie Becket. Becket Actress Album (C), begun 1872. Blue leather-bound album (33.7 × 27.3 × 5.7 cm) containing 120 portraits of celebrities (royalty and actresses), as well as sports teams, with pages decorated in ink.

– Page 9. Hugh Wylie Becket. "Camille Dubois/Langford/Helen Barry/Clara Vesey." Ink drawing with collaged photographs, 32 × 24.7. (52)

MP 032/80. Mrs Charles W. Wagner. Wagner Gaspé Album 1928–1933 (C), c. 1933. Brown imitation-leather adjustable

album (18.5 × 28.5 × 4 cm) recording domestic life and scenery on the Gaspé peninsula (276 gelatin silver prints).

– Page 47. Mrs Charles W. Wagner, informal portrait of friends and scenic view of the Gaspé, c. 1930. Two gelatin silver prints, each 9 × 14.6 cm. (119)
– Page 81. Mrs Charles W. Wagner, scenes of poverty in the Gaspé, c. 1930. Two gelatin silver prints, each 14.6 × 9 cm. (120)

MP 033/80. Mrs Charles W. Wagner. Wagner Wartime Album 1912–1917 (C), c. 1917. Black imitation-morocco album (18.5 × 26 × 4 cm) containing snapshots taken in Canada around the time of the First World War (391 gelatin silver prints).

– Page 62. Mrs Charles W. Wagner, serial portrait of sailor with child and loaded lifeboat (?), c. 1917. Gelatin silver prints, three 11.7 × 7.4 cm and one 4.4 × 6.6 cm. (74)

MP 032/81 (N 012/81). W.W. Ogilvie. Ogilvie Album (C), begun 1868. Stuart tartan bound album (30.5 × 23.5 × 5 cm) containing a collection of 200 cartes-de-visite, all portraits or ethnographic studies, most captioned.

– Page 15. "Alma Dancing Girl," "Syrian Girl," and "Egyptian Women." Four cartes-de-visite. (45)
– Page 48. J. Beckett, Glasgow, "A Scotch Washing"; "Kate Kearney's Granddaughter"; Abdullah Frères, Constantinople, "Constantinople Sedan Chair"; and "Venetian Scissor Grinder." Four cartes-de-visite. (47)

MP 198/81. John C. Webster Memorial Album (C), c. 1931. Black cloth-covered expandable photographic album and scrapbook (32.5 × 28 × 3 cm) compiled in memory of "Johnny" Webster, a Canadian aviator who died in 1931 of injuries sustained in a flying accident (42 gelatin silver prints and 92 newspaper clippings).

– Page 9. John C. Webster as a cadet, c. 1912. Gelatin silver print, 16.5 × 11.5 cm. (62)

MP 107/82. Emily Ross. Emily Ross Album (C), begun 1869. Black leather-bound album (29 × 24.2 × 2.8 cm) containing photographic collages and sketches (45 photographs, many trimmed and framed in vignettes sketched in pencil, finished in watercolour and ink).

– Pages 32–3. Emily Ross, collages (the letter and portrait of a man), c. 1869. Two collages of albumen prints, watercolour, ink, and pencil, each 26.8 × 22.8 cm. (53)

MP 127/84. Fred, W. Berchem. Fred W. Berchem Album 1921–1927 (C), c. 1927. Black linen-covered expandable album (28 × 39.5 × 2.5 cm) containing snapshots of the Canadian north in three sections: photographs on board and from the Hudson's Bay Company steamer *Nascopie*, a sealing expedition, and the sinking of the HBC steamer *Bayeskimo* in Ungava Bay, July 1925 (150 gelatin silver prints, each captioned by the compiler).

– Page 23. Fred W. Berchem, "Returning aboard"; "Returning aboard"; "Scrambling 'home'"; "Hauling and panning seals," 1927. Four gelatin silver prints, each 7.5 × 12.7 cm. (80)

MP 128/84. Fred W. Berchem. Fred W. Berchem Album 1922–1924 (C), c. 1924. Black leather expandable album (23 × 20.3 × 2.5 cm) containing snapshots of the Canadian north and representing Berchem's service as second officer on the HBC steamer *Bayeskimo* (39 gelatin silver prints, each captioned by the compiler).

– Page 14. Fred W. Berchem, "Eskimo woman. Pond Inlet. Aug. 1922" and "Eskimo pilot. Lake Harbour. July 1922." Two gelatin silver prints, each 12.7 × 7.5 cm. (49)

MP 145/84. Langlois/Gélinas Album (C); part 1, c. 1925; part 2, c. 1960. Black morocco adjustable album (17.7 × 28 × 3.5 cm) containing 263 snapshots and photographic keepsakes from two periods of compilation, 1900–25 and 1940–60 (part 2 begins from the back of the album, upside down).

– Part 1, page 21. "Euzebie" (two young women in costumes). Two gelatin silver prints, 9.3 × 11.6 cm and 11.1 × 9.5 cm. (148)
– Part 2, page 18. Six gelatin silver prints, 5.5 × 5.5 cm to 9 × 12 cm. (90)

MP 079/86. Cynthia Jones (née Holt). Cynthia Jones Album, 1917–1923 (C), c. 1923. Black leather expandable album (17 × 27 × 4.5 cm) containing 226 snapshots, postcards, purchased

photographs, coupons, and letters chronicling Miss Holt's wartime nursing experiences, as well as her European and ski vacations after the war.

– Page 8. Cynthia Holt, "Watching the Huns coming over," 1917. Four gelatin silver prints, 8.1 × 5.5 cm, 6 × 8.2 cm, 5.7 × 8.2 cm, and 8 × 5.5 cm. (72)

MP 028/89. Mina M. Hare (?). Souvenirs of a few pleasant summer days 1898 (I), 1898. Burgundy leather-bound album (27.2 × 20.8 × 4.5 cm) containing 96 captioned snapshots recording sightseeing in Montreal and Quebec and a cruise along the riverways of eastern Ontario and Quebec.

– Pages 16–17. "Light-house in Lake St Francis, July 28"; "Coteau on the St Lawrence, July 28"; "Coteau Bridge, July 28;" "Coteau Rapids, July 28." Gelatin silver prints, each 9 × 11.5 cm. (82)

MP 040/90. Mrs W.D. Chambers. Chambers Red Cross Album (C), c. 1945. Multicoloured "wickerwork" album (27.7 × 24 × 2.5 cm) containing 47 snapshots and military photographs of related to Mrs Chambers's wartime role as commandant of transport services for the Woman's Voluntary Service Corps committee of the Red Cross.

– Page 18. "On The Job" (Mrs W.D. Chambers in Italy), c. 1943. Four gelatin silver prints: 14 × 8.5 cm, 10.5 × 6.5 cm, 6.5 × 10.5 cm, and 6.5 × 9 cm. (77)

MP 042/90. Charles-Philippe Beaubien. Charles-Philippe Beaubien Album 1903–1908 (C), begun c. 1903. Soft-covered album (28.5 × 38 × 5 cm) with green fabric binding containing 424 gelatin silver prints, mainly snapshots, with some purchased views and postcards inserted.

– Page 50. Charles-Philippe Beaubien, sailing and family pictures (self-portrait), c. 1905. Gelatin silver prints: top row, each 11.6 × 9 cm; bottom row, 10.5 × 15.5 cm and 11.5 × 16 cm. (146)

– Page 64. Charles-Philippe Beaubien, informal portraits of family members in the country, c. 1905. Gelatin silver prints: top row, 11.3 × 15.5 cm and 11.5 × 13.2 cm; bottom row, 9 × 13.6 cm and 10 × 14.5 cm. (110)

MP 016/92. William Hilliard Snyder. William Hilliard Snyder Album (C), 1916. Black morocco-bound snapshot album (18.3 × 26.7 × 2 cm) containing snapshots, documentary photographs, postcards, and printed material related to the compiler's enlistment and training for military service overseas (160 gelatin silver prints).

– Page 18. William Hilliard Snyder and friends, "Vancouver: Constance/Eric"; "North Arm/Leslie/Kim"; "Eric/George"; "Eric/Muh!"; "Muh/Eric"; "Dark Creek/Leslie/Allen"; "Gwen"; "Leslie/Amy/Muh/Katie"; 1916. Eight gelatin silver prints, each 7 × 4.8 cm. (142)

– Page 25. William Hilliard Snyder (?). "W.O. Reid, 114th Batt. CEF"; "LANGARA B.S.," 1916. Gelatin silver prints: 14 × 8.8 cm and 10.2 × 7.8 cm. (71)

MP 035/92. "Photographs" 1916–1945 (C), c. 1945. Brown leather expandable album (18.5 × 28 × 3.5 cm) containing 234 gelatin silver prints (3 unmounted, 3 hand-coloured), 5 photographic studio portraits, 6 postcards, an "In Memoriam" card, and a clipping. Titles and dates have been transcribed from the back as well as the front of the prints. All the reproductions are of gelatin silver prints, unless otherwise specified.

– Page 1. "1936," 12.2 × 7.6 cm; 12.2 × 7.6 cm; 12.5 × 8 cm; insert, 12.2 × 7.6 cm. (9)

– Page 2. "4 septembre 1933 Baie Georgia," 12 × 7.3 cm; "St-Jean," 12.3 × 8 cm; 11.5 × 7 cm. (10)

– Page 3. 7.8 × 12.2 cm; 6.9 × 11 cm; "Cap de la Madeleine," 7 × 11.5 cm; "Baie Georgia 1933," 7.7 × 12.3 cm. (12)

– Page 4. 7.5 × 12.2 cm; 8.6 × 6.2 cm; 8.6 × 6.2 cm; 7.9 × 12.5 cm (13)

– Page 5. "St Donat 27 Août 1933," 7.6 × 12 cm; 6.7 × 11.3 cm; 8.4 × 6 cm; 7.9 × 12.5 cm. (14)

– Page 6. 7.8 × 12.7 cm; 6.9 × 11.5 cm; 8.2 × 6.5 cm; 7.9 × 12.5 cm. (165)

– Page 7. "1926," 8.6 × 6.4; Art Studio, 48 St Catherine Street E., Montreal, portrait of a young woman, c. 1916, 14 × 8.8 cm; "1926," 8.1 × 6.1 cm. (161)

– Page 9. "St Ours," 12.5 × 8 cm; 8.7 × 6.5 cm; "St Ours," 13.9 × 8.9 cm. (16)

- Page 11. "Terrebonne 24 Août 1933," 12.2 × 7.6 cm; 7 × 11.6 cm; "Ste Julienne," 7.6 × 12.2 cm. (188)
- Page 12. 13.4 × 9 cm; 14 × 8.2 cm. (164)
- Page 13. 13.8 × 8.5 cm; 13.9 × 8.7 cm. (179)
- Page 14. Newspaper clipping; E. David, 170 Blvd Monk, studio portrait of two children (1912–29), 13.4 × 8.8 cm; "1924," 8.9 × 4.4 cm. (167)
- Page 21. "14 Août 1932," 12.5 × 7.9 cm; ? × 4.9 cm; 12.5 × 8 cm; 12.5 × 8 cm. (162)
- Page 22. 12.5 × 8 cm; "Sept. 1932," 12.5 × 8 cm; 12.5 × 8 cm. (181)
- Page 23. 12.5 × 8 cm; "1929," 12.5 × 8 cm; "St Ours 1929," 12.3 × 8 cm. (166)
- Page 25. "St Maurice 1933," 12 × 7.7 cm; 12.4 × 7.8 cm; "Ste Julienne 1933," 12.2 × 7.6 cm. (183)
- Page 27. 12.2 × 7.6 cm; 12 × 7.8 cm; "St. Maurice 27 Août 1933," 12 × 7.8 cm. (194)
- Page 28. "Lac Noir," 11.5 × 7.3 cm; "St Donat 1933," 12.2 × 7.6 cm; "St Barnabé," 12.2 × 7.6 cm. (195)
- Page 29. "1932. Beaconsfield. Vraie partie," 8.7 × 13.8 cm; "Terrebonne 1933," 7.7 × 12.1 cm; 13.5 × 8.2 cm. (196)
- Page 31. "13 août 1933," 12.1 × 7.8 cm; "St Donat 1933," 7.6 × 12.2 cm; "St Barnabé," 7.6 × 12 cm. (171)
- Page 36. "1936 Pension Ducharme," 7.6 × 12 cm; 7.6 × 12.3 cm; "Caughnawaga," 13.4 × 8.2 cm. (186)
- Page 40, detail. 7.5 × 11.2 cm. (192)
- Page 41, detail. "Lac Noir. Août 1939," 7.4 × 11.7 cm (176)
- Page 46. 16.5 × 10.7 cm; 17.8 × 12.6 cm. (169)
- Page 53. 8.2 × 12.4 cm; 8.2 × 12.4 cm; 8.2 × 12.4 cm; 8.2 × 12.4 cm. (174)
- Page 57. "St Maurice 27 Août 1933," 7.7 × 11.7 cm; 7.1 × 11.5 cm; "1945 St Adèle," 7 × 11.5 cm; 7.6 × 12.2 cm. (177)
- Page 64. 12.9 × 17.2 cm. (173)
- Page 70, detail. "Juillet 1943," 7 × 11.5 cm. (184)
- Page 71, detail. "Juillet 1943," 7 × 11.5 cm. (185)
- Page 74. 12.3 × 7.6 cm; 7.7 × 12 cm; 7.2 × 11.8 cm. (17)
- Page 75. 7 × 11.5 cm; "Août 1938," 7 × 11.5 cm. (189)
- Page 76. 9.2 × 12.5 cm; 14.5 × 9.3 cm. (191)

N 060. McCord Family Album (c), c. 1874. Black morocco album (29 × 23 × 6 cm) containing 105 cartes-de-visite or half-stereos and 10 cabinet cards.

- Pages 2–3. Page 2: W. Notman, copied portrait of Judge McCord (23065), 1866; W. Notman, Mr [David Ross] McCord (28853), 1867–68; W. Notman, Miss [Eleanor Elizabeth] McCord (358), 1861; view of graveyard; three cartes-de-visite and one half-stereo. Page 3: Elisson & Co., Quebec, R.A. [Robert Arthur] McCord (signed); W. Notman, McCord brothers [John Davidson and David Ross?] (984), 1861; W. Notman, D.R. [David Ross] McCord (34510), 1868; three cartes-de-visite. (94)

N 005/86. Etheldred Norton Frothingham Benson (?). Frothingham/Benson Carte-de-visite Album (c), c. 1890. Dark green leather-bound album (16.5 × 14 × 4.5 cm) containing 48 cartes-de-visite, mainly portraits of the Frothingham family, but also including members of the Benson family.

- Pages 12–13. W. Notman, "What is it? G.H.F. & Harriet [George Henry Frothingham and Harriet Frothingham], March 12th 1865" (14761), 1865; W. Notman, "L.D.F. and E.N.F. [Louisa Davenport Frothingham and Etheldred Norton Frothingham]" (17483), 1865. Two cartes-de-visite (17483 hand-coloured). (Cover [page 12]; 112)

N 006/86. Louisa Davenport Frothingham Album (c), begun 1876. Brown leather-bound album (17.4 × 21.7 × 7 cm) containing 26 cabinet cards and 31 cartes-de-visite, mainly photographs of the Frothingham family taken in studio and at their country home on the lower St Lawrence.

- Pages 10–11. William Notman & Sons, "John Joseph Frothingham"; "John Joseph Frothingham and May Louisa Frothingham"; "Louisa Davenport Frothingham with May & Jo."; "Family nurse, 'Growler,' Sarah Campbell and May Frothingham." Four cartes-de-visite. (134)
- Pages 38–9. J.D. Wallis (John Woodruff), Ottawa, "Monte Shanti: Sarah & Nancy at Front Door; Grace Robertson, Annie Law, Annie Lawford, Dora Cundell, Harriet and Ethel," c. 1885; "Monte Shanti, Rivière du Loup," c. 1885. Two cabinet cards. (114)

N 007/86. Mrs George Benson (née Etheldred Norton Frothingham). Benson Family Album, c. 1914, with an addition or alteration after 1938. Beige leather imitation-snakeskin album (23 × 20.5 × 5.5 cm) containing 31 cabinet cards or cabinet-sized studio portraits and 1 clipping.

– Pages 22–3. William Notman & Sons. "Mrs George F. Benson, 'Geof,' Dorothy and 'Bill' Benson [George Frothingham, Etheldred Dorothy, and William Davenport Benson]," 1905; "G.F. Benson Family. Bill 7 1/4 years, Geof 9 years, Dorothy 4 years," 1908 or 1909. Gelatin silver prints, 17.2 × 11 cm and 16.4 × 11 cm. (113)

NOTES

PREFACE

1 Joyce, *Ulysses*, 114.

INTRODUCTION

1 Barthes, "The Photographic Message," in *A Barthes Reader*, 202.
2 Paster, "Advertising Immortality by Kodak," 138. As Paster explains, Kodak's first mass-marketing efforts of 1888 concentrated on ease and instantaneity, but by the turn of the century the company had introduced an association with memory that it uses to this day.
3 "Keep the Doors of Memory Open with an Ansco," advertisement in *The American Annual of Photography*, 1920, 1.
4 Chalfen, *Turning Leaves*, 5.
5 Ibid., 221.
6 See Schwarz, *Art and Photography*, and Galassi, *Before Photography*.
7 Batchen's *Burning with Desire* effectively draws on Foucault and Derrida to "supplement" the already complex ecology of early-eighteenth-century aesthetics.
8 Author's translation of Garat, *Photos de familles*, 27.
9 Sayre, *The Object of Performance*, 2.
10 McCarthy, *Suttree*, 129.
11 Bisbee, "Photography – Then and Now," 128.
12 Welling, *Collectors' Guide to Nineteenth-Century Photographs*, 93.
13 Padgett Powell, "Hitting Back," in *A World Unsuspected*, ed. Harris, 14.
14 Brilliant, *Portraiture*, 7–21; Brilliant refers to Hans-Georg Gadamer's *Truth and Method*, trans. G. Barden and J. Cumming (London, 1975).

15 Couillard Després, *Histoire de la Famille et de la Seigneurie de Saint-Ours*, 2: 11–13.
16 For an interesting curatorial perspective on the problem of exhibiting personal photographs in the museum, see Alison Devine Nordström, "Family Photographs and Museums/The Dilemma of Display," in Southeast Museum of Photography, *Telling Our Own Stories*, 26–8.
17 Hooper-Greenhill, *Museums and the Shaping of Knowledge*, 18–22.
18 Starl, "A Short History of Snapshot Photography," 8.
19 Benjamin, "The Task of the Translator," in *Illuminations*, 82.
20 Hardy, *Tellers and Listeners*, ix.
21 Robert Frank in *Photography within the Humanities*, ed. Janis and MacNeil, 58.
22 McLuhan, *Understanding Media*, 170–1.
23 Barthes, *A Barthes Reader*, 196; Berger, "Stories," in Berger and Mohr, *Another Way of Telling*, 288.
24 Author's translation of Garat, *Photos de familles*, 24.
25 Pollock, *Differencing the Canon*, 26. Pollock's feminist critical practice – her mode of reception – is part of a movement that has expanded both the subjects and the forms of art history to the point where the field now accepts amateur albums into the discourse.
26 A good *fin de siècle* example is *Imagining the Twentieth Century*, ed. Stewart and Fritzsche.
27 Persuasive arguments against the mental enclosures of foreshadowing and "backshadowing" are advanced in Bernstein, *Foregone Conclusions*, and Morson, *Narrative and Freedom*.
28 Ong, *Orality and Literacy*, 31–77.
29 On the basis of his fieldwork, Chalfen estimates each snapshot at a thousand spoken words. See *Snapshot Versions of Life*, 70.

1 Dickens, *The Personal History of David Copperfield*, 395.

2 From Sir David Brewster's letter to William Henry Fox Talbot, 22 October 1842; quoted in Smith, *Disciples of Light*, 13.

3 To situate the album in the early history of photographic production and consumption, see Henisch and Henisch, *The Photographic Experience, 1839–1914*, 150–62.

4 Statistical analyses of amateur photographic practices are always impressive because of the high numbers – like fast-food hamburgers, billions and billions of snapshots sold. Numbers alone are not very revealing, especially when the statistics were compiled by the American Photo Marketing Association. Anne Higonnet cites the 1992 *Wolfman Report* on the United States photo industry to show how photographs of family events and children are valued (suitable for framing or not) and which economic strata of American society buy cameras (44 per cent to families with over $35,000 a year; 41 per cent to families with $10,000–34,999 a year). More valuable "snapshots" are made by sociologists. Higonnet refers to a survey by Mihaly Csikszentmihalyi and Eugene Rochberg-Halton, noting that "family photographs" were third on their list of valued objects in the home. The study is flagged without giving the actual percentages of the total sample who mentioned these items: furniture, 36 per cent; visual art, 26 per cent; photographs, 23 per cent ("all mention of photos coded under this category" – 27 per cent of reasons given related to "memories," 26 per cent related to "immediate family," "intrinsic qualities" accounted for 17 per cent, "experiences" counted for 9 per cent). At 23 per cent photographs places third, very close to books at 22 per cent; stereo, 22 per cent; musical instruments, 22 per cent; and television, 21 per cent. These statistics demonstrate that photographs are valued by those who take them just as books are valued by readers, musical instruments by musicians, and so on. Higonnet's reflections on her own attitudes as a mother reinforce this point. See Higonnet, *Pictures of Innocence*, 87–96, and Csikszentmihalyi and Rochberg-Halton, *The Meaning of Things*, 55–69, 268–77.

5 Taft, *Photography and the American Scene*, 138; cited in Chalfen, *Turning Leaves*, 3.

6 Dickson, *Covered Wagon Days*, 20–3.

7 As Elizabeth O'Leary explains, "The term 'servant' was used in a general way to signify various situations of dependency: indentured workers, slaves, apprentices, hired men or women who worked for a limited period of time, or unmarried females who exchanged domestic labor for room and board. Orphans and young children of families who could not support them were bound out by church committees and courts, a practice that continued long into the nineteenth century." See O'Leary, *At Beck and Call*, 8–9.

8 Dickson, *Covered Wagon Days*, 41, 192.

9 John Towles, *Humphrey's Journal*; cited by Barbara McCandless, "The Portrait Studio and the Celebrity," in *Photography in Nineteenth-Century America*, ed. Sandweiss, 62.

10 Stewart, *On Longing*, 48–9.

11 Sontag, *On Photography*, 8.

12 Barthes, *Camera Lucida*, 7.

13 Krauss, "A Note on Photography and the Simulacral."

14 Bourdieu, *Photography: A Middle-brow Art*, 30.

15 Ibid., 30–1.

16 Le Goff, *History and Memory*, 89–90.

17 Bourdieu, *Un Art moyen*, 346. The appendices, including a list of focus groups, the questionnaire, and resultant statistics, are not included in the English-language edition.

18 Bourdieu, *Photography: A Middle-brow Art*, 53.

19 Sontag, *On Photography*, 8.

20 Ibid., 9.

21 Author's translation of Tisseron, "L'inconscient de la photographie," 84.

22 Kerouac, *Desolation Angels*, 333–4.

23 Bourdieu, *Photography: A Middle-brow Art*, 25.

24 Illich and Sanders, *A B C*, 145–6.

25 Lamoureux, "L'album ou la photographie corrigée par son lieu."

26 Becker and Philips, *Paris and the Arts, 1851–1896*, 40.

27 Ong, *Orality and Literacy*, 81.

28 Bazin, "The Ontology of the Photographic Image," 14.

29 De Duve, "Time Exposure and Snapshot."

30 Mavor, *Pleasures Taken*, 25–6.

31 Hirsch draws on Kaja Silverman's elaboration of Jacques Lacan's *Four Fundamental Concepts of Psychoanalysis*.

32 Hirsch, *Family Frames*, 93.

33 Barthes, *Camera Lucida*, 27, 67, 74. This is not to say that Barthes was adverse to photographic albums. On the contrary, he had incorporated a prefatory album into his autobiographical book of fragments, *Roland Barthes par Roland Barthes*, published in 1975. For Barthes, photography could only show his pre-textual body. The book's separation of the imaginary from the symbolic has been seen by some critics as a reflection of Barthes's concurrent fascination with Lacan. See Jay, *Downcast Eyes*, 437–56.

34 Hirsch, *Family Frames*, 107.

35 Ibid.

36 "Imagetexts" include the work of Urs Lüthi, Ralph Eugene Meatyard, and Cindy Sherman, whose various uses of the mask strike Hirsch as complex metaphors for photographic concealment and the semiotic screen.

37 Hirsch, *Family Frames*, 214–15.

38 See Bernstein, *Foregone Conclusions*.

39 Heath and Depardon have something else in common, which is their use of internalized experience as a touchstone in public works

of art and communication. Heath, who studied with W. Eugene Smith, created in *A Dialogue with Solitude* (1965) a monumental extension of the humanist photo-essay. Depardon has been a professional photojournalist since the 1960s, covering the latter half of the twentieth century's wars while interrogating his own motives in autobiographical films and photographic works of art. Heath's *Le grand album ordinaire* (Canadian Museum of Contemporary Photography, 1994) is an hour-long, multi-projector slide presentation of family photographs collected by the artist and accompanied by popular music from the 1960s. Depardon's *La Ferme du Garet* (Théâtre Denise-Pelletier, Montreal, 1999) is a play interweaving the author's memories of his young life in rural France and his work as a photojournalist, and given theatrical shape as a storyteller's slide show in a kitchen. Both of these works can be interpreted as searches for origins: Heath's in the collective memory of photographic experience, Depardon's in a nostalgic rehearsal of his cultural roots.

40 Bakhtin, *Rabelais and His World*, 24.

41 For further discussion of Meatyard and the grotesque, see Langford, "A Machine in the Grotto."

42 Art Gallery of Ontario, *Michael Snow / A Survey*.

43 In a series of five articles, all from 1970, Margery Mann, columnist for *Popular Photography*, explored the phenomenon, mentioning the snapshot's effect not only on photographic art but also on contemporary painting.

44 In his conceptualization of the Social Landscape, Lyons was inspired by photographer Gyorgy Kepes's *The New Landscape* (probably *The New Landscape in Art and Science*, 1956), thus broadening the definition of the genre to include the "man-made" landscape and specifically the meanings imbedded in the "environmental relationships of objects." See Lyons, *Contemporary Photographers*, 5–6.

45 Duane Michals quoted by Nathan Lyons in *Contemporary Photographers*, 7.

46 1 Cor. 13:11.

47 Stryker, *In This Proud Land*, 7. Roy Stryker was the driving force behind the United States's Resettlement Administration (later Farm Security Administration) mission to document the effects of the Depression.

48 "Family Snapshots in Frank Tengle's Home, Hale County, Alabama, Summer 1936" (Library of Congress catalogue number LC-USF342–8153A). See Library of Congress, *Walker Evans*. The photograph in question was produced while Evans was photographing sharecroppers under contract to *Fortune* magazine. No field photographer's shooting script of the period that I am aware of specifically lists the subjects' photographs as worthy of documentation, although other aspects of the vernacular were singled out. Stryker asked the FSA photographers to record wall decorations in homes; his shooting script is reproduced in his *In This Proud Land*, 187. Evans's shot list for New York included chalk drawings. But his study of the Tengle

snapshots may have related to his own photographic development. He was at that time taking what he called "snapshots," in 35 mm format, made with a Leica. See Jerry L. Thompson, "Walker Evans: Some Notes on His Way of Working," in Evans and Thompson, *Walker Evans at Work*, 13, and Evans's list in the same volume, 107.

49 Agee and Evans, *Let Us Now Praise Famous Men*, 163–4.

50 Moholy-Nagy, "From Pigment to Light," 78.

51 Kracauer, *Theory of Film*, 3–23.

52 Halpern, "Souvenirs of Experience: The Victorian Studio Portrait and the Twentieth-Century Snapshot," in *The Snapshot*, ed. Green, 66.

53 Lisette Model, untitled statement in *The Snapshot*, ed. Green, 6.

54 Goldin, *The Ballad of Sexual Dependency*, 6.

55 Philip Brookman, "Windows on Another Time: Issues of Autobiography," in National Gallery of Art, *Robert Frank. Moving Out*, 159–60.

56 Ong, *Rhetoric, Romance and Technology*, 298.

57 Chalfen, *Snapshot Versions of Life*, 152–3.

58 See Crimp, "Positive/Negative: A Note on Degas's Photographs."

59 Lartigue, *Les photographies de J.-H. Lartigue*.

60 See, for example, Solomon-Godeau, "A Photographer in Jerusalem, 1855"; see also Christopher Phillip's correction in the following issue, *October* 19: 120–1.

61 E.C. Hughes, *The Sociological Eye: Selected Papers on Work, Self, and the Study of Society* (1971); cited in Christopherson, "From Folk Art to Fine Art," 144.

62 John S. Weber, "Joachim Schmid – Anti-Auteur, Photo-Flâneur," in *Bilder von der Straße*, ed. Schmid, 11.

63 Boltanski's early album-type book works include *Tout ce que je sais d'une femme qui est morte et que je n'ai pas connue* (1970) and *Inventaire des objets appartenant à un habitant d'Oxford précédé d'un avant-propos et suivi de quelques réponses à ma proposition* (1973).

64 Gumpert, *Christian Boltanski*, 30–6.

65 Van Alphen, *Caught by History*, 93–112.

66 See Feldman, *Porträt*. The purchaser of a related project, Feldman's *Ferien*, receives a packet of anonymous holiday pictures and a blank book to put them in according to personal preference.

67 The work was published in 1997 with an introduction by Helmut Friedel; see Richter, ATLAS *of the Photographs, Collages, and Sketches*.

68 Dia Center for the Arts, *Hanne Darboven*.

69 Ferrarotti, *The End of Conversation*, 1–2.

70 The art of memory, a mnemonic system based on the association of symbolic objects and architectural elements, is discussed in the next chapter; see also Yates, *The Art of Memory*.

71 Foto Biennale Enschede, *Obsessies*, 54–5. See also Bénichou and Doyon, "Collection/fabrication."

72 Spector, *Felix Gonzalez-Torres*, 111–33.

73 Patricia Holland, "History, Memory and the Family Album," in *Family Snaps*, ed. Spence and Holland, 3.

74 Burgin, *Thinking Photography*, 144.

75 Holland, "History, Memory and the Family Album," in *Family Snaps*, ed. Spence and Holland, 7.

76 Kotkin, "The Family Photo Album as a Form of Folklore," 4.

77 Greenhill, *So We Can Remember*, 124. In her introduction, Greenhill clarifies the basis of her study: "The stated focus of study, the family photograph album, will be defined in a somewhat unorthodox manner. 'Family album' seems to be the term used most often by families to describe the personal photographs in their home, but often these pictures are not found between the pages of an album. The album, in fact, seems to be one of the most impermanent aspects of the family photograph collection" (4). Listing the various places that the photograph may be stored on the way to the album or placed on permanent displayed, Greenhill states, "For the purposes of this report, then, the boundaries of a family album will be the walls of family homes" (5).

78 Johnson, "A Post-Retinal Documenta," 83.

79 Friedländer, *When Memory Comes*, 58.

80 Robert Storr, "Introduction," in Wallach, *Ilya Kabakov*, 7–10.

81 In addition to Wallach's chapter on Kabakov's ten albums, see Kabakov's own note on the different types and particular difficulties of the album form, both in Wallach, *Ilya Kabakov*, 55–64, 115.

82 See Salvioni, "The Whitney Biennial," and Adams, "Turtle Derby."

83 Rosy Martin and Jo Spence, "Photo Therapy: New Portraits for Old. 1984 Onwards," in Spence, *Putting Myself in the Picture*, 174.

84 Kuhn, *Family Secrets*, 48. See also Val Williams's review, "*Cultural Sniping: The Art of Transgression* and *Family Secrets*."

85 Lury, *Prosthetic Culture*, 82.

86 Higonnet, *Pictures of Innocence*, 196. As Higonnet continues, any doubt gives way to admiration for Mann's work (201–5).

87 Techniques of appropriation and transformation through close cropping and grainy or unfocused enlargements have been applied to family-type photographs by artists such as Emmanuel Galland (Canada), Al McWilliams (Canada), Maria Miesenberger (Sweden) Catherine Poncin (France), and Christian Walker (United States).

88 Ballerini, *Sequence (con)Sequence*, 81.

89 Smithsonian Institution/The National African American Museum, *Imagining Families*, 40–1.

90 Three groups of images from Buchanan's *Some Partial Continua* (1991–96) illustrated an earlier version of this chapter, published in *Blackflash*; see Langford, "The Idea of Album."

91 The *Photo-Mirrors* seem infinitely in progress, and it is interesting to note that Lum has used two different methods to create them. In 1997, for the inaugural exhibition of a Tuscan village gallery, he installed only a long mirror, inviting members of the community to insert their own pictures in the frame. In 1998, at the XXII Bienal Internacional de São Paulo, the snapshots were provided and arranged by the artist. See Walter Phillips Gallery, The Banff Centre for the Arts, *Ken Lum: Photo-Mirrors*.

92 Sayre, *The Object of Performance*, 65.

93 Sontag, *On Photography*, 8.

94 Bossard and Boll, *Ritual in Family Living*, 130–3.

95 Sontag, *On Photography*, 8.

96 Vanderbilt, *Amy Vanderbilt's* New *Complete Book of Etiquette*, 75.

97 In *Say "Cheese!"* King includes pictures of English couples recreating studio conditions in their backyards (94–8). Of the four pictured wedding parties, two are from the 1960s; in the pictures from 1917 and the 1940s, the grooms are in military uniform.

98 Jack Goody, "Against 'Ritual': Loosely Structured Thoughts on a Loosely Defined Topic," in *Secular Ritual*, ed. Moore and Myerhoff, 25–35.

99 Myerhoff, *Number Our Days*, 224–5.

100 Berger, "Uses of Photography" (1978), reprinted in his *About Looking*, 51; cited in Lisa McCoy, "Looking at Wedding Pictures," in *The Zone of Conventional Practice*, ed. Simon, 70.

101 McCoy, "Looking at Wedding Pictures," in *The Zone of Conventional Practice*, ed. Simon, 76.

102 Eliade, *Myths, Dreams and Mysteries*, 23.

103 Berger, *About Looking*, 61–2.

104 Berger and Mohr, *Another Way of Telling*; see "Stories," 288; "Appearances," 108.

105 Berger's introduction to the peasant trilogy can be found in *Pig Earth*, xi–xxvii. For another perspective on French agricultural workers, memory, and oral history, see Michel Bozon and Anne-Marie Thiesse, "The Collapse of Memory: The Case of Farm Workers (French Vexin, Pays de France)," *Between Memory and History*, ed. Bourguet, Valensi, and Wachtel, 31–53.

THE ALBUM AS COLLECTION

1 Halbwachs, *The Collective Memory*, 48. A useful review of Halbwachs's ideas and their extension by another sociologist (and ethnologist), Roger Bastide, is provided by Wachtel in *Between Memory and History*, ed. Bourguet, Valensi, and Wachtel, 5–11.

2 Stewart, *On Longing*, 151–69.

3 Frazier, *Family*, 37.

4 The historical connections between architecture, memory, rhetoric, and magic are chronicled by Yates in *The Art of Memory*.

5 See Hooper-Greenhill, *Museums and the Shaping of Knowledge*, 78–132. Yates's *The Art of Memory* and Foucault's *The Order of Things* both inform Hooper-Greenhill's argument.

6 Bazin, *What Is Cinema?* 9–16.

7 Dubois, *L'Acte photographique et autres essais*, 266–9.

8 Grier, "The Decline of the Memory Palace: The Parlor after 1890," in *American Home Life, 1880–1930*, ed. Foy and Schlereth, 53, 58.

9 Grier, *Culture & Comfort*, 44–8.

10 Clifford adopts the term to designate a place of mental collection, Claude Lévi-Strauss's syncretic view of New York during the Second World War. See Clifford, "On Collecting Art and Culture." Bakhtin's semi-metaphoric use of the term is developed in "Forms of Time and of the Chronotope in the Novel," in *The Dialogic Imagination*.

11 Poignant, "Surveying the Field of View," in Edwards, *Anthropology & Photography*, 58–60.

12 Ibid., 45.

13 See ibid., 69–70, note 42.

14 Said, *Orientalism*, 63.

15 Henisch and Henisch, *The Photographic Experience, 1839–1914*, 350–3.

16 Colin Ford, "Introduction," in Hill and Adamson, *An Early Victorian Album*, 36–7, illus. 155–91; in the same volume, see also Roy Strong, "D.O. Hill and the Academic Tradition," which details the Newhaven fisherwoman's costume (58–9).

17 Taussig, *Mimesis and Alterity*, 185–7.

18 Triggs, "The Notman Photographic Archives," 183. In an album of 227 snapshots, this unusual episode is not given much space. The museum indexer has noted three places in the album where Lapps and reindeer appear (pages 23, 34, and 57). The landing of the reindeer is included in another Mack album (MP 597), whose poor condition precluded consideration, but again without much more emphasis.

19 McCord Museum, accession number M 20107.

20 According to Maria Tippett, "ornamental skills" was a pejorative term for the fine arts. See *Making Culture*, 38. A survey of Canadian women's artistic pastimes can be found in Abrahamson, *God Bless Our Home*, 136–43. Women's albums are analyzed in Higonnet, "Secluded Vision," 16–36.

21 Perugini, *Victorian Days and Ways*, 234.

22 Notman Photographic Archives, no. 14647–1; also illustrated in Henisch and Henisch, *The Photographic Experience, 1839–1914*, 65.

23 Rosen and Zerner, *Romanticism and Realism*, 81–4. Thompson builds on their observations in "Narrative Closure in the Vignettes of Thomas and John Bewick."

24 Rodgers, "Socializing Middle-Class Children," 358–9. Rodgers's note 14 (366) brackets his period of interest with Martha Finley's *Elsie Dinsmore* (1868) and Eleanor H. Porter's *Pollyana* (1913).

25 Seiberling and Bloore, *Amateurs, Photography, and the Mid-Victorian Imagination*, 1–16, 102.

26 Trudel, "Une élite et son musée," 22–3.

27 Triggs, "Alexander Henderson."

28 The history of the McCord and Ross families given here is based on Pamela Miller and Brian Young, "Private, Family and Community Life," in McCord Museum of Canadian History, *La famille McCord*, 55–83. The publication includes a family tree.

29 John Samuel's McCord will had divided his estate equally between his three sons and two daughters, making provision for the support of his wife and compensating for the expenses of his sons' education by settling an additional sum on each of his surviving daughters. The death of John Samuel and the dissipation of Robert Arthur placed John Ross within reach of controlling the estate, which legal action against his brother eventually achieved. The complete takeover of Temple Grove followed his marriage to a woman whom his sisters did not approve of; they moved out. His relationship with his sisters apparently survived all this; they depended on his support, and when Jane Catherine died, she left her entire estate to her brother, with some provision of income to her sister Anne. See Pamela Miller and Brian Young, "Private, Family and Community Life," in the McCord Museum of Canadian History catalogue, *La famille McCord*, 45–9, 79.

30 Stewart, *On Longing*, 136–7.

31 The existence of Barnes's studio was confirmed by the listing in Dési's thesis, "L'histoire de la photographie au Quebec à travers les périodiques 1839–c. 1880." The extension of the studio's dates was determined by a search in Lovell's Montreal directory.

32 Henisch and Henisch make this point in relation to the photographically illustrated book, citing the memoirs of Edmund Gosse (1849–1928), who saw his first sculpture in reproduction when he was thirteen. See Henisch and Henisch, *The Photographic Experience, 1839–1914*, 336.

33 Abrahamson, *God Bless Our Home*, 137.

34 Stewart, *On Longing*, 132–51; quotation, 136.

35 Ibid., 135.

36 Ibid., 145.

37 Pearce, *On Collecting*, 175–6.

38 Parkes, *Bereavement*, 66–9.

39 Metz, however, bases his argument on the fixed meaning of the photographic image, having established its symbolic connection with death. A photograph of the departed helps the mourner through this passage because the photograph's inherent morbidity urges acceptance of the fact. While this interpretation may be true, the metamorphosis of the mourner complicates the meaning of the photograph, whether in contemplation or in presentation. Its usefulness as a fetish is undermined in the process. See Metz, "Photography and Fetish," 83–5.

40 Illich and Sanders, *A B C*, 72.

MEMOIRS AND TRAVELOGUES

1 Pepys, *The Diary of Samuel Pepys*, 1: 169.

2 Other, less famous examples may also exist. The Charles-Philippe Beaubien Album (MP 042/90) represents an engagement that runs to many volumes. The point here relates, not to quantity or persistence, but to the challenge of keeping an album as a journal.

Not even Lartigue made an entry for each day, and he is known to have excised certain painful or embarrassing passages.

3 Mallon, *A Book of One's Own*, 1.

4 Ibid., 28–33.

5 Robinson opens his discussion to themes set by William Labov and Joshuah Waletzky and elaborated by Teun A. Van Dijk in light of changing criteria, examining both narrations of the commonplace and accounts of victimization. See Robinson, "Personal Narratives Reconsidered."

6 Quoted in Mallon, *A Book of One's Own*, 143, from Albert Camus, *Notebooks, 1935–1942*, trans. Philip Thody (New York: Harcourt Brace Jovanovich, 1978).

7 Fried, *Makers of the City*, 68.

8 Cox, "Autobiography and America," 256. Illich and Sanders build on this observation in their chapter "The Self," in *A B C*, 71–83.

9 Fussell, *The Great War and Modern Memory*.

10 The positive effect of the war on Kodak's sales is discussed by Coe and Gates in *The Snapshot Photograph*, 34. British and Italian perspectives are presented in *Photography/Politics: Two*, ed. Holland, Spence, and Watney. The issue includes an article by Silvana Rivoir, "The Soldier Photographer," which makes particular mention of albums (82–9).

11 William Hilliard Snyder's letters and an account of his death were among his sister's papers. Mrs Katherine Jessie Speirs (Katie Snyder) served as an ambulance driver in France, recording her experiences in "With the F.A.N.Y.'S in France," in *The Gold Stripe* (n.d.).

12 "'But this is *our* war! How do you get into a war?'" Grace Morris Craig vividly remembered that excited response to the declaration of war in August 1914. See Craig, *But This Is Our War*, 26.

13 An Ansco Company advertisement published in 1917 reflects the general tenor of the home-front photographic campaign. Entitled "In War as in Peace" and illustrated with a vignetted snapshot of a uniformed soldier, the advertisement begins: "Ansco Photography has a very real place to fill. Pictures tell a story better and quicker than words. They convey an instant impression of places and persons and things that pages of written description cannot adequately portray. To keep in closest touch with friends who are far away nothing suffices so well as pictures of people and events sent from one to another in letters." The same issue includes tips on military photography during training. See *The American Annual of Photography*, 1918.

14 William Hilliard Snyder's letters are in the archives of the McCord Museum of Canadian History.

15 Langness and Frank, 114.

16 Cox, "Autobiography and America," 254–5.

17 Langness and Frank, *An Anthropological Approach to Biography*, 90.

18 In his survey of private collections, Chalfen makes a connection between portraits of young recruits and "Earlier snapshots featuring a G.I. Joe or sailor's outfit … repeated in somewhat of a self-fulfilling prophecy." These pictures are not necessarily of the same people; Chalfen is commenting on a general trend. Organizations that want to ban military toys for children draw similar parallels. See Chalfen, *Snapshot Versions of Life*, 86. Wagner, on the other hand, seems deliberately predictive in her doublings and juxtapositions. Her photographs and compilations draw these types and antitypes into the same frame.

19 With reference to the connection between photography and sport, it is interesting to note the existence of the Montreal Amateur Athletic Association Camera Club, organized on 1 May 1906. See *The American Annual of Photography*, 1918, 297.

20 Schlereth, *Victorian America*, 277–8.

21 Kett, *Rites of Passage*, 173.

22 The passage from T.C. Sandars is quoted by Hall from Merle Mowbray Bevington, *The Saturday Review, 1855–1868* (New York: Columbia University Press, 1941), 188; see Hall, *Muscular Christianity*, 7.

23 Hall, "On the Making and Unmaking of Monsters: Christian Socialism, Muscular Christianity, and the Metaphorization of Class Conflict," in his *Muscular Christianity*, 64.

24 Robinson, "Personal Narratives Reconsidered," 70.

25 Nicholson, *Canada's Nursing Sisters*, 133.

26 National Archives of Canada, Ottawa, Canadian Military Photograph no. 23670, Lieut. F.G. Whitcombe, probably August 1943.

27 National Archives of Canada, Ottawa, Canadian Military Photograph no. 26475, Lieut. A. Stirton, probably November 1943.

28 Mallon, *A Book of One's Own*, 42.

29 Taylor, *A Dream of England*, 14. Taylor ascribes distinct ways of seeing to three groups, whose touring practices have been analyzed by Daniel Boorstin, Dean MacCannell, Paul Fussell, and Jonathan Culler; see Taylor, 7–8.

30 Lippard, *The Lure of the Local*.

31 Nancy Spector's thoughts on the meaning of travel in the work of Gonzalez-Torres are indebted to Georges van den Abbeele, *Travel as Metaphor: From Montaigne to Rousseau* (Minneapolis: University of Minneapolis Press, 1992). See Spector, *Felix Gonzalez-Torres*, 56–7; 84, note 8.

32 Gikandi, *Maps of Englishness*, 89. Gikandi, like Nancy Spector, is indebted to Georges van den Abbeele, whose ideas continue to travel. An earlier version of one of Gikandi's chapters appeared as an article, "Englishness, Travel, and Theory: Writing the West Indies in the Nineteenth-Century," in *Nineteenth-Century Contexts* 18 (1994) and was applied by Jennifer Green-Lewis to her discussion of Roger Fenton's photographs of the Crimea, which was an interesting place to find it. See Green-Lewis, *Framing the Victorians*, 140.

33 See Taylor, *A Dream of England*, 7, and Mrs Charles W. Wagner's album (MP 034/80).

34 For Thomas, see McCord Museum, *Canadian Painting and Photography, 1860–1900*, 102, note 101.

35 Burkart and Medlik, *Tourism*, 19.

36 Squire, "The Cultural Values of Literary Tourism," 109.

37 Grahame, *The Wind in the Willows*, 36.

38 Knaplund, *The Unification of South Africa*, 12–20.

39 Gikandi, "Englishness and the Culture of Travel," in *Maps of Englishness*, 84–118.

40 Cameron, *A Woman's Winter in Africa*, 89–95.

41 Ibid., 76–80.

42 Hattersley, *The Baganda at Home*, 6.

43 Ibid., 87.

44 Burkart and Medlik, *Tourism*, 20.

45 Thomas Cook pamphlet quoted in Pemble, *The Mediterranean Passion*, 47.

46 Flashbulb memories are the personal memories associated with public milestones: "what people can remember of the circumstances in which they learned of an outstanding and usually surprising national/international event." They are generally associated with high levels of emotional reaction and consequentiality; they are often revisited. Personal anecdotes associated with the assassinations of Abraham Lincoln and John F. Kennedy are prime examples. See Conway, *Autobiographical Memory*, 61–87.

47 MacCannell, *The Tourist*, 59, 53–5, 6, 9.

48 Sontag, *On Photography*, 10.

THE IDEA OF FAMILY

1 Beloff, *Camera Culture*, 188.

2 McDannell, *Material Christianity*, 67–102.

3 Brilliant, *Portraiture*, 12.

4 Turner, *The Anthropology of Performance*, 43.

5 Hirsch, *Family Photographs*, 3.

6 Chalfen, *Turning Leaves*, 188, 196–206.

7 Boerdam and Martinius, "Family Photographs," 96.

8 Kouwenhoven, "Living in a Snapshot World," in his *Half a Truth Is Better than None*, 149.

9 Hareven, "The Family as Process," 32.

10 Thomas, "The Family Chronicle," in *Time in a Frame*, 43–64.

11 Hareven, "Cycles, Courses and Cohorts." See also Hareven's "Synchronizing Individual Time, Family Time, and Historical Time," in *Chronotypes*, ed. Bender and Wellbery, 167–82.

12 Here again I seem to take issue with Christian Metz, who follows Peter Wollen's distinction between film and photography in terms of spatiotemporal dimensions and the conditions of reception. While one can agree that a single image or page from an album can be the object of fascination (a fetish), the presentation of an album, as imagined and rehearsed by the compiler, lives within an optimum temporal framework as an act of communication. Fundamental to Metz's photographic theory is his assumption of silent contemplation and automatic response – no heuristic dialogue, even with oneself. See Metz, "Photography and Fetish," 81–5.

13 Hirsch, *Family Photographs*, 5.

14 See also Zacharias, "The Photograph Album."

15 Zacharias, "The Photograph Album," 79.

16 Kaufmann, "Photographs & History," 195, 198.

17 Boerdam and Martinius, "Family Photographs," 116. The behaviour of the couple was observed by P. Berger and H. Kellner in "Marriage and the Construction of Reality," in *Recent Sociology*, ed. H.P. Dreitzel (New York: MacMillan Company, 1970), 50–73.

18 Berger, *Science, God, and Nature in Victorian Canada*, 9, 10–14.

19 Donna R. Braden, "'The Family that Plays Together Stays Together': Family Pastimes and Indoor Amusements, 1890–1930," in *American Home Life*, ed. Foy and Schlereth, 146–7.

20 Ward, *Courtship, Love and Marriage in Nineteenth-Century English Canada*, 89.

21 Morgan, ed. *The Canadian Men and Women of the Time*, 76.

22 Author's interview with Gretta Chambers, recorded at the McCord Museum on 19 June 1995.

23 Ways of seeing and photographically preserving vestiges of Elizabethan England are explored in Taylor, *A Dream of England*, 64–89.

24 McCord Museum, accession MP 080/86. This is a group of photographs originally compiled as an album whose binding has now completely failed, making the sequence unreconstructable.

25 The full text of "Nocturne" by Hazel Marion Shaughnessy, as preserved in Annie Craven's album, is as follows:
The world is quiet; mankind is now at rest,
The rising moon enchants the evening breeze,
The darkling thrush has hurried to her nest;
I stand alone beneath the leafless trees.
I watch the sun set in the golden west,
A ball of fire beyond the Hebrides,
And now weird thoughts my weary mind infest,
For night brings with it strange anxieties.
I wonder if the lonely trees can hear
The hooting owl. I wonder what I fear ...
But as I ponder 'neath the fading moon,
In the far east appears a silver light,
It is the dawn that comes, alas! too soon,
I have not solved the mysteries of the night.

26 In William Catermole, *Emigration, the Advantages of Emigration to Canada* (London, 1831), David Gagan found a warning to "employers of emigrant English girls of 'the only real evil' they could anticipate – 'they are sure to get married.'" See Gagan, "'The Prose of Life,'" 372.

27 Robbins, *The Servant's Hand*, 92, 94.

28 Bossard and Boll, *Ritual in Family Living*, 130.

29 Etheldred was the third of three daughters from a family noted for its wealth and independence of mind. Her aunt, Louisa G. Frothingham, married John H.R. Molson in 1873 (the Henderson album, Photographs: Canadian Scenery [MP 1452] has been discussed in this connection), but not without a detailed marriage contract guaranteeing her free administration and enjoyment of her assets. See Ward, *Courtship, Love, and Marriage in Nineteenth-Century English Canada*, 146.

30 Calhoun, *A Social History of the American Family*, 3: 193.

ORALITY AND PHOTOGRAPHY

1 Finnegan, *Oral Traditions and the Verbal Arts*, 25–52; quotation, 51.

2 Bakhtin, *The Dialogic Imagination*, 3.

3 This is a conscious allusion to André Bazin's sticky simile – his image of photographic fragments being like "flies in amber" – which is attributed to Peter Wollen, "Fire and Ice," in *Photographies* 4 (1984), by Metz ("Photography and Fetish," 84) and Mavor (*Pleasures Taken*, 4), among others. See Bazin, "The Ontology of the Photographic Image," 14.

4 The article appeared originally as "Epische Gesetze der Volksdichtung," in *Zeitschrift für Deutsches Altertum* 51 (1909): 1–12. However startling to the modern reader, Olrik's taxonomy has worn well over nearly a century. From a visual standpoint, it is engaging to *see* him entering his own framework, as a sort of tableau: "When a folklorist comes upon a three, he thinks, as does the Swiss who catches sight of his Alps again, 'Now I am home!'" See Olrik, "Epic Laws of Folk Narrative," 133.

5 Foley, *Oral-Formulaic Theory*, xiii.

6 Goody, *The Interface between the Written and the Oral*, 78–86; quotation, 88.

7 O'Donnell, "Towards Total Archives," 111.

8 Ong, *The Presence of the Word*, and *Interfaces of the Word*, 92–120; alternatively, for "African Talking Drums and Oral Noetics," see Foley, *Oral-Formulaic Theory*, 109–35, reprinted from *New Literary History* 8 (1977): 411–29.

9 Lumpp, "A Biographical Portrait of Walter Jackson Ong" and "Selected Bibliography of Ong's Writings."

10 Gronbeck, Farrell, and Soukup, eds. *Media, Consciousness, and Culture.*

11 Hutton, *History as an Art of Memory*, 13–22, 49–50, 165; quotation, 16.

12 Jay, *Downcast Eyes*, 2, note 4. The rest of Jay's comments on Ong appear on 22–3 (note 6), 41 (note 68), and 66–8.

13 The passage, from *An Essay Concerning Human Understanding* (book 2, chapter 11), first published in 1690, is transcribed as follows: "*Dark room.* – I pretend not to teach, but to inquire: and therefore cannot but confess here again, that external and internal sensations are the only passages that I can find of knowledge to the understanding. These alone, so far as I can discover, are the windows by which light is let into this dark room. For methinks the understanding is not much unlike a closet wholly shut from light, with only some little openings left to let in external visible resemblances or ideas of things without: would the pictures coming into such a dark room but stay there, and lie so orderly as to be found upon occasion, it would very much resemble the understanding of a man in reference to all objects of sight, and the ideas of them." See Ong, *The Presence of the Word*, 66–7.

14 Ruth El Saffar, "The Body's Place: Language, Identity, Consciousness," in *Media, Consciousness and Culture*, ed. Gronbeck, Farrell, and Soukup, 182.

15 Ibid., 192.

16 Both phrases are from the conclusion to El Saffar's essay, in which she argues forcefully for Ong as a repairer of the mind-body split (ibid., 192–3).

17 Ong, *The Presence of the Word*, 92–100.

18 Ibid., 117–18.

19 See Fried, *Absorption and Theatricality*, 51.

20 Ibid., 8–10.

21 Ong, *The Presence of the Word*, 128.

22 Quoted by Bruce Bawer from Flannery O'Connor, *Collected Works*, in "Under the Aspect of Eternity," 36.

23 Sussman, *High Resolution*, 210, 219–20.

24 Ong, *Orality and Literacy*, 175.

25 Sussman, *High Resolution*, 217.

26 Ong, *Orality and Literacy*, 32, 34, 36.

27 Ibid., 36–57. In "African Talking Drums and Oral Noetics," Ong outlined seven salient features of oral culture: "(1) stereotyped or formulaic expression, (2) standardization of themes, (3) epithetic identification for 'disambiguation' of classes or of individuals, (4) generation of 'heavy' or ceremonial characters, (5) formulary, ceremonial appropriation of history, (6) cultivation of praise and vituperation, (7) copiousness." Explanations of Ong's terminology will draw from these two texts without further annotation; his sources should be sought in his original text; quotations and references to other works by Ong will be noted as required.

28 McArthur, "Rhetoric," in *The Oxford Companion to the English Language*, 863–7.

29 Ong, *Orality and Literacy*, 42.

30 Ong, "From Epithet to Logic: Miltonic Epic and the Closure of Existence," in his *Interfaces of the Word*, 191, 197.

31 Starl, "Die Bildwelt der Knipser," 64; Coe and Gates, *The Snapshot Photograph*, 47–135.

32 Bourdieu, *Un art moyen*, 347.

33 The now-famous example is the school photograph from the Linz Realschule in which some analysts claim to recognize two fourteen-year-old boys, Adolf Hitler and Ludwig Wittgenstein. The origins of Nazism are traceable to their overlapping attendance at the school in the close proximity documented by this photograph, according to Cornish, *The Jew of Linz*.

34 King, *Say "Cheese!"* 19–39.

35 Chalfen, *Snapshot Versions of Life*, 75–99; quotation, 99.

36 Csikszentmihalyi and Rochberg-Halton, *The Meaning of Things*, 20–38; quotation, 29.

37 Ibid., 27.

38 Brilliant, *Portraiture*, 7–21.

39 Hirsch, *Family Photographs*, 98.

40 Schwartz, *The Culture of the Copy*, 94.

41 Types are reliable subjects of photographic debate. Here I am registering my gentle disagreement with critics who have analyzed nineteenth-century typing and classification as an ideological stranglehold that photographic technology not only tightened but practically invented. My discussion will build on the pre-existence of types and typological structure. For an excellent review of Marxist and post-structuralist criticism, see Lury, *Prosthetic Culture*, especially her chapter entitled "The Family of Man," 41–75.

42 See Goffman, *The Presentation of the Self in Everyday Life*.

43 Brilliant (*Portraiture*, 10–11) cites Philip Fisher, who pinpoints the years between 1890 and 1910 as manifesting a shift in American definitions of fame. See Fisher, "Appearing and Disappearing in Public."

44 Grier, *Culture & Comfort*, 257.

45 Henisch and Henisch, *The Photographic Experience, 1839–1914*, 11–35.

46 An Outsider, "My First Carte de Visite," 340.

47 Carlyle, *Past and Present*, 123.

48 Sussman, *Victorian Masculinities*, 26, 44.

49 Turner, *The Anthropology of Performance*, 24, 74–5.

50 Sussman, *Victorian Masculinities*, 9.

51 See Cohen, Nir, and Almagor, "Stranger-Local Interaction in Photography."

52 Margaret Homans, "Victoria's Sovereign Obedience," in *Victorian Literature and the Victorian Visual Imagination*, ed. Christ and Jordan, 169–97; quotation, 173. See also Bhabha, "Of Mimicry and Man."

53 Joshua Meyrowitz integrates Erving Goffman's findings on the relationship between audiences and human behaviour with Marshall McLuhan's theories on the impact of electronic media. See Meyrowitz, *No Sense of Place*.

54 Griselda Pollock, "Territories of Desire: Reconsiderations of an African Childhood. Dedicated to a woman whose name was not really 'Julia,'" in *Travellers' Tales*, ed. Robertson et al., 63–89; quotation, 72.

55 Jan Lewis, "Mother's Love: The Construction of an Emotion in Nineteenth-Century America," in *Social History and Issues in Human Consciousness*, ed. Barnes and Stearns, 215–8, 223.

56 Korshin, *Typologies in England, 1650–1820*, 370.

57 Foucault, *The Order of Things*, 35.

58 See Marx, *The Machine in the Garden*.

59 Korshin, *Typologies in England, 1650–1820*, 373.

60 Weaver, "Roger Fenton: Landscape and Still Life," in his *British Photography in the Nineteenth Century*, 106.

61 Ibid., 109. Weaver's analysis is extended in Green-Lewis, *Framing the Victorians*, 97–144.

62 Wind, "The Revolution of History Painting," 117.

63 For Canadian applications of Victorian progress, see Lawrence S. Fallis Jr, "The Idea of Progress in the Province of Canada: A Study in the History of Ideas," and W.L. Morton, "Victorian Canada," in *The Shield of Achilles*, ed. Morton, 169–83, 311–34.

64 Morgan and Burpee, *Canadian Life in Town and Country*, 115–16.

65 Bell, "Representing the Prairies," 20–1.

66 See Osborne, "Interpreting a Nation's Identity."

67 Weaver, "Roger Fenton: Landscape and Still Life," in his *British Photography in the Nineteenth Century*, 106.

68 Kotkin, "The Family Photo Album as a Form of Folklore," 5.

69 Barbara Myerhoff, "Life History Among the Elderly: Performance, Visibility, and Remembering"; quoted in Turner, *From Ritual to Theatre*, 75.

70 Korshin, *Typologies in England, 1650–1820*, 380.

71 Dubois, *L'Acte photographique et autre essais*, 64–5.

72 My analysis of the photographic act, much indebted to Eliade, anticipated Dubois's pairing of production and reception in spatiotemporal bundles. As I wrote, "The viewing (first viewing/endless viewing) and the taking (first taking/endless taking) are infinitely repeated, encircling the image, detaching it from circumstance (yet hallowing its circumstance), removing it to sacred time." See National Film Board of Canada, *Paradise*, 14.

73 Roberts, *The Art of Interruption*, 4.

74 Ong, "African Talking Drums and Oral Noetics."

75 Ong, *Orality and Literacy*, 44.

76 Ibid., 37.

77 Punctuation as structure belongs to written language, according to Ong; the congruence of language with the body – with the need to breathe – was the grammatical guide as late as 1640; see "African Talking Drums and Oral Noetics."

78 The link between landscape and memory has been explored by Lucy Lippard, Pierre Nora, Simon Schama, Raymond Williams, and others. The particular implications of a rephotographed site are considered in my essay for the exhibition catalogue *On Space, Memory and Metaphor*.

79 Hattersley, "Family Photographs as a Sacrament"; quotation, 108.

80 Duane Michals, interviewed by Heiferman and Kismaric, in *Talking Pictures*, 106–8.

81 Photographers who have used this device include Jim Goldberg, Fred Lonidier, Wendy Snyder MacNeil, and Robert Minden, among others. For a discussion of these and related practices in an American context, see Green, "Biographical Narrative," in his *American Photography*, 210–13.

82 Milgram and Banish, "City Families."

83 Musello, "Family Photography," 110–12.

84 Langford, "Literacy through Photography," 5.

85 Trachtenberg, "Walker Evans' America," 59, 60, 65.

86 Donna R. Braden, "'The Family that Plays Together Stays Together': Family Pastimes and Indoor Amusements, 1890–1930," in *American Home Life, 1880–1930*, ed. Froy and Schlereth, 148–51.

87 Kozloff, *The Privileged Eye*, 138.

88 For Szarkowski, see Museum of Modern Art, *Mirrors and Windows*.

89 George E. Hein's *Learning in the Museum* should be required reading for any curator or exhibition designer, as an act of humility if nothing else. His chapter "Studying Visitors" summarizes behavioural studies, from spatial tracking to interviews, including Anderson and Roe's inspired idea of providing visitors with instant cameras to take pictures that would later be used in interview to explore why certain exhibits drew their attention (124).

90 See Dubois, "Le coup de la coupe," in his *L'Acte photographique*, 151–202.

91 It is easy to imagine the subjects of Mrs Wagner's photographs reminiscing about her visit, since similar experiences have already recorded. The documentary photographs taken during the Depression under the aegis of the Farm Security Administration of the United States government have been the object of several research and rephotographic projects. Subjects such as Florence Thompson (Dorothea Lange's *Migrant Mother*, 1936) have been located and interviewed about their memories of the photographer's visit and their opinion of photographic fame. Bill Ganzel's *Dust Bowl Descent* takes a very respectful approach to the FSA mission and material; other critics have not been so positive.

92 Kristin M. Langellier and Eric E. Peterson, "Spinstorying: An Analysis of Women Storytelling," in *Performance, Culture and Identity*, ed. Fine and Speer, 163. Langellier and Peterson, who connect kernel stories with women, also table the dissenting view of Polly Stewart Deemer, who believes that the kernel story is gender neutral and can derive from any communal experience. Langellier and Peterson go on to show that the conversational atmosphere must be propitious, meaning cooperative, not competitive (164–77).

93 Ong, *Orality and Literacy*, 46.

94 See Jack Goody and Ian Watt, "The Consequences of Literacy," in *Literacy in Traditional Societies*, ed. Goody, 30–4.

95 Ong, *Orality and Literacy*, 46, 48–9.

96 Vansina, *Oral Tradition as History*, 114–23.

97 Goody and Watt, "The Consequences of Literacy," in *Literacy in Traditional Societies*, ed. Goody, 33.

98 Illich and Sanders, *A B C*, 84–6.

99 Ong, *Orality and Literacy*, 48. See also Wachtel's introduction and general bibliography in *Between Memory and History*, ed. Bourguet, Valensi, and Wachtel, 1–18.

100 Ong, "Text as Interpretation," 148.

101 Vansina, *Oral Tradition as History*, 156–7.

102 Dwight Conquergood, "Fabricating Culture: The Textile Art of Hmong Refugee Women," in *Performance, Culture and Identity*, ed. Fine and Speer, 206–48; quotations, 211 (note 16, 245) and 233.

103 Bazin, "The Ontology of the Photographic Image," 13–14.

104 Author's translation. Dubois's treatment of the album is transcribed in full as follows: "Sur un mode plus trivial, toute la pratique de l'album de famille va dans le même sens: par-delà les poses figées, les stéréotypes, les clichés, les codes surannés, par-delà les rituels de l'ordonnancement chronologique et l'inévitable scansion des événements familiaux (naissance, baptême, communion, mariage, vacances, etc.), l'album de famille ne cesse pas d'être un objet de vénération, soigné, cultivé, entretenu comme une momie, rangé dans un coffret (avec les premières dents de bébé ou la mèche de cheveux de grand-mère!); on ne l'ouvre qu'avec émotion, dans une sorte de cérémonial vaguement religieux, comme s'il s'agissait de convoquer les esprits. Assurément ce qui confère une telle valeur à ces albums, ce ne sont ni les contenus représentés en eux-mêmes, ni les qualités plastiques ou esthétiques de la composition, ni le degré de ressemblance ou de réalisme des clichés, mais c'est leur dimension pragmatique, leur statut d'index, leur poids irréductible de référence, le fait qu'il s'agit de véritables *traces* physiques de personnes singulières qui ont été là et qui ont des rapports particuliers avec ceux qui regardent les photos." See Dubois, *L'Acte photographique*, 77.

105 Barthes, *Camera Lucida*, 106, 67, 69, 99–100, 84.

106 Ibid., 100.

107 Sayre, *The Object of Performance*, xiv.

108 Mavor, *Pleasures Taken*, 4.

109 Ibid., 111, 119–20.

110 Elizabeth C. Fine, "Performative Metaphors as Ritual Communication," in *Performance, Culture and Identity*, ed. Fine and Speer, 23.

111 The literature that has accrued to the Carroll corpus is both copious and controversial. An interesting contribution which grapples creatively and intelligently with the recurrent issues of childhood sexuality and sexual abuse of children is George Dimock's article "Childhood's End: Lewis Carroll and the Image of the Rat."

112 Turner, *The Anthropology of Performance*, 77.

113 Hall, *The Silent Language*, 160–1.

114 Langellier and Peterson, "Spinstorying," in *Performance, Culture and Identity*, ed. Fine and Speer, 167.

115 Clarke, "Family Photos: The Living and the Dead," A20.

116 Illich and Sanders, *A B C*, 53–4.

"PHOTOGRAPHS" 1916–1945

1 The method applied to this album was the creation of a series of chronological storyboards running from 1916 to 1945. The album had already been copied, and all information from the back of the prints, as well as comparative notes, had been transferred to labels that were added to the copy. The copy was then copied, and these third-generation images were separated by year and organized chronologically. The storyboards made the years of greatest activity immediately apparent. Lists were also essential, beginning with all the inscribed places and dates; the constructed information was then added as it began to emerge from internal comparison and external sources, such as newspapers.

2 The studio is actually listed at 46 St Catherine Street East, but such minor discrepancies are not uncommon in the directory.

3 The prints are relatively small (an image size of 7.8 × 5.4 cm), with a generous deckle-edged border that survives in an example on page 10 and has elsewhere been unevenly trimmed. The images are quite faded and some are yellowing.

4 This print size (12.5 cm × 8 cm) and format (curlicue border) was in use from the late twenties through 1937, to be replaced by a snapshot format with a white deckle-edged border.

5 The St-Ours picture format is 13.5 cm × 9 cm. It is used sparingly throughout the album.

6 The format of the print is also the same, although the picture of the girl has been partially masked, creating a deep bottom border.

7 The number on the front of the house, clearly legible as 123 in the 1929 portrait of Rachel, offered a tantalizing clue. In 1929 there were approximately eighty-seven houses listed in Lovell's Montreal directory with 123 as the street number. The numbers have subsequently been changed, but the directory is organized according to streets and cross streets. All of these leads were eliminated or checked, but no house resembling Rachel's could be found.

8 It was intriguing to read a notice in *La Presse* (Saturday, 13 August 1932) for a pilgrimage to Notre-Dame de Lourdes de Rigaud, to be held on Saturday, 20 August 1932. Our group seems to have gone on its own and on a Sunday, according to the inscription, but perhaps it was inspired by the organized event.

9 A comparison was made with 4382 Saint-Hubert, which is still standing. The house at 1569 de Bullion has been demolished.

10 The sole indication of the war effort is a series of haying photographs made in August 1940. Curiously enough, a full-page advertisement for Kodak was published in the picture supplement of *La Presse* for 31 August that featured children on a hay wagon and the ominous caption, "Les amis d'aujourd'hui se disperseront et se perdront de vue. Mais en appuyant simplement sur un bouton, vous pouvez les conserver tels qu'ils sont." Hillel Schwartz has detected a similar warning in a Kodak advertisement of 1937, featuring "Sara Delano Roosevelt, the president's mother, holding a snapshot: 'Not many of us are able to remember as we'd like ...'" See Schwartz, *The Culture of the Copy*, 199.

11 Lurie, *The Language of Clothes*, 73–7.

12 The storyboards show that there were a number of possible endings for the album, some happy, some sad. In 1945 the sisters were at a cottage at Pointe-du-Lac; the pictures appear in the middle of the album. They also went to Ste-Adèle on the train (page 57). The portrait of Rachel in bed was taken either in 1941, at the time of the party, or in 1945. On one hand, I lean to the later date, simply because Rachel looked relatively robust in 1941. On the other, it was not terribly unusual for elderly people to receive visitors in bed, and it did not necessarily mean that they were deathly ill. Still, Rachel was already well past middle age in 1929, so her photographic appearance in the 1940s, tucked up in bed and surrounded by bouquets of flowers, suggests an outpouring of love and concern.

CONCLUSION

1 Appel, *Signs of Life*, 152–7. Weaving together movie stills, photojournalism, work of art, and photo-phantasms, *Signs of Life* is a compilation of photographic allusions drawn from contemporary writing that substitutes photographic art for life experience, or does not distinguish between the two. Serpentine, copious, and conversational, Appel's essay is very like an album.

2 Goody and Watt, "The Consequences of Literacy," 30–1.

3 See Vansina, *Oral Tradition as History*, 114–23.

4 Iser, "Indeterminacy and the Reader's Response in Prose Fiction."

5 Beer, *Arguing with the Past*, 9. Beer cites Tzvetan Todorov, "The Quest of Narrative," in *The Poetics of Prose* (Oxford, 1977), 132.

6 Szarkowski, "Atget and the Art of Photography," in *The Work of Atget*, vol. 1, *Old France*, ed. Szarkowski and Hambourg, 11.

7 Ong, *Orality and Literacy*, 36.

APPENDIX I

1 John Towles, *Humphrey's Journal*, cited by McCandless, "The Portrait Studio and the Celebrity," in *Photography in Nineteenth-Century America*, ed. Sandweiss, 62.

2 Donald Wright, "David Ross McCord's Crusade," in McCord Museum of Canadian History, *La famille McCord, The McCord Family*, 91. In a conversation with the author, Pamela Miller, former curator of archival collections, explained the motto featured on David Ross McCord's letterhead and pointed to its biblical source, Proverbs 29:18: "Where there is no vision, the people perish: but he that keepeth the law, happy is he." McCord drew inspiration from the King James Version. A modern translation of Proverbs 29:18 underscores the motto's hidden meaning: "Where there is no vision the people get out of hand."

3 For a history of McCord's collecting from an ethnographic perspective, see McCaffrey, "Rononshonni – The Builder."

4 Triggs, "The Notman Photographic Archives," 183.

BIBLIOGRAPHY

Abrahamson, Una. *God Bless Our Home: Domestic Life in Nineteenth Century Canada*. Toronto: Burns & MacEachern, 1966

Adams, Brooks. "Turtle Derby." *Art in America* 85, no. 6 (June 1997): 34–41

Agee, James, and Walker Evans. *Let Us Now Praise Famous Men*. Boston: Houghton Mifflin Company, 1980

The American Annual of Photography. 1918, 1920. New York: American Annual of Photography, 1917, 1919

Appel, Alfred, Jr. *Signs of Life*. New York: Alfred Knopf, 1983

Art Gallery of Ontario. *Michael Snow / A Survey*. Exhibition catalogue by Michael Snow, Dennis Young, Robert Fulford, and P. Adams Sitney. Toronto, 1970

– *William Notman: The Stamp of a Studio*. Exhibition catalogue by Stanley G. Triggs. Toronto, 1985

Auerbach, Erich. "'Figura.'" In *Scenes from the Drama of European Literature*, trans. Ralph Manheim. New York: Meridian Books, 1959

Bakhtin, Mikhail. *The Dialogic Imagination: Four Essays*. Ed. Michael Holquist. Trans. Caryl Emerson and Michael Holquist. Austin: University of Texas Press, 1990

– *Rabelais and His World*. Trans. Hélène Iswolsky. Bloomington: Indiana University Press, 1984

Baldwin, Gordon. *Looking at Photographs: A Guide to Technical Terms*. Malibu: J. Paul Getty Museum, 1991

Ballerini, Julia, ed. *Sequence (con)Sequence: (sub)Versions of Photography in the 80s*. New York: Aperture, in association with Bard College, 1989

Barnes, Andrew E., and Peter N. Stearns, eds. *Social History and Issues in Human Consciousness: Some Interdisciplinary Connections*. New York and London: New York University Press, 1989

Barrow, Thomas F., Shelley Armitage, and William E. Tydeman, eds. *Reading into Photography: Selected Essays, 1959–1980*. Albuquerque: University of New Mexico Press, 1982

Barthes Roland. *A Barthes Reader*. Ed. Susan Sontag. New York: Hill and Wang, 1983

– *Camera Lucida: Reflections on Photography*. Trans. Richard Howard. New York: Noonday Press, 1981

– *Roland Barthes par Roland Barthes*. Paris: Éditions du Seuil, 1975, 1995

– *The Pleasure of the Text*. Trans. Richard Miller. New York: Hill and Wang, 1975

Batchen, Geoffrey. *Burning with Desire: The Conception of Photography*. Cambridge, Mass., and London: MIT Press, 1999

Bawer, Bruce. "Under the Aspect of Eternity: The Fiction of Flannery O'Connor." *New Criterion* 7, no. 5 (January 1989): 35–41

Bazin, André. "The Ontology of the Photographic Image," *What Is Cinema?* Trans. Hugh Gray. Berkeley and Los Angeles: University of California Press, 1967

Beaubien, Charles-Philippe. *Écrin d'amour familial: Détails historiques au sujet d'une famille, comme il y en a tant d'autres au Canada qui devraient avoir leur histoire*. Montreal: Arbour & Dupont, 1914

Becker, George J., and Edith Philips, eds. and trans. *Paris and the Arts, 1851–1896: From the Goncourt Journal*. Ithaca and London: Cornell University Press, 1971

Beer, Gillian. *Arguing with the Past: Essays in Narrative from Woolf to Sidney*. London and New York: Routledge, 1989

Bell, Keith. "Representing the Prairies: Private and Commercial Photography in Western Canada 1880–1980." In *Thirteen Essays on Photography*, ed. Geoffrey James, Raymonde April, Richard Baillargeon, and Martha Langford. Ottawa: Canadian Museum of Contemporary Photography, 1988

Bellour, Raymond. *L'Entre-images: Photo, cinéma, vidéo*. Paris: La Différence, 1990

Beloff, Halla. *Camera Culture*. Oxford: Basil Blackwell, 1985

Bender, John, and David E. Wellbery, eds. *Chronotypes: The Construction of Time*. Stanford: Stanford University Press, 1991

Bénichou, Anne, and Jacques Doyon. "Collection/fabrication: Regards croisés sur l'œuvre de George Legrady." *Parachute* 92 (October–December 1998): 24–35

Benjamin, Walter. *Illuminations*. Ed. Hannah Arendt. New York: Schocken Books, 1978

Berger, Carl. *Science, God, and Nature in Victorian Canada*. Toronto: University of Toronto Press, 1983

– *The Writing of Canadian History: Aspects of English-Canadian Historical Writing since 1900*. Toronto: University of Toronto Press, 1986

Berger, John. *About Looking*. New York: Pantheon Books, 1980

– *Pig Earth*. 1979; New York: Vintage Books, 1992

– and Jean Mohr. *Another Way of Telling*. London: Writers and Readers Publishing Cooperative Society, 1982

Bernstein, Michael André. *Foregone Conclusions: Against Apocalyptic History*. Berkeley: University of California Press, 1994

Bhabha, Homi. "Of Mimicry and Man: The Ambivalence of Colonial Discourse," 1984, reprinted in *October: The First Decade, 1976–1986* (Cambridge: MIT Press, 1987)

Bisbee, Jessie Robinson. "Photography – Then and Now." In *The American Annual of Photography*, 1918, 128–30. New York: American Annual of Photography, 1917

Boerdam, Jaap, and Warna Oosterbaan Martinius, "Family Photographs – A Sociological Approach." *Netherlands Journal of Sociology* 16 (1980): 95–119

Bossard, James H.S., and Eleanor S. Boll. *Ritual in Family Living: A Contemporary Study*. Philadelphia: University of Pennsylvania Press, 1956

Bourdieu, Pierre, Luc Boltanski, Robert Castel, and Jean Claude Chamboredon. *Un Art moyen: Essai sur les usages sociaux de la photographie*. Paris: Éditions de minuit, 1965

– et al. *Photography: A Middle-brow Art*. Trans. Shaun Whiteside. Stanford: Stanford University Press, 1990

Bourguet, Marie-Noëlle, Lucette Valensi, and Nathan Wachtel, eds. *Between Memory and History*. Chur: Harwood Academic Publishers, 1990

Bowlby, John. *Attachment and Loss*. 3 vols. London: Hogarth Press and Institute of Psycho-Analysis, 1969–80

Braden, Su. *Committing Photography*. London: Pluto Press, 1983

Brannan, Beverly W., and Judith Keller. "Walker Evans: Two Albums in the Library of Congress." *History of Photography* 19, no. 1 (spring 1995): 60–6

Briggs, Asa, and Archie Miles. *A Victorian Portrait: Victorian Life and Values as Seen through the Work of Studio Photographers*. New York: Harper & Row, 1989

Brilliant, Richard. *Portraiture*. Cambridge: Harvard University Press, 1991

Brooks, Peter. *Reading for the Plot: Design and Intention in Narrative*. New York: A.A. Knopf, 1984

Buchloh, Benjamin H.D. "Divided Memory and Post-Traditional Identity: Gerhard Richter's Work of Mourning." *October* 75 (winter 1996): 61–82

– "Warburg's Model: The Photographic Structure of Memory in Broodthaers and Richter." Paper presented at Modernist Utopias. Postformalism and Pure Visuality, conference organized by the Musée d'art contemporain, Montreal, 9–10 December 1995

Bullock, F.J. *Ships and the Seaway*. Toronto: J.M. Dent & Sons, 1959

Burgin, Victor, ed. *Thinking Photography*. London and Basingstoke: MacMillan, 1984

Burkart, A.J., and S. Medlik, *Tourism: Past, Present, and Future*. London: Heinemann, 1974

Byers, Paul. "Cameras Don't Take Pictures." *Columbia University Forum* 9 (1966): 27–31

Calhoun, Arthur W. *A Social History of the American Family from Colonial Times to the Present*. Vol. 3. Cleveland: Arthur H. Clark Co., 1919

Cameron, Charlotte. *A Woman's Winter in Africa: A 26,000 Mile Journey*. London: Stanley Paul & Co., 1913

Carlyle, Thomas. *Past and Present*. London: Dent, 1947

Carr, David. *Time, Narrative, and History*. Bloomington: Indiana University Press, 1986

Centre Canadien d'Architecture / Canadian Centre for Architecture. *Collections Documentation Guide*. Montreal, 1994

Centre Georges Pompidou. *Livres d'artistes*. Exhibition catalogue by Anne Moeglin-Delcroix. Paris, 1985

Chalfen, Richard. *Snapshot Versions of Life: Explorations of Home Made Photography*. Bowling Green: Bowling Green State University Popular Press, 1987

– *Turning Leaves: The Photograph Collections of Two Japanese American Families*. Albuquerque: University of New Mexico Press, 1991

Christ, Carol T., and John O. Jordan, eds. *Victorian Literature and the Victorian Visual Imagination*. Berkeley: University of California Press, 1995

Christopherson, Richard W. "From Folk Art to Fine Art: A Transformation in the Meaning of Photographic Work." *Urban Life and Culture* 3, no. 2 (July 1974): 123–58

Clarke, Deborah Kurschner. "Family Photos: The Living and the Dead." *Globe and Mail*, 11 April 1995, A20

Clifford, James. "On Collecting Art and Culture." In *The Predicament of Culture: Twentieth-Century Ethnography, Literature, and Art*. Cambridge, Mass., and London: Harvard University Press, 1988

Coe, Brian, and Paul Gates. *The Snapshot Photograph: The Rise of Popular Photography, 1888–1939*. London: Asch and Grant, 1977

Cohen, Erik, Yeshayahu Nir, and Uri Almagor. "Stranger-Local Interaction in Photography." *Annals of Tourism Research* 19 (1992): 213–33

Collier, John, Jr, and Malcolm Collier. *Visual Anthropology: Photography as a Research Method*. Albuquerque: University of New Mexico Press, 1986

Connerton, Paul. *How Societies Remember*. Cambridge and New York: Cambridge University Press, 1989

Conway, Martin A. *Autobiographical Memory: An Introduction*. Buckingham: Open University Press, 1990

Cornish, Kimberley. *The Jew of Linz: Wittgenstein, Hitler and their Secret Battle for the Mind.* London: Century Books, 1998

Corrigan, Philip. "In/Formation: A Short Organum for PhotoGraphWorking." *Photo Communique,* Fall 1985, 12–17

Couillard Després, Abbé A. *Histoire de la Famille et de la Seigneurie de Saint-Ours.* Vol. 2, *La Famille et la Paroisse de Saint-Ours, 1785–1916.* Montreal: Imprimerie des Sourds-Muets, 1917

Cox, James M. "Autobiography and America." *Virginia Quarterly Review* 47, no. 2 (spring 1971): 252–77

Craig, Grace Morris. *But This Is Our War.* Toronto: University of Toronto Press, 1981

Creative Camera. "Manchester Studies Archive." *Creative Camera* 193–4 (July–August 1980): 260–5

Creighton, Luella. *The Elegant Canadians.* Toronto: McClelland and Stewart, 1967

Crimp, Douglas. "Positive/Negative: A Note on Degas's Photographs." *October* 5 (summer 1978): 89–100

Csikszentmihalyi, Mihaly, and Eugene Rochberg-Halton. *The Meaning of Things: Domestic Symbols and the Self.* Cambridge: Cambridge University Press, 1981, 1989

Cubitt, Sean. "The Great Conversation: On the Ethics of Appropriating Business Media for Inappropriate Ends." In *Fotofeis: Scottish International Festival of Photography* 1993. Edinburgh: Fotofeis, 1993

– *Videography: Video Media as Art and Culture.* Basingstoke: Macmillan, 1993

Daniel, Malcolm. *The Photographs of Édouard Baldus.* New York: Metropolitan Museum of Art; Montreal: Canadian Centre for Architecture, 1995

de Duve, Thierry. "Time Exposure and Snapshot: The Photograph as Paradox." *October* 5 (summer 1978): 113–25

Dési, Louise. "L'histoire de la photographie au Quebec à travers les périodiques 1839-c. 1880." 2 vols. Master's thesis, Université du Quebec à Montreal, 1984

Dia Center for the Arts. *Hanne Darboven: Kulturgeschichte, 1880–1983 (1980–83).* Exhibition brochure by Lynne Cooke. New York, 1996

Dickens, Charles. *The Personal History of David Copperfield.* New York: Book-of-the-Month Club, 1997

Dickson, Arthur Jerome, ed. *Covered Wagon Days: A Journey across the Plains in the Sixties, and Pioneer Days in the Northwest; from the Private Journals of Albert Jerome Dickson.* Cleveland: Arthur H. Clark Company, 1929

Dimock, George. "Childhood's End: Lewis Carroll and the Image of the Rat." *Word & Image* 8, no. 3 (July–September 1992): 183–205

Dimond, Frances, and Roger Taylor. *Crown & Camera: The Royal Family and Photography, 1842–1910.* Harmondsworth and New York: Viking, 1987

Docherty, Thomas. *After Theory: Postmodernism/Postmarxism.* London and New York: Routledge, 1990

Dubois, Philippe. *L'acte photographique et autre essais.* Paris: Nathan, 1990

Edwards, Elizabeth. *Anthropology & Photography.* London: Royal Anthropological Institute, 1992

Eliade, Mircea. *Myths, Dreams and Mysteries: The Encounter between Contemporary Faiths and Archaic Realities.* Trans. Philip Mairet. New York: Harper & Row, 1975

Enos, Richard Leo, ed. *Oral and Written Communication: Historical Approaches.* Newbury Park: Sage Publications, 1990

Evans, Walker, and Jerry L. Thompson. *Walker Evans at Work.* New York: Harper & Row, 1982

Feldman, Hans-Peter. *Ferien.* Düsseldorf: Wiener Secession, 1994

– *Porträt.* Munich: Schirmer/Mosel, 1994

Ferrarotti, Franco. *The End of Conversation: The Impact of Mass Media on Modern Society.* Contributions in Sociology, 71. New York: Greenwood Press, 1988

Fine, Elizabeth C., and Jean Haskell Speer, eds. *Performance, Culture, and Identity.* Westport: Praeger Publishers, 1992

Finnegan, Ruth. *Oral Traditions and the Verbal Arts: A Guide to Research Practices.* London and New York: Routledge, 1992

Fisher, Philip. "Appearing and Disappearing in Public: Social Space in Late-Nineteenth-Century Literature and Culture." In *Reconstructing American Literary History,* ed. Sacvan Bercovitch. Cambridge, Mass., and London: Harvard University Press, 1986

Foley, John Miles, ed. *Oral-Formulaic Theory: A Folklore Casebook.* New York and London: Garland Publishing, 1990

Ford, Colin, and Karl Steinorth. *You Press the Button, We Do the Rest: The Birth of Snapshot Photography.* London: Dirk Nishen Publishing, 1988

Foto Biennale Enschede. *Obsessies: Van Wunderkammer tot Cyberspace / Obsessions: From Wunderkammer to Cyberspace.* Exhibition catalogue ed. Bas Vroege. Enschede, 1995

Foucault, Michel. *The Order of Things: An Archaeology of the Human Sciences.* New York: Vintage Books, 1994

Foy, Jessica H., and Thomas J. Schlereth, eds. *American Home Life, 1880–1930: A Social History of Spaces and Services.* Knoxville: University of Tennessee Press, 1992

Frazier, Ian. *Family.* New York: Farrar, Straus and Giroux, 1994

Fried, Lewis. *Makers of the City: Jacob Riis, Lewis Mumford, James T. Farrell, and Paul Goodman.* Amherst: University of Massachusetts Press, 1990

Fried, Michael. *Absorption and Theatricality: Painting and Beholder in the Age of Diderot.* Berkeley: University of California Press, 1980

Friedländer, Saul. *When Memory Comes.* Trans. Helen R. Lane. New York: Noonday Press, 1979

Frye, Northrop. *The Great Code: The Bible and Literature.* Toronto: Academic Press Canada, 1982

Fussell, Paul. *The Great War and Modern Memory.* New York and London: Oxford University Press, 1975

Gadamer, Hans-Georg. "On the Philosophic Element in the Sciences and the Scientific Character of Philosophy." In *Reason in the Age of Science,* trans. Frederick G. Lawrence. Cambridge, Mass., and London: MIT Press, 1982

Gagan, David. "'The Prose of Life': Literary Reflections of the Family, Individual Experience and Social Structure in Nineteenth-Century Canada." *Journal of Social History* 9, no. 3 (spring 1976): 367–81

Galassi, Peter. *Before Photography: Painting and the Invention of Photography.* New York: Museum of Modern Art, 1981

Ganzel, Bill. *Dust Bowl Descent.* Lincoln and London: University of Nebraska Press, 1984

Garat, Anne-Marie. *Photos de familles.* Paris: Éditions du Seuil, 1994

Gernsheim, Helmut, and Alison Gernsheim. *The History of Photography from the Camera Obscura to the Beginning of the Modern Era.* London: Thames and Hudson, 1969

Gikandi, Simon. *Maps of Englishness: Writing Identity in the Culture of Colonialism.* New York: Columbia University Press, 1996

Goffman, Erving. *Behaviour in Public Places: Notes on the Social Organization of Gatherings.* London: Free Press of Glencoe/MacMillan Company, 1963

– *Frame Analysis: An Essay on the Organization of Experience.* Cambridge: Harvard University Press, 1974

– *The Presentation of the Self in Everyday Life.* Garden City, NY: Doubleday Anchor Books, 1959

Goldin, Nan. *The Ballad of Sexual Dependency.* New York: Aperture Foundation, 1986

Goody, Jack. *The Interface between the Written and the Oral.* Cambridge: Cambridge University Press, 1987

– *Literacy in Traditional Societies,* London: Cambridge University Press, 1968

Gosse, Philip Henry. *The Romance of Natural History.* London: J. Nisbet, 1869

Gower, H.D. *The Camera as Historian.* London: Sampson Low, Marston and Co., 1916

Grahame, Kenneth. *The Wind in the Willows.* New York: Charles Scribner's Sons, 1960

Graves, Ken, and Mitchell Payne, eds. *American Snapshots.* Oakland: Scrimshaw Press, 1977

Green, David. "Veins of Resemblance: Photography and Eugenics." In *Photography/Politics: Two,* ed. Patricia Holland, Jo Spence, and Simon Watney. London: Comedia Publishing Group, 1986

Green, Jonathan. *American Photography: A Critical History, 1945 to the Present.* New York: Harry N. Abrams, 1984

– , ed. *The Snapshot.* Millerton: Aperture, 1974. Also published as *Aperture* 19, no. 1

Green-Lewis, Jennifer. *Framing the Victorians: Photography and the Culture of Realism.* Ithaca and London: Cornell University Press, 1996

Greenhill, Pauline. *So We Can Remember: Showing Family Photographs.* CCFCS Mercury Series, no. 36. Ottawa: National Museum of Man, 1981

Greenhill, Ralph, and Andrew Birrell. *Canadian Photography, 1839–1920.* Toronto: Coach House Press, 1979

Grier, Katherine C. *Culture & Comfort: People, Parlors, and Upholstery, 1850–1930.* Rochester: Strong Museum, 1988

Gronbeck, Bruce E., Thomas J. Farrell, and Paul A. Soukup, eds. *Media, Consciousness, and Culture: Explorations of Walter Ong's Thought.* Newbury Park: Sage Publications, 1991

Guest, Tim. *Books by Artists.* Toronto: Art Metropole, 1981

Gumpert, Lynn. *Christian Boltanski.* Paris: Flammarion, 1994

Hafsteinsson, Sigurjón Baldur. "Post-mortem and Funeral Photography in Iceland." *History of Photography* 23, no. 1 (spring 1999): 49–54

Halbwachs, Maurice. *The Collective Memory.* Trans. Francis J. Ditter Jr and Vida Yazdi Ditter. New York: Harper & Row, 1980

Hales, Andrea. "The Album of Camille Silvy." *History of Photography* 19, no. 1 (spring 1995): 82–7

Hall, Donald E., ed. *Muscular Christianity: Embodying the Victorian Age.* Cambridge: Cambridge University Press, 1994

Hall, Edward T. *The Silent Language.* Garden City, NY: Doubleday and Company, 1959

Hall, Roger, Gordon Dodds, and Stanley Triggs. *The World of William Notman: The Nineteenth Century Through a Master Lens.* Toronto: McLelland & Stewart, 1993

Hardy, Barbara. *Tellers and Listeners: The Narrative Imagination.* London: Athlone Press, University of London, 1975

Hare, A. Paul, and Herbert H. Blumberg. *Dramaturgical Analysis of Social Interaction.* New York: Praeger, 1988

Hareven, Tamara K. "Cycles, Courses and Cohorts: Reflections on Theoretical and Methodological Approaches to the Historical Study of Family Development." *Journal of Social History* 12 (1978–79): 97–109

– "The Family as Process: The Historical Study of the Family Cycle." *Journal of Social History* 7, no. 3 (1974): 322–9

Harkin, Michael. "Modernist Anthropology and Tourism of the Authentic." *Annals of Tourism Research* 22, no. 3 (1995): 650–70

Harper, J. Russell, and Stanley Triggs, eds. *Portrait of a Period: A Collection of Notman Photographs, 1856 to 1915.* Montreal: McGill University Press, 1967

Harris, Alex, ed. *A World Unsuspected: Portraits of Southern Childhood.* Chapel Hill and London: University of North Carolina Press, 1987

Hattersley, C.W. *The Baganda at Home.* London: Religious Tract Society, 1908

Hattersley, Ralph M. "Family Photography as a Sacrament." *Popular Photography* 68, no. 6 (June 1971): 106–9

Heiferman, Marvin, and Carole Kismaric. *Talking Pictures: People Speak about the Pictures That Speak to Them.* San Francisco: Chronicle Books, 1994

Hein, George E. *Learning in the Museum.* London and New York: Routledge, 1998

Henige, David P. *Oral Historiography.* London and New York: Longman, 1982

Henisch, Heinz K., and Bridget A Henisch. *The Photographic Experience, 1839–1914: Images and Attitudes.* University Park, Penn.: Pennsylvania State University Press, 1994

Higonnet, Anne. *Pictures of Innocence: The History and Crisis of Ideal Childhood*. London: Thames and Hudson, 1998

– "Secluded Vision: Images of Feminine Experience in Nineteenth-Century Europe." *Radical History Review* 38 (1987): 16–36

Hill, David Octavius, and Robert Adamson. *An Early Victorian Album: The Photographic Masterpieces, 1843–1847, of David Octavius Hill and Robert Adamson*. Ed. Colin Ford. New York: Alfred A. Knopf, 1976

Hirsch, Julia. *Family Photographs: Content, Meaning, and Effect*. New York: Oxford University Press, 1981

Hirsch, Marianne. *Family Frames: Photography, Narrative, and Postmemory*. Cambridge, Mass., and London: Harvard University Press, 1997

– "Masking the Subject: Practicing Theory." In *The Point of Theory: Practices of Cultural Analyses*, ed. Mieke Bal and Inge Boer. Amsterdam: Amsterdam University Press, 1994

Holland, Patricia, Jo Spence, and Simon Watney, eds. *Photography/Politics: Two*. London: Comedia Publishing Group, 1986

Holliday, Peter J., ed. *Narrative and Event in Ancient Art*. Cambridge: Cambridge University Press, 1993

Holmes, Jon. "Pictures without Exhibition." *Village Voice*, 29 November 1976, 67–9

Hooper-Greenhill, Eilean. *Museums and the Shaping of Knowledge*. London and New York: Routledge, 1992

Hunt, Lynn, ed. *The New Cultural History: Essays*. Berkeley: University of California Press, 1989

Hurwit, Jeffrey M. "The Words in the Image: Orality, Literacy, and Early Greek Art." *Word & Image* 6, no. 2 (April–June 1990): 180–97

Hutton, Patrick H. *History as an Art of Memory*. Hanover and London: University of Vermont/University Press of New England, 1993

Huyda, Richard J. *Camera in the Interior 1858: H.L. Hime, Photographer, the Assiniboine and Saskatchewan Exploring Expedition*. Toronto: Coach House Press, 1975

– "Canadian Portfolios and Albums: Nineteenth Century Records and Curiosities." In *Canadian Perspectives, a National Conference on Canadian Photography, March 1–4, 1979*. Toronto: Ryerson Polytechnical Institute, 1979

Illich, Ivan, and Barry Sanders. *A B C: The Alphabetization of the Popular Mind*. New York: Vintage Books, 1989

Iser, Wolfgang. *The Implied Reader: Patterns of Communication in Prose Fiction from Bunyan to Beckett*. Baltimore and London: Johns Hopkins University Press, 1974

– "Indeterminacy and the Reader's Response in Prose Fiction." In *Aspects of Narrative*, ed. J. Hillis Miller. New York and London: Columbia University Press, 1971

Janis, Eugenia Parry, and Wendy MacNeil, eds. *Photography within the Humanities*. Danbury, NH: Addison House, 1977

Jay, Martin. *Downcast Eyes: The Denigration of Vision in Twentieth-Century French Thought*. Berkeley: University of California Press, 1994

Johnson, Ken. "A Post-Retinal Documenta." *Art in America* 85, no. 10 (October 1997): 80–8

Joyce, James. *Ulysses*. New York: Vintage Books, 1990

Kaufman, James C.A. "Learning from the Fotomat." *American Scholar* 492 (1980): 244–6

– "Photographs & History: Flexible Illustrations." In *Reading into Photography: Selected Essays, 1959–1980*, ed. Thomas F. Barrow, Shelley Armitage, and William E. Tydeman. Albuquerque: University of New Mexico Press, 1982

Kermode, Frank. *Forms of Attention*. London: University of Chicago Press, 1985

– *The Genesis of Secrecy: On the Interpretation of Narrative*. Cambridge, Mass., and London: Harvard University Press, 1979

Kerouac, Jack. *Desolation Angels*. New York: Coward-McCann, 1965

Kett, Joseph F. *Rites of Passage: Adolescence in America, 1790 to the Present*. New York: Basic Books, 1977

King, Graham. *Say "Cheese!" Looking at Snapshots in a New Way*. New York: Dodd, Mead and Co., 1984

Knaplund, Paul. *The Unification of South Africa: A Study in British Colonial Policy*. N.p.: Wisconsin Academy of Sciences, Arts and Letters, 1924

Koltun, Lilly, Andrew Birrell, Peter Robertson, Andrew C. Rodger, and Joan M. Schwartz. *Private Realms of Light: Amateur Photography in Canada, 1839–1940*. Toronto: Fitzhenry & Whiteside, 1984

Korshin, Paul J. *Typologies in England, 1650–1820*. Princeton: Princeton University Press, 1982

Kotkin, Amy. "The Family Photo Album as a Form of Folklore." *Exposure* 16, no. 1 (March 1978): 4–8

Kouwenhoven, John A. *Half a Truth Is Better than None: Some Unsystematic Conjectures about Art, Disorder, and American Experience*. Chicago and London: University of Chicago Press, 1982

Kozloff, Max. *The Privileged Eye: Essays on Photography*. Albuquerque: University of New Mexico Press, 1987

Kracauer, Siegfried. *Theory of Film: The Redemption of Physical Reality*. New York: Oxford University Press, 1960

Krauss, Rosalind. "A Note on Photography and the Simulacral." *October* 31 (winter 1984): 49–68

Kuhn, Annette. *Family Secrets: Acts of Memory and Imagination*. London and New York: Verso, 1995

Lafleur, Théodore. *A Semi-Centennial Historical Sketch of the Grande-Ligne Mission, 1885*. Montreal: s.n., [1886?]

Lamoureux, Johanne. "L'album ou la photographie corrigée par son lieu." *Trois* 6, nos 2–3 (hiver/printemps 1991): 185–91. Also published in *Corriger les lieux après la photographie de voyage* (exhibition catalogue). Montréal: Dazibao, 1991

Langford, Martha. "The Black Clothing of Things: Photography and Death." *Border Crossings* 14, no. 2 (April 1995): 22–7

– "A Machine in the Grotto: The Grotesque in Photography." *JAISA: The Journal of the Association of the Interdisciplinary Study of the Arts* 1, no. 2 (spring 1996): 111–23

– "The Idea of Album." *Blackflash* 14, no. 4 (1996): 5–7

– "Literacy through Photography." In *Reading the Museum: The Literacy Program of the Canadian Museums Association* 5, no. 1 (May/June 1999): 3–5. Also published in French as "La photographie, un moyen d'alphabétisation," in *Lire le musée: Un programme de l'Association des musées canadiens* 5, n. 1 (mai/juin 1999): 3–5

– *On Space, Memory and Metaphor: The Landscape in Photographic Reprise.* Montreal: Vox Populi, 1997

Langness, L.L., and Gelya Frank. *Lives: An Anthropological Approach to Biography.* Navato: Chandler & Sharp Publishing, 1981

Lartigue, Jacques-Henri. *Les photographies de J.-H. Lartigue: Un album famille de la Belle Époque.* Lausanne, 1966

Laslett, Peter. *Household and Family in Past Time: Comparative Studies in the Size and Structure of the Domestic Group over the Last Three Centuries in England, France, Serbia, Japan and Colonial North America, with Further Materials from Western Europe.* Cambridge: Cambridge University Press, 1972

Layton, Robert. *The Anthropology of Art.* Cambridge: Cambridge University Press, 1991

Le Goff, Jacques. *History and Memory.* Trans. Steven Rendall and Elizabeth Claman. New York: Columbia University Press, 1992

Legouvé, Ernest. *À propos d'un album photographique: Lu dans la séance publique annuelle des cinq Académies, le mercredi 25 octobre 1871.* La Rochelle: Rumeur des Ages, 1995

Lesy, Michael. *Time Frames: The Meaning of Family Pictures.* New York: Pantheon Books, 1980

Library of Congress. *Walker Evans: Photographs for the Farm Security Administration, 1935–1938.* New York: Da Capo Press, 1975

Linteau, Paul-André, René Durocher, and Jean-Claude Robert. *Quebec: A History, 1867–1929.* Trans. Robert Chodos. Toronto: James Lorimer & Company, 1983

– and François Ricard. *Quebec since 1930.* Trans. Robert Chodos and Ellen Garmaise. Toronto: James Lorimer & Company, 1991

Lipovenko, Dorothy. "Death of Children Price of Long Life." *Globe and Mail,* 8 March 1996, A1, A6. Photograph by Fred Lum

Lippard, Lucy R. *The Lure of the Local: Senses of Place in a Multicentered Society.* New York: New Press, 1997

Lower, Arthur Reginald Marsden. *Canadians in the Making: A Social History of Canada.* Toronto: Longmans, Green, 1958

Lumpp, R.F. "A Biographical Portrait of Walter Jackson Ong." *Oral Tradition* 2 (1987): 13–18

– "Selected Biography of Ong's Writings." *Oral Tradition* 2 (1987): 19–30

Lundström, Jan-Erik. "Maria Miesenberger 'Sverige/Schweden.'" In *Fotofeis: International Festival of Photography in Scotland, 1995.* Edinburgh: Fotofeis, 1995

Lurie, Alison. *The Language of Clothes.* New York: Random House, 1981

Lury, Celia. *Prosthetic Culture: Photography, Memory and Identity.* London and New York: Routledge, 1998

Lyons, Nathan. *Contemporary Photographers: Toward a Social Landscape.* New York: Horizon Press, in collaboration with the George Eastman House, Rochester, 1966

McArthur, Tom, ed. *The Oxford Companion to the English Language.* Oxford: Oxford University Press, 1992

McCaffrey, Moira T. "Rononshonni – The Builder: David Ross McCord's Ethnographic Collection." In *Collecting Native America, 1870–1960,* ed. Shepard Krech III and Barbara A. Hail. Washington and London: Smithsonian Institution Press, 1999

MacCannell, Dean. *The Tourist: A New Theory of the Leisure Class.* New York: Schocken Books, 1976

McCarthy, Cormac. *Suttree.* New York: Vintage Books, 1992

McCauley, Elizabeth Anne. *Industrial Madness: Commercial Photography in Paris, 1848–1871.* New Haven and London: Yale University Press, 1994

McCord Museum. *Canadian Painting and Photography, 1860–1900.* Exhibition catalogue by Ann Thomas. Montreal, 1979

McCord Museum of Canadian History. *La famille McCord: Une vision passionnée/The McCord Family: A Passionate Vision.* Exhibition catalogue by Patricia Miller et al. Montreal, 1992

– *Les Photographies composites de William Notman / The Composite Photographs of William Notman.* Exhibition catalogue by Stanley G. Triggs. Montreal, 1994

– *Le Pont Victoria: Un lien vital / Victoria Bridge: The Vital Link.* Exhibition catalogue by Stanley G. Triggs, Brian Young, Conrad Graham, and Gilles Lauzon. Montreal, 1992

– *Le studio de William Notman: Objectif Canada / William Notman's Studio: The Canadian Picture.* Exhibition catalogue by Stanley G. Triggs. Montreal, 1992

McCoy, Liza. "Looking at Wedding Pictures." In *The Zone of Conventional Practice and Other Real Stories,* ed. Cheryl Simon. Montreal: Optica, 1989

McDannell, Colleen. *Material Christianity: Religion and Popular Culture in America.* New Haven and London: Yale University Press, 1995

McIlwraith, Jean N. *Sir Frederick Haldimand.* Toronto: Morang & Co., 1906

McInnis, Edgar. *Canada: A Political and Social History.* Toronto: Holt, Rinehart and Winston of Canada, 1969

McLean, Malcolm S., Jr, and William R. Hazard. "Women's Interest in Pictures: The Badger Village Study." *Journalism Quarterly* 30 (1953): 139–62

McLuhan, Marshall. *Understanding Media: The Extensions of Man.* New York, Scarborough: New American Library, 1964

Malcolm, Janet. *Diana & Nikon.* Boston: David R. Godine, 1980

Mallon, Thomas. *A Book of One's Own: People and Their Diaries.* New York: Ticknor & Fields, 1984

Mann, Margery. "Children and Cameras: Sophisticated Vision from the Daughter of a Migrant Worker." *Popular Photography* 66, no. 2 (February 1970): 64–5

– "Must That Social Landscape be Horizontal?" *Popular Photography* 66, no. 6 (June 1970): 25–6, 126

– "Revolutions in Medium – But What about the Message?" *Popular Photography* 67, no. 2 (August 1970): 25–6

– "The Snapshot: Family Record or Social Document?" *Popular Photography* 67, no. 3 (September 1970): 29–30

– "Today's Painters Use the Photographer's Eye." *Popular Photography* 66, no. 5 (May 1970): 29, 68

Marian Goodman Gallery. *Gerhard Richter: Documenta IX, 1992*. Exhibition catalogue. Essays by Benjamin H.D. Buchloh. New York, 1993

Marrelli, Nancy, ed. *Montreal Photo Album / Montréal: Un album de photos:* Montréal: Véhicule Press, 1993

Marx, Leo. *The Machine in the Garden: Technology and the Pastoral Ideal in America*. London, Oxford, New York: Oxford University Press, 1964

Mavor, Carol. *Pleasures Taken: Performances of Sexuality and Loss in Victorian Photographs*. Durham and London: Duke University Press, 1995

Meatyard, Ralph Eugene. *The Family Album of Lucybelle Crater*. Millerton, NY: Jargon Society / Book Organization, 1974

Melion, Walter S. "Memory and the Kinship of Writing and Picturing in the Early Seventeenth-Century Netherlands." *Word & Image* 8, no. 1 (January–March, 1992): 48–70

Mellinger, Wayne Martin. "Toward a Critical Analysis of Tourism Representations." *Annals of Tourism Research* 21, no. 4 (1994): 756–79

Metz, Christian. *The Imaginary Signifier: Psychoanalysis and the Cinema*. Trans. Celia Britton et al. Bloomington: Indiana Univerisity Press, 1982

– "Photography and Fetish." *October* 34 (1985): 81–90

Meyrowitz, Joshua. *No Sense of Place: The Impact of Electronic Media on Social Behaviour*. New York, Oxford: Oxford University Press, 1985

Milgram, Stanley. "The Image-Freezing Machine." *Psychology Today* 9 (January 1977): 50–4, 108

– and Roslyn Banish. "City Families: Britons and Americans Talk about Their Own Images, Frozen Forever on Film." *Psychology Today* 9 (January 1977): 56–65

Mitchell, W.J. Thomas, ed. *The Language of Images*. Chicago and London: University of Chicago Press, 1980

Mitchell, William J. *The Reconfigured Eye: Visual Truth in the Post-Photographic Era*. Cambridge: MIT Press, 1994

Moholy-Nagy, László. "From Pigment to Light," 1936. In *Photographers on Photography*, ed. Nathan Lyons. Englewood Cliffs: Prentice Hall, 1966

Moniot, Drew Herbert. "Photographs and Their Meaning: An Experimental Study Assessing the Cognitive Dimensions Which Viewers of Three Photographic Competence Levels Use in Generating Meaning from Photographs Embedded in Art versus Documentary Contexts." PhD dissertation, Temple University, 1979

Moore, Sally F., and Barbara G. Myerhoff, *Secular Ritual*. Assen: Van Gorcum, 1977

Morgan, Henry J. *The Canadian Men and Women of the Time: A Handbook of Canadian Biography of Living Characters*. Toronto: W. Briggs, 1912

– and Lawrence J. Burpee. *Canadian Life in Town and Country*. London: George Newnes, 1905

Morris, Wright. "In Our Image," 1978. In *Photography in Print: Writings from 1816 to the Present*, ed. Vicki Goldberg. New York: Simon and Schuster, 1981

– *Photographs & Words*. Ed. James Alinder. Providence: Matrix Publications / Friends of Photography, 1982

Morrison, Toni. "The Site of Memory." In *Out There: Marginalization and Contemporary Cultures*, ed. Russell Ferguson, Martha Gever, Trinh T. Minh-ha, and Cornel West. New York: New Museum of Contemporary Art; Cambridge, Mass., and London: MIT Press, 1990, 1994

Morson, Gary Saul. *Narrative and Freedom: The Shadows of Time*. New Haven and London: Yale University Press, 1994

Morton, Desmond. *When Your Number's Up: The Canadian Soldier in the First World War*. Toronto: Random House of Canada, 1993

Morton, W.L., ed. *The Shield of Achilles: Aspects of Canada in the Victorian Age/Le Bouclier d'Achille: Regards sur le Canada de l'ère victorienne*. Toronto: McClelland and Stewart, 1968

Motz, Marilyn F. "Visual Autobiography: Photograph Albums of Turn-of-the-Century Midwestern Women." *American Quarterly* 41, no. 1 (March 1989): 63–92

Musello, Christopher. "Family Photography." In *Images of Information: Still Photography in the Social Sciences*. Ed. Jon Wagner. Beverley Hills: Sage Publications, 1979

– "Studying the Home Mode: An Exploration of Family Photography and Visual Communications." *Studies in Visual Communication* 61 (1980): 26–7

Museum of Modern Art. *Mirrors and Windows: American Photography since 1960*. Exhibition catalogue by John Szarkowski. New York, 1978

Myerhoff, Barbara. *Number Our Days*. New York: E.P. Dutton, 1978

National Film Board of Canada, Still Photography Division. *Paradise/Le Paradis*. Exhibition catalogue by Martha Langford. Ottawa, 1980

National Gallery of Art. *Robert Frank: Moving Out*. Exhibition catalogue by Sarah Greenough, Philip Brookman, et al. Washington, DC, 1994

Needham, Gerald. *19th Century Realist Art*. New York: Harper & Row, 1988

Neisser, Ulric, and Eugene Winograd, eds. *Remembering Reconsidered: Ecological and Traditional Approaches to the Study of Memory*. Cambridge: Cambridge University Press, 1988

Newhall, Beaumont. *The History of Photography*. New York: Museum of Modern Art, 1964

Nicholson, Gerald W.L. *Canada's Nursing Sisters*. Toronto: Samuel Stevens, Hakkert, 1975

O'Donnell, Lorraine. "Towards Total Archives: The Form and Meaning of Photographic Records." *Archivaria* 38 (fall 1994): 105–18

Oestreicher, Richard. "From Artisan to Consumer: Images of Workers, 1840–1920." *Journal of American Culture* 4, no. 1 (1981): 47–64

Ohrn, Karin Becker. "The Photo Flow of Family Life: A Family Photograph Collection." *Folklore Forum* 13 (1975): 27–36

O'Leary, Elizabeth L. *At Beck and Call: The Representation of Domestic Servants in Nineteenth-Century American Painting*. Washington and London: Smithsonian Institution Press, 1996

Olrik, Axel. "Epic Laws of Folk Narrative." In *The Study of Folklore*, ed. Alan Dundes. Englewood Cliffs, NJ: Prentice Hall, 1965

O'Neill, Paul. *A Picture That Hangs Upon Your Wall*. Dublin: Irish Museum of Modern Art, 1995

Ong, Walter J. *Fighting for Life: Contest, Sexuality, and Consciousness*. Ithaca: Cornell University Press, 1981

– *Interfaces of the Word: Studies in the Evolution of Consciousness and Culture*. Ithaca: Cornell University Press, 1977

– *Orality and Literacy: The Technologizing of the Word*. London and New York: Methuen, 1982

– *The Presence of the Word: Some Prolegomena for Cultural and Religious History*. New Haven and London: Yale University Press, 1967

– *Rhetoric, Romance and Technology: Studies in the Interaction of Expression and Culture*. Ithaca: Cornell University Press, 1971

– "Text as Interpretation: Mark and After." In *Oral Tradition in Literature: Interpretation in Context*, ed. John Miles Foley. Columbia: University of Missouri Press, 1986

Osborne, Brian S. "Interpreting a Nation's Identity: Artists as Creators of National Consciousness." In *Ideology and Landscape in Historical Perspective: Essays on the Meanings of Some Places in the Past*, ed. Alan R.H. Baker and Gideon Biger. Cambridge: Cambridge University Press, 1992

Outsider, An. "My First Carte de Visite." *American Journal of Photography* 5, no. 15 (1 February 1863): 337–43

Parkes, Colin Murray. *Bereavement: Studies of Grief in Adult Life*. Madison, Conn.: International Universities Press, 1986

Paster, James E. "Advertising Immortality by Kodak." *History of Photography* 16, no. 2 (summer 1992): 135–9

Pearce, Susan M. *On Collecting: An Investigation into Collecting in the European Tradition*. London and New York: Routledge, 1995

Peel, C.S. Dorothy C. *The Stream of Time: Social and Domestic Life in England, 1805–1861*. London: John Lane, The Bodley Head, 1931

Pemble, John. *The Mediterranean Passion: Victorians and Edwardians in the South*. Oxford: Clarendon Press; New York: Oxford University Press, 1987

Pepys, Samuel. *The Diary of Samuel Pepys*. Vol. 1, 1660. Ed. Robert Latham and William Matthews. Berkeley and Los Angeles: University of California Press, 1970

Perugini, Mark Edward. *Victorian Days and Ways, Illustrated by Reproductions from "Punch" and from Contemporary Prints*. London: Jarrolds, 1932

Pollock, Griselda. *Differencing the Canon: Feminist Desire and the Writing of Art's Histories*. London and New York: Routledge, 1999

Poncin, Catherine, and Paul Ardenne. *Catherine Poncin*. Trézélan: Filigranes Éditions, 1999

Quennell, Peter. *Victorian Panorama. A Survey of Life & Fashion from Contemporary Photographs*. London: B.T. Batsford, 1937

Richter, Gerhard. ATLAS *of the Photographs, Collages and Sketches*. Ed. Helmut Friedel and Ulrich Wilmes. New York: Distributed Art Publishers, 1997

Rivoir, Silvana. "The Soldier Photographer." Trans. Stuart Hood. In *Photography/Politics: Two*, ed. Patricia Holland, Jo Spence, and Simon Watney. London: Comedia Publishing Group, 1986

Robbins, Bruce. *The Servant's Hand: English Fiction from Below*. New York: Columbia University Press, 1986

Roberts, John. *The Art of Interruption: Realism, Photography and the Everyday*. Manchester and New York: Manchester University Press, 1998

Robertson, George, Melinda Mash, Lisa Tickner, Jon Bird, Barry Curtis, and Tim Putnam, eds. *Travellers' Tales: Narratives of Home and Displacement*. London and New York: Routledge, 1994

Robinson, John A. "Personal Narratives Reconsidered." *Journal of American Folklore* 94, no. 371 (1981): 58–85

Rodgers, Daniel T. "Socializing Middle-Class Children: Institutions, Fables, and Work Values in Nineteenth-Century America." *Journal of Social History* 13 (1979–80): 354–67

Rosen, Charles, and Henri Zerner. *Romanticism and Realism: The Mythology of Nineteenth-Century Art*. Markham: Penguin Books, 1984

Rosenblum, Barbara. *Photographers at Work*. New York: Holmes & Meier, 1978

Rosenblum, Naomi. *A World History of Photography*. New York: Abbeville Press, 1984

Roskill, Mark, and David Carrier. *Truth and Falsehood in Visual Images*. Amherst: University of Massachusetts Press, 1983

Rubin, David C., ed. *Autobiographical Memory*. Cambridge: Cambridge University Press, 1986

Ruby, Jay. "Post-Mortem Portraiture in America." *History of Photography* 8, no. 3 (July–September 1984): 201–22

– *Secure the Shadow: Death and Photography in America*. Cambridge, Mass., and London: MIT Press, 1995

Russell, G.W.E. *Collections and Recollections, by One Who Has Kept a Diary*. New York and London: Harper & Brothers, 1899

Said, Edward W. *Orientalism*. New York: Vintage Books, 1979, 1994

Salvioni, Daniela. "The Whitney Biennial: A Post 80s Event." *Flash Art* 30, no. 195 (summer 1997): 114–17

Sandweiss, Martha A., ed. *Photography in Nineteenth-Century America*. Fort Worth: Amon Carter Museum, 1991

Sarbin, Theodore R. *Narrative Psychology: The Storied Nature of Human Conduct*. New York: Praeger, 1986

Sayre, Henry M. *The Object of Performance: The American Avant-Garde since 1970*. Chicago and London: University of Chicago Press, 1989

Schlereth, Thomas J. *Victorian America: Transformations in Everyday Life, 1876–1915*. New York: Harper Collins, 1991

Schmid, Joachim. *Bilder von der Straße*. Berlin: Edition Fricke & Schmid, 1994

– "Der Knipser/The Snapshooter." *European Photography* 32 (1987): 39–42

– "The World of Pictures." In *Taking Snapshots: Amateur Photography in Germany from 1900 to the Present*, English insert, 5–6. N.p.: Institute for Foreign Cultural Relations, 1993

Scholes, Robert, and Robert Kellogg. *The Nature of Narrative.* New York: Oxford University Press, 1966

Schwartz, Dona B., and Michael Griffin. "Amateur Photography: The Organizational Maintenance of an Aesthetic Code." In *Natural Audiences: Qualitative Studies of Media Uses and Effects,* ed. Thomas R. Lindlof. Norwood, NJ: Ablex, 1987

Schwartz, Hillel. *The Culture of the Copy: Striking Likenesses, Unreasonable Facsimiles.* New York: Zone Books, 1996

Schwarz, Heinrich. *Art and Photography: Forerunners and Influences.* Ed. William E. Parker. Chicago and London: University of Chicago Press, 1987

Seiberling, Grace, and Carolyn Bloore. *Amateurs, Photography, and the Mid-Victorian Imagination.* Chicago: University of Chicago Press, 1986

Sekula, Allan. *Photography against the Grain: Essays and Photo Works, 1973–1983.* Halifax: Press of the Nova Scotia College of Art and Design, 1984

Shaw, Renata V. "Picture Organization: Practices and Procedures," 2 parts. *Special Libraries* 63 (October 1972): 448–56; 63 (November 1972): 502–6

Simon, Cheryl, ed. *The Zone of Conventional Practice and Other Real Stories.* Montreal: Optica, 1989

Smith, Graham. *Disciples of Light: Photographs in the Brewster Album.* Malibu: J. Paul Getty Museum, 1990

Smithsonian Institution/National African American Museum. *Imagining Families: Images and Voices.* Exhibition catalogue by Deborah Willis. Washington, DC, 1994

Solomon-Godeau, Abigail. "A Photographer in Jerusalem, 1855: Auguste Salzmann and His Times." *October* 18 (1981): 90–107

Sontag, Susan. *On Photography.* New York: Farrar, Straus and Giroux, 1978

Southeast Museum of Photography, Daytona Beach Community College. *Telling Our Own Stories: Florida's Family Photographs.* Exhibition catalogue by Alison Devine Nordström and Casey Blanton. Daytona Beach, 1997

Southern Alberta Art Gallery. *Al McWilliams.* Exhibition catalogue by Ian Carr-Harris. Lethbridge, 1989

Spector, Nancy. *Felix Gonzalez-Torres.* New York: Guggenheim Museum Publications, 1995

Spence, Jo. *Putting Myself in the Picture: A Political, Personal and Photographic Autobiography.* London: Camden Press, 1986

– and Patricia Holland, eds. *Family Snaps.* London: Virago Press, 1991

Squire, Shelagh J. "The Cultural Values of Literary Tourism." *Annals of Tourism Research* 21 (1994): 103–20

Starl, Timm. "Die Bildwelt der Knipser: Eine empirische Untersuchung zur privaten Fotografie." *Fotogeschichte* 14, no. 52 (1994): 59–68

– "A Short History of Snapshot Photography." In *Taking Snapshots: Amateur Photography in Germany from 1900 to the Present,* English insert, 7–13. N.p.: Institute for Foreign Cultural Relations, 1993

Stewart, Charles C., and Peter Fritzsche, eds. *Imagining the Twentieth Century.* Urbana and Chicago: University of Illinois Press, 1997

Stewart, Susan. *On Longing: Narratives of the Miniature, the Gigantic, the Souvenir, the Collection.* Baltimore and London: Johns Hopkins University Press, 1984

Stryker, Roy Emerson. *In This Proud Land: America as Seen in the FSA Photographs.* Greenwich, Conn.: New York Graphic Society, 1973

Sussman, Henry S. *High Resolution: Critical Theory and the Problem of Literacy.* New York and Oxford: Oxford University Press, 1989

Sussman, Herbert L. *Fact into Figure: Typology in Carlyle, Ruskin, and the Pre-Raphaelite Brotherhood.* Columbus: Ohio State Press, 1979

– *Victorian Masculinities: Manhood and Masculine Poetics in Early Victorian Literature and Art.* Cambridge: Cambridge University Press, 1995

Szarkowski, John, and Maria Morris Hambourg. *The Work of Atget.* Vol. 1, *Old France.* New York: Museum of Modern Art, 1981

Taft, Robert. *Photography and the American Scene: A Social History, 1839–1889.* 1938; Mineola, NY: Dover Publications, 1964

Taussig, Michael. *Mimesis and Alterity: A Particular History of the Senses.* New York and London: Routledge, 1993

Taylor, John. *A Dream of England: Landscape, Photography and the Tourist's Imagination.* Manchester and New York: Manchester University Press, 1994

Thomas, Alan. *Time in a Frame: Photography and the Nineteenth-Century Mind.* New York: Schocken Books, 1977

Thomas, Earle. *Sir John Johnson, Loyalist Baronet.* Toronto and Reading: Dundurn Press, 1986

Thompson, Hilary. "Narrative Closure in the Vignettes of Thomas and John Bewick." *Word & Image* 10, no. 4 (October–December 1994): 395–408

Tippett, Maria. *Art at the Service of War: Canada, Art and the Great War.* Toronto: University of Toronto Press, 1984

– *Making Culture: English Canadian Institutions and the Arts before the Massey Commission.* Toronto: University of Toronto Press, 1990

Tisseron, Serge. "L'inconscient de la photographie." *La Recherche photographique* 17 (automne 1994): 80–5

Trachtenberg, Alan. *Reading American Photographs: Images as History: Mathew Brady to Walker Evans.* New York: Hill and Wang/Noonday Press, 1989

– "Walker Evans' America: A Documentary Invention." In *Observations: Essays on Documentary Photography,* ed. David Featherstone. Carmel: The Friends of Photography, 1984

Triggs, Stanley G. "Alexander Henderson: Nineteenth-Century Landscape Photographer." *Archivaria* 5 (1977–78): 45–59

– "The Notman Photographic Archives." *History of Photography* 20, no. 2 (1996): 180–5

Trudel, Jean. "Une élite et son musée." *Cap-aux-Diamants* 25 (printemps 1991): 22–5

Tufte, Virginia, and Barbara Myerhoff. *Changing Images of the Family.* New Haven and London: Yale University Press, 1979

Turner, Victor. *The Anthropology of Performance.* New York: PAJ Publications, 1986

– *Dramas, Fields and Metaphors: Symbolic Action in Human Society.* Ithaca: Cornell University Press, 1974

– *From Ritual to Theatre: The Human Seriousness of Play.* New York: Performing Arts Journal Publications, 1982

van Alphen, Ernst. *Caught by History: Holocaust Effects in Contemporary Art, Literature, and Theory.* Stanford: Stanford University Press, 1997

Vanderbilt, Amy. *Amy Vanderbilt's New Complete Book of Etiquette.* Garden City, NY: Doubleday & Company, 1963

Vansina, Jan. *Oral Tradition as History.* Madison: University of Wisconsin Press, 1985

Varenne, Hervé. *Ambiguous Harmony: Family Talk in America.* Norwood, NJ: Ablex Publishing, 1992

Wallach, Amei. *Ilya Kabakov: The Man Who Never Threw Anything Away.* New York: Harry N. Abrams, 1996

Walter Phillips Gallery, Banff Centre for the Arts. *Ken Lum: Photo-Mirrors.* Exhibition catalogue by Jon Tupper and Lisa Gabrielle Mark. Banff, 1998

Ward, Peter. *Courtship, Love, and Marriage in Nineteenth-Century English Canada.* Montreal and Kingston: McGill-Queen's University Press, 1990

Watkins, Mary. *Invisible Guests: The Development of Imaginal Dialogues.* Boston: Sigo Press, 1990

Weaver, Mike, ed. *British Photography in the Nineteenth Century: The Fine Art Tradition.* Cambridge: Cambridge University Press, 1989

Welling, William. *Collectors' Guide to Nineteenth-Century Photographs.* New York: Collier Books, 1976

White, Annie Randall. *Twentieth Century Etiquette.* N.p., 1901

Williams, Val. "*Cultural Sniping: The Art of Transgression* and *Family Secrets.*" Creative Camera 335 (August–September 1995): 37–8

– *Who's Looking at the Family?* London: Barbican Art Gallery, 1994

Willumson, Glenn. "The Getty Research Institute: Materials for a New Photo-History." *History of Photography* 22, no. 1 (spring 1998): 31–9

Wind, Edgar. "The Revolution of History Painting." *Journal of the Warburg Institute* 2 (1938): 116–27

Yates, Frances A. *The Art of Memory.* London and Henley: Routledge and Kegan Paul, 1966, 1972

Zacharias, Lee. "The Photograph Album." In *Helping Muriel Make It through the Night.* Baton Rouge: Louisiana State University Press, 1975

Zunz, Olivier, ed. *Reliving the Past: The Worlds of Social History.* Chapel Hill: University of North Carolina Press, 1985

INDEX